Canada

Photographs by Mike Grandmaison | *Text by Shelagh Rogers*

KEY PORTER BOOKS

Library and Archives Canada Cataloguing in Publication data available upon request

ISBN-13: 978-1-55470-219-0
ISBN-10: 1-55470-219-4

The publisher gratefully acknowledges the support of the Canada Council for the Arts and the Ontario Arts Council for its publishing program. We acknowledge the support of the Government of Ontario through the Ontario Media Development Corporation's Ontario Book Initiative.

We acknowledge the financial support of the Government of Canada through the Book Publishing Industry Development Program (BPIDP) for our publishing activities.

Key Porter Books Limited
Six Adelaide Street East, Tenth Floor
Toronto, Ontario
Canada M5C 1H6

www.keyporter.com

Text design: Peter Maher
Electronic formatting: Jean Peters

Printed and bound in Canada

09 10 11 12 13 6 5 4 3 2 1

*To my wife Annette Rayner and our two daughters, Vanessa and Nadine Grandmaison
And to my mother Thérèse Grandmaison and the memory of my father Ti-Jean Grandmaison MG*

To Charlie, mon beau and to Dorothy Williamson and Patrick Lane for the directions SR

ACKNOWLEDGMENTS

A book project of this magnitude requires the assistance of many. While making images across this vast country, many people have offered their support, advice and generosity over the years which has made my task that much easier. For this, I would like to take this opportunity to thank:

My parents, Thérèse and Ti-Jean, who always supported me and my siblings in our goals. Their support always came with unconditional love, and through their generosity, their hardworking ethic and sound family values, gave us a tremendous start in life.

Dr. Gérard Courtin (Laurentian University) for teaching botany in an interesting and enjoyable manner, and to the Biology Department for creating a wonderful learning environment.

My former colleagues at the Canadian Forest Service for the camaraderie and for so eagerly sharing their knowledge and experience of the natural world.

Dick Toews (Photo Central) and Gregg Emslie (Technicare) and their staff for ensuring I was never without the proper equipment no matter where I was travelling across Canada.

Paul and Shirley Martens (The Lab Works) and their staff for processing my film and prints with the proper care and always with a smile!

Rob Peters (Circle Design) and his wonderful team (past and present) for making me "look good."

Freeman Patterson who, through his images, teachings and writings, has given so much to the Canadian photographic community.

My photography colleagues across Canada for always sharing. The Canadian photographic community must be the friendliest bunch on earth!

Shelagh Rogers for not only writing passionately about Canada but also for sharing her passion of this country and its people as host of CBC's radio program *Sounds Like Canada*.

Fine art prints of Mike's images are available by contacting Mike Grandmaison at (204) 254-3131,
or mike@grandmaison.mb.ca
www.grandmaison.mb.ca

My publisher, Key Porter Books, for the opportunity to produce this collection of images. In particular, Michael Mouland (senior editor) and Peter Maher (art director) have been most steadfast in ensuring that this book closely reflects my vision of this country.

My family and friends across Canada who have always welcomed me, no matter what time of day I showed up on their doorstep. Whether for a cup of coffee, a chat or a warm bed, I'm truly grateful for their hospitality over the years.

My wife Annette who is always present at my side. She has been a loving companion and dedicated mother of our two wonderful daughters, Vanessa and Nadine. She not only coordinates the family activities, she also keeps my photography business running smoothly. I am forever grateful. MG

Many individuals have lead me to really see this country. Chief among them are our poets, best in the world.
CBC Radio has given me the opportunity to travel this land as part of what I do for a living. I am grateful for that and for "my people" at *Sounds Like Canada*. My thanks to Key Porter for the invitation to write, and to Saint Michael Mouland, for making me better at it. Christopher Broadhurst taught me to see the world in living colour. And I must thank my parents for those happy summers at the cottage and for everything else. SR

1. A solitary cottonwood covered in hoarfrost, in the middle of the open prairie is a testament to the hardiness of all living things found in this northern climate. Yet, in this struggle, there is simplicity, elegance and beauty to be found.

2. Tombstone Range Along the Dempster Highway, Yukon

Left: Canadian Rockies at Saskatchewan River Crossing, Banff National Park, Alberta
Middle: Mule deer, near Mud Creek, Saskatchewan
Right: Lighthouse at Woody Point, Gros Morne National Park, Newfoundland

Contents

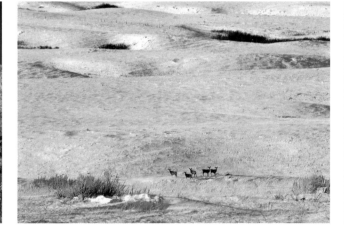

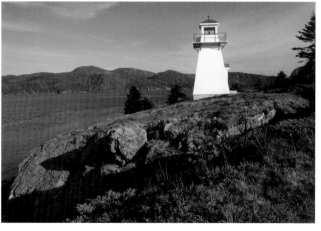

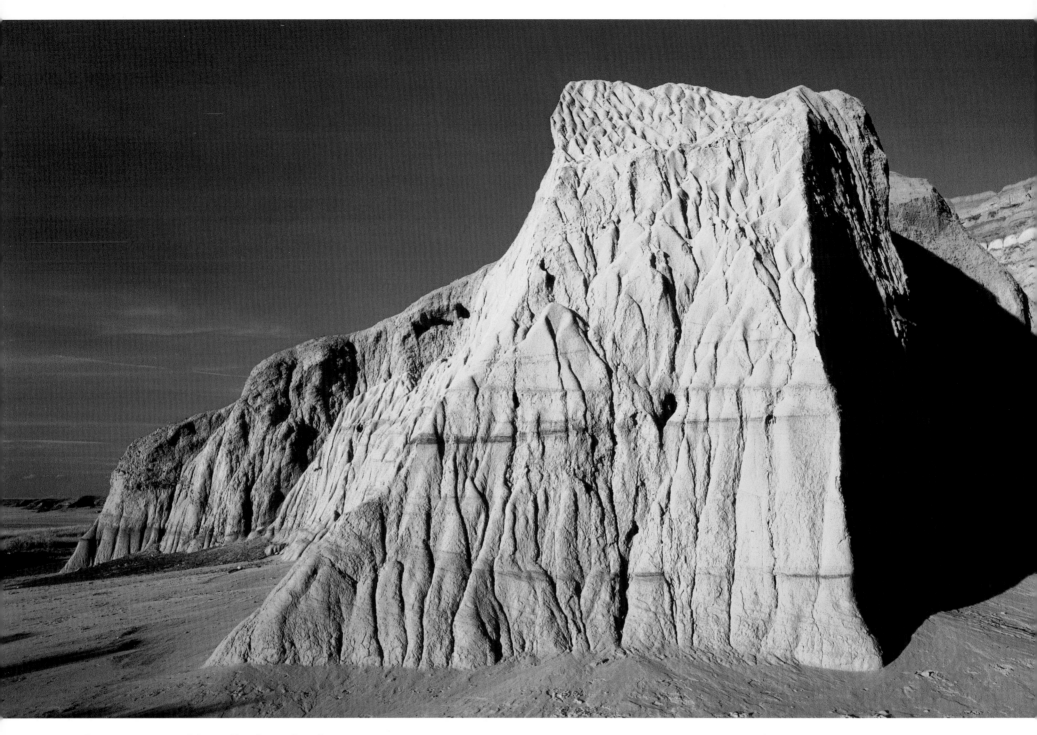

Castle Butte, Big Muddy Badlands, Saskatchewan

I am having an affair with Canada. Every place I visit, intoxicates in its own way. I form relationships with these places, even if they are not long term. They follow the usual pattern: a casual, if cautious, approach. Then a date for further exploration. Next, I get physical: climb its mountains, walk its paths, and swim in its waters, depending on the geography, and at night, drink in its bars. If it all clicks, I begin wondering if we could live with each other, so I pick up a local paper and check out the real estate listings to edge this relationship toward something a little more permanent.

Maybe my feelings for Canada are heightened because I travel frequently as part of my job with CBC Radio. In the past year, for example, I have been smitten by places as diverse as Bruno, Saskatchewan; Yellowknife, Northwest Territories; and Woody Point, Newfoundland. When I left each of them, as the plane lifted off, there was a golf-ball size lump in my throat and my eyes were full of tears. When I fall, I fall hard…until the next place comes along. Raymond Carver, the American author, once wrote "the heart is a

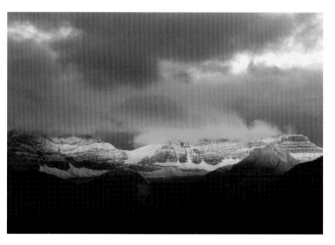

Canadian Rockies in storm light near Canmore, Alberta

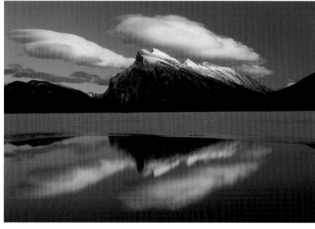

Cloud reflection in Vermillion Lake, Banff National Park, Alberta

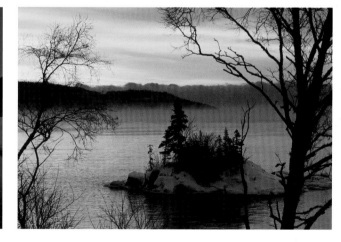

Lake Superior dawn, Rossport, Ontario

hotel," and I take some comfort from this. When I come home to Vancouver, one of the most spectacular cities on the planet, I have to retreat from this new-found ardour.

"Retreat" is an interesting word. It's what the glaciers did after carving out so much of the land. It can signal an advance, like the advance of spring when a long winter retreats. And it also can mean the place in the wilderness I'm hiding out in right now as I write, which is a cabin on Gabriola Island, British Columbia, overlooking the Strait of Georgia and the mountains of the Coast Range in the distance. There are amenities, so it's not the raw wilderness experience of a voyageur trek or even an Outward Bound weekend. I suppose there is "hard" wilderness and "soft" wilderness, just as there are "hard" lofts and "soft"

lofts in the trendy urban centres. Hard lofts don't have plumbing and sometimes don't have heating. They remain closer to their original industrial purpose than the soft lofts with running water, flush toilets, heating, and sand-blasted brick.

My first encounter with the wilderness was soft. We had a cottage in the middle of a landscape full of towering Scots pines, crocheted ferns, and huge boulders with bibs of lichen in lurid shades. It was about forty-five minutes from Ottawa, at a lake in the Gatineau Hills, in that area of Québec featuring towns with a do-si-do of English and French names: Templeton-Nord, St. Pierre-de-Wakefield, Perkins-sur-le-Lac.

The first thing I can recall about being there is the smell of the place—the tang in the air from the trees; the sour but not unpleasant smell from

the farmers' fields; a slightly acrid scent from the oil used to slick down the dust on the dirt roads; a cotton-candy sweetness from the meadows.

Then there was the light—a dramatic play of it in the forest that changed constantly, and the sunlight reflected off the lake like a million diamonds. My all-time favourite light show was *l'heure bleue*, "the blue hour," when the sky, just before darkness descended, was a deep and dramatic shade of blue like you would find on a Noxzema jar. Then there was the light of dawn, warm and "sweet," as Mike Grandmaison, whose expressive images of Canada lie ahead, likes to call it. Even as a child, I was an early riser, waking to "sweet light."

Our cottage, built in the forties, was pale yellow with dark green trim and had a

 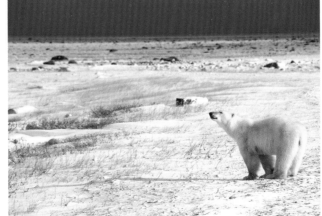 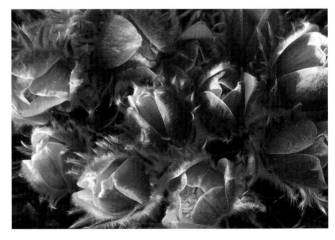

wraparound verandah. Inside, it was crammed with antiques that were regarded as junk in the sixties, a decade in which the trend was for decors dominated by modern furnishings. In that era of Tupperware, Shake and Bake, and Hamburger Helper, the lake was a place where you could retreat from the growing culture of speed. We had a generator that was run only after dinner, so all the electrical appliances were dormant during the day. There weren't many people in the area then and even fewer who had motorboats, and personal watercraft had yet to be invented. My mother did the washing in the lake while perched on a rock. It was work, but it was a kind of meditative leisure at the same time. Wood had to be split for the old stone fireplace and the hardworking, sturdy six-legged cast-iron stove in the kitchen.

I recall the quiet and serenity of those times. We had siestas in the afternoon when it was too hot to function. Everything seemed to stop—the cicadas, the birds, the fish. There was no sense of clock time, just a long, lazy, endless stretch. The tall trees and ageless, elephantine rock created a sense of being part of eternity. There was something sacred about the spirit of the place, a quality enhanced when the bullfrogs performed vespers in their basso profundo or when, in the middle of the night, a big trout would leap out of the water and make a splash for no reason at all.

As a child, I found the wilderness was a source of much intrigue. I would go out on my own with no fear, and discovered all sorts of secrets: discarded birds' nests with eggs that seemed to radiate a translucent light from within;

patches of gold where mica had peeled off the rocks; a shaft of sunlight beaming underwater at four in the afternoon, illuminating the minnows and the perch under the dock; the heron whose precise fishing weapon was a needle-nose beak; the play of the intertwined branches as I lay on the ground, looked up, and dreamed with my eyes open—the wonder of it all.

That was just one small piece of Canadian heaven and all I knew at the time, except for my home in Ottawa. I didn't go anywhere beyond the region known as the Outaouais (which includes southwestern Québec) until the Centennial year when our family went to Montreal for two weeks for Expo. I got to drive there with my father in his new Mustang convertible. It was, at that time and to this day, one of the coolest models on the road.

Left: Water flowing over ice at Tilton Lake, Sudbury, Ontario
Middle: Polar bear on the tundra, Churchill, Manitoba
Right: Prairie crocus at sunset, Sandilands Provincial Forest, Manitoba

What a car! He let me put on my favourite radio station at the time, CFRA, and we listened to the Monkees singing "Daydream Believer," the Doors and "Light My Fire," a group called the Box Tops and their hit, "The Letter," and the only tune my father really liked—"Something Stupid" by Frank and Nancy Sinatra.

The wind blew through my Twiggy haircut, and we were on the road to a new destination. Near Montreal, I thought we were really just going to the cottage again because the land, trees, and rocks all felt so familiar.

That was the summer of '67. In the summer of 2004, the singer k.d. lang left her voiceprint on a personal selection of Canadian songs that ignited her emotions. The CD, called *Hymns of the 49th Parallel,* includes songs penned by Neil Young,

Joni Mitchell, Jane Siberry, and Leonard Cohen, among others. k.d., now living happily in Los Angeles, calls it her love letter to Canada. You can take the girl out of the country, but you can't take this country out of the girl.

To select the songs she would record, she went through decades of Canadian folk music— a happy assignment!—and she began to notice how often Canadian songwriters turned to the landscape for their imagery and metaphors. She thinks that songs such as Jane Siberry's "The Valley" or Joni Mitchell's "Jericho" are innate—that is, we know the land, so we carry the songs within us.

Her roots still show. k.d. has the country in her blood, so much so that she credits the Prairies with the way she sings: "Nature had an amazing impact on me growing up in Alberta: the vast

openness, the plains being so minimal and when there was an event, it was a tree or a barn or something. It really had an impact on how I approach my vocal style, which is pretty straightforward—long tones and holding the vibrato back until the last minute. . . . So much horizon and vast openness as a kid . . . I think that's why I have a tendency to sing very loudly. There wasn't anyone around to really hear me, so I reached out far."

k.d. used to get on her motorcycle and head off to empty hockey arenas or churches to sing. She would walk in and sing her heart out with no one else around. All that great Canadian space— she loved it, and it gave k.d. her vocal wings.

Now she compares her feelings about Canada to those for a lover you can't forget—the one

Left: Gulf of St. Lawrence shoreline, Cap Chat, Québec

Middle: Great Gray Owl, Duck Mountain Provincial Park, Manitoba

Right: Wild-lilies-of-the-valley, Cap-des-Rosiers, Québec

you always cast your mind back to. For k.d., these feelings are acute because, since she doesn't live in Canada at the moment, it's unrequited. Will she come home? "One of these years," she says.

I've experienced that "lover-you-can't-shake" feeling many times. Recently, I was in Gros Morne National Park for a festival featuring the stories and songs of some of the best of Newfoundland's writers. It is an area of such vast and varied beauty: fjords, alpine meadows, waterfalls, precipitous cliffs, deep valleys, unspoiled lakes. There was that feeling of familiarity again. I felt I knew the landscape. It was already a part of me. It reminded me of the Gatineau Hills, and I learned from Greg Dunning, a local geologist, that in fact it is the same rock from the same fault line.

Over millions of years, the rocks beneath Gros Morne went through a transformation that produced a rare geological phenomenon. A continental shelf shifted and large sections of land collided, eventually eliminating a primordial ocean. Rocks that had been buried many kilometres beneath the earth's mantle emerged at the surface. It is as if the earth turned itself inside out, forming the "tablelands," where you can walk on the crust, the inner earth. There is nothing like it anywhere else in the world, and the United Nations Educational, Scientific, and Cultural Organization designated it a World Heritage Site in 1987. This beautiful, almost alien, landscape was the result of shifting tectonic plates.

Research into the theory of plate tectonics continues at Gros Morne. And it was a pioneering Newfoundlander, Professor Hank Williams, who put forward the idea that Newfoundland originated because of the continental collisions of ancient land masses.

Another famous east coast Hank, the country singer Hank Snow, wrote a song called "I've Been Everywhere" and, in spite of his Canadian roots, the song lists dozens of American place names.

The great Canadian balladeer, Gordon Lightfoot, has sung passionately of Canada's beauty and history. Like k.d. lang, the land is in his voice—sweet and strong, dramatic and restrained, tough and tender. Gordon is a licensed pilot and he has criss-crossed this country many times. When I was younger, whenever I saw a small plane flying low overhead, I'd yell, "Hi, Gordon!" I bet he's been everywhere. It's clear in his songs.

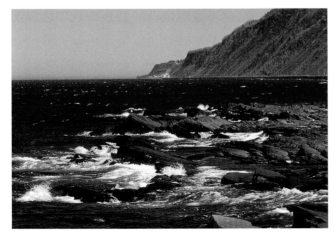
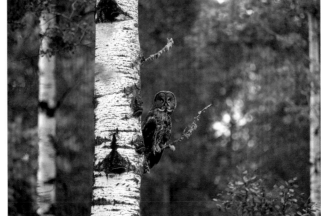
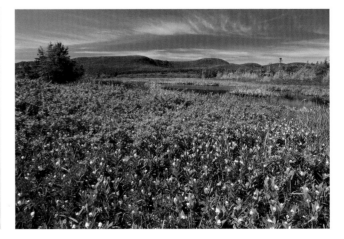

Some people try to see Canada's "everywhere." My friend, the writer and broadcaster Peter Gzowski, used to talk about how, upon graduation, all his friends headed for Paris or Zagreb. And Peter? In early 1957, he hopped on a train to Moose Jaw, Saskatchewan, where he was to be the city editor for the *Times Herald*. Peter had a wonderful vignette about the train ride to Moose Jaw. Seated beside him was an Englishman, who told him that the Prairies were "the biggest expanse of bugger all" that he had ever seen in his life. Peter saw a lot of this country as the host of *Morningside* on CBC Radio, as a pan-Canadian promoter of universal literacy, and as an author who went on many book tours. He didn't make it to Paris until he was in his sixties, and I think he was kind of proud that it had taken him so long to get there.

On the prairies I find an intimacy with the sky, a feeling that I don't have anywhere else. There are no mountains and few trees to get in the way. You're surrounded by an expanse of the heavens. Until I visited the Prairies, I was skeptical of the ratio of sky to land in the landscapes of the Prairie painter William Kurelek, nor could I believe the colours he used—sometimes the sky in his paintings was green. But when I was there and watched the sky turning a shade of mint green before a thunderstorm, I offered up an apology to William. He was the painter of the prairie sky in its many moods.

Last year the sky put on a spectacular light show during a great prairie supper in Bruno, Saskatchewan, where my step-grandmother Marie lives. The meal was served in the basement, as that was the coolest place in the house. We had a summer buffet of dilled potato salad, Caesar salad with freshly picked garlic, summer sausage made on the farm, homemade bread, pickles, relish, chicken that tasted like chicken, choke-cherry wine, and raspberry cordial. At about 10:00, I thought it was time for a walk to work off some of this bounty. I emerged from the basement to see the northern lights, crimson and pale green sheets like curtains in the sky. My relatives were rather blasé about the spectacle and couldn't be roused from their seats to watch. To me, though, this was like seeing the restored colours of the Sistine Chapel without having to leave the country.

Canada is my destination, my place of exploration. I have chosen, as the tourist ad says,

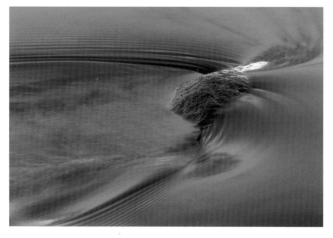
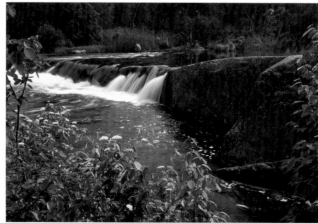
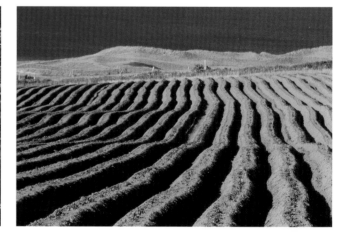

to "see Canada first." I've driven the entire length of the Trans-Canada Highway a number of times, but feel that I've hardly been anywhere. And, as this book shows, the country is so much more than a ribbon of highway. You discover the most interesting parts of the country when you get off the asphalt and get lost in small villages where time is slower; when you venture into forests and walk off the trails, feeling as if you were the first person to ever visit this wilderness; when you lie in the middle of a field and watch for faces or animal shapes in the clouds. There is nothing like this carefree feeling of not knowing where you are in this GPS world, and not caring, but nevertheless knowing that you are home because this is Canada.

To see the country best, my chosen mode of transportation would be my feet. I once proposed walking across Canada as a radio program, starting in September in Newfoundland and ending in June in British Columbia and somehow getting up north at some point. I called my proposal, variously, "Shelagh Takes a Hike," "A Walk in the Snow" or "Walk the Walk, Talk the Talk." The idea occurred to me after I read Wayne Johnston's stirring account of Joey Smallwood's mythical walk along the entire Newfoundland railway (with his suitcase slung over his shoulders in the manner of a cigarette girl) in *The Colony of Unrequited Dreams*, and how Joey got to know the people and the communities of Newfoundland. During the walk, he conducted a union drive, signing up railway sectionmen as he went. My walk, I thought grandly, would address the disparity between urban and rural centres. Like Smallwood, I would visit places off the main line, and all voices would be heard (cue the orchestra—something along the lines of "Jerusalem" or "Land of Hope and Glory," maybe even "The Maple Leaf Forever"). CBC Radio would come to the people. I thought that by walking across Canada, I would be approachable—no office, no phone, no e-mail or voicemail—a woman of the people.

When I regained consciousness, as Dave Broadfoot's Sergeant Renfrew used to say, I still thought it made sense, even as a way for a national program to commit to the word "nation" in "national." There would be the bonus of losing the 20 pounds or so that have dogged me for a decade.

Left: Whirlpool Creek detail at sunrise, Riding Mountain National Park, Manitoba
Middle: Rainbow Falls, Whiteshell Provincial Park, Manitoba
Right: Potato field at springtime near Cape Tryon, Prince Edward Island

The World Health Organization calls walking "the forgotten art." Bruce Chatwin, the restless English writer who loved to travel, wrote a book that was about the wonder of wandering. In *The Songlines* he wrote about how the essence of a country could be read in the stories written in the landscape. He thought that the paths of our nomadic ancestors were "vastly grander" than buildings or boulevards, cathedrals or cities. The land is grand. One of my favourite Bruce Chatwin quotes is "the pyramids are little mudpies by comparison." Interestingly, not long before Chatwin died, Greg Gatenby, founder of the renowned reading series at Toronto's Harbourfront, asked Chatwin if there was a place in the world that he hadn't been to, but would like to visit. His answer was no. Then he said,

"Actually there is one place—the Canadian Arctic." I love to imagine, in that place where souls end up, a conversation about the meaning of "north" between Bruce Chatwin, who never made it there, and the pianist Glenn Gould, who did and thought deeply about it.

Bruce Chatwin's revelations in his books, which are set in Wales, Patagonia, and Australia, often came to him during his walks. This country was discovered by people who walked or paddled, rode or dog-sledded. We are born, we live, and we die against the backdrop of the land. The historian Michael Bliss writes: "the trails we take and the trails we make and leave behind us are the signs of who we are, where we came from, where we went and where we hoped we would go." And he is right.

To see as much of the country in as short a time as possible often means that we have to fly. It's such an impossibly vast country that the plane is the most efficient way to get around. Flying from Deer Lake, Newfoundland, to Vancouver in a day (2,865 miles or 4610 kilometres) is a strange feeling. I don't like flying. It's still too much technology for me to understand. And then there's the discomfort of having to fold my legs into origami to fit into the seat. I'm afraid to look out the window, even though you can't get a better sense of, say, the cultivated land of the Prairies, which Margaret Sweatman, the Winnipeg novelist, describes accurately and imaginatively as "bolts of gingham fabric."

Mike Grandmaison, whose images make up this book, doesn't like flying either, so he takes

Left: Iceberg near Griquet, Newfoundland
Middle: Lake Superior shoreline near Rossport, Ontario
Right: Red Rock Coulee Natural Area, Alberta

the train, or drives, or walks, which, I think, gives him a feeling for scale. He has lived the length and breadth, the height and depth of what he has photographed and there's a quality of immediacy in his work. His affection for his subject matter is great, and it is reflected in his images. When I think of what he takes with him out in the field—the cameras, lenses and tripods, the reflectors and diffusers, the film and the graduated filters—I am reminded of the painters who went out into the wilds with their big wooden boxes of paints, brushes, and easels, all the equipment they needed to achieve "the desired effect" or to record, with pigments and canvas, a scene they had not expected.

Before he became a photographer, Mike was a forestry technician. His devotion to the environment and passion for nature is evident in every image. He understands the essence of his subjects, and his images are a celebration of both the colossal and intimate beauty of the land.

There is much to celebrate, but there is some requisite mourning, too. Back to my cottage for a moment. Even though I cling to my memory of the place, it has changed. There are more people, for one thing, and they now have powerboats and SUVs. They have paved the dirt roads, rolled out tennis courts, and dug in-ground swimming pools—right next to one of the most swimmable lakes in the world. The guy who bought our cottage brought all his old cars and left them to rust in the forest. We have left our debris everywhere, from the beaches of Skedans Island in Haida Gwaii to the summit of the Chilkoot Trail.

The idea of "pristine wilderness" is a contradiction in terms.

And yet, beauty abounds. There is still "wild" in wilderness. I don't need to tell you how majestic Gros Morne is (you'll see it yourself in the pages ahead) or how haunting the brilliantly named Badlands are. Or how, if you're above the treeline in Cape Dorset, for instance, you can come across a puddle of water with purple saxifrage so perfectly placed beside it that it looks as if it were designed by a bonsai gardener. It is hard to feel despair when so many small miracles abound. And this book, though it began solely as a labour of love on the part of the photographer, actively agitates against despair as it preserves the images of miracles from so many places in this big, abundant, beautiful country.

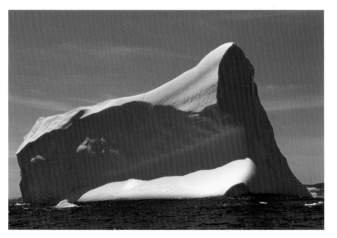

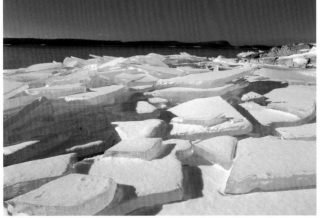

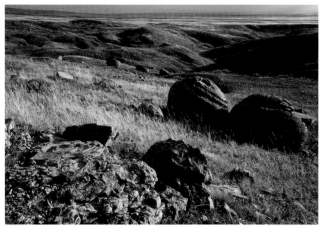

Autumn

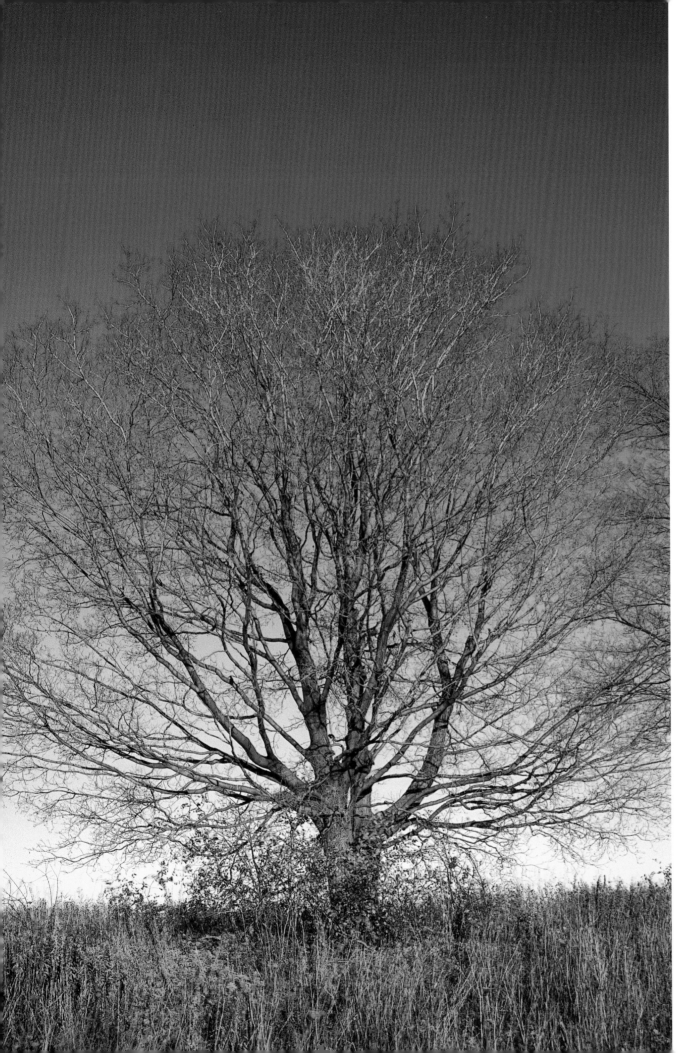

Tree in autumn, Breslau, Ontario

Autumn is such a lovely stretch in the cycle of seasons—beauty and bounty, the fall fairs of fair fall—yet when one is said to be in the autumn of life, the end is approaching. For a soundtrack to accompany autumn, I would turn to the music of Johannes Brahms or Gustav Mahler, whose works often have that autumnal, minor-key wistfulness. Fifty-odd years ago, Johnny Mercer captured that wistfulness in a song, "Autumn Leaves," which was inspired by a song with lyrics in French by the poet Jacques Prévert. Mercer didn't translate directly from the French, but kept the poetic spirit of the original. The French song was called "Les Feuilles Mortes" ("The Dead Leaves"). Now there's an uplifting title. France at the time was just emerging from the Second World War. The song was sung for the first time in 1946 by the charismatic actor and chansonnier Yves Montand. I love to think of Montand in his characteristic trench coat and fedora, standing under a lamppost, singing "Les Feuilles Mortes."

There is something about autumn that elicits melancholy, some notion of farewell, a eulogy for summer, perhaps. But with its valedictory beauty comes the cleanest air, the bounty of the harvest, and the last offerings from the garden. I am not a confident enough gardener to believe in the renewable magic of perennials. Will they really come up again in the spring? Writer Patrick Lane loves his fall garden for its depth of rich colour, the filigreed veins of leaves, for a chance to observe. In his gripping, heart-stirring memoir *There Is a Season*, he says: "The hostas sprawl like spilled gold at the feet of the firs and cedars. The monkshood have put out their last lateral blooms. They nod in the breeze like tired men in a chilly cloister." The truth of his words almost convinces me to feel more at ease with the garden and enjoy the decline of life back into the earth. About fifteen years ago the poet Lorna Crozier (who happens to be Patrick Lane's wife) wrote a saucy suite of poems—"The Sex Life of Vegetables" in a collection that is titled (and I take comfort from this) *The Garden Going on Without Us*.

My idea of paradise, even in middle age, is a giant mound of leaves. Pile them high and you can dive in and have a dry swim. Those piles make good hiding places as long as they aren't by the sidewalk and someone tries to park on your leg. Unraked leaves on a road provide a path where

you leave no tracks. When I lived in Ontario, every fall I would visit the cottage we used to own. No point in going in the winter or rainy spring—my size nines and my weight would leave too deep an imprint, but come fall, not a trace. I wasn't an invasive trespasser: a step or two off the dirt road onto the driveway, just to see if the old cabins were still standing and what kind of shape they were in, just to breathe air full of the sharp smell of spruce gum, just to catch a bolt of the clear light, watch the wind on the lake to see what Milton Acorn called "that corrugated look to water," and maybe hear the call of a loon, not to mention seeing both canopy and carpet of leaves in the Gatineau Hills. People now go on fall-foliage or cavalcade-of-colour driving tours right across the country. There are toll-free hotlines offering state-of-the-trees reports, all this for our national deciduous instrument of photosynthesis and transpiration, the maple leaf.

Autumn is one of the blessings of living in this country. How miraculous it is that at a time of year when plants, grasses, and leaves are dying that we have such a dazzling rush of colour. September and October are the most lurid months of the year. The colours are as loud as New Year's noisemakers and seventy-six trombones in the big parade. They make a joyous fanfare. Even as they subside, as they do in bleak November, winter's trailblazer, the land is not bereft. Trees are shrouded in a miasma of soft pink. The rocks are violet. And our golden land reveals itself without cover.

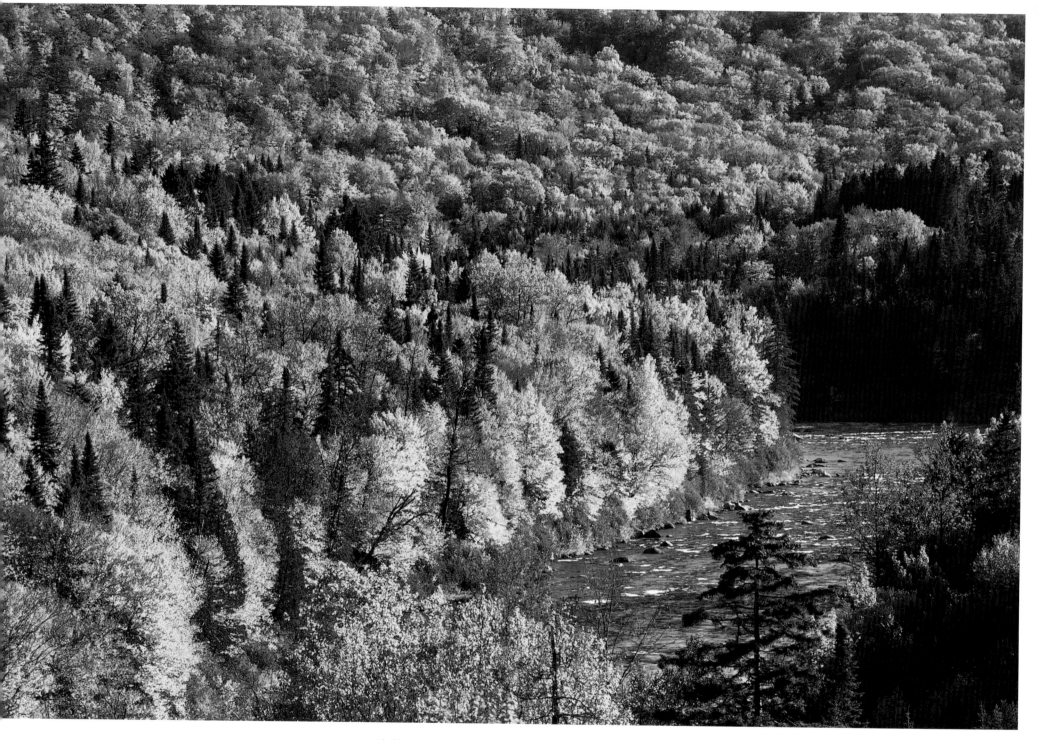

Rivière Montmorency in the Laurentians, Québec

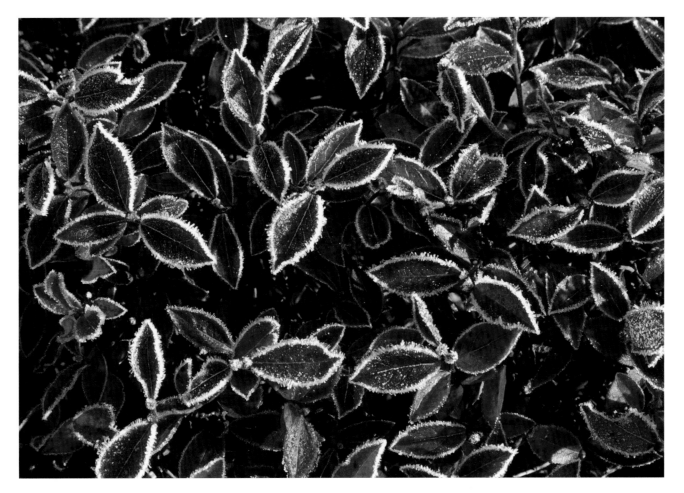

Frost on blueberry leaves, Whitefish, Ontario

OVERLEAF Autumn colours near Deux Rivières, Ontario

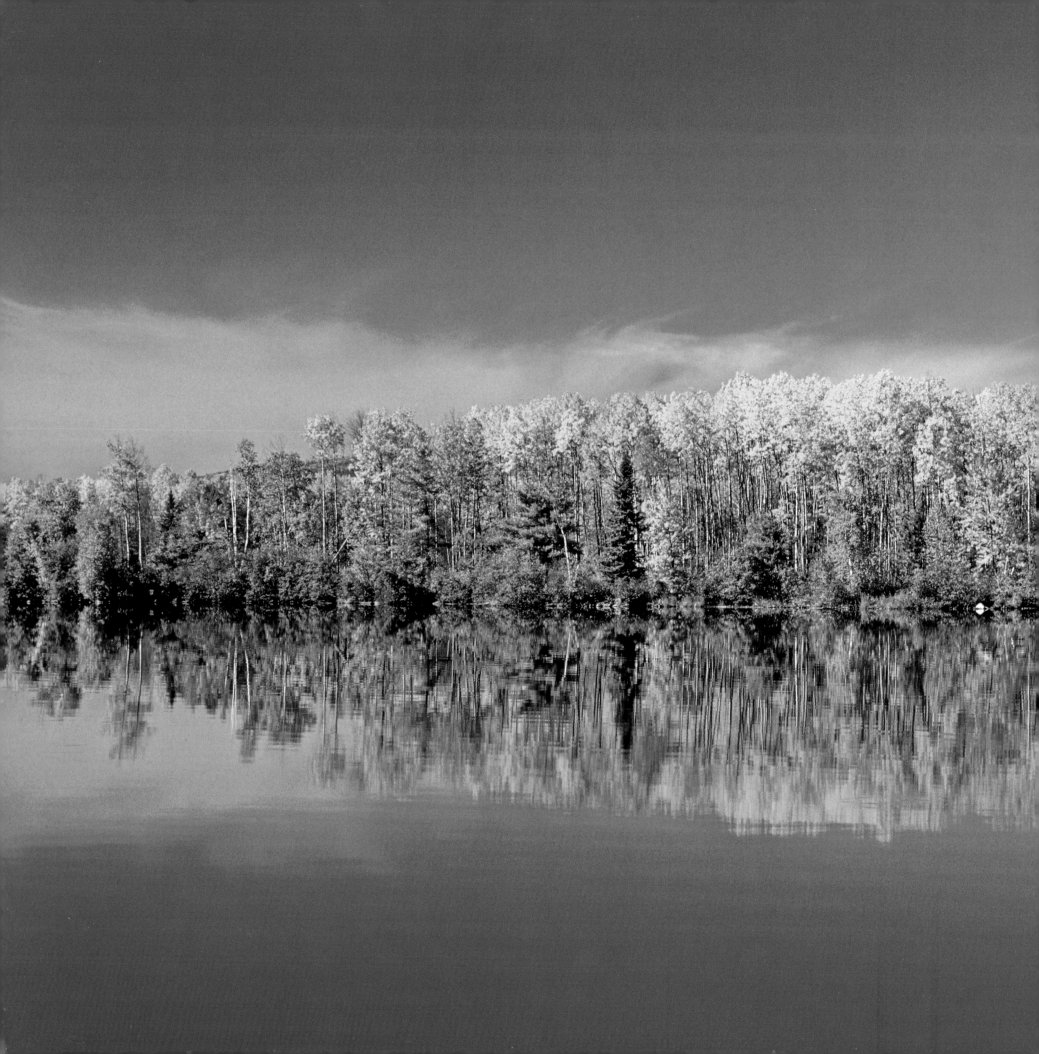

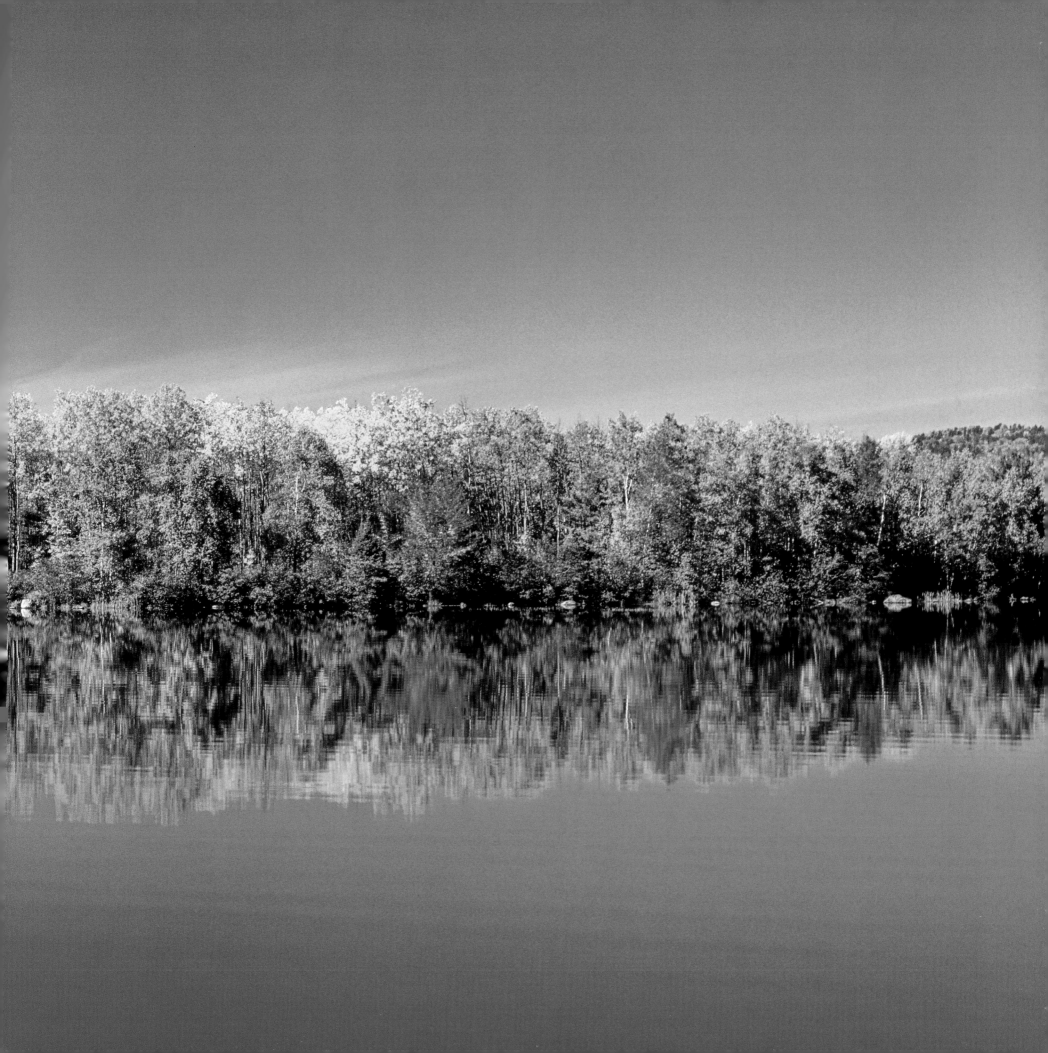

Fireweed in autumn colour, Kluane National Park, Yukon

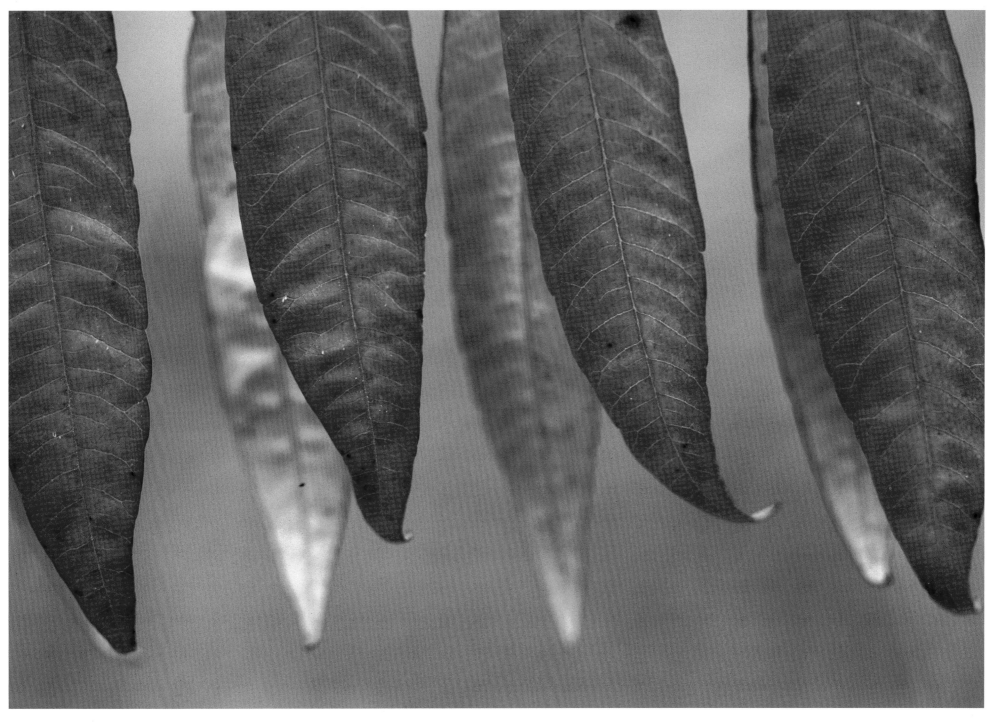

Smooth sumac leaves, Whiteshell Provincial Park, Manitoba

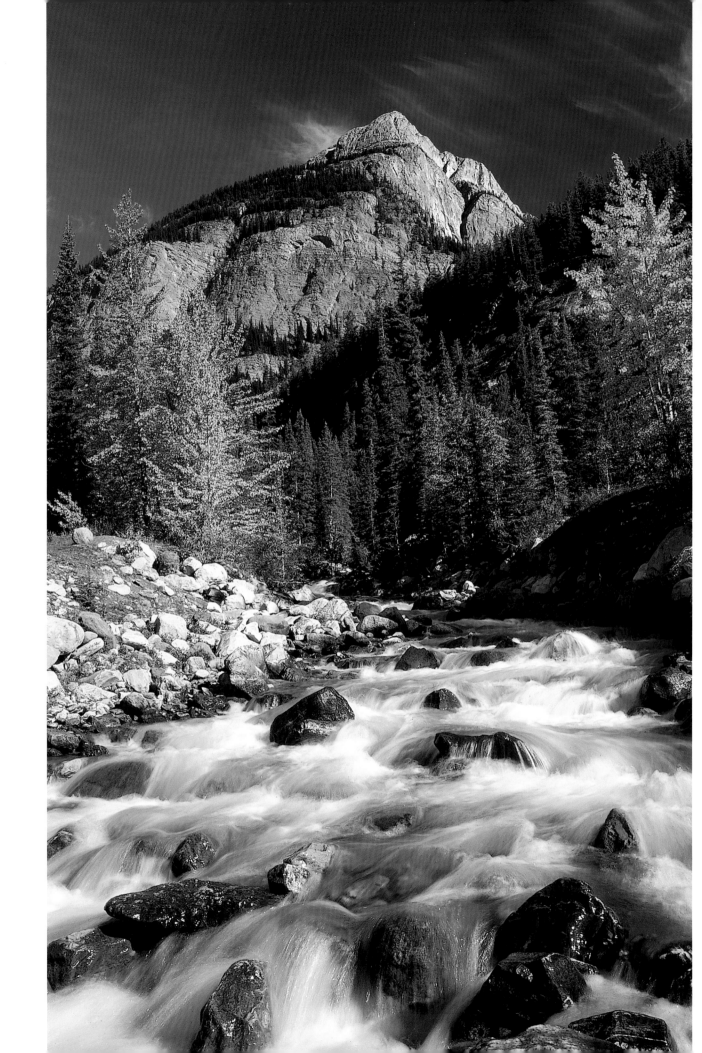

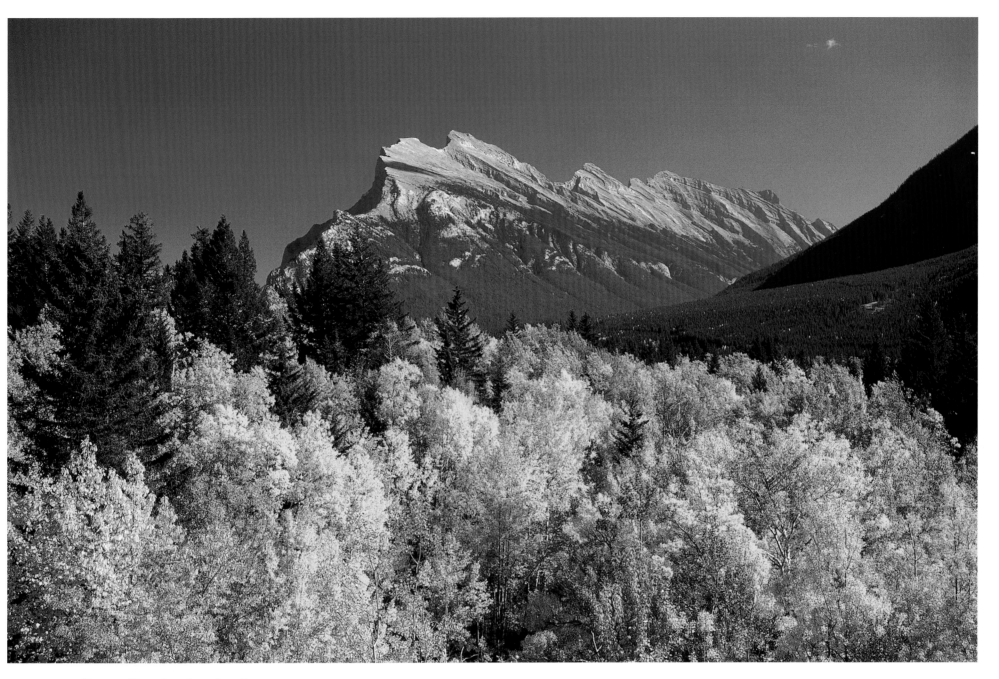

Mount Rundle, Banff National Park, Alberta

Rampart Creek, Banff National Park, Alberta

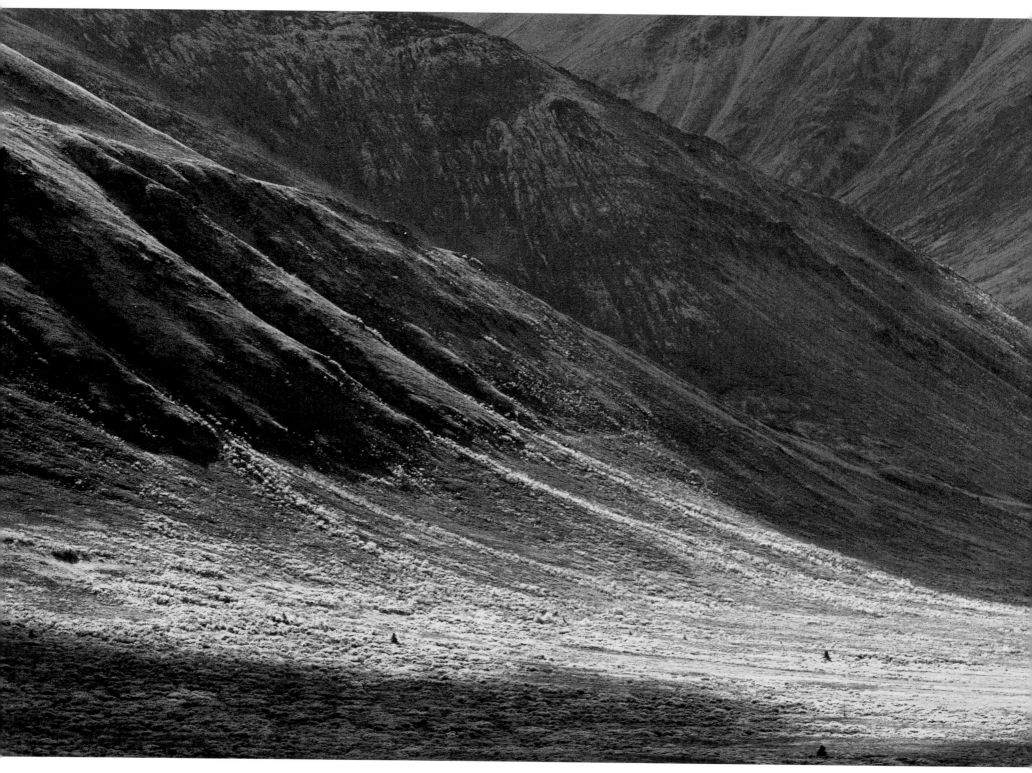

Tombstone Range along the Dempster Highway, Yukon

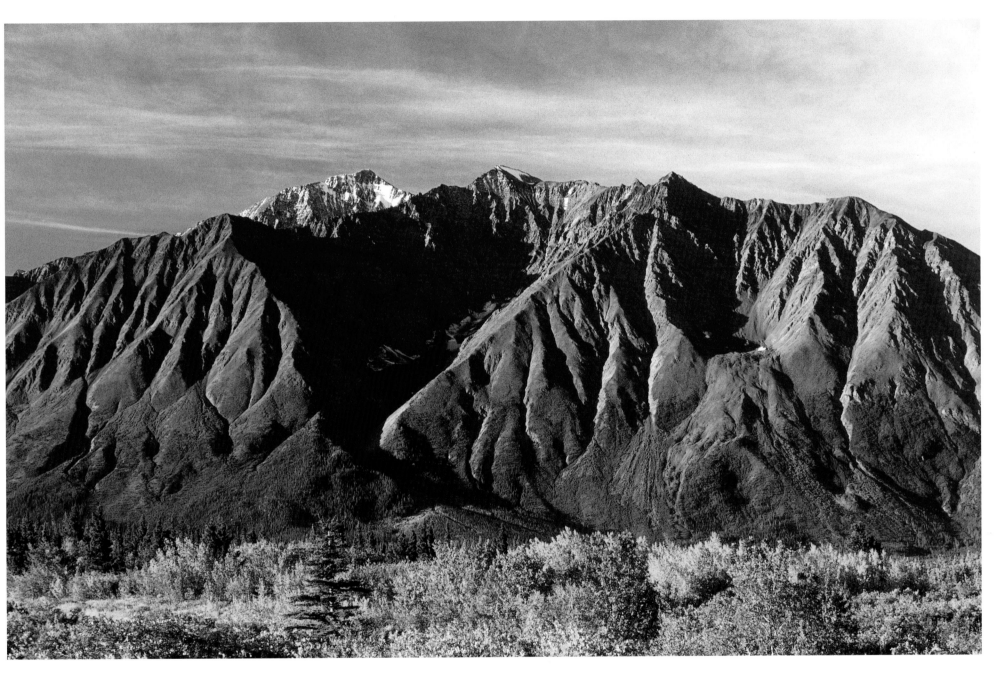

St. Elias Mountains, Kluane National Park, Yukon

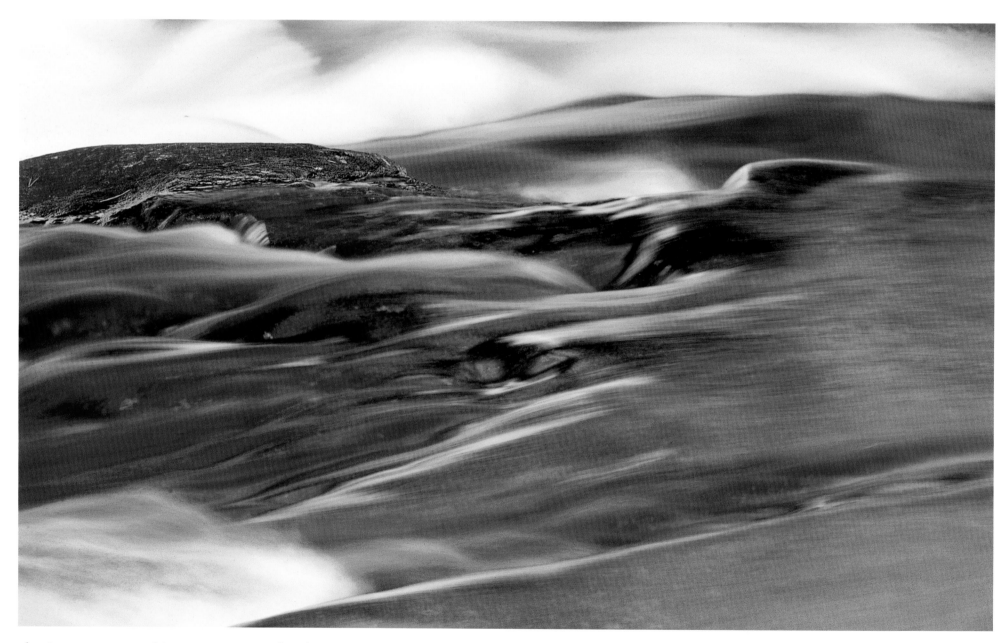

Flowing waters at Rushing River Provincial Park, Ontario

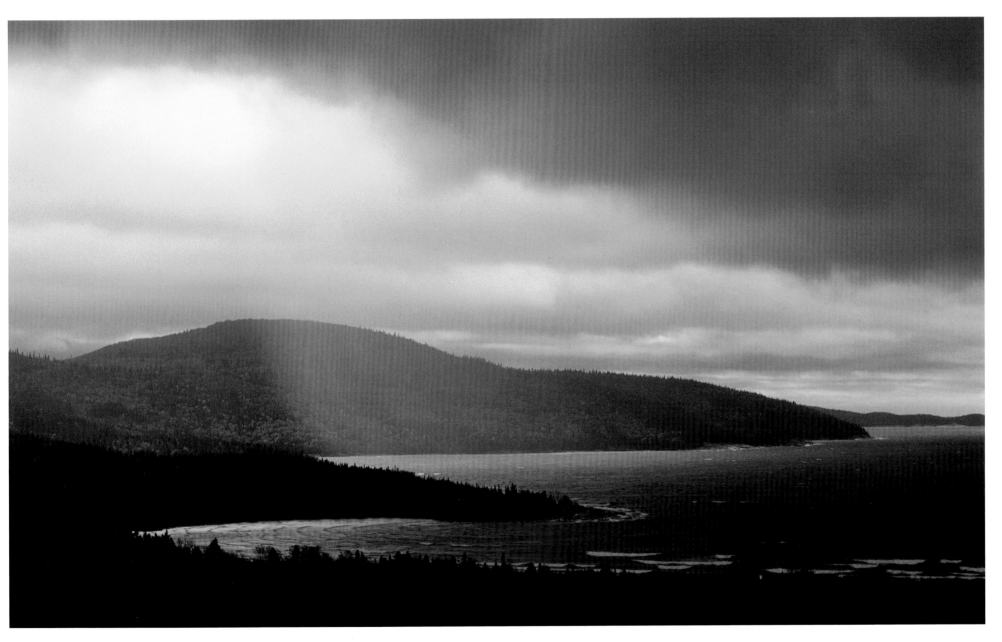

Storm, Lake Superior Provincial Park, Ontario

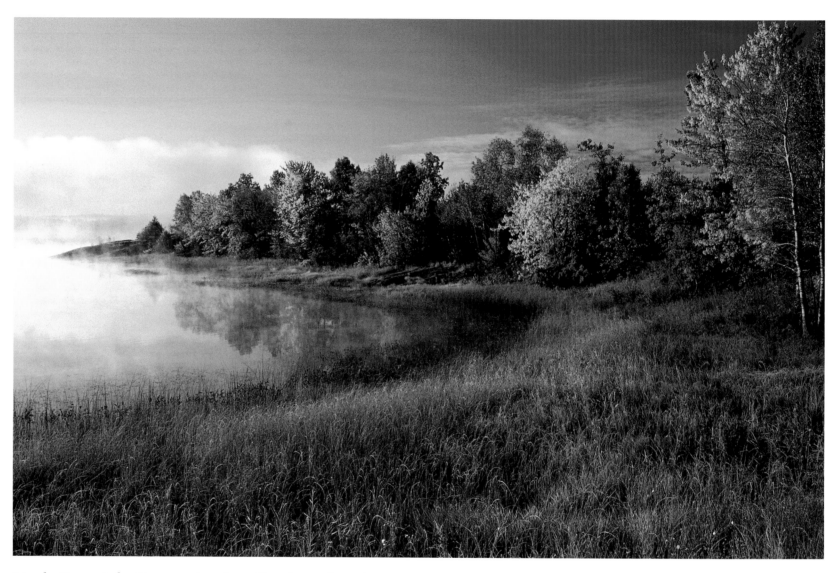

Marsh, Simon Lake Conservation Area, Naughton, Ontario

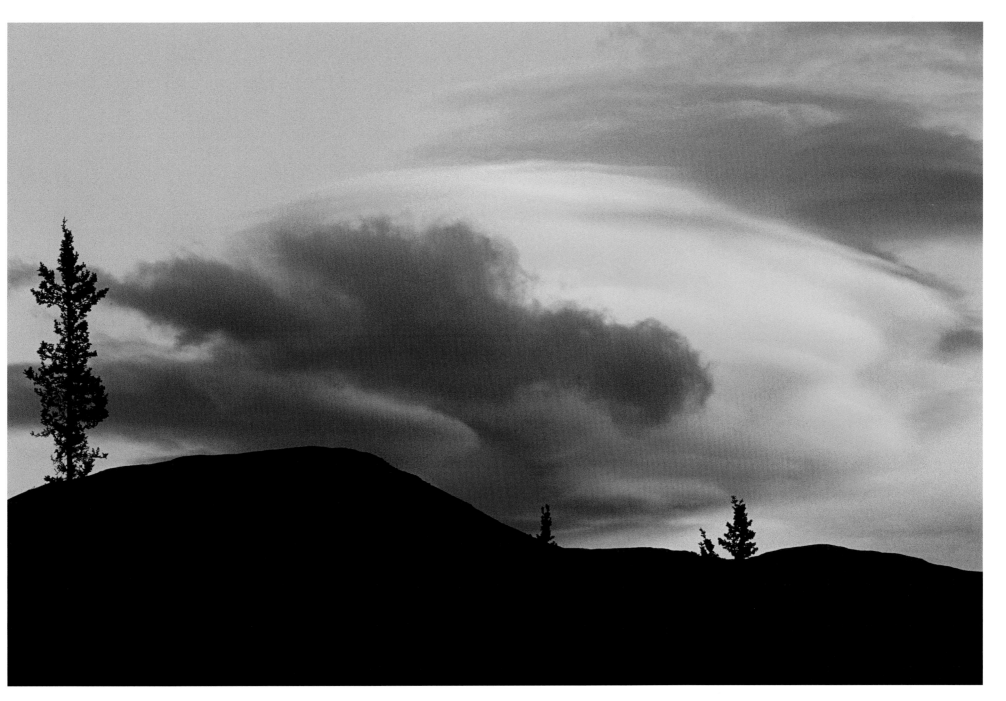

Lenticular cloud at sunset near Whitehorse, Yukon

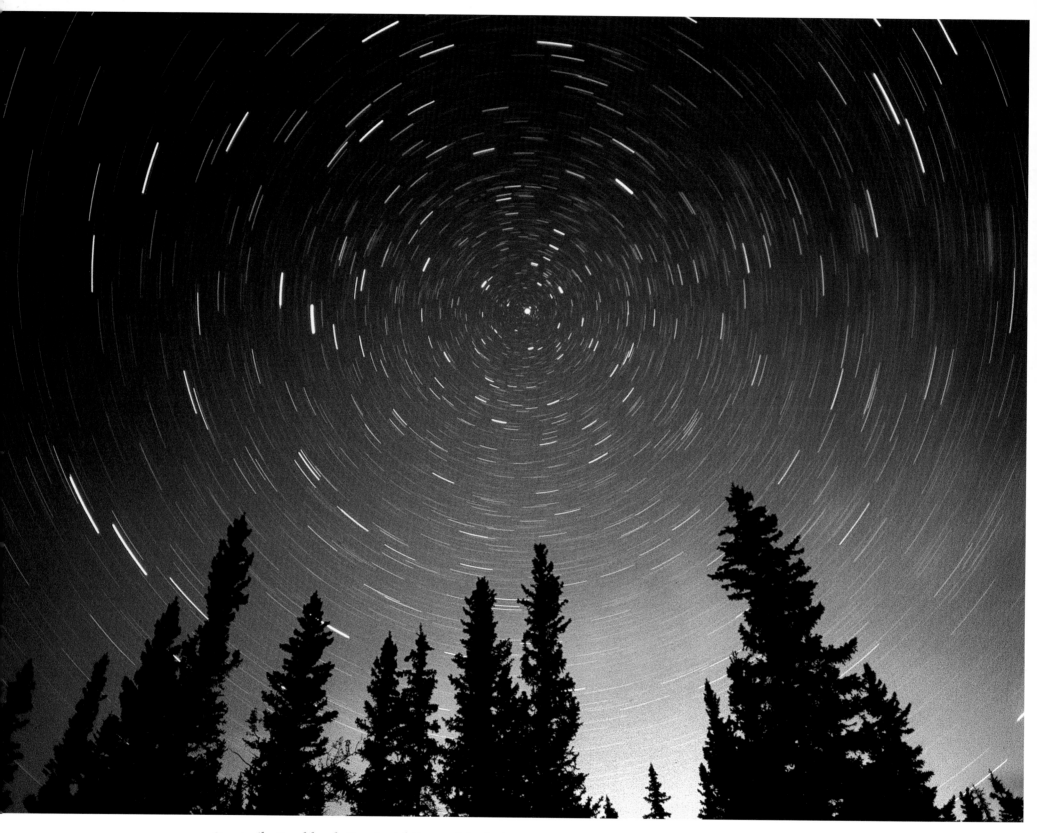

Star trails, Sandilands Provincial Forest, Manitoba

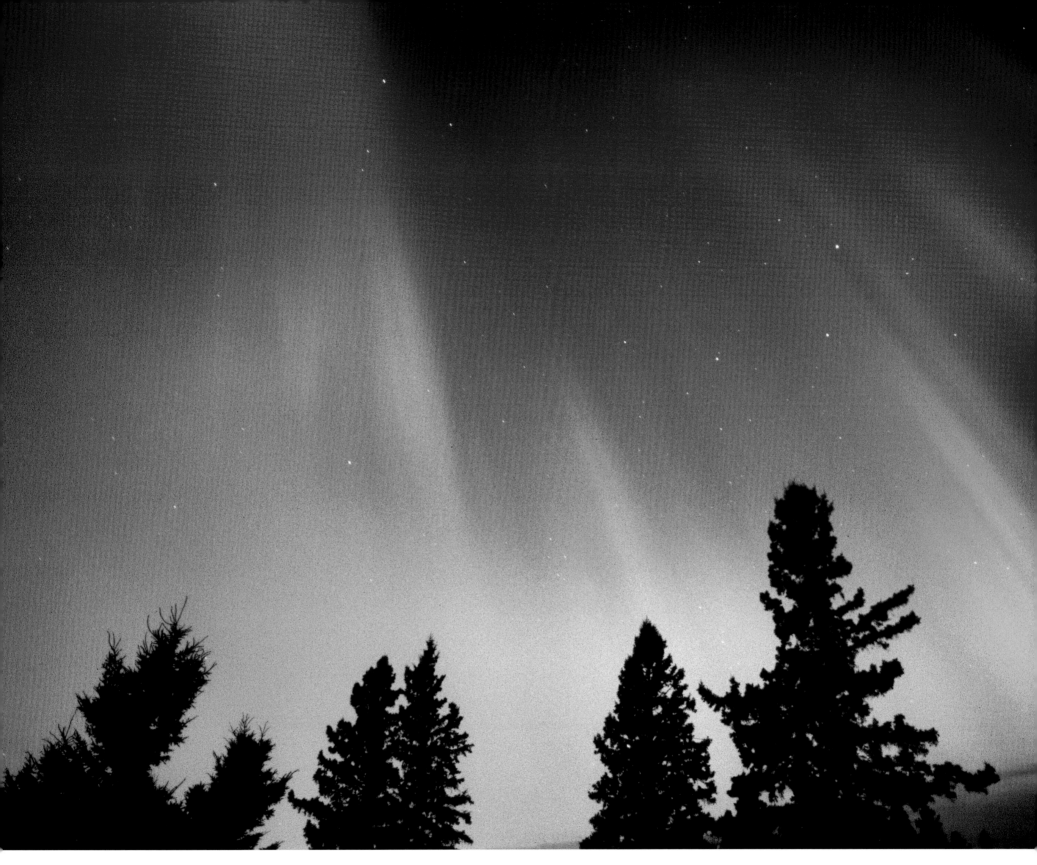

Northern lights, Birds Hill Provincial Park, Manitoba

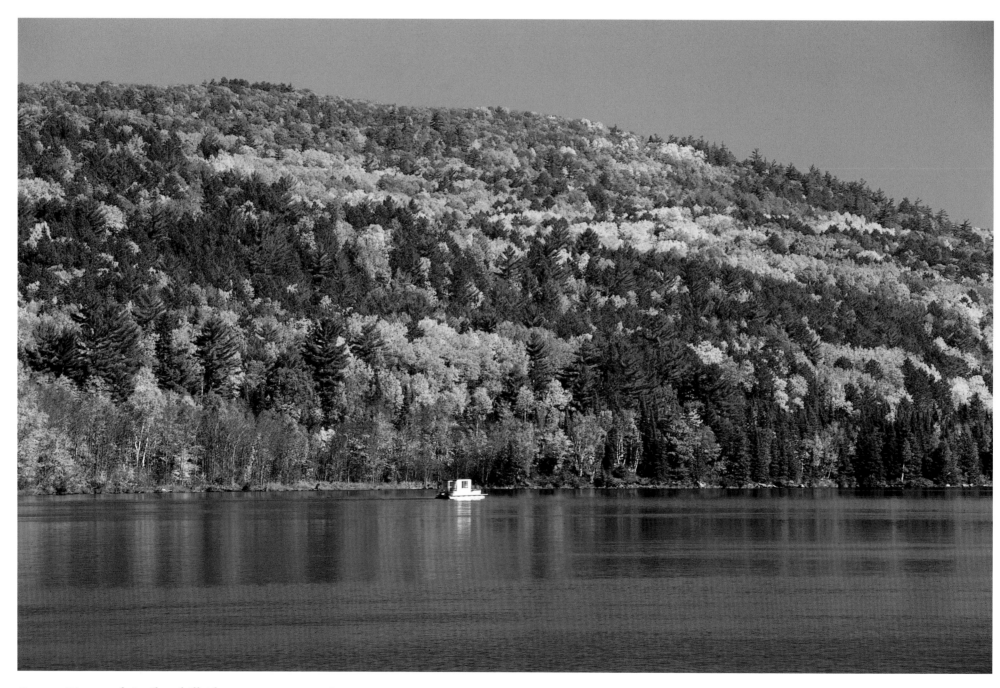

Ottawa River and Québec hillside, Mattawa, Ontario

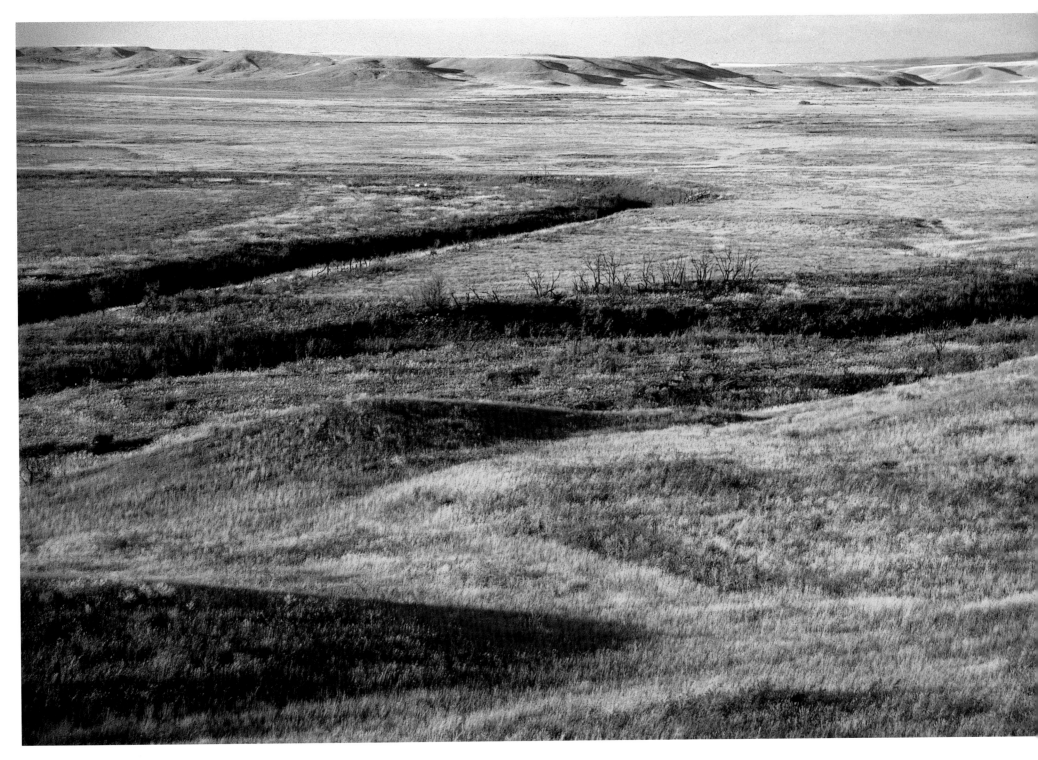

Grasslands National Park, Saskatchewan

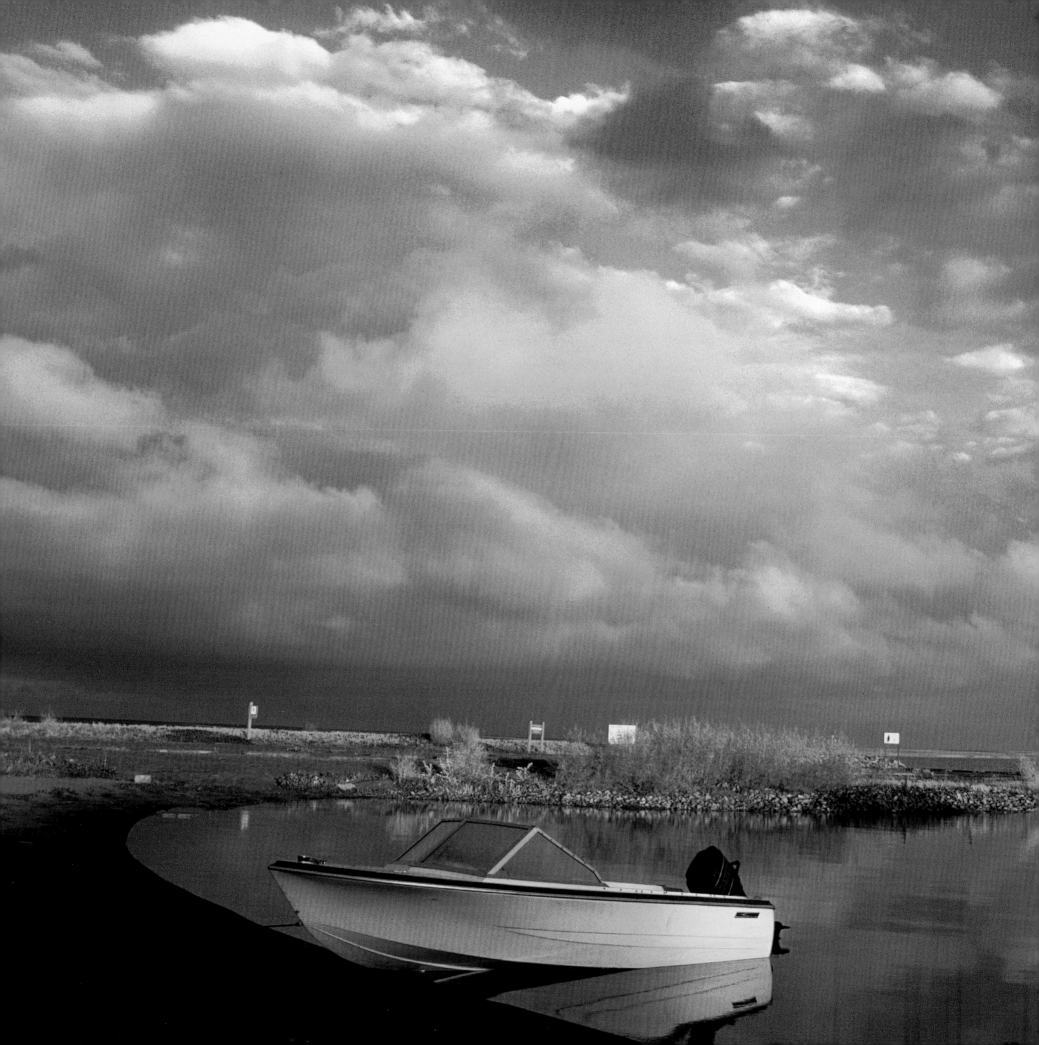

Lake Newell, Kinbrook Island Provincial Park, Alberta

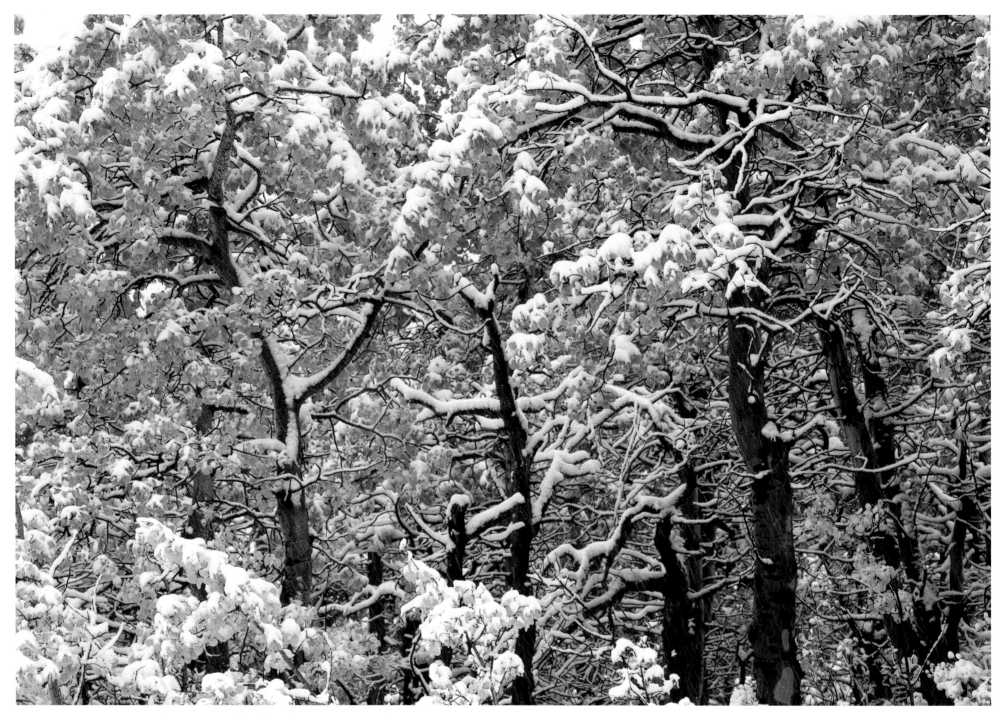

First snow, Waterton Lakes National Park, Alberta

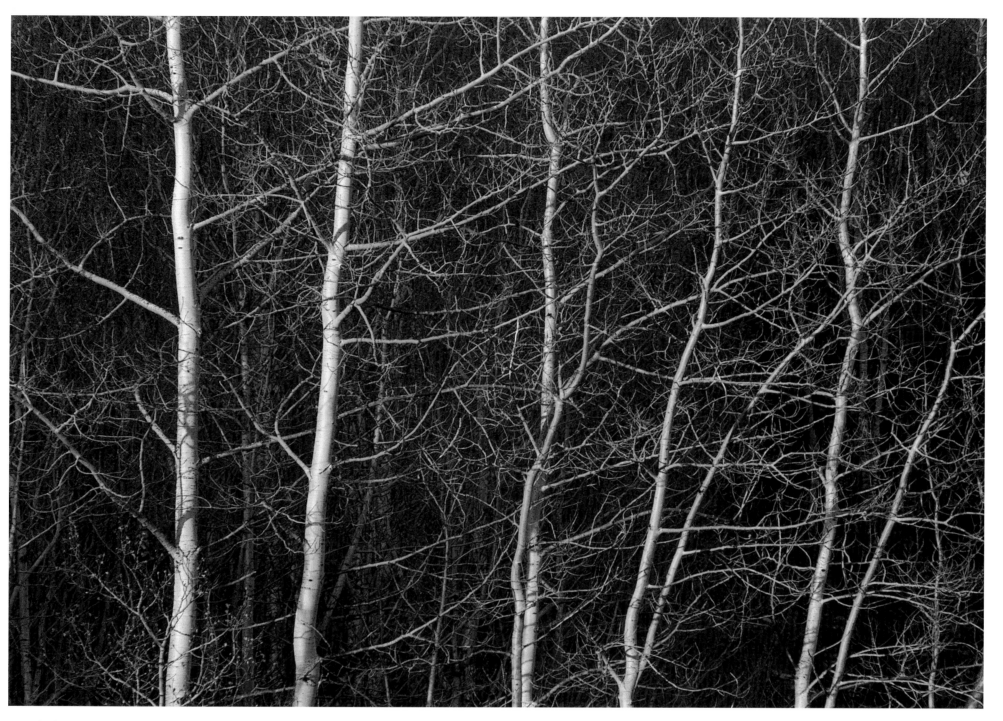

Last light on aspens, Riding Mountain National Park, Manitoba

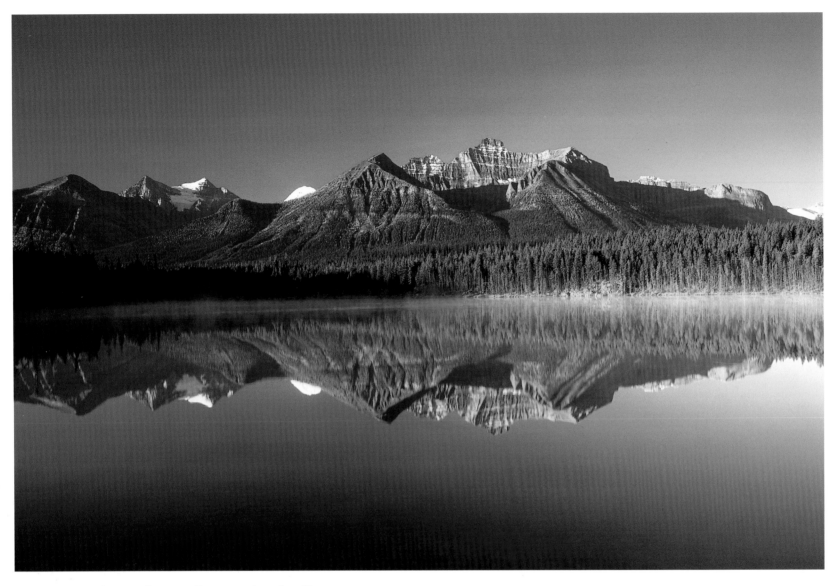

Sunrise at Herbert Lake, Banff National Park, Alberta

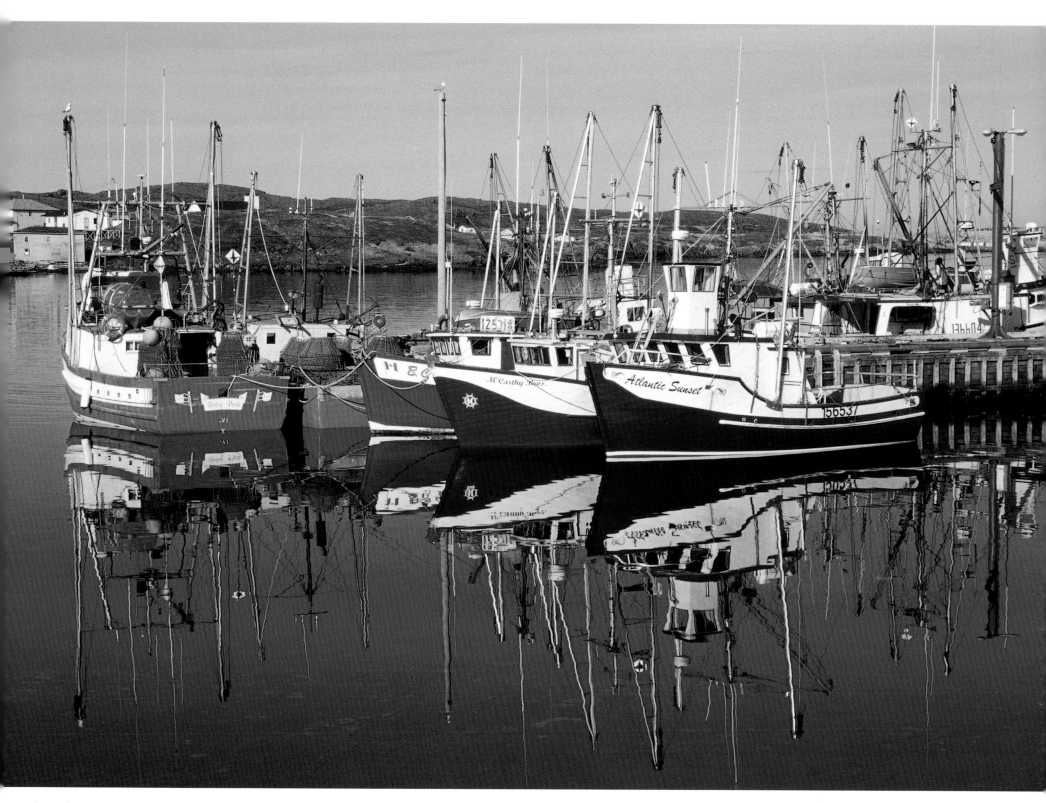

Fishing boats, Goose Cove, Newfoundland

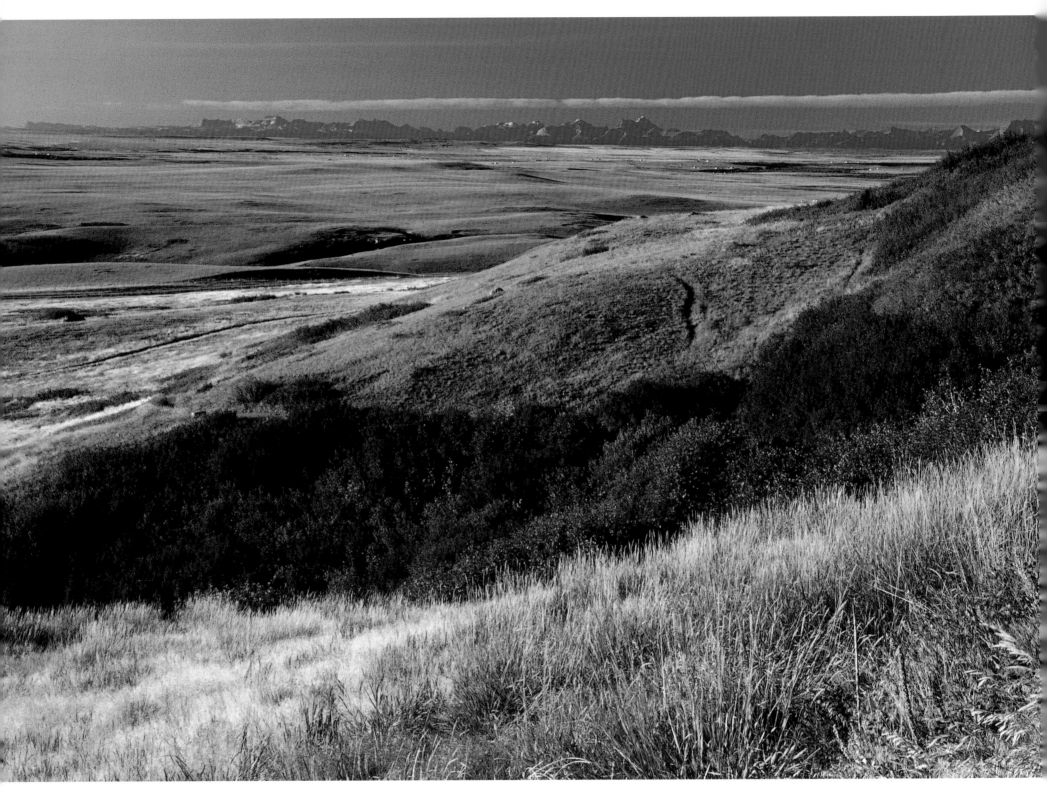

Prairie at Head-Smashed-In Buffalo Jump, Alberta

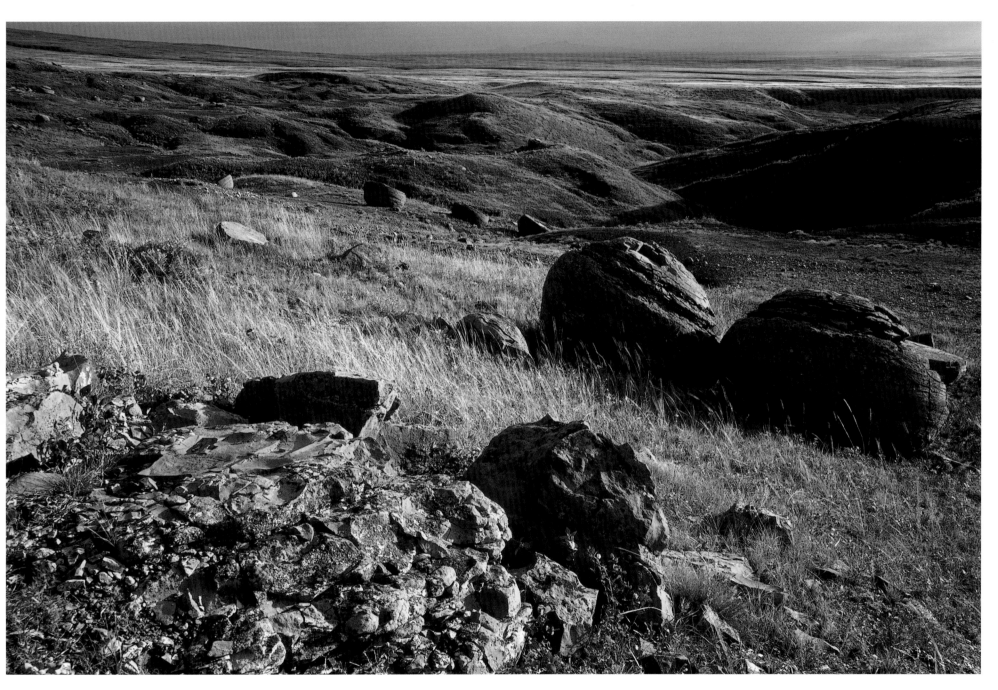

Red Rock Coulee Natural Area, Alberta

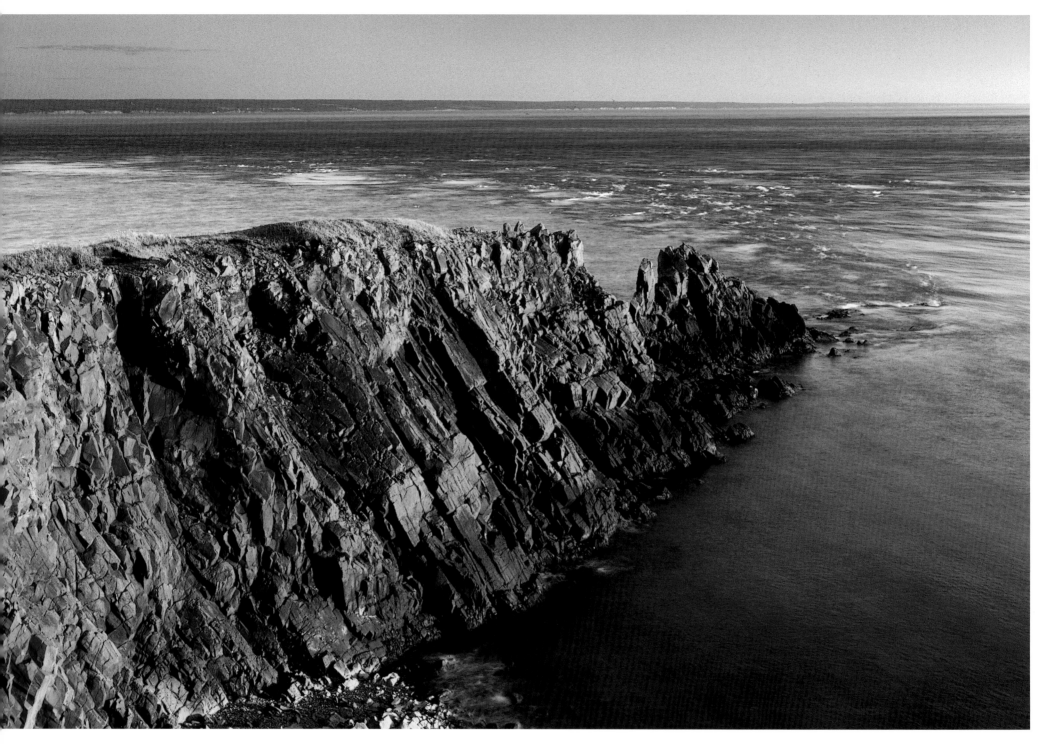

Last light on cliffs, Cape d'Or, Nova Scotia

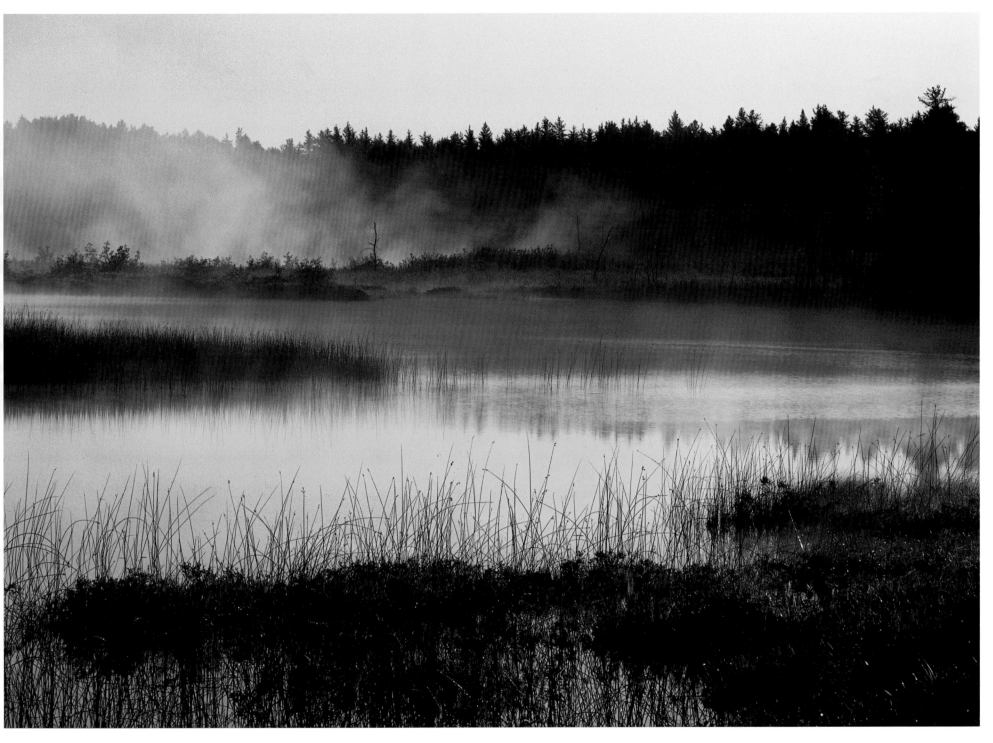

Fog on Vermilion River at sunrise near Capreol, Ontario

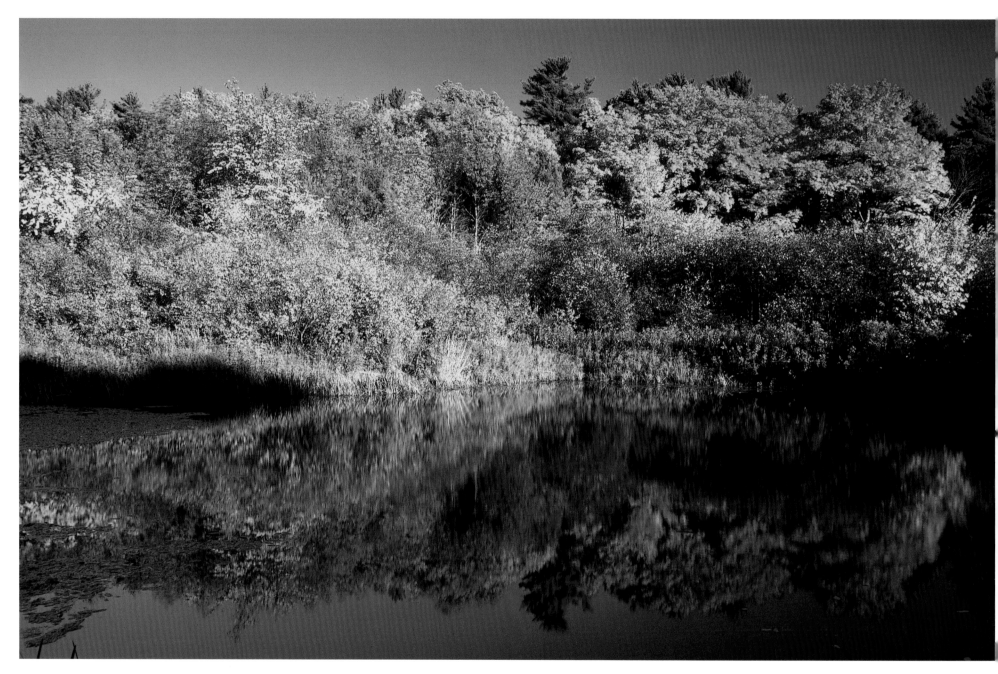

Blackburn Creek reflection, Old Chelsea, Québec

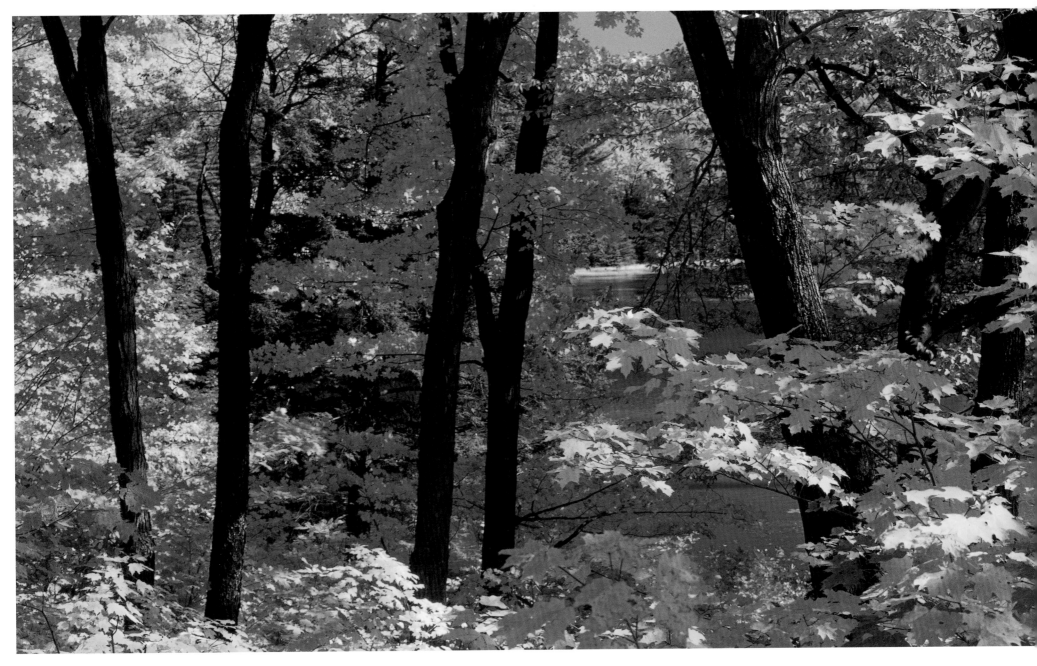

Sugar maples in autumn splendour, Gatineau Park, Québec

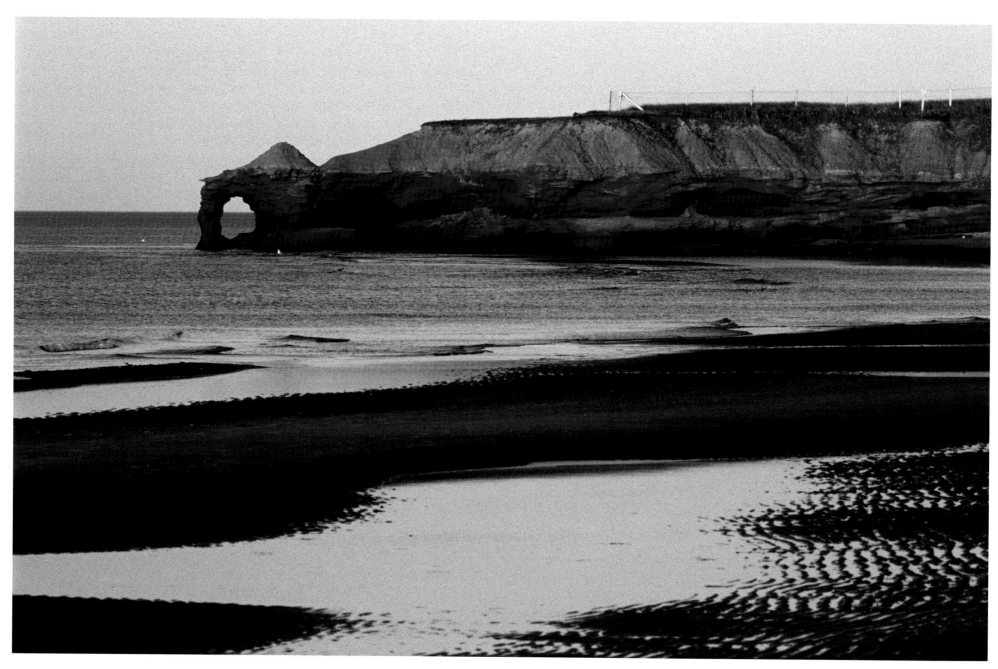

Red cliffs at sunset near Darnley, Prince Edward Island

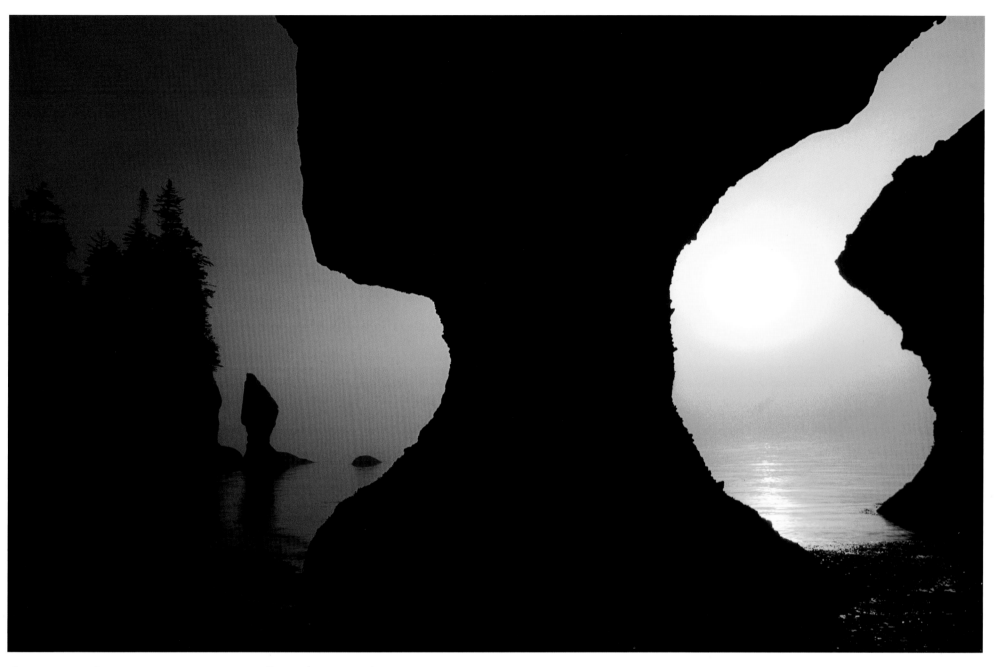

Flowerpot rocks at sunrise, Cape Hopewell, New Brunswick

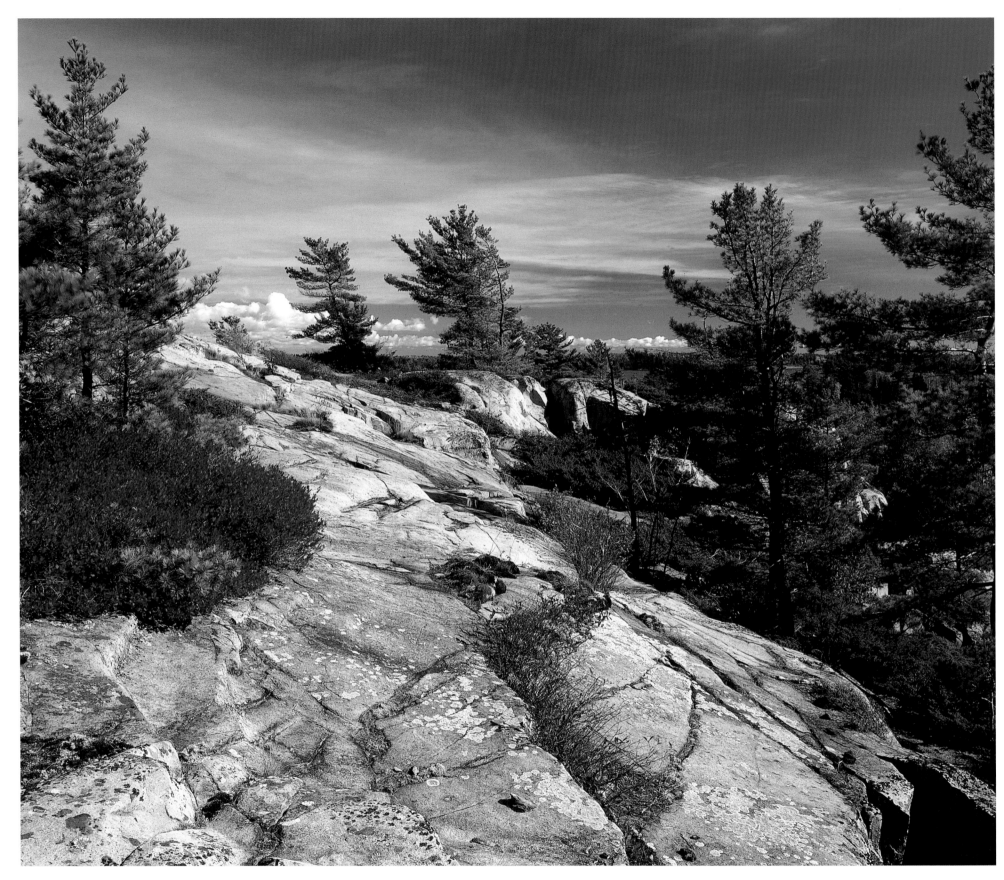

Chikanishing Trail, Killarney Provincial Park, Ontario

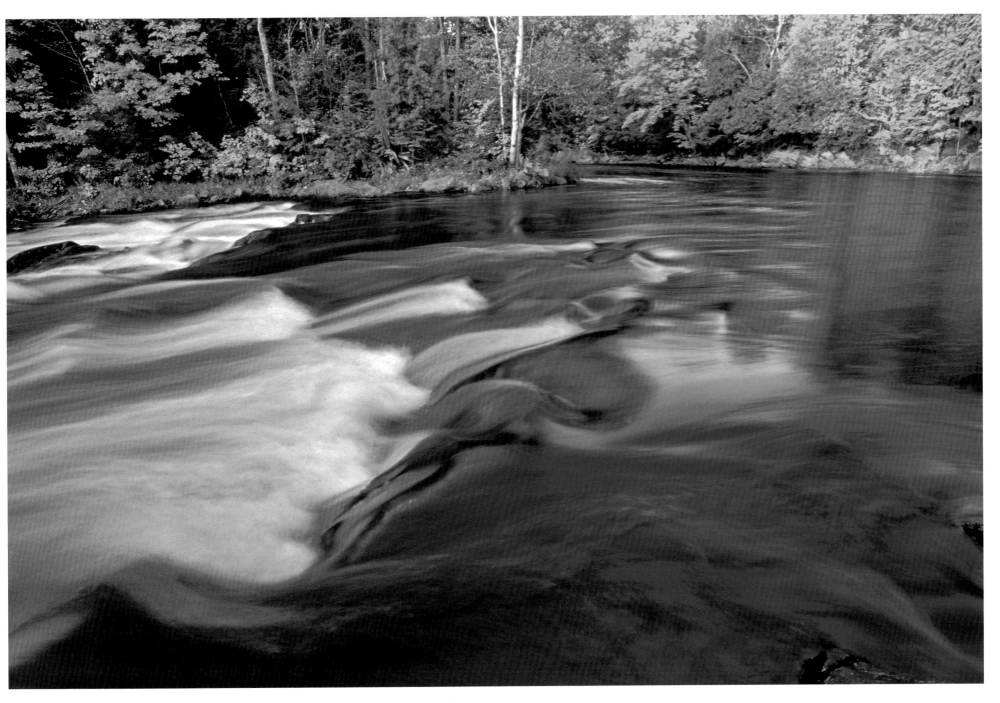

Oxtongue River near Algonquin Provincial Park, Ontario

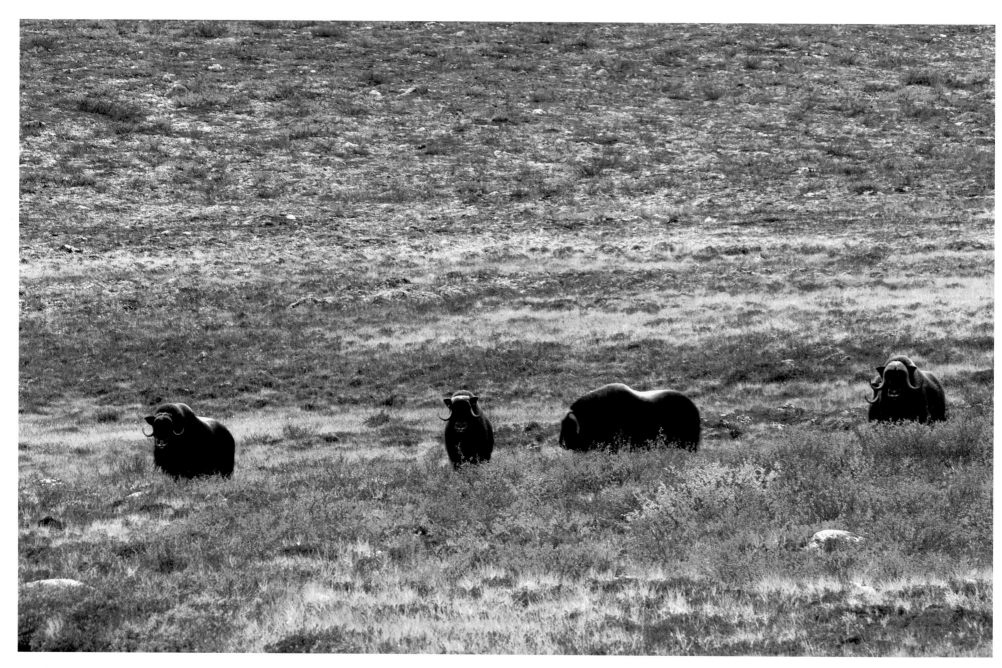

Muskoxen on tundra near the Thelon River, Northwest Territories

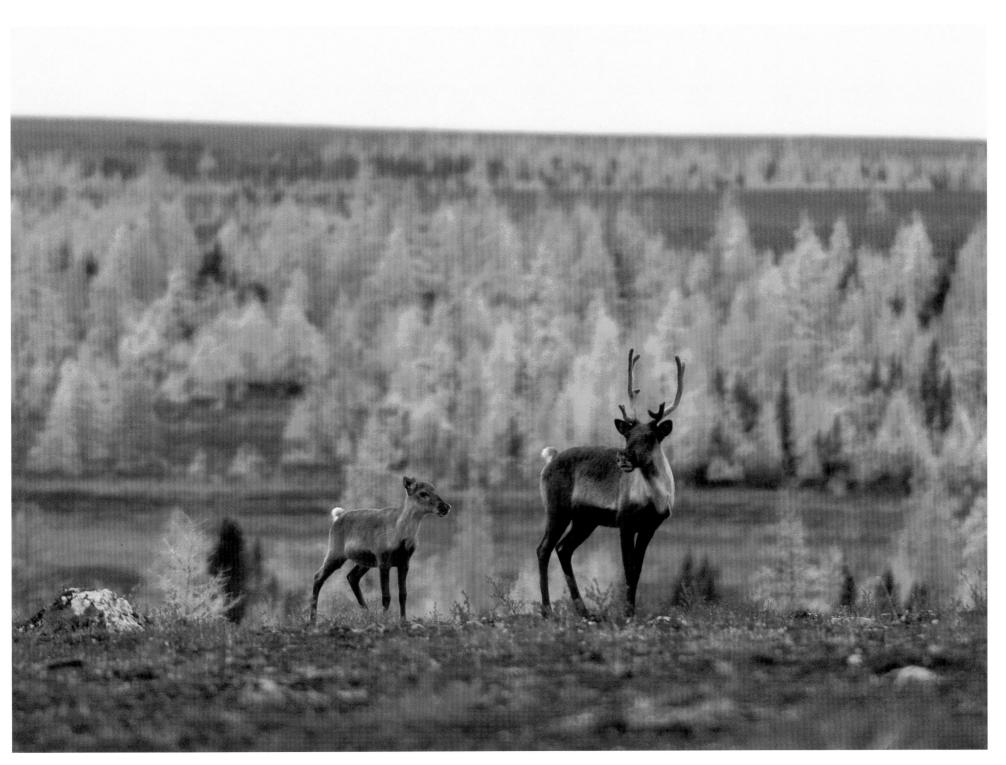

Barren ground caribou cow and calf, Nunavut–Manitoba border

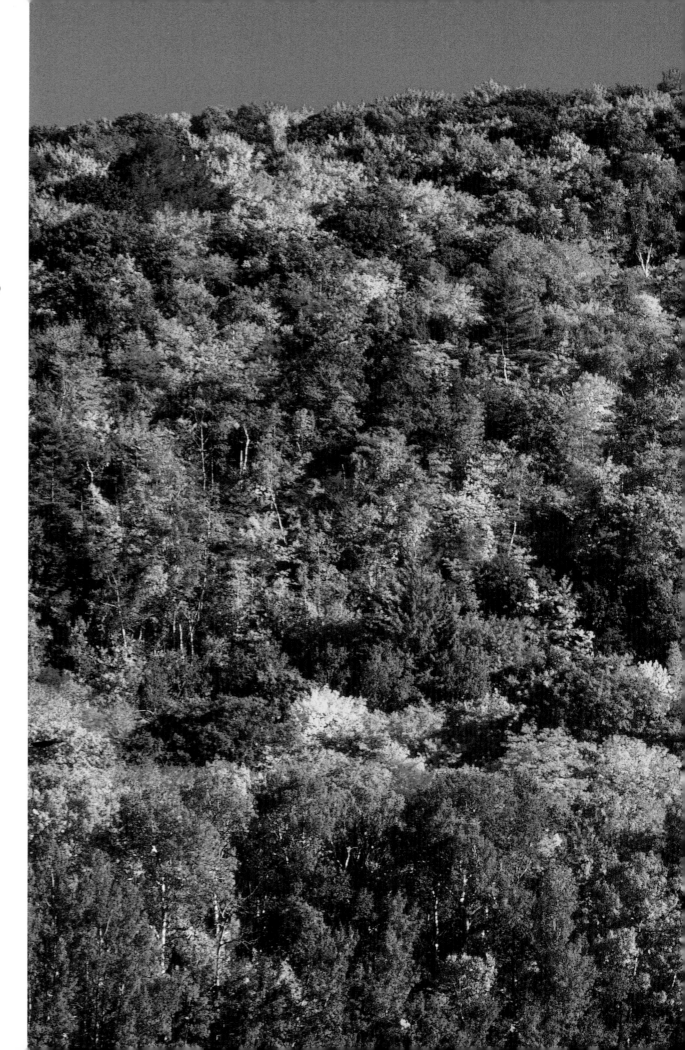

Autumn colours near Sault Sainte Marie, Ontario

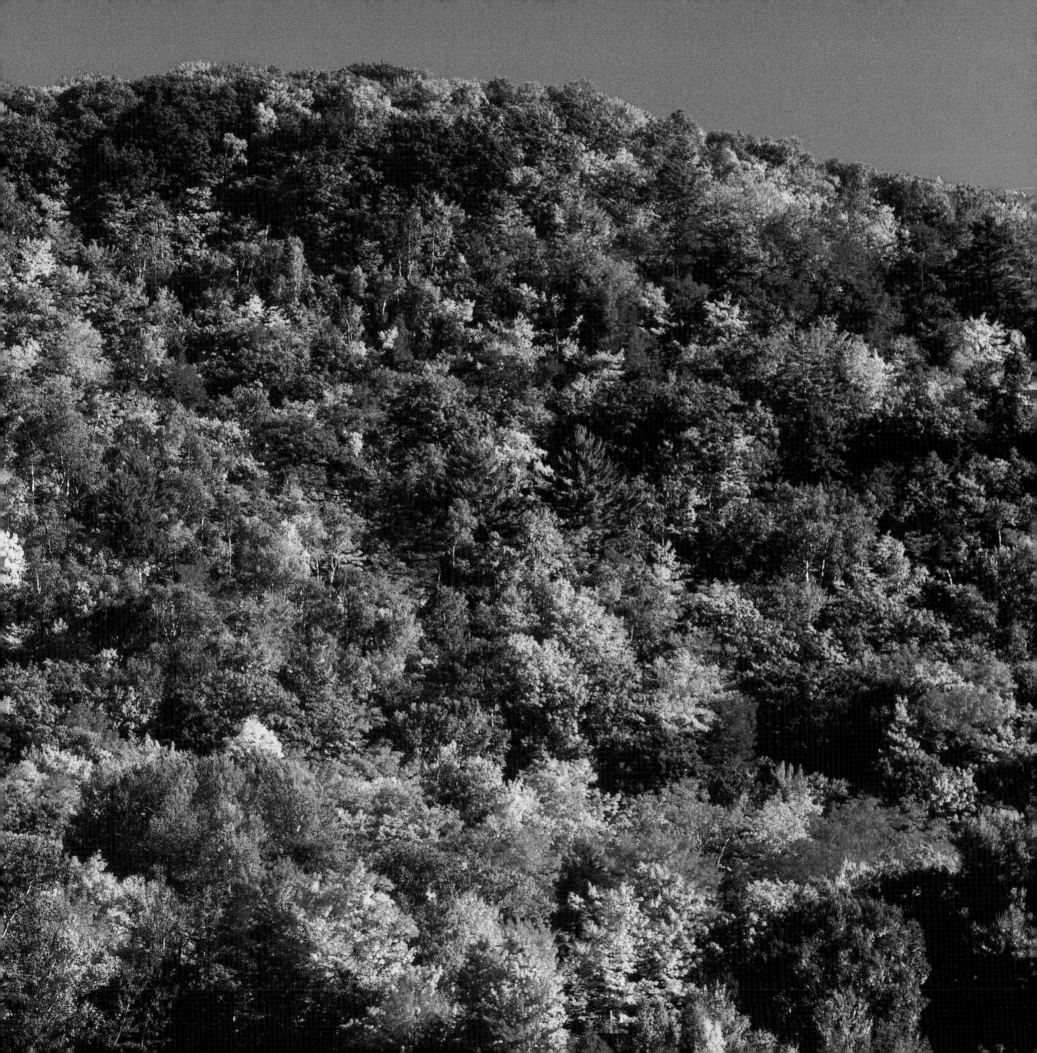

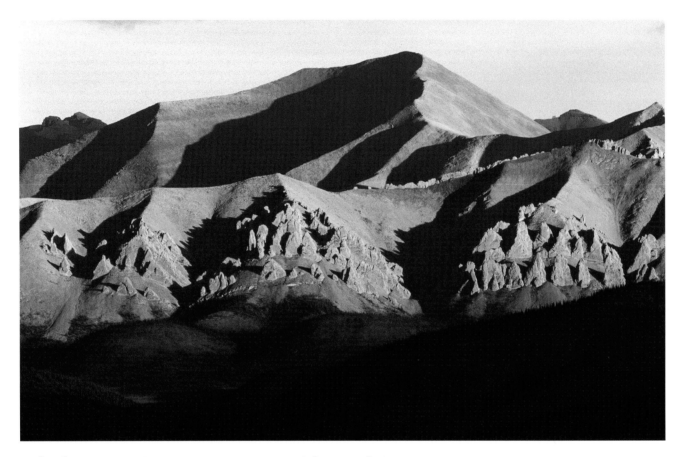

Richardson Mountains at sunset, Dempster Highway, Yukon

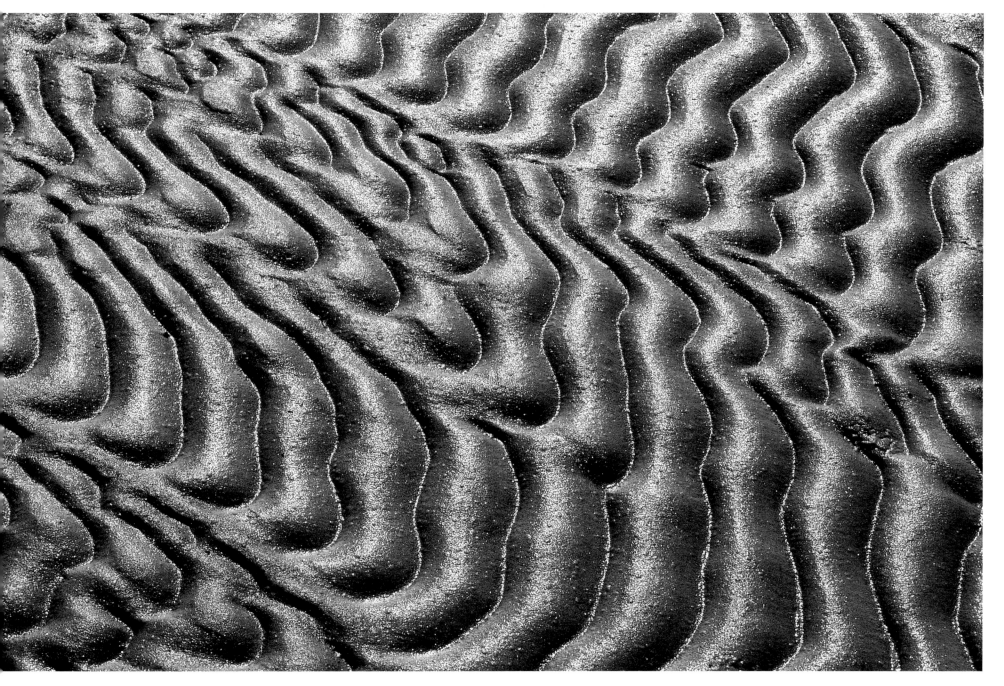

Sand pattern, Grand Beach Provincial Park, Manitoba

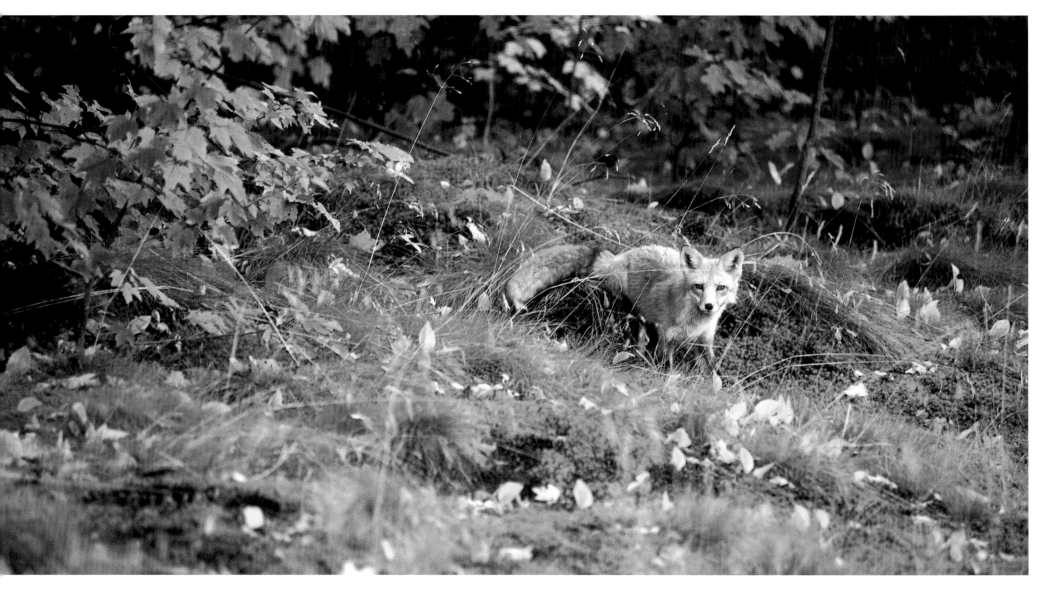

Red fox, Fairbanks Provincial Park, Ontario

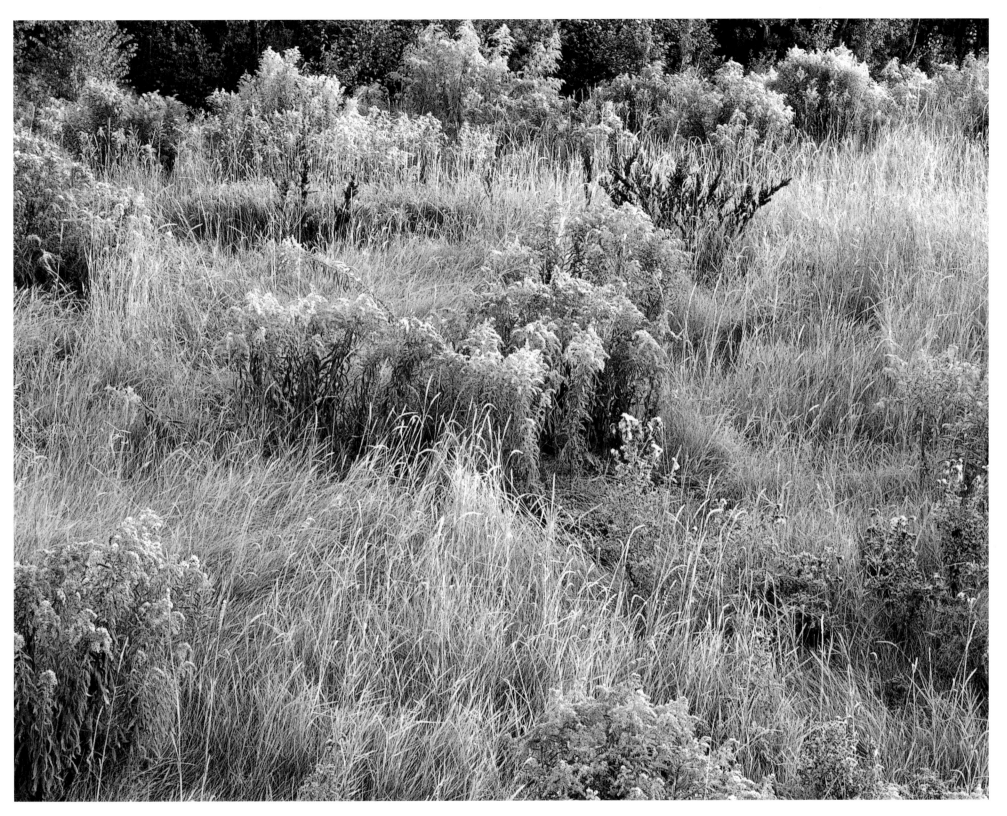

Morning frost on marsh near Naughton, Ontario

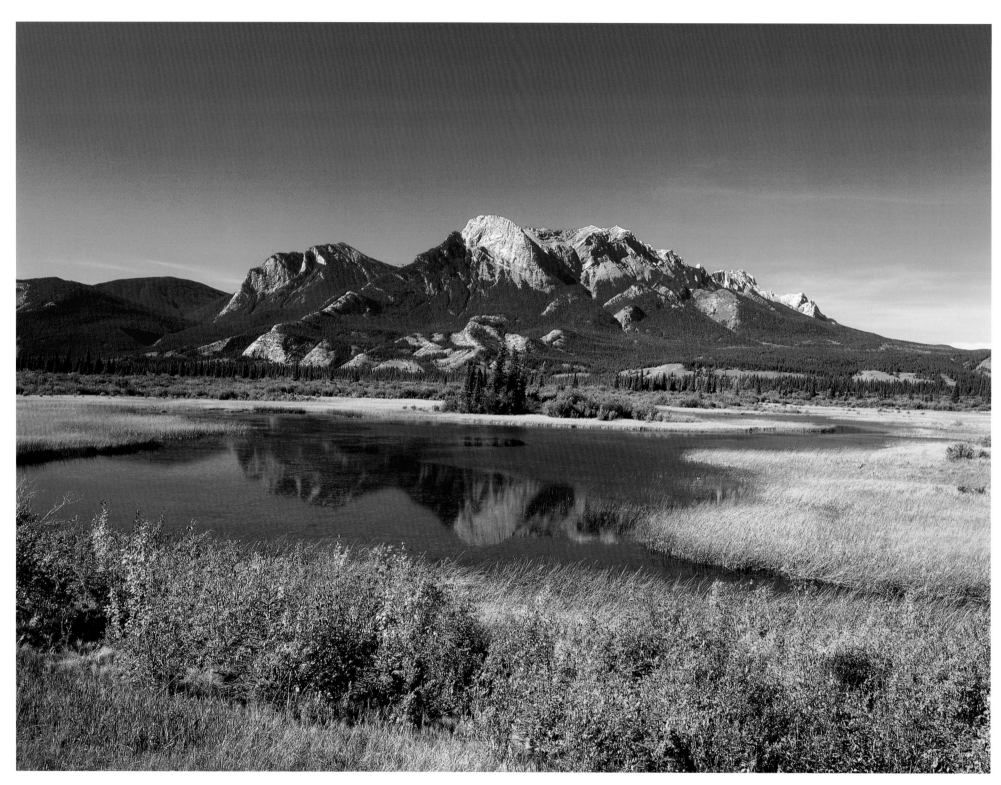

Canadian Rockies reflection, Jasper National Park, Alberta

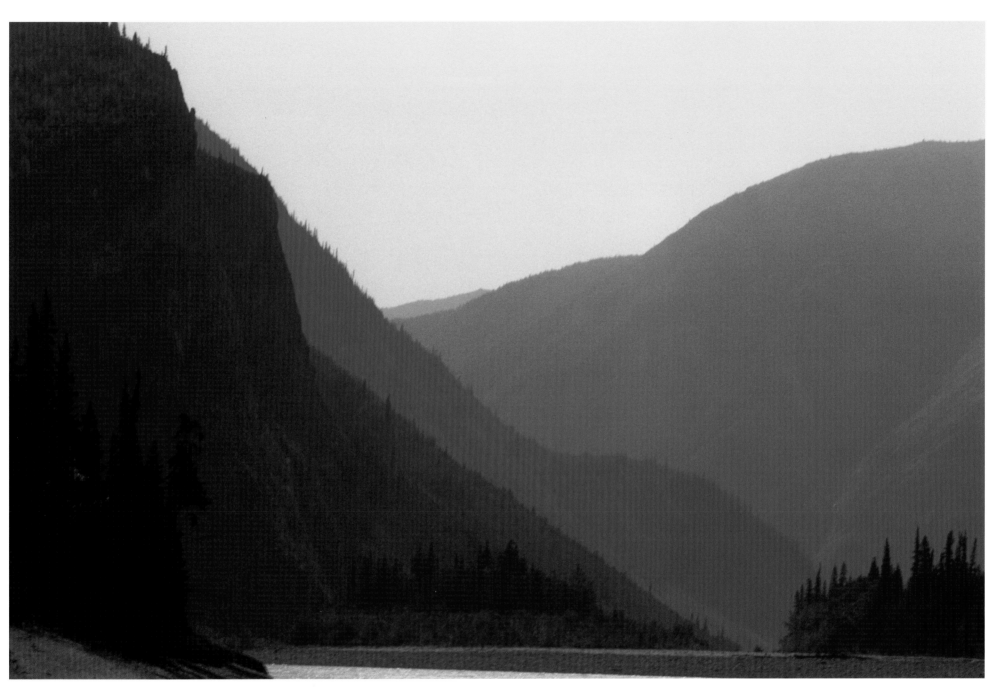

Nahanni River and the Mackenzie Mountains, Nahanni National Park, Northwest Territories

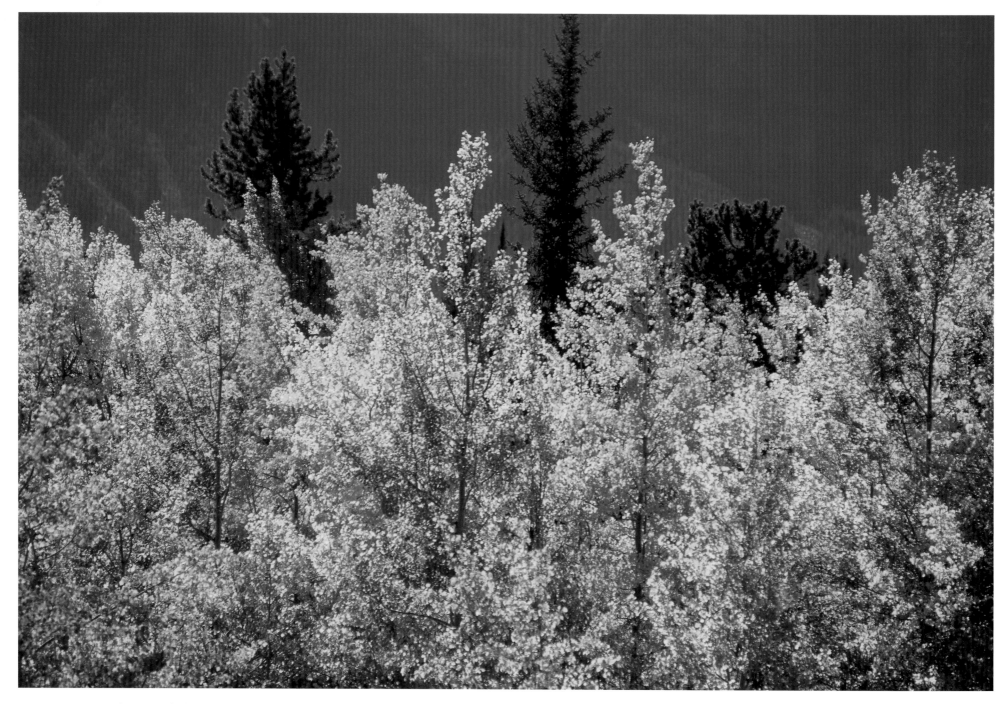

Aspen trees on the David Thompson Highway, Alberta

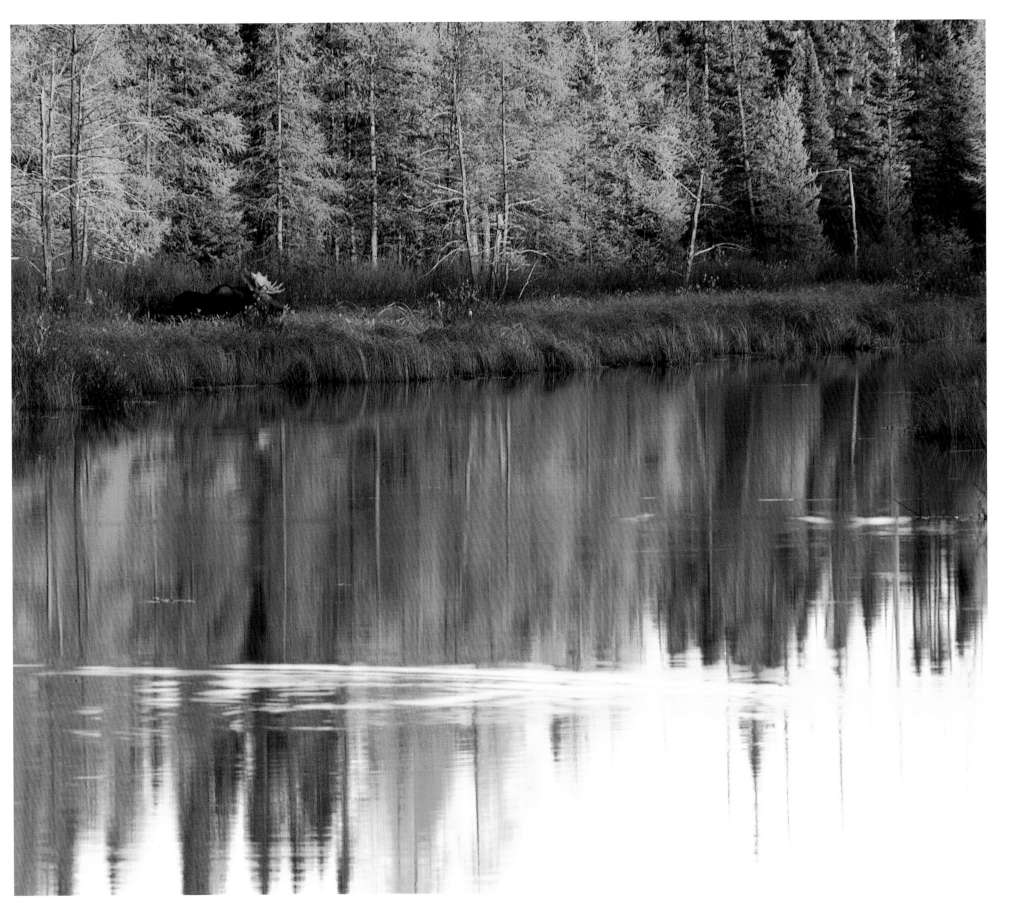

Bull moose, Riding Mountain National Park, Manitoba

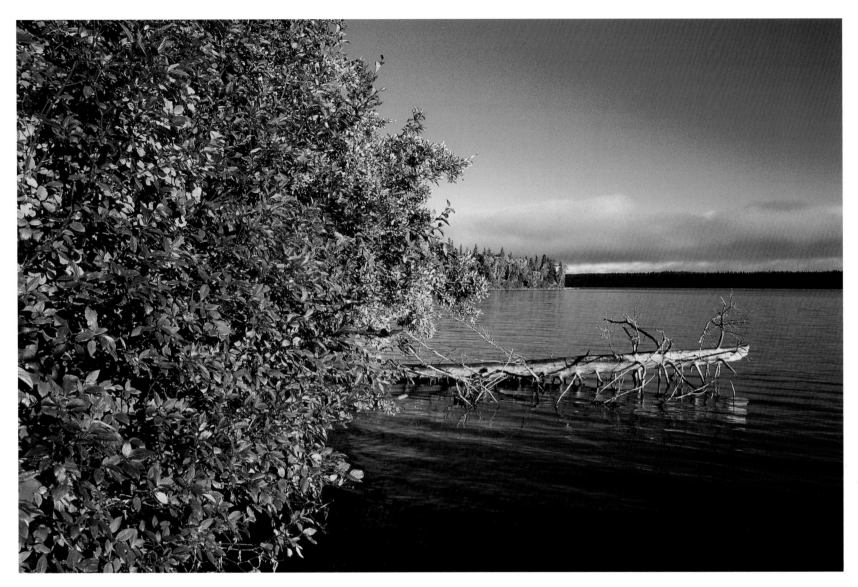

Waskesiu Lake, Prince Albert National Park, Saskatchewan

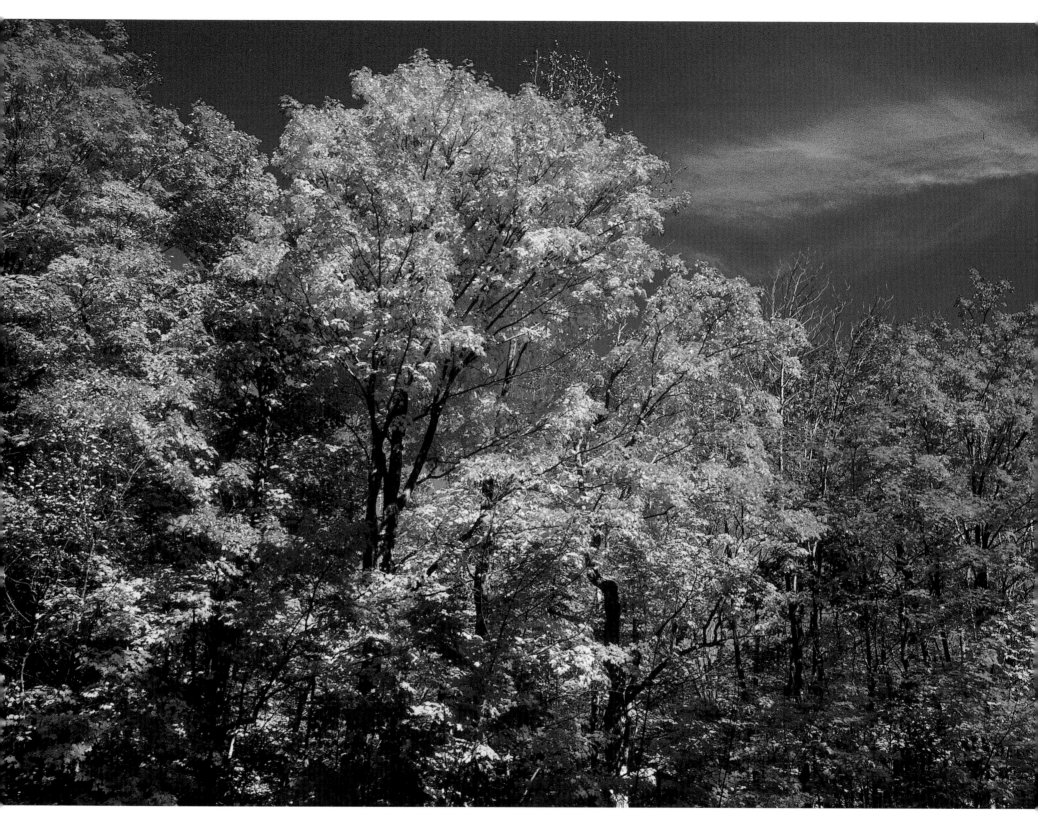

Maples in autumn splendour, Muskoka Country, Ontario

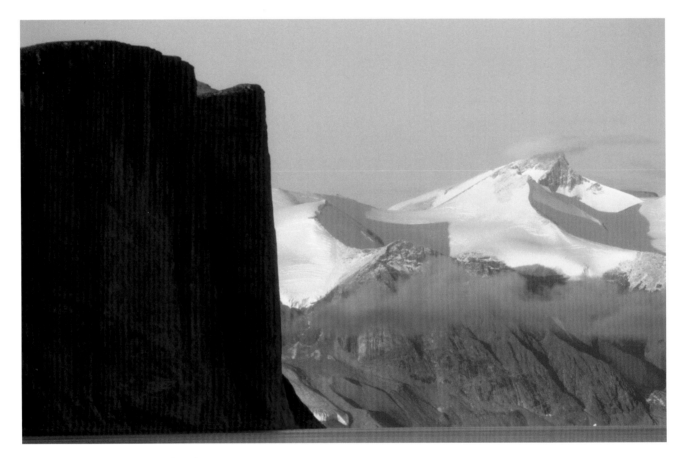

Gibb's Fjord on Baffin Island, Nunavut

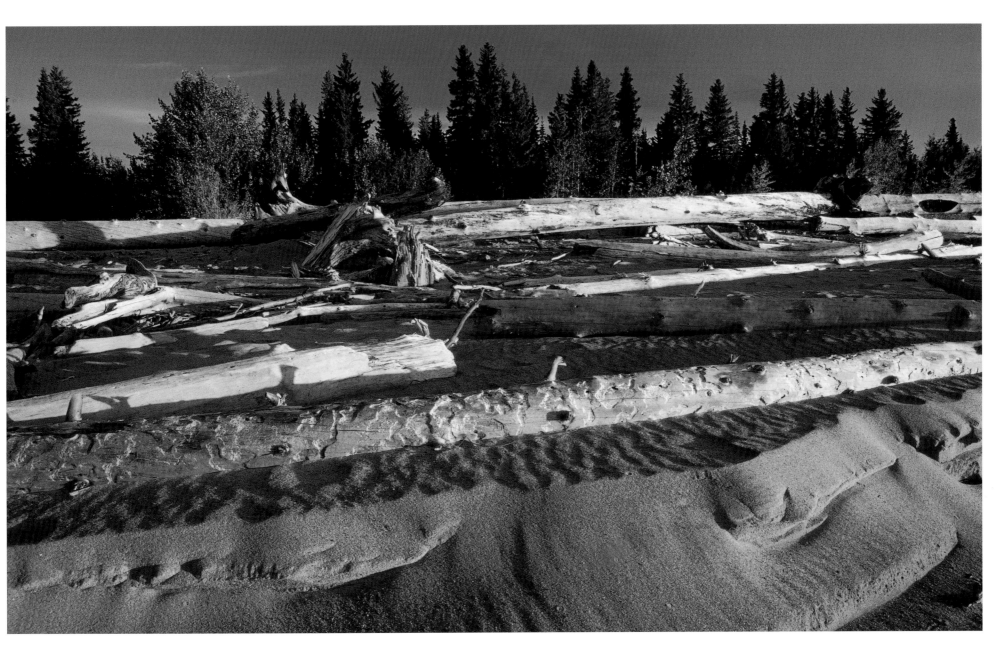

Shore of Great Slave Lake, Hay River, Northwest Territories

Winter

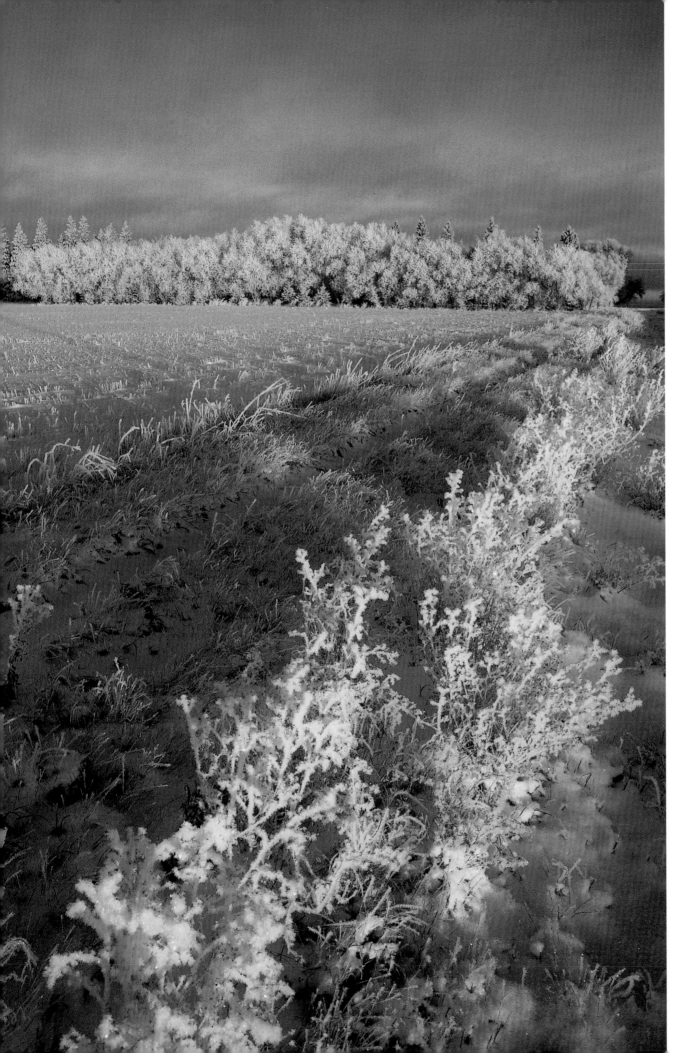

Hoarfrost on farmer's field near Dugald, Manitoba

Winter is a time of year to be "gotten through," to be endured.

It is the time of year that inspires carols such as "In the Bleak Midwinter" and lines like "Now is the winter of our discontent." You never get a hoary summer's night. "Hoary" always means winter, and winter always means darkness, deprivation, and cold. It's the season we love to hate, the season when we Canadians flee in the thousands to more welcoming places of warmth and light.

There are many good reasons not to love winter. If you've lived through a power outage, a huge snowfall, or an ice storm like the one that hit Québec and Southern Ontario and the Maritimes a few years ago, winter is hard and it's hell.

It's also a drag to have less, little, or no light. Walking through slush or shaving ice off your car before you head to work in traffic slowed by a snowfall is not fun either. And it is depressing when it's still dark when you come to work and dark again when you leave.

But if winter is darkness, it also heralds light as the days begin to lengthen after December 21. And a big snowfall can also mean tobogganing, snowshoeing, and cross-country skiing. Winter is a time for skating, curling, hockey, cider, and clothes that hide your abdominal "Canadian tire." It's the season for the kind of clothes I love—it's sweater weather.

Winter means chopping wood and fires and the smell of the smoke. It's kitchen parties with fiddles and dancing on the East Coast. It's potluck suppers on the Prairies with epic cribbage matches and bridge games. In the North: community feasts of country food: muskox stew, roast caribou, and the food that scares southerners, the food that makes you warm at first bite—muktuk, raw whale blubber—and dancing to drums and accordions and women as partners, facing each other and holding each other's shoulders. Then they sing deep, guttural sounds—throat singing—into each other's faces. And the song stops when someone bursts into laughter. There are the Aya-ya songs, the chants of ancient legends and praise. The Canadian writer James Houston lived in the North for many years and helped establish the first Inuit artist co-operatives in the 1950s. He found that the old songs celebrated winter as a time of beauty and strength. He translated a song from the eastern Inuit that goes like this:

Ayii, Ayii,
I walked on the ice of the sea.
Wondering, I heard
The song of the sea
And the great sighing
Of new formed Ice.
Go, then, go!
Strength of soul
Brings health
To the place of feasting.

And we do feast in the winter. I love leafing through the old *Canadiana Cookbook* by the late Madame Jehane Benoit, God bless her. She was a wonderful person, cook and food historian. I met her a couple of times and she impressed me as a straight-talking elder. Once she commented on my new hairdo, a perm that was popular in the mid-1970s, saying, "I'm sure it's all in vogue, but don't worry, dear, it will grow out." I admit now that it was kind of poodle-ish. Madame Benoit was small, but fearless. And she loved the pleasure of eating. She feasted her way across Canada, gathering traditional recipes from all points and showed that, along with the railway and the CBC, food really binds us together. *The Canadiana Cookbook* came out

in 1970, and it proves that we have always used food as a barricade against the cold. She has a recipe for Meat Loaf *Coureurs des Bois* that includes ground beef chuck, link sausages, and the secret ingredient— two cans of baked beans. She wrote, "this is a popular dish with Québec hunters and great to serve after skiing or skating." It would surely keep you going. She has a winter chowder from Ontario made with root vegetables. From Alberta, there's "a typically western dish and very good winter fare:" Pig and Corn in the Pan with six ribs, pork chops, and two cans of corn kernels. And from New Brunswick, an Acadian Meat Pie with dough between layers of meat that could be hare or rabbit, pork, chicken, or wild birds. I can't help but think that we would all be better off in the winter with more of Madame Benoit's hearty fare.

Winter has not only inspired recipes, but also some wonderful poetry. T.S. Eliot writes about how "Winter kept us warm, covering Earth in a forgetful snow, feeding a little life with dried tubers" in "The Waste Land." But a poem that appeals more to the Canadian soul, because almost all of us have driven in the inky darkness of winter, would have to be John Newlove's "Driving:"

You never say anything in your letters. You say, I drove all night long through the snow in someone else's car and the heater wouldn't work and I nearly froze.

But I know that. I live in this country too. I know how beautiful it is at night with the white snow banked in the moonlight.

Around black trees and tangled bushes, how lonely and lovely that driving is, how deadly. You become the country.

You are by yourself in that channel of snow and pines and pines, whether the pines and snow flow backwards smoothly, whether you drive or you stop or you walk or you sit.

This land waits. It watches. How beautifully desolate our country is, out of the snug cities, and how it fits a human. You say you drove.

It doesn't matter to me.
All I can see is the silent cold car gliding, walled in, your face smooth, your mind empty, cold foot on the pedal, cold hands on the wheel.

As you look at the pages ahead, maybe you will hear John Newlove's voice saying "this land waits. It watches. How beautifully desolate our country is, out of the snug cities, and how it fits a human."

It's rather like being in the middle of some vast promise. As you look through the photographs of the Canadian landscape in winter, maybe you will see the beauty, the hope, that drives us to spring.

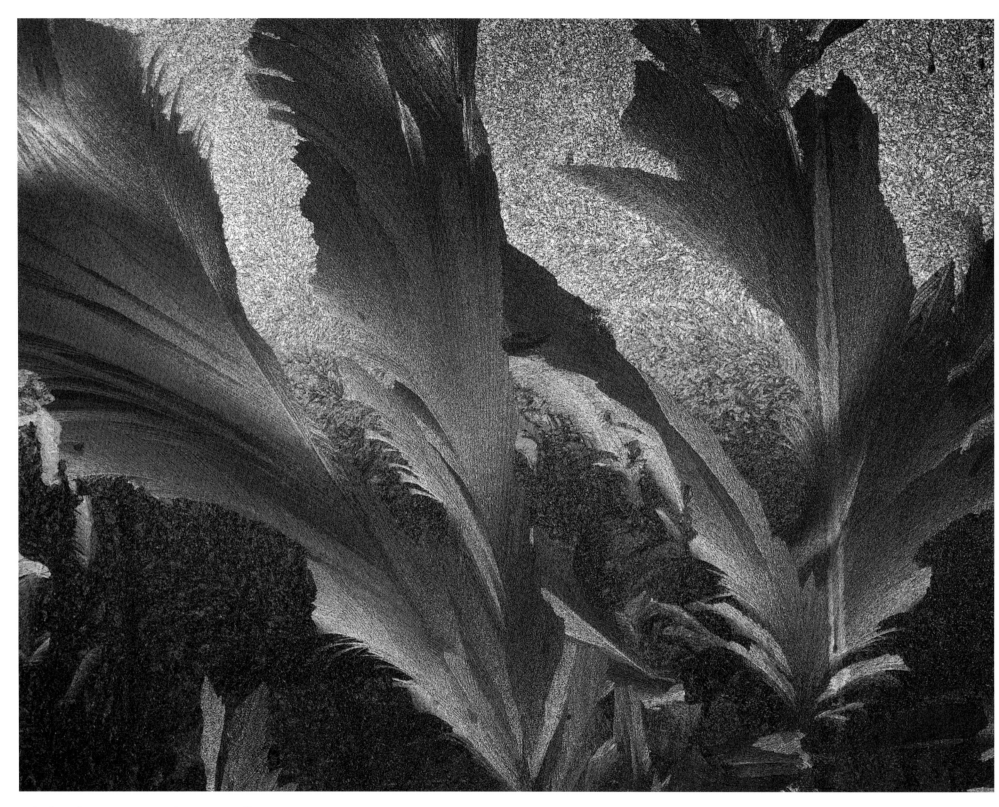

Window frost pattern, Edmonton, Alberta

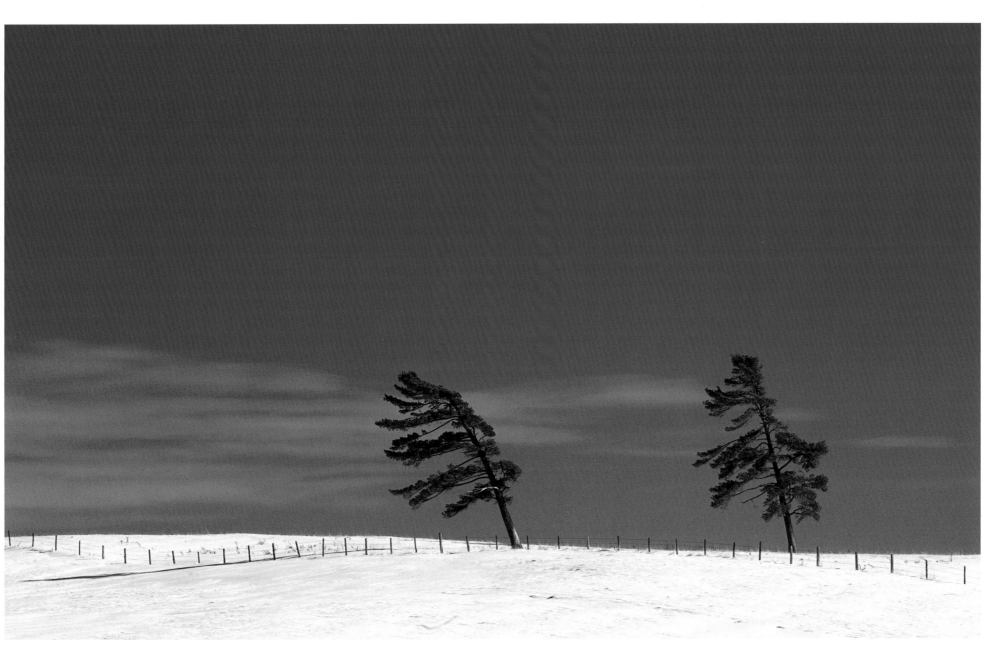

White pines and fence near Fabre, Québec

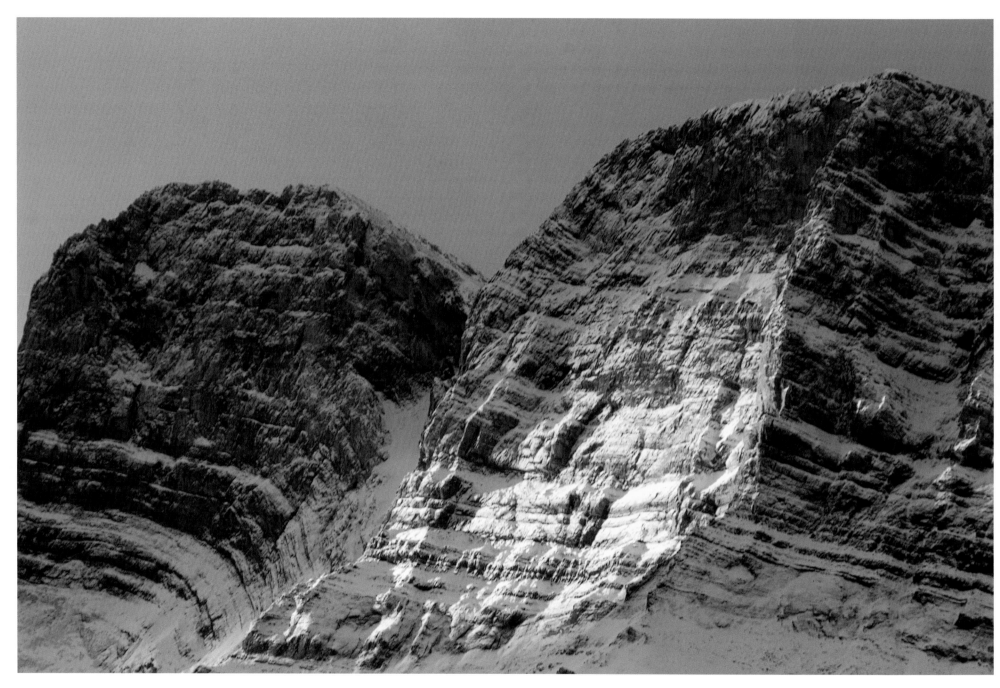

Mountain peak at sunrise, Banff National Park, Alberta

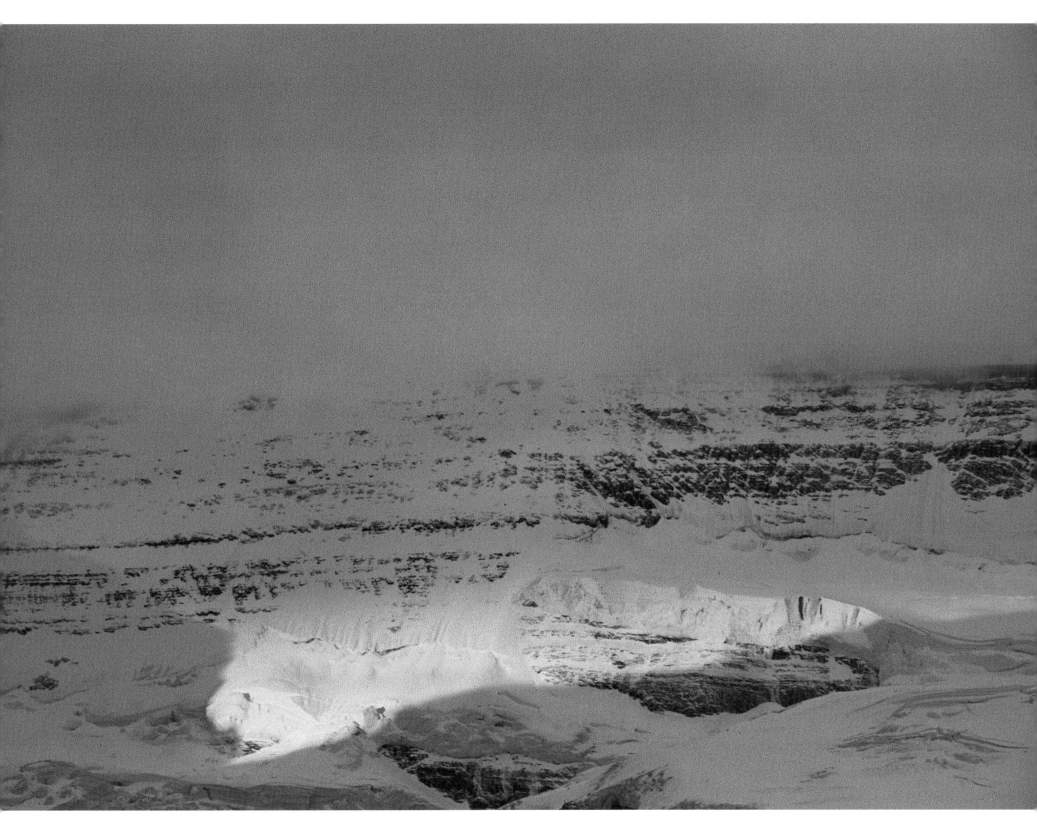

Storm light on Mount Victoria, Lake Louise, Banff National Park, Alberta

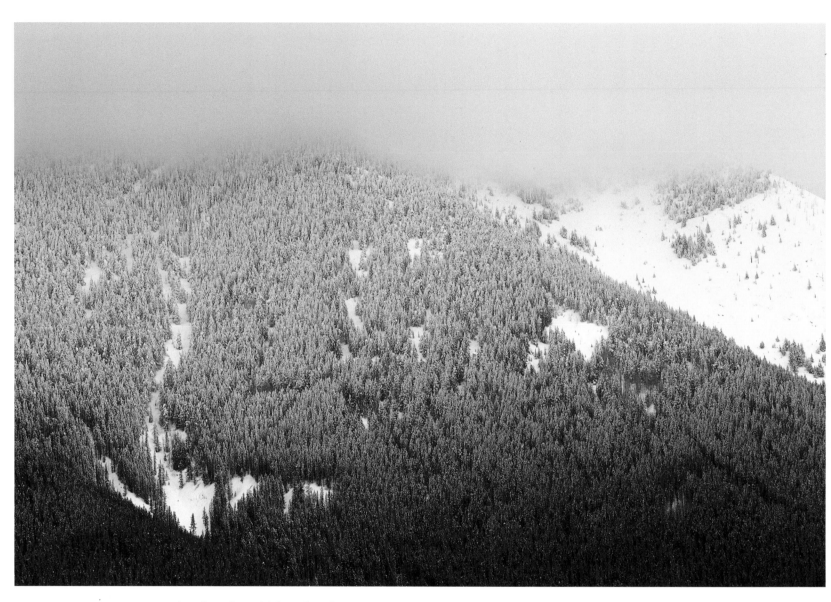

Snowstorm, Kootenay National Park, British Columbia

Forest in winter, Kootenay National Park, British Columbia

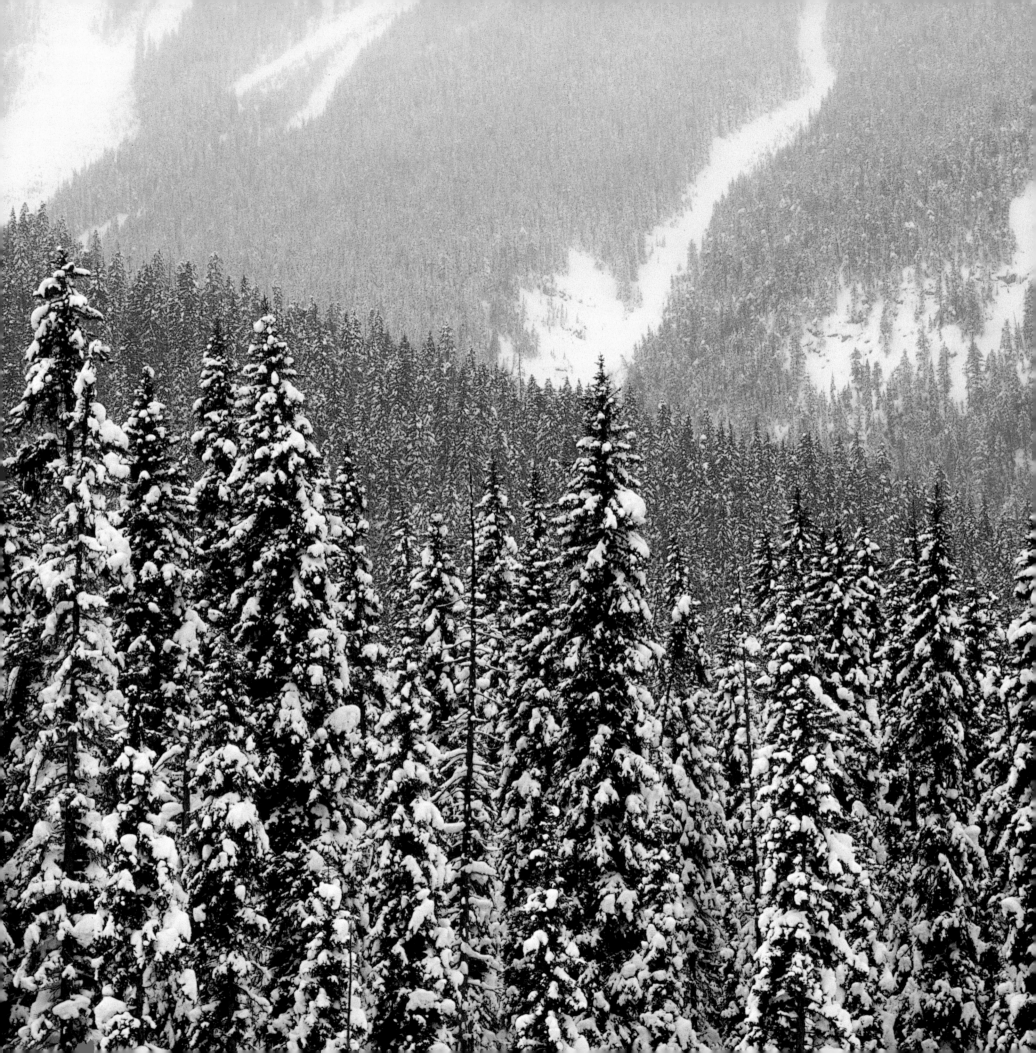

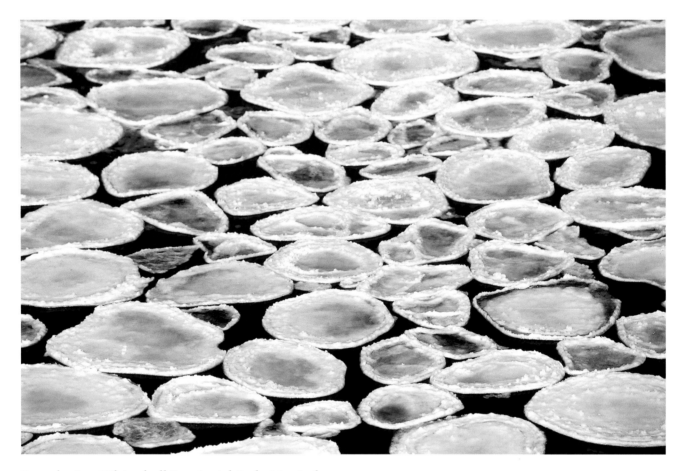

Pancake ice, Whiteshell Provincial Park, Manitoba

PREVIOUS PAGE Whiteout on the prairie near Elma, Manitoba

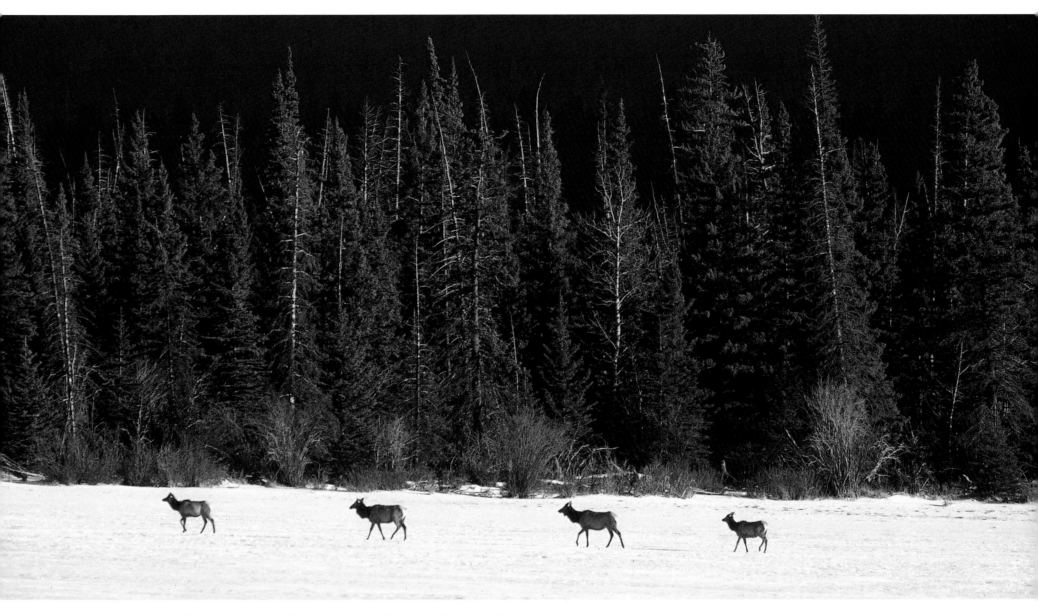

Elk crossing Vermillion Lake, Banff National Park, Alberta

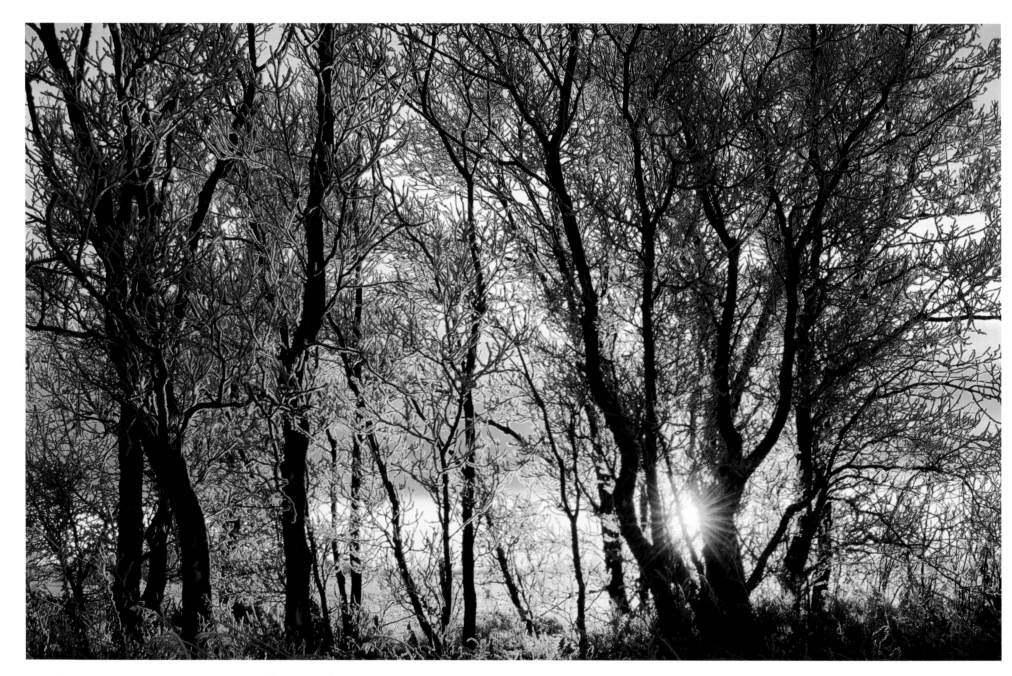

Hoarfrost on trees at sunset near Dugald, Manitoba

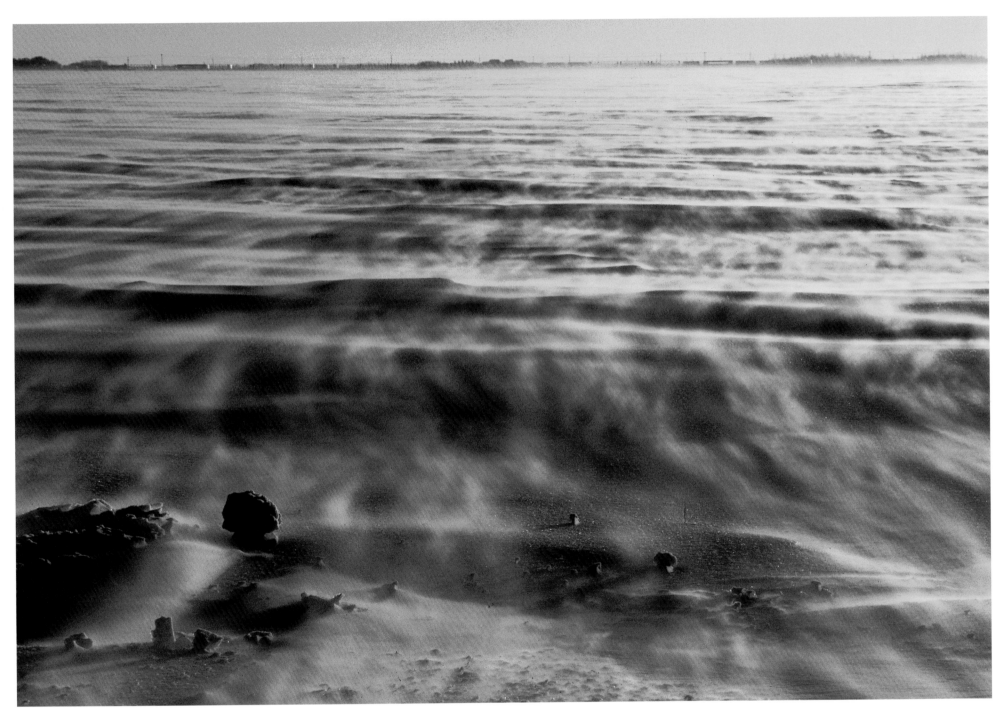

Windswept prairie near Oakbank, Manitoba

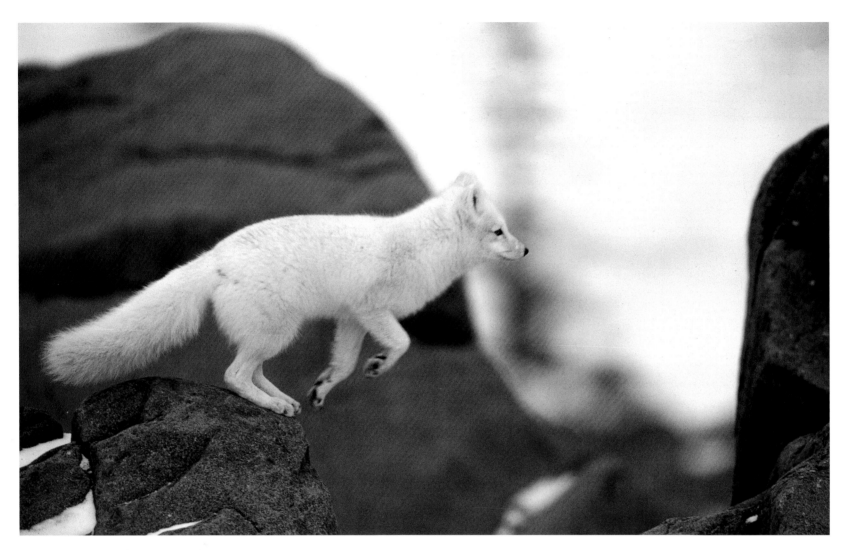

Arctic fox, Churchill, Manitoba

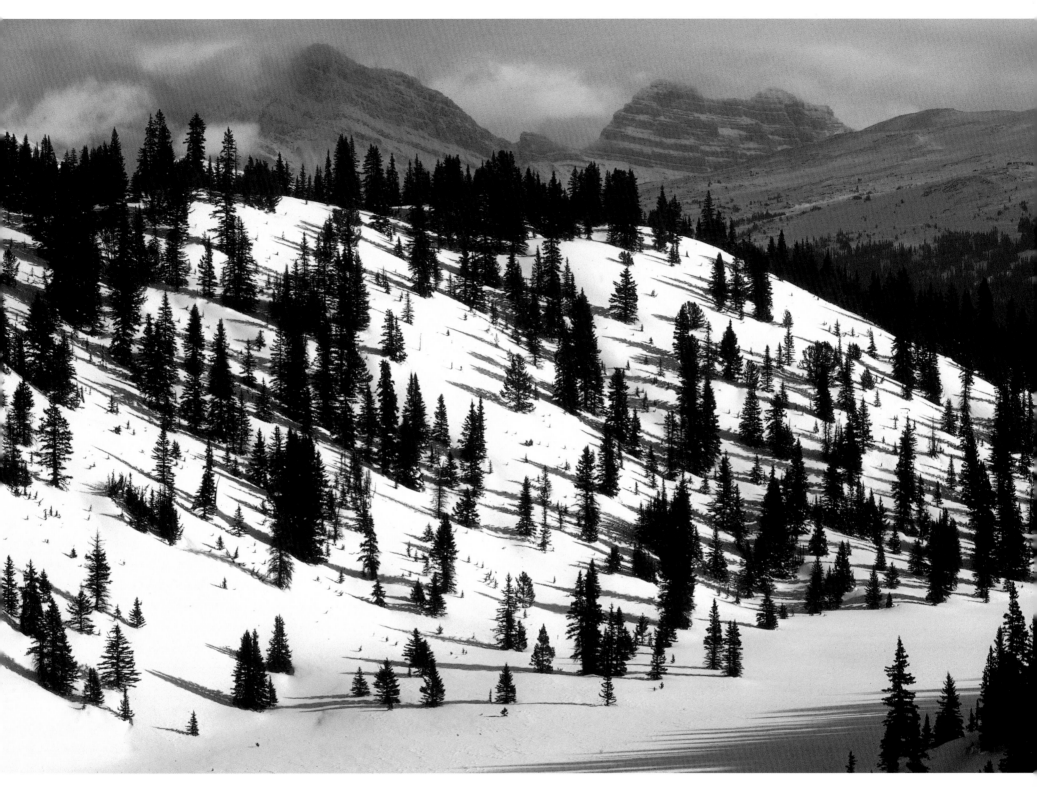

Winter in the Canadian Rockies, Banff National Park, Alberta

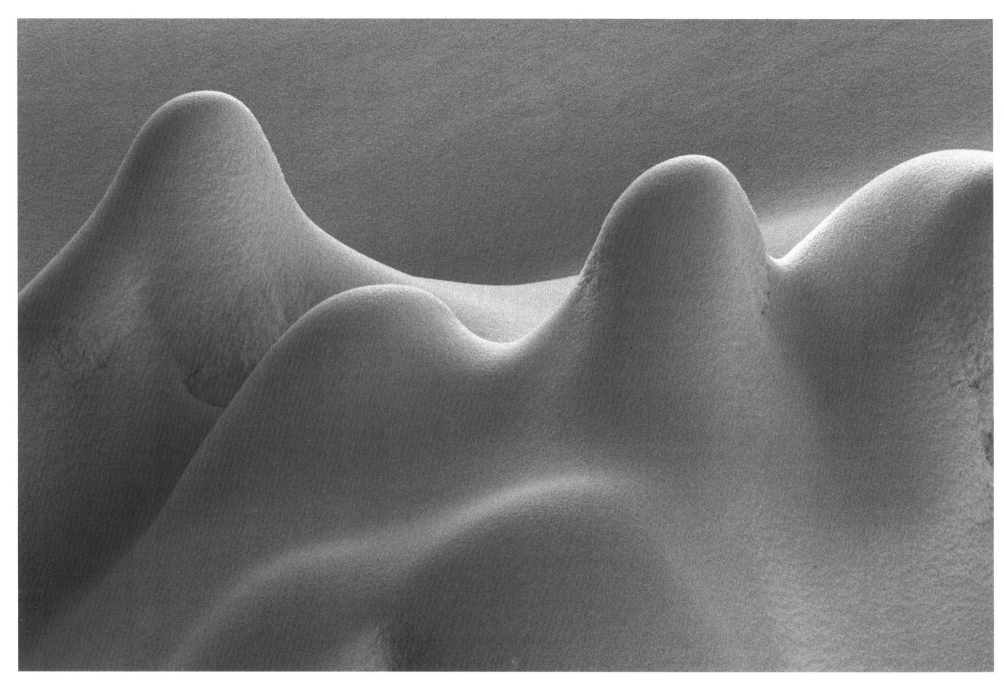

Trees covered in snow, Pisew Falls Provincial Park, Manitoba

Kootenay River, Kootenay National Park, British Columbia

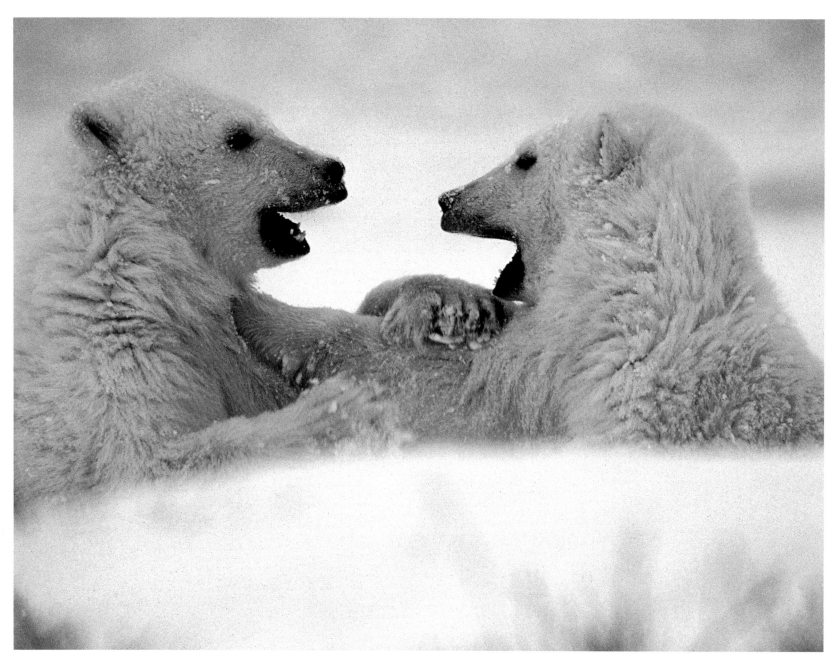

Polar bear cubs sparring, Churchill, Manitoba

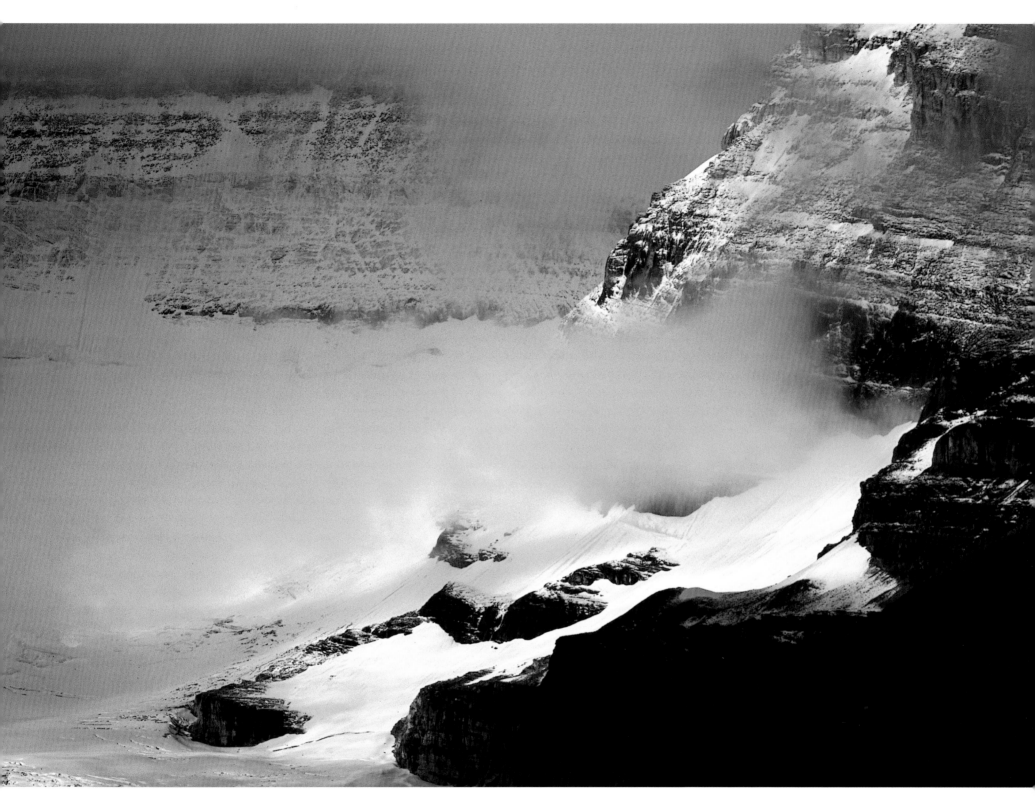

Mount Victoria, Banff National Park, Alberta

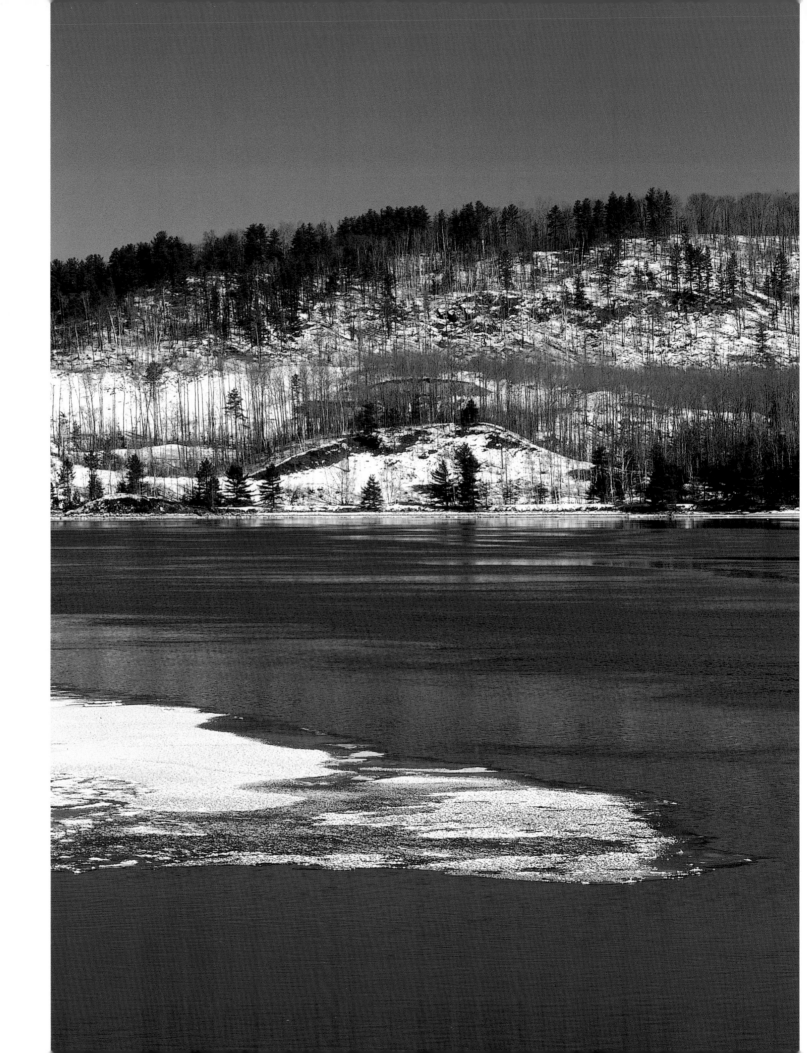

Ottawa River, Témiskaming,
Québec

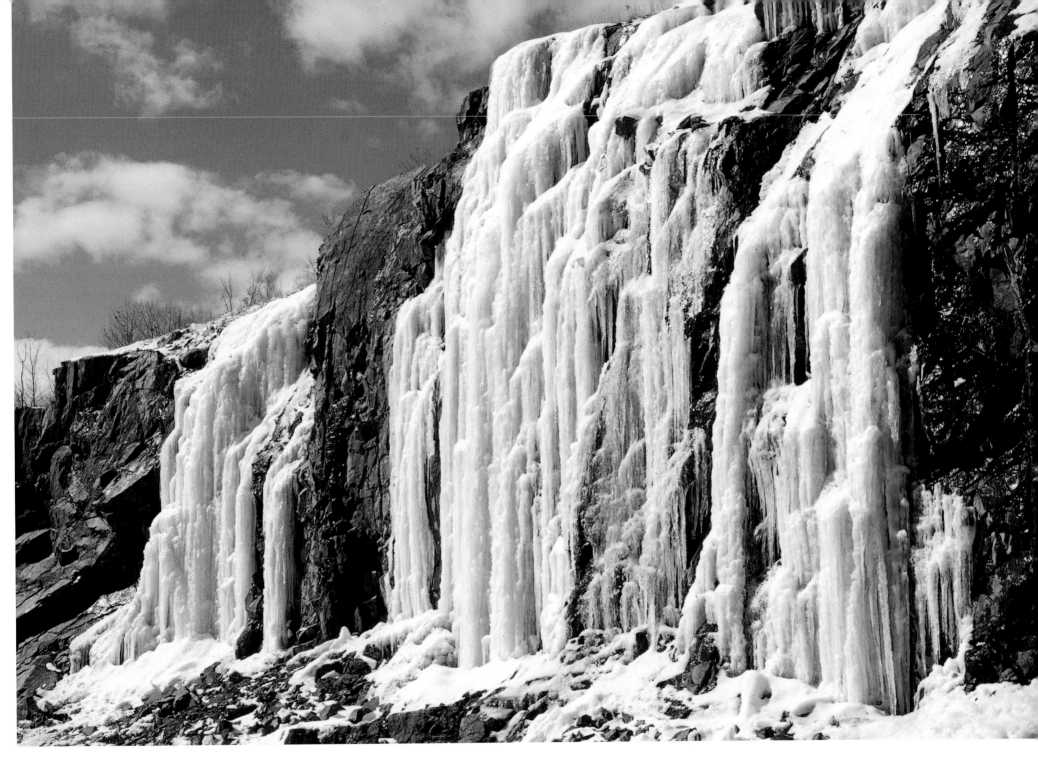

Ice on rock, Sudbury, Ontario

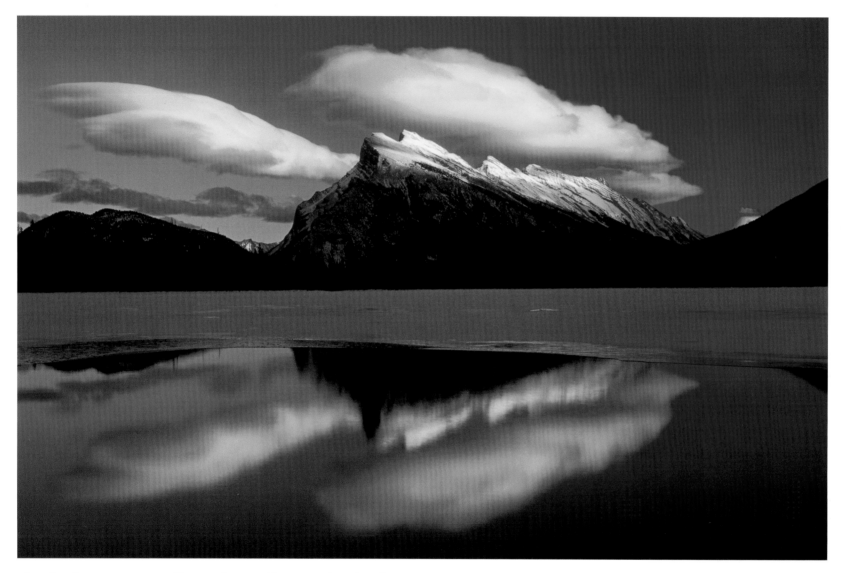

Cloud reflection in Vermillion Lake, Banff National Park, Alberta

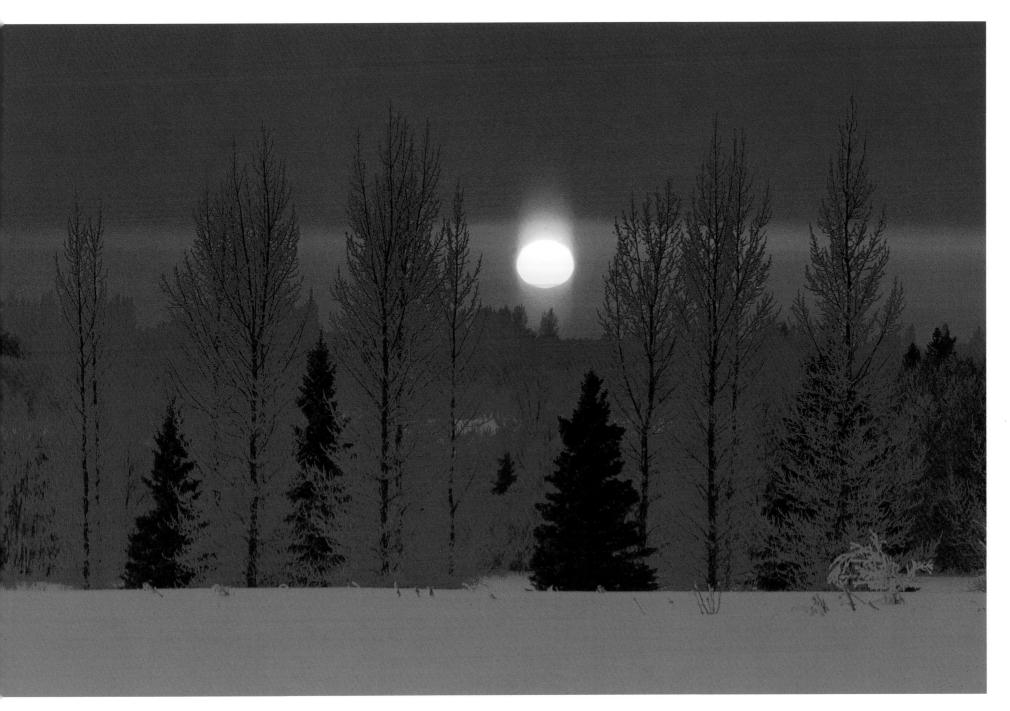

Sunset, Birds Hill Provincial Park, Manitoba

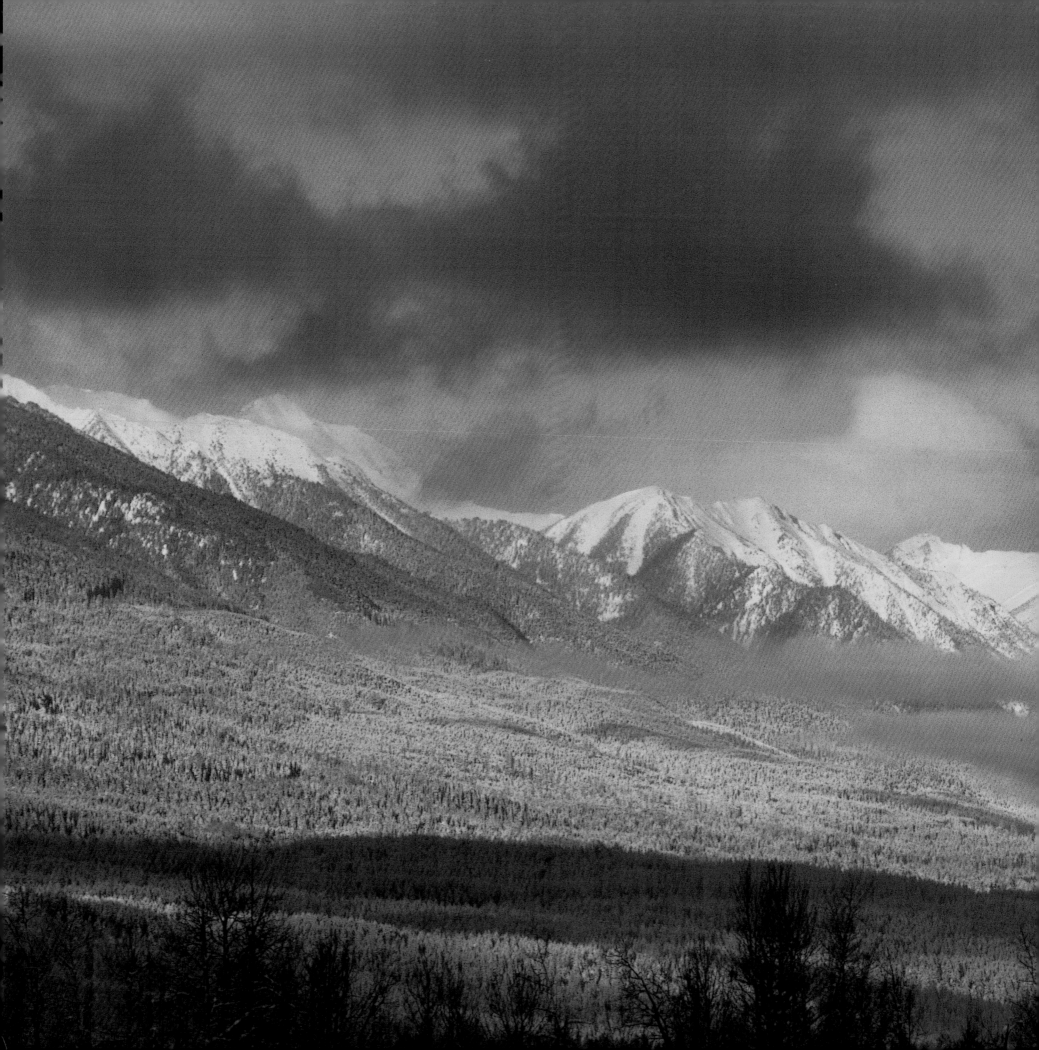

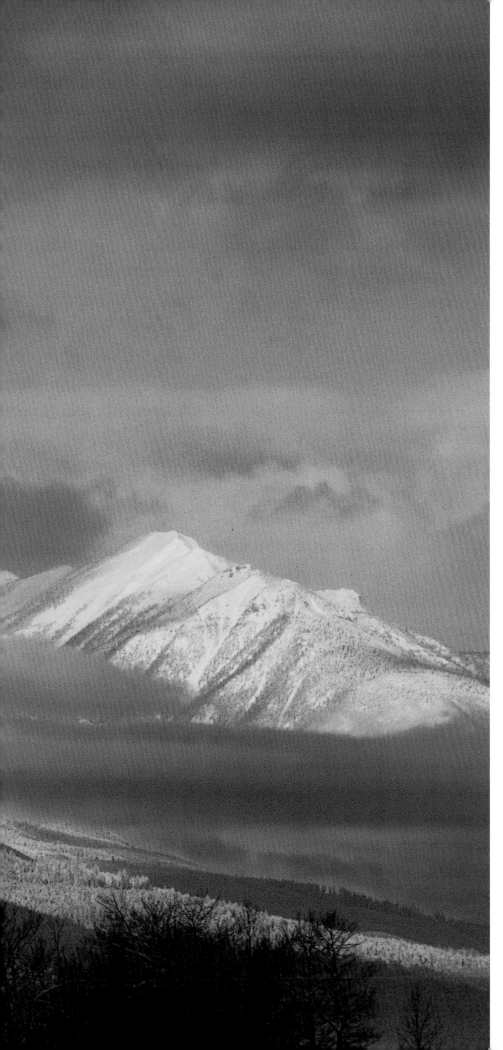

Morning light over the Selkirk Mountains,
Edgewater, British Columbia

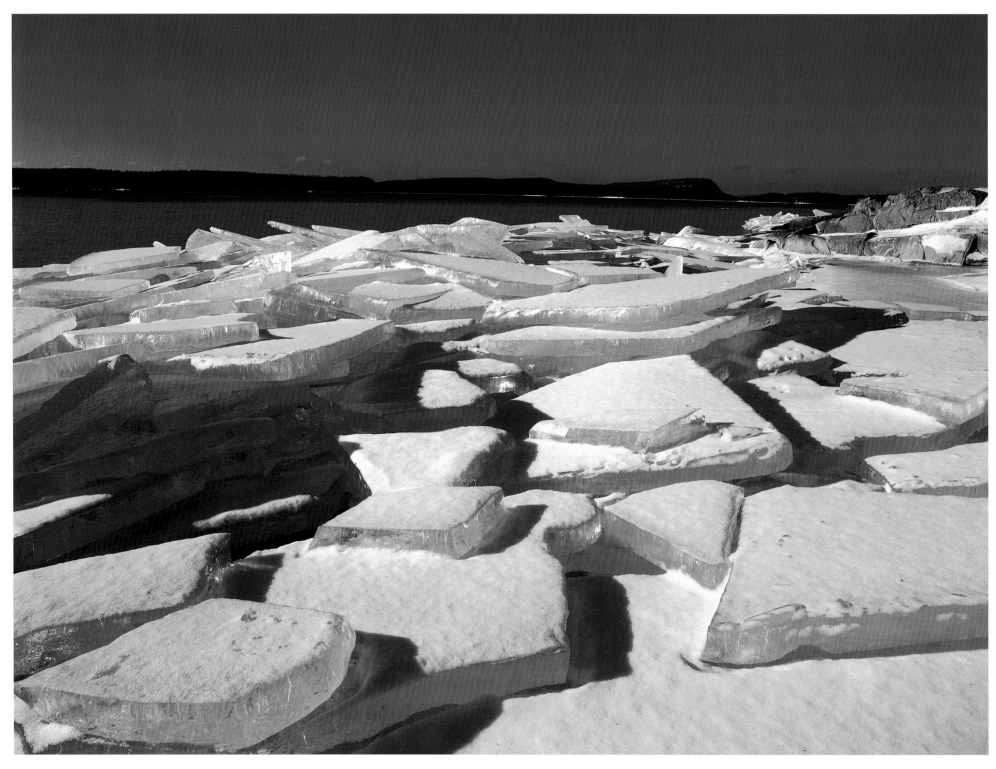

Lake Superior shoreline near Rossport, Ontario

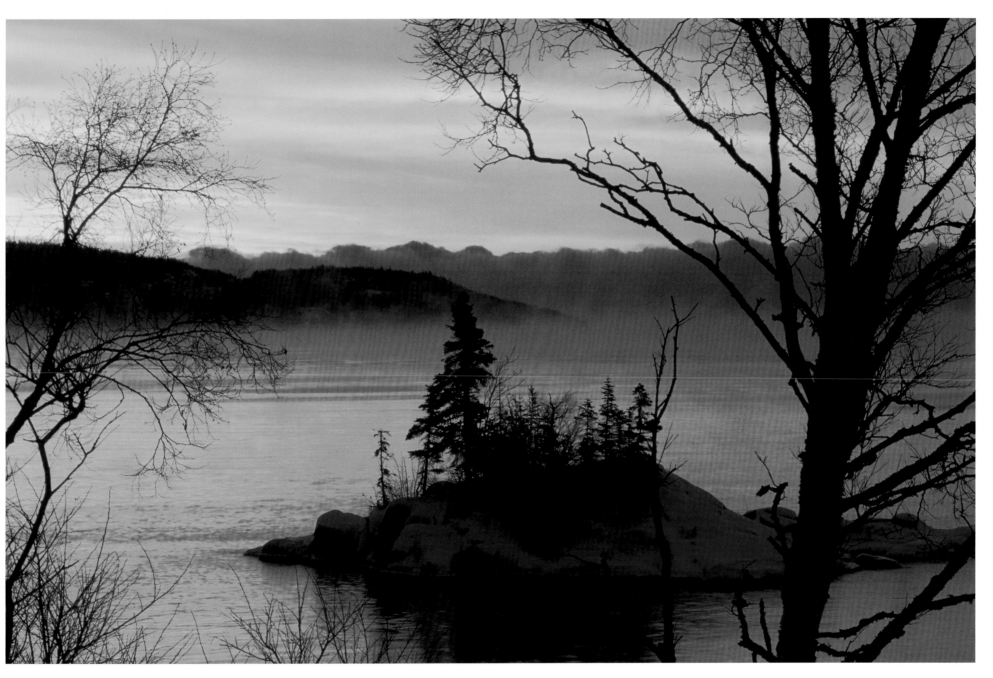

Lake Superior shoreline at dawn near Rossport, Ontario

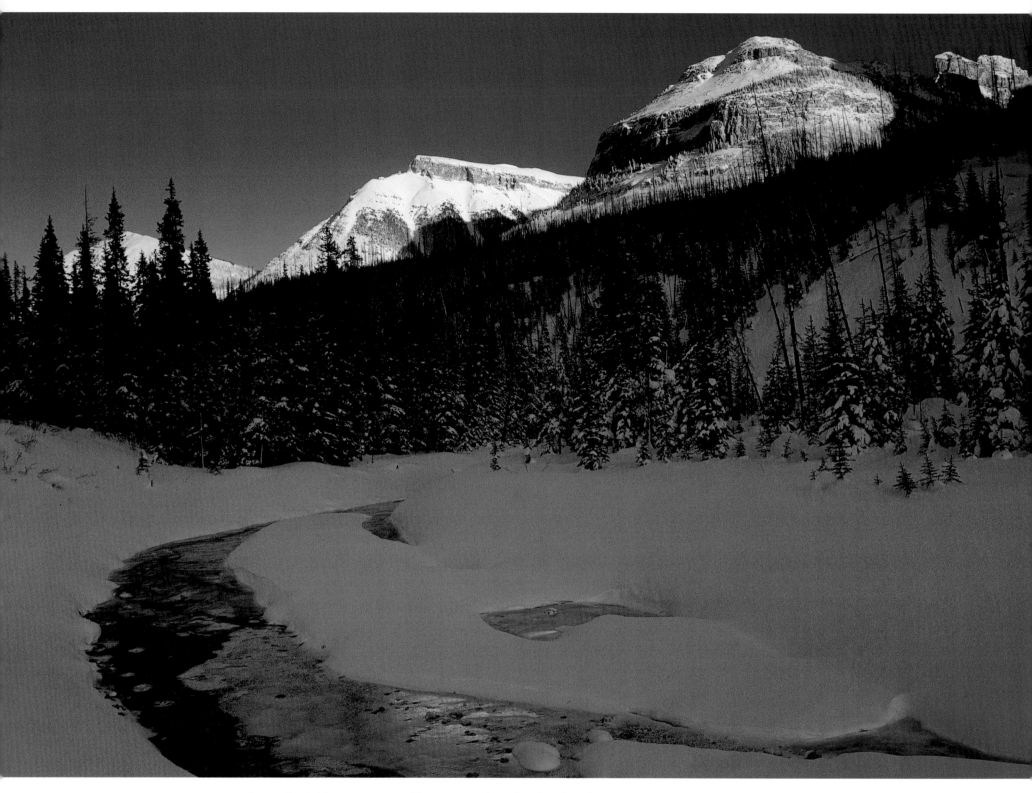

Continental Divide at sunset, Alberta–British Columbia border

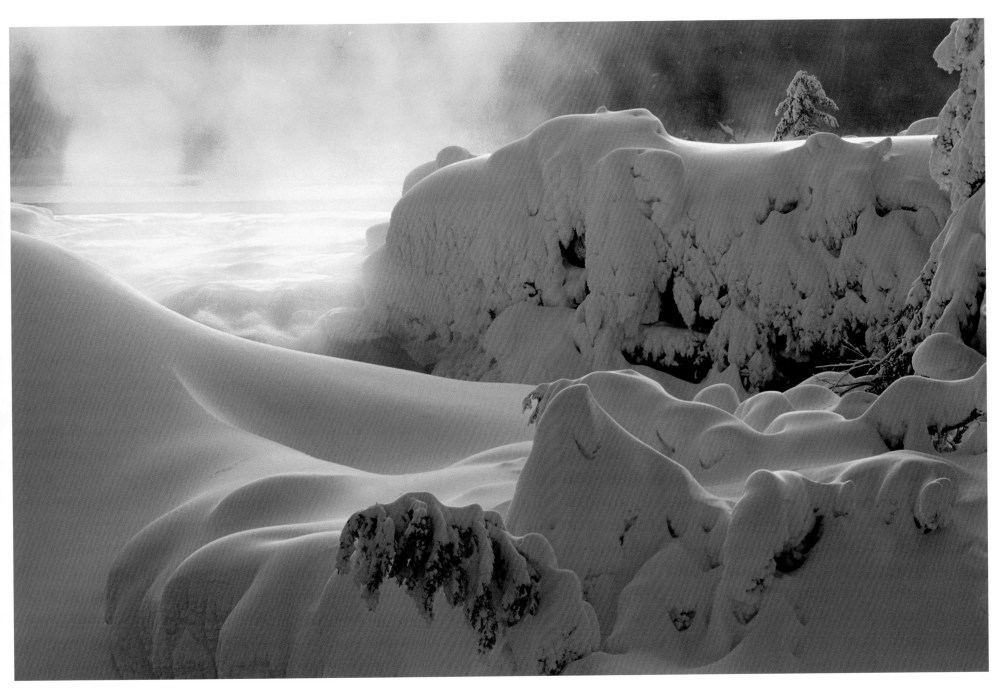

Pisew Falls Provincial Park, Manitoba

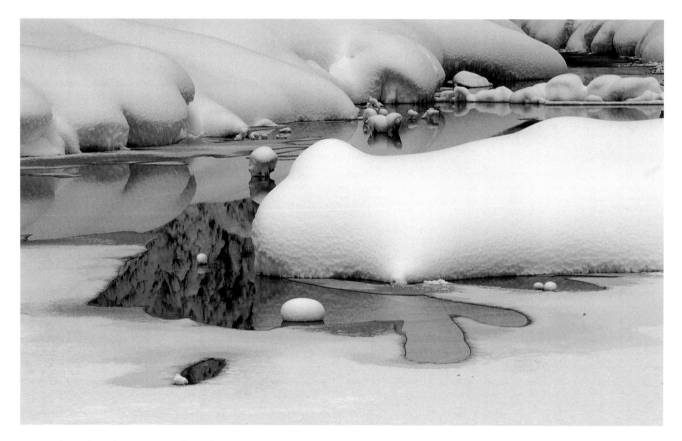

River detail, Yoho National Park, British Columbia

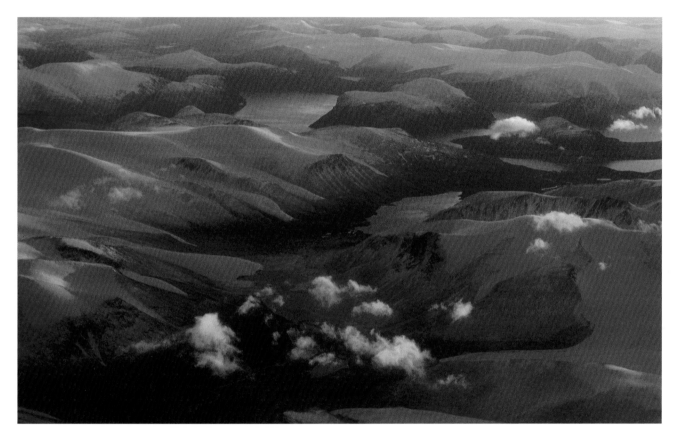

Aerial view of eastern Baffin Island, Nunavut

Hoarfrost on Scots pines, Birds Hill Provincial Park, Manitoba

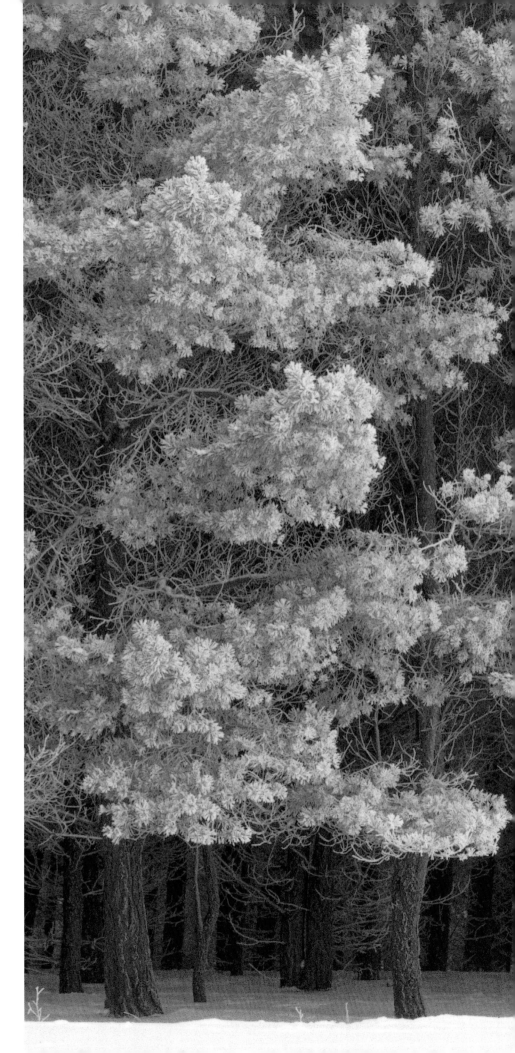

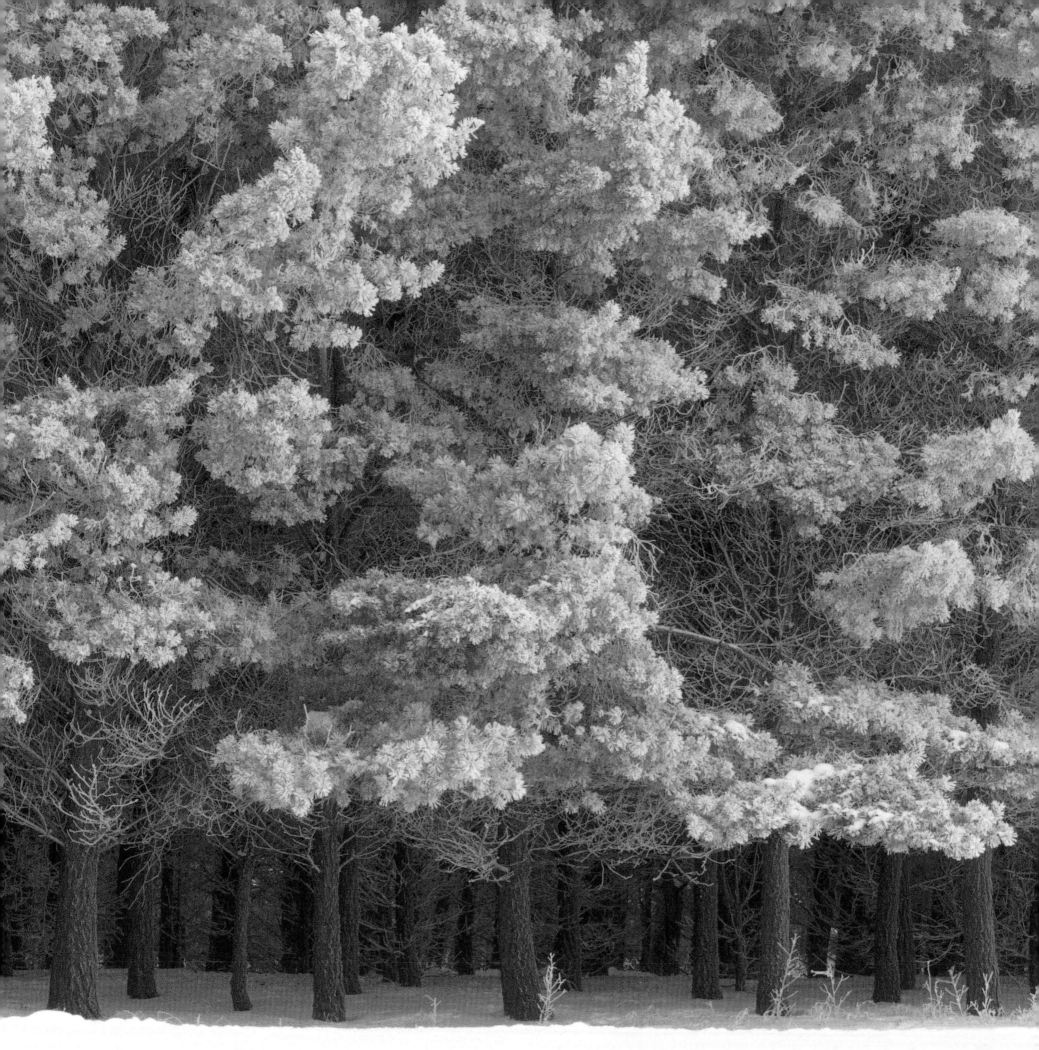

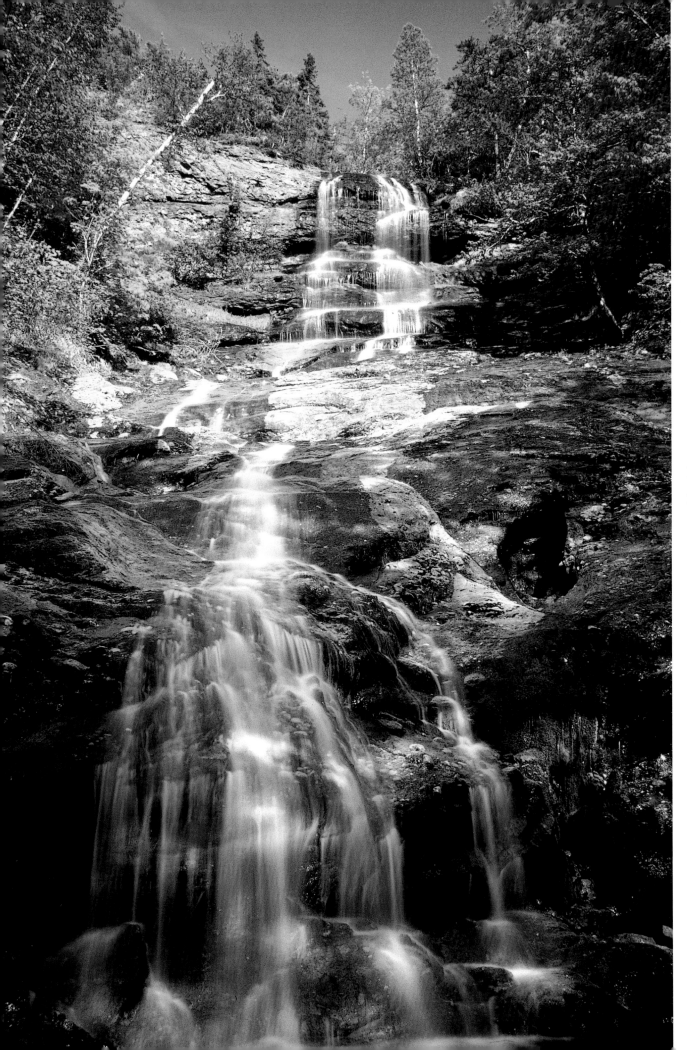

Beulach Ban Falls, Cape Breton Highlands
National Park, Nova Scotia

Stirring—things stir in the spring. Crocuses pop up, tree buds pop out, and blooms pop open. Something stirs in us, too. Nature pushes us out of our own hibernation and into action.

In the age of Arthur and Guinevere, everyone danced around maypoles in their wispy gowns and daisy coronas. May does have the power to turn one into a pagan. The festival they celebrated was probably Beltane, a pagan spring festival to honour the power of fertility and the growth that lay ahead in the fields. The word "Beltane" is of Celtic origin, meaning "fire of Bel," the Celtic god of light. Beginning at sundown on April 30, bonfires were lit for the night. Farmers and their animals would walk between two bonfires in a ritual to bring about good fortune and fertility.

Light, luck, and fertility—I have only to look at my garden to see all three in action. All those shoots and spears, surfacing.

We are desperate for spring by the time it arrives. It's hard to say which is the best part of this season. The beginning? Not with all its false springs. The middle? Perhaps. It is so delicate and tentative a time. Then there's the full-blown climax that is, especially in these times of climate change, summer by any other name. Let's break it down by months. For most of the country, March doesn't count. People call it Farch because it acts like February, though tongue-twisting poets like Sheree Fitch will celebrate its mud-loveliness. April might still be too fickle. The restraint of that time of year appealed to the turn-of-the-last-century poet Marjorie Pickthall. In 1907, she wrote "The Green Month:"

What of all the colours shall I bring you for
	your fairing,
Fit to lay your fingers on, fine enough for
	you?—
Yellow for the ripened rye, white for ladies'
	wearing,
Red for briar-roses, or the skies' own blue?

Nay, for spring has touched the elm, spring
	has found the willow,
Winds that call the swallow home sway the
	boughs apart;
Green shall all my curtains be, green shall be
	my pillow,
Green I'll wear within my hair, and green
	upon my heart.

Who says Canadians are not romantic?

May is the best part of spring because I can get out the motorcycle, an old Yamaha Virago 250. "Virago" has two meanings: A woman regarded as noisy, scolding, or domineering, or a large, strong, courageous woman. (This is according to the website dictionary.com). I like them both. My bike is hardly domineering or large, but for its size, it kicks a lot of horsepower. So the motorcycle comes out of the garage, I whip the sheet off it, polish it up, and then go for that first spring ride. The freedom is wonderful—just me and the road…and the smell of new life all around. Everything is sprouting, budding, bursting. The former MP, and virago in the best sense of the word, Deb Gray rides a bigger bike than mine, a Kawasaki Voyager. Maybe one day I'll graduate to more power, as she did. You can see a picture of her and her bike on the cover of her autobiography *Never Retreat, Never Explain, Never Apologize: My Life, My Politics.* We had a conversation about that first spring ride and the raptures of being on a bike while taking in the heady scent of the lilacs in first bloom. We got downright giddy about it. It's like a drug and, yes, you inhale. The lilacs.

In the North there is limitless light on the endless land. I spent a few days last spring in Holman, Northwest Territories, on the Diamond Jenness Peninsula, about 575 miles (925 kilometres) by air north of Yellowknife. It's a small community of hunters, trappers, fishermen, printmakers, and artists. Everyone was up through the so-called night snowmobiling, fishing for Arctic char or lake trout, or following muskox herds. Who can sleep with the longitudinal gift of twenty-four-hour sunlight when spring is bursting out all over?

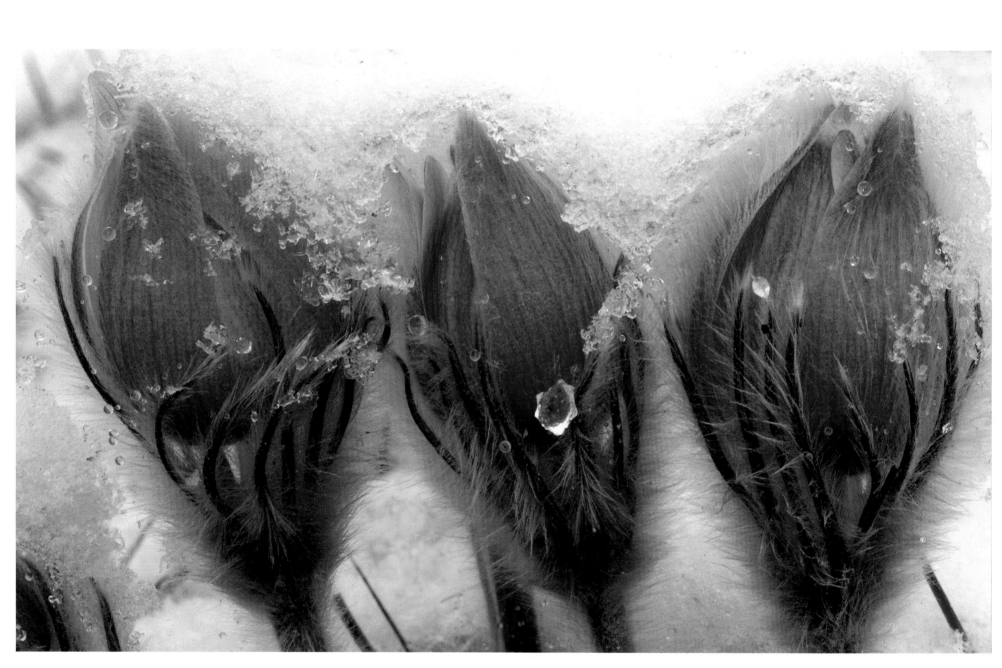

Prairie crocuses after snowfall, Sandilands Provincial Forest, Manitoba

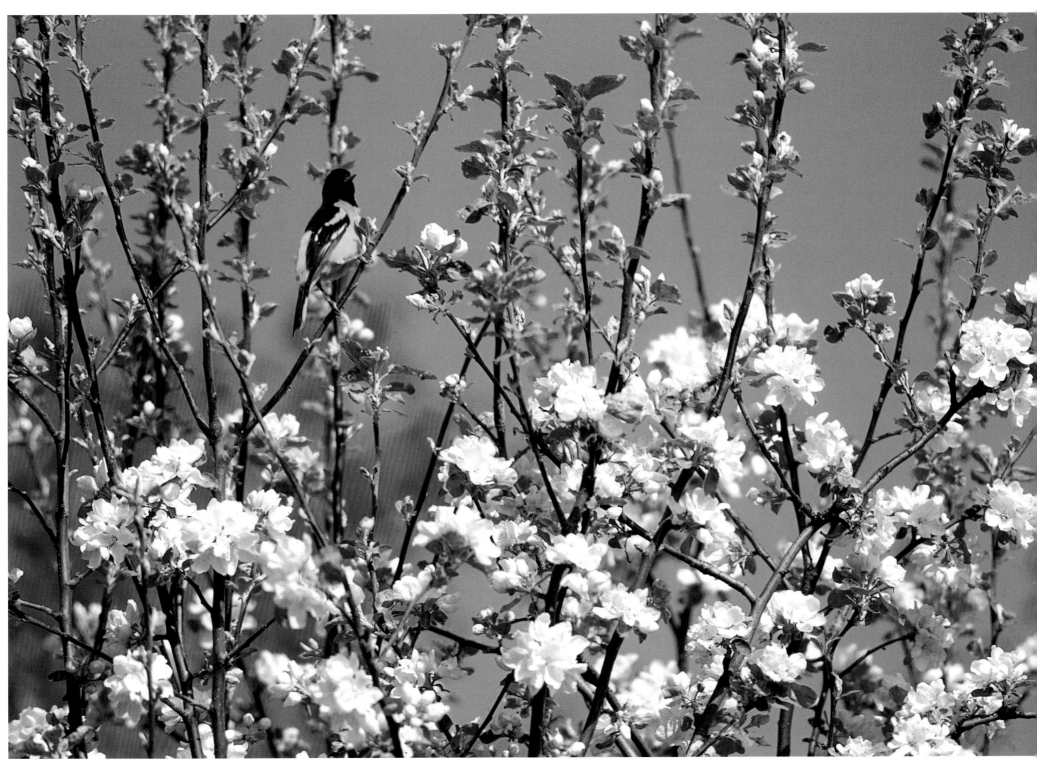

Northern oriole in apple tree, Winnipeg, Manitoba

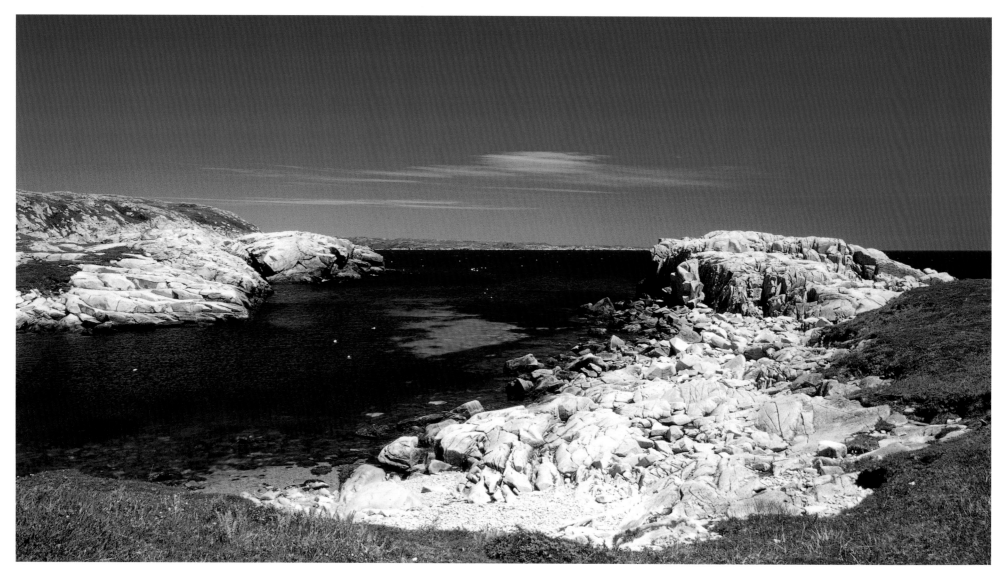

Shoreline and Cabot Strait, Rose Blanche, Newfoundland

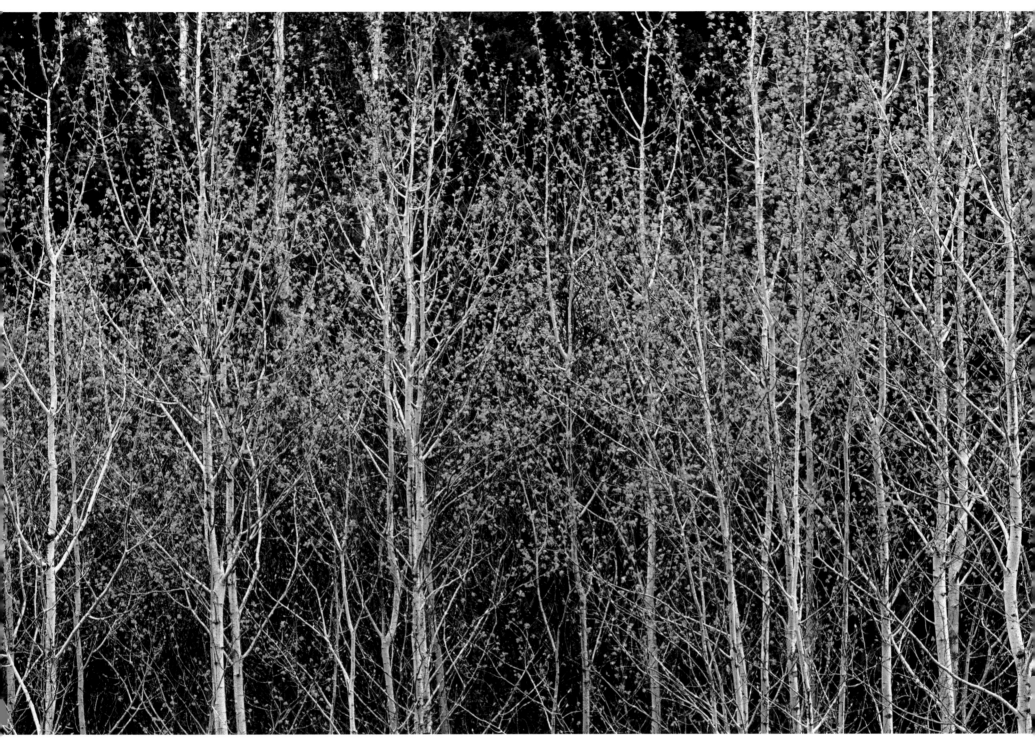

Aspen in spring foliage, Worthington, Ontario

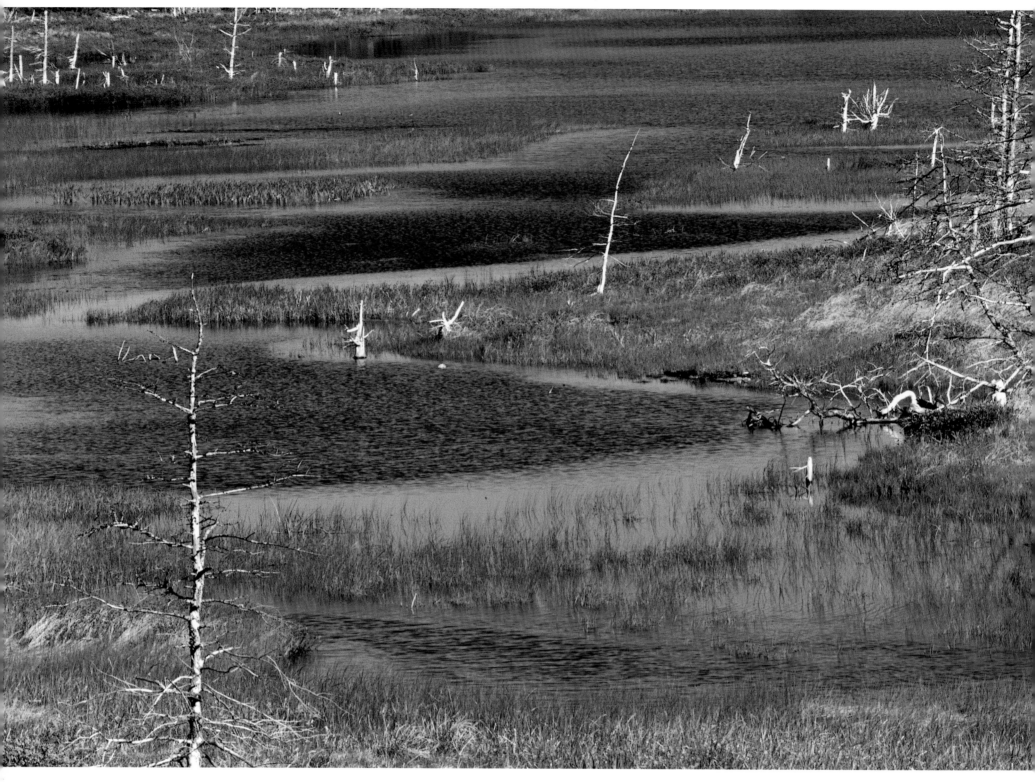

Wetland near Stephenville, Newfoundland

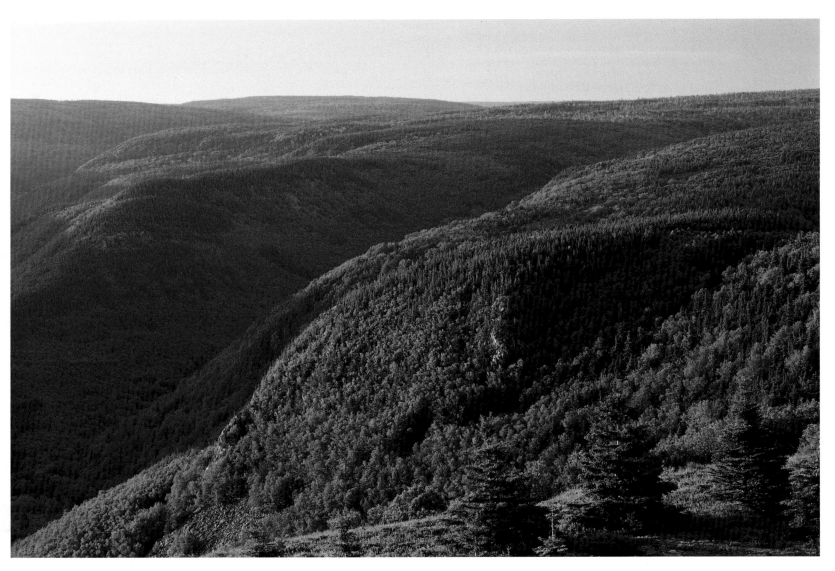

Summit at sunrise, Cape Breton Highlands National Park, Nova Scotia

OVERLEAF Tundra in bloom, Churchill, Manitoba

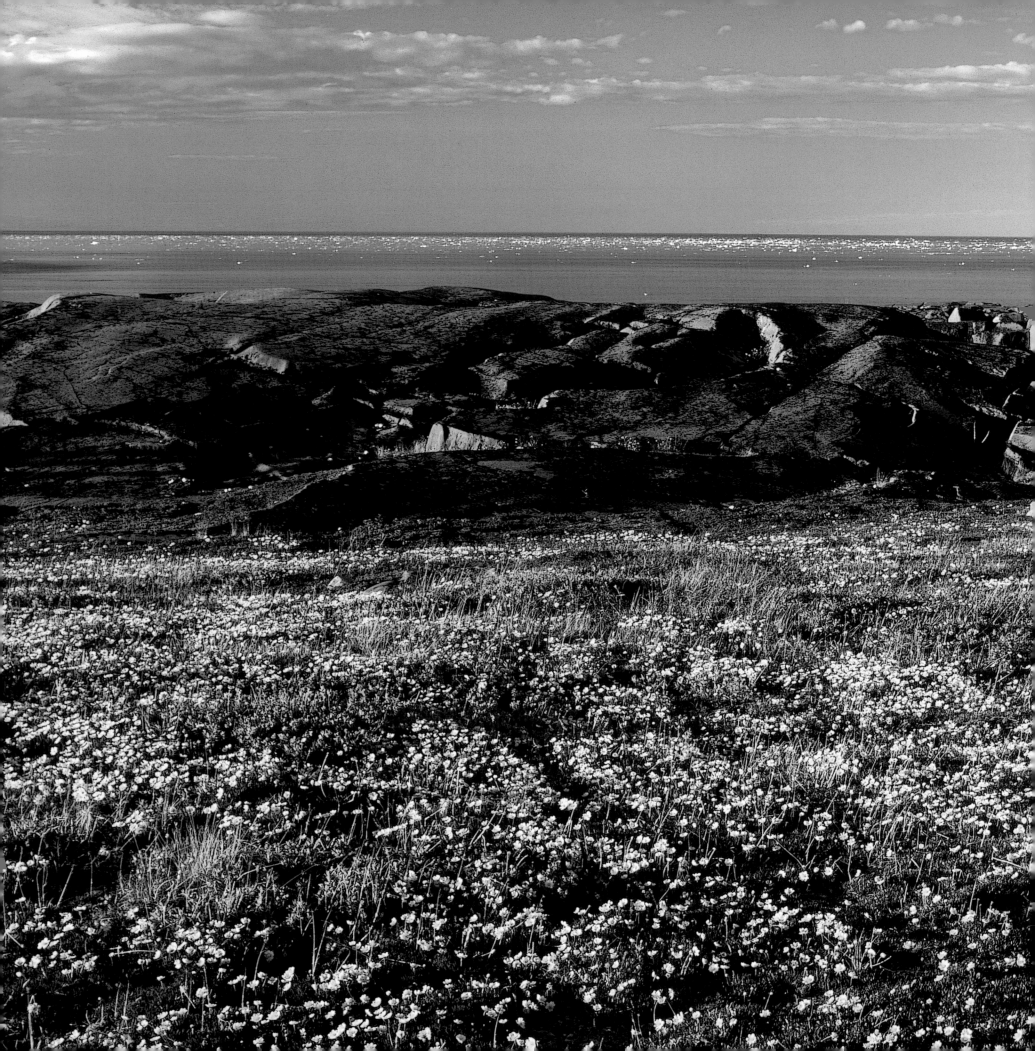

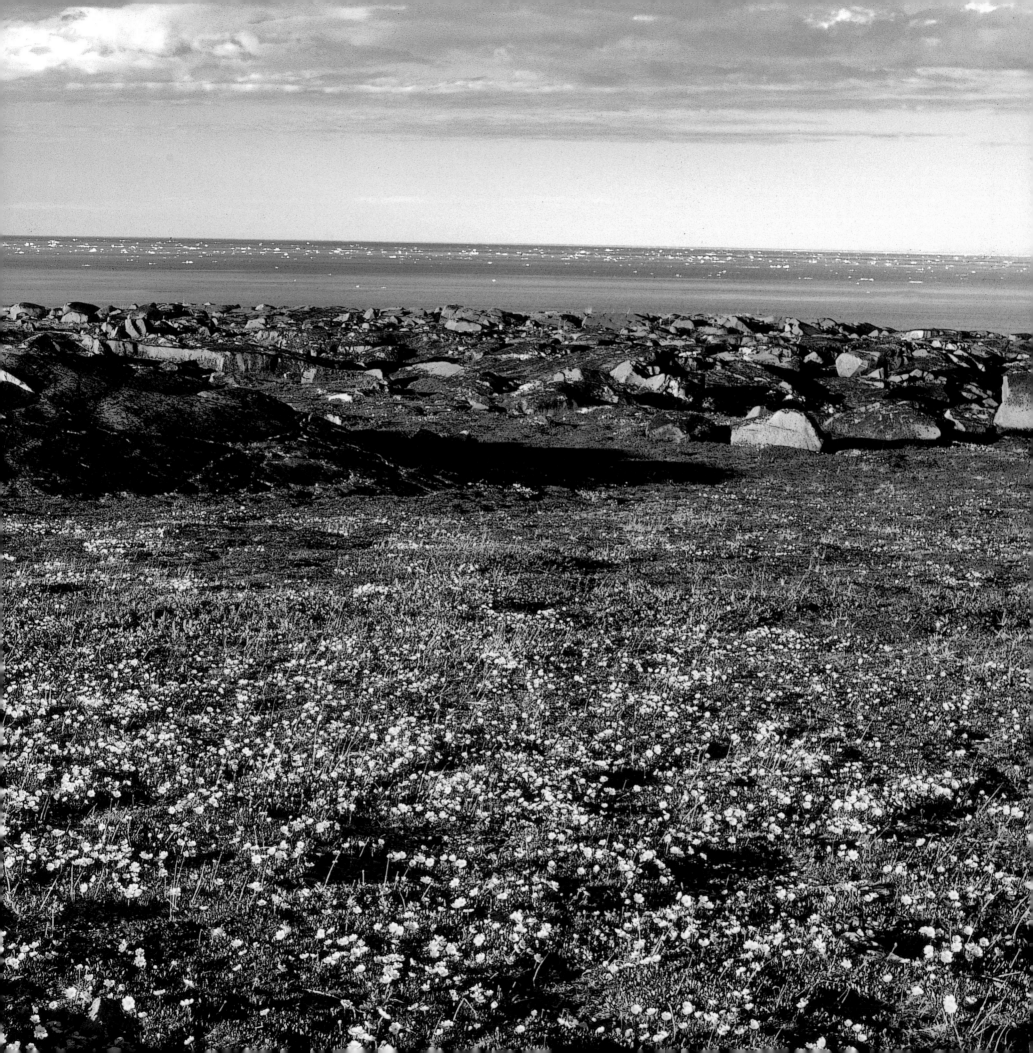

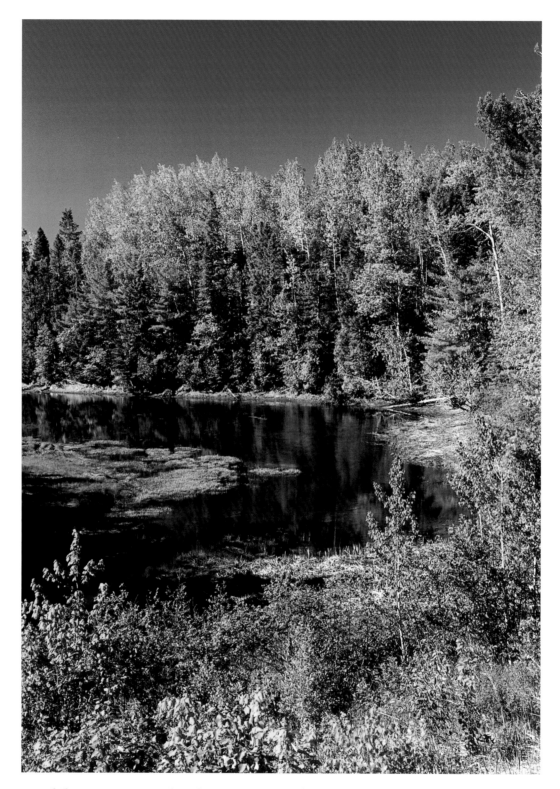

Kouchibouguac National Park, New Brunswick

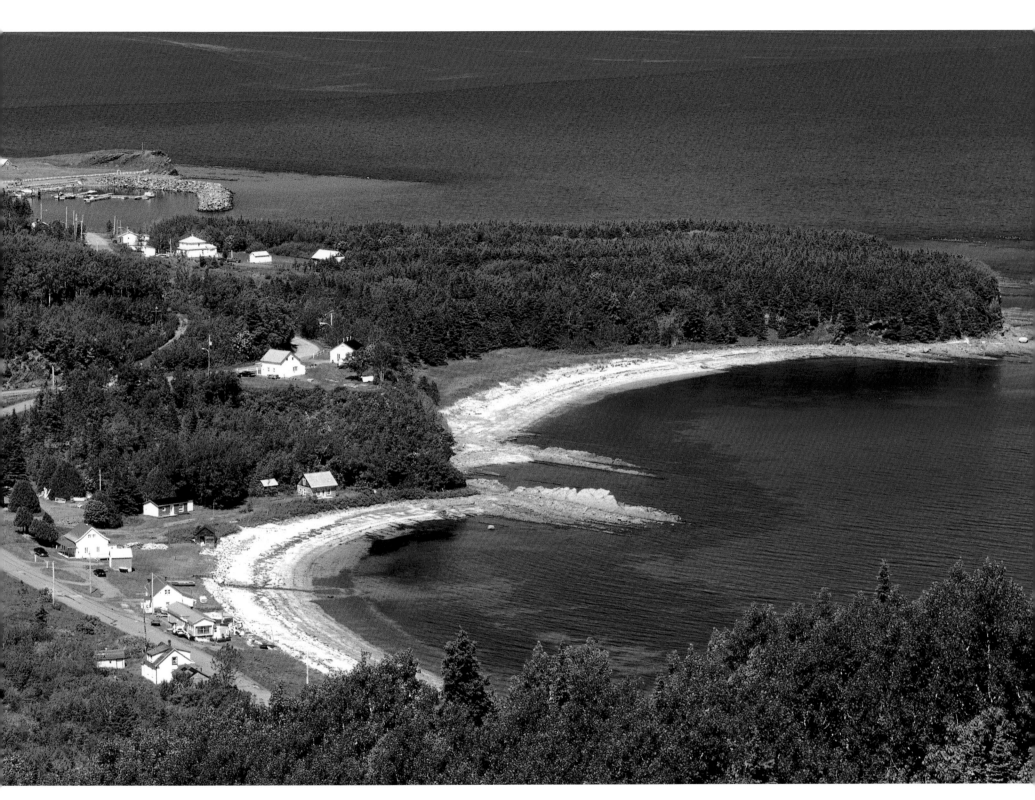

Gaspé shoreline, Grande-Anse, Québec

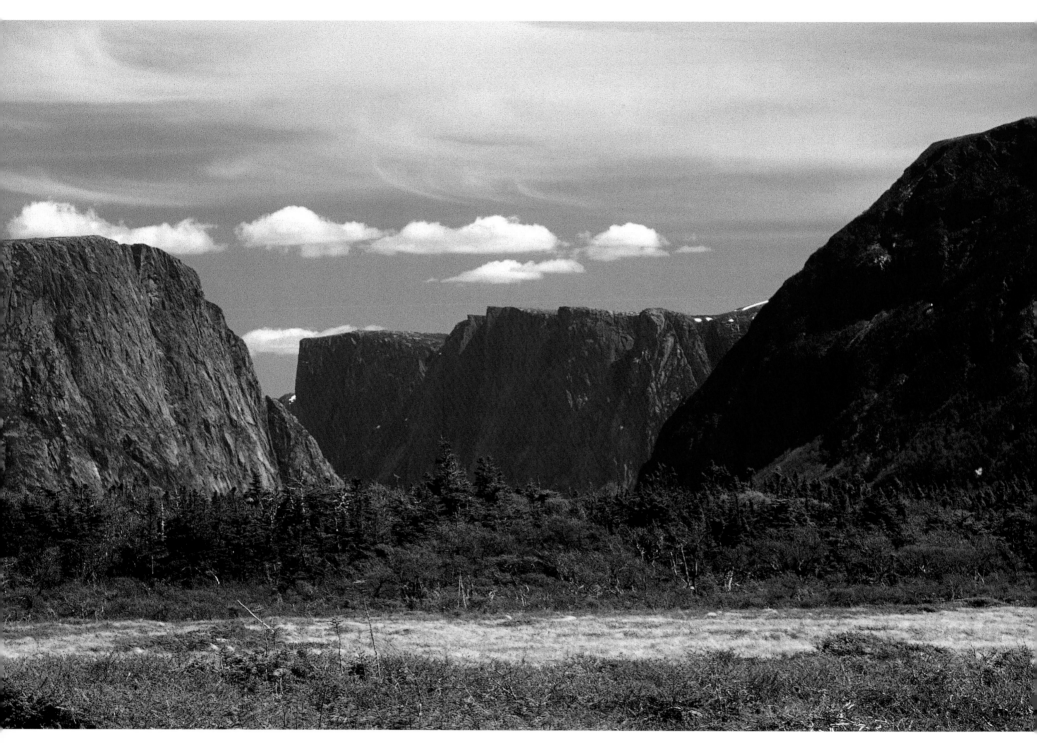

Inland fiords, Gros Morne National Park, Newfoundland

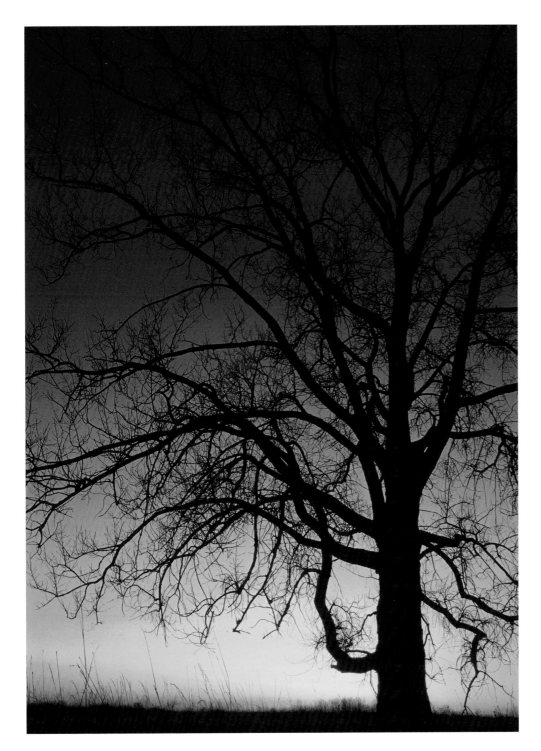

Cottonwood at sunset, Tolstoi Tall Grass Prairie Preserve, Manitoba

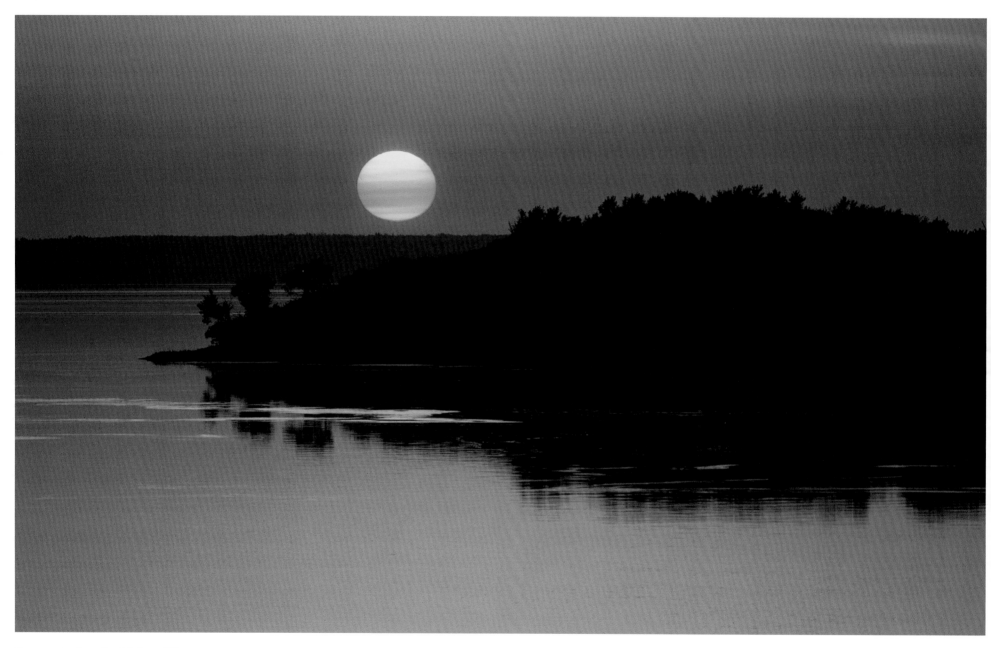

Sunset in Lac La Biche, Alberta

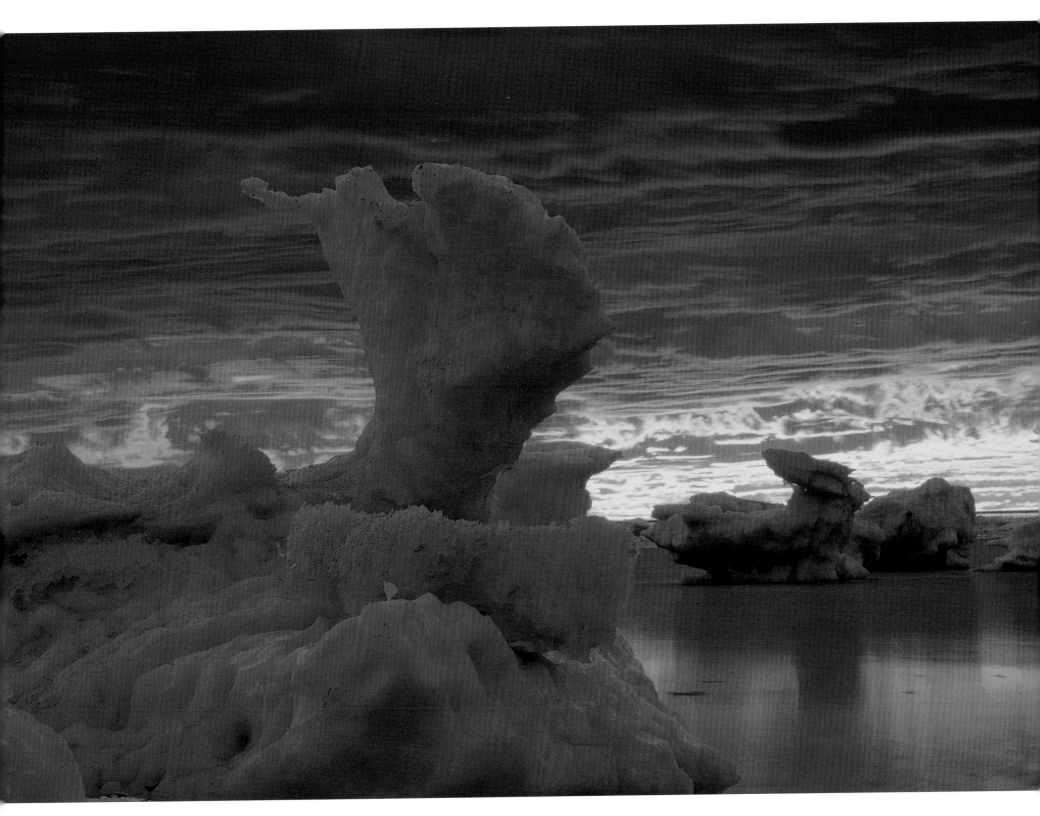

Ice floes at dusk, Churchill, Manitoba

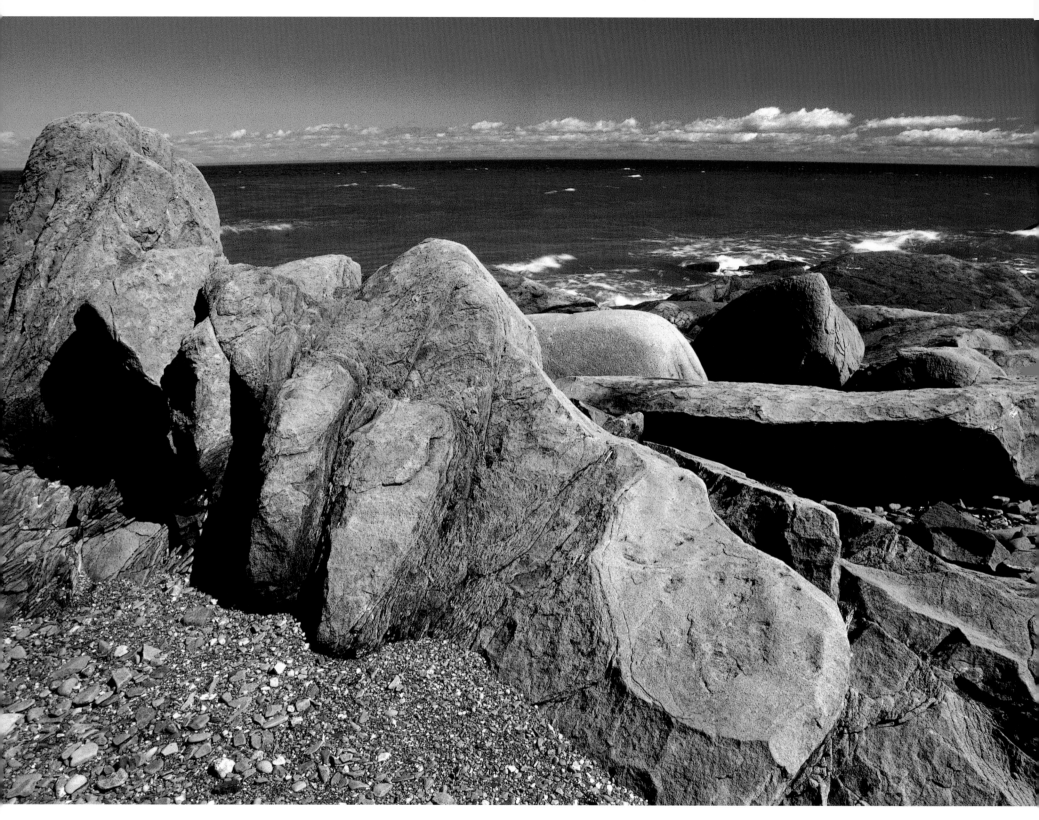

Gulf of St. Lawrence shoreline, Matane, Québec

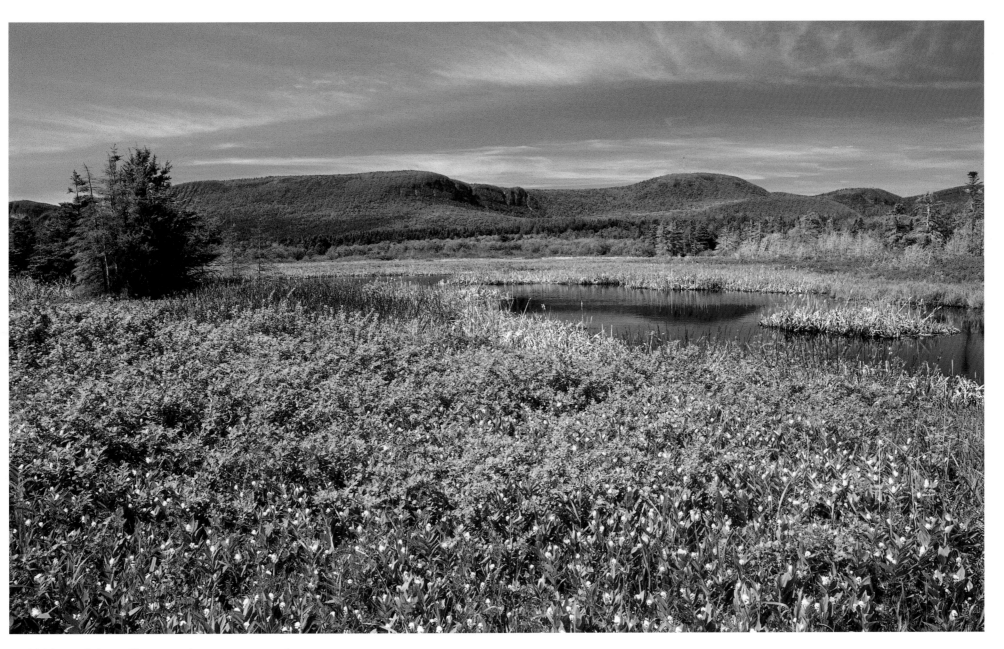

Wild lilies-of-the-valley, Cap-des-Rosiers, Québec

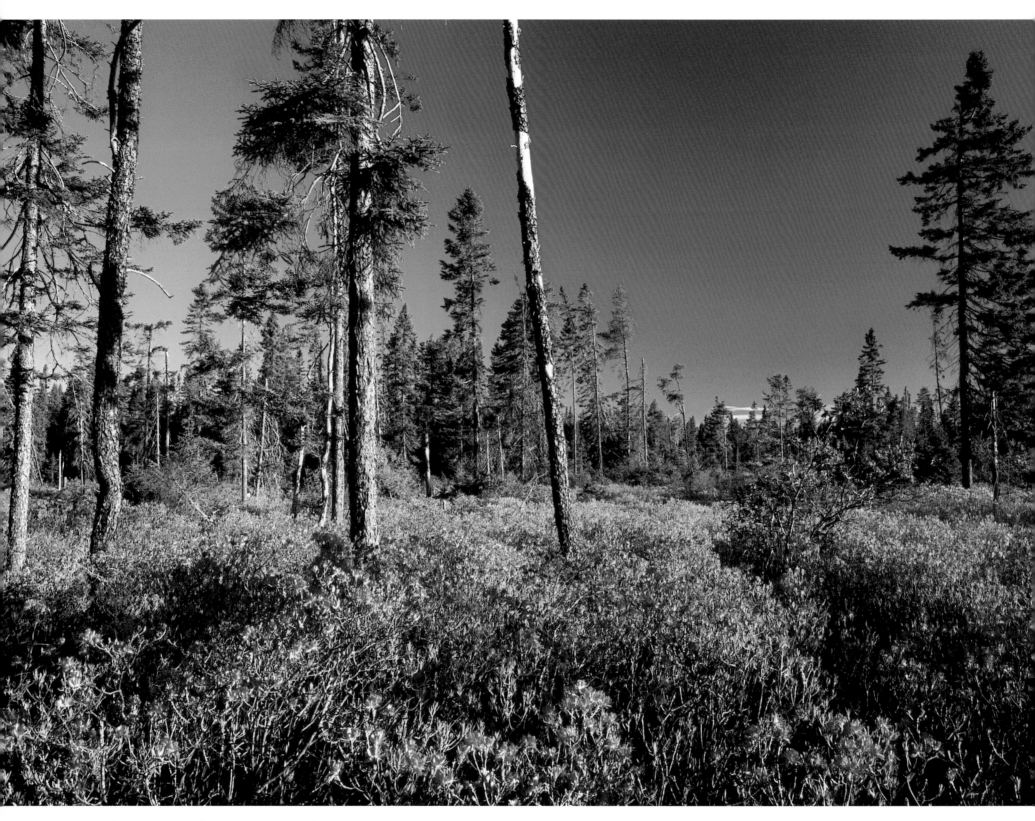

Bog laurel near Miramichi, New Brunswick

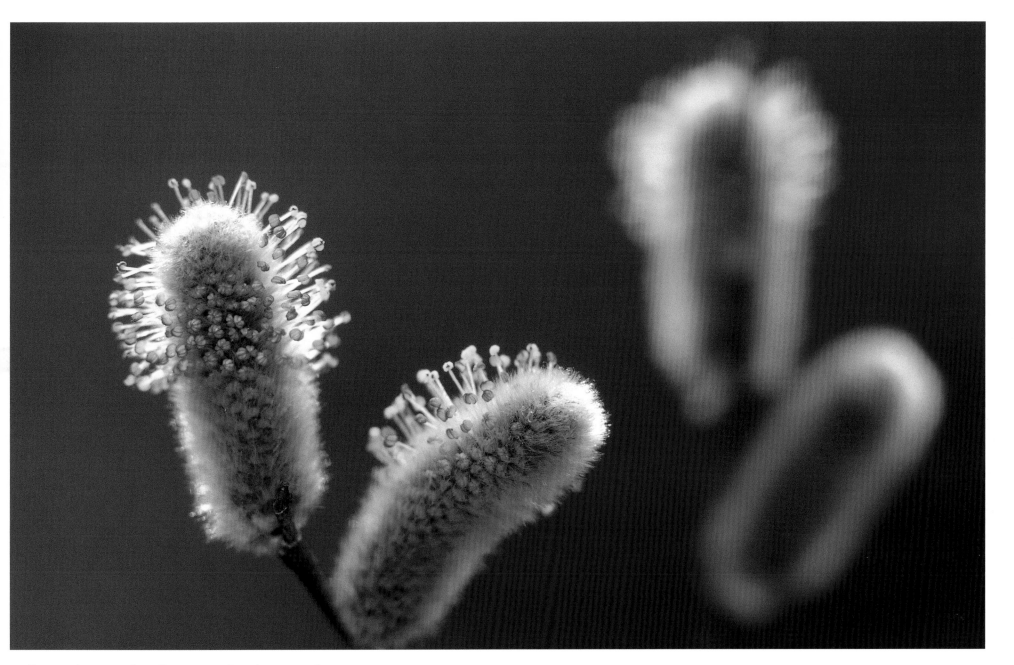

Willow catkins, Birds Hill Provincial Park, Manitoba

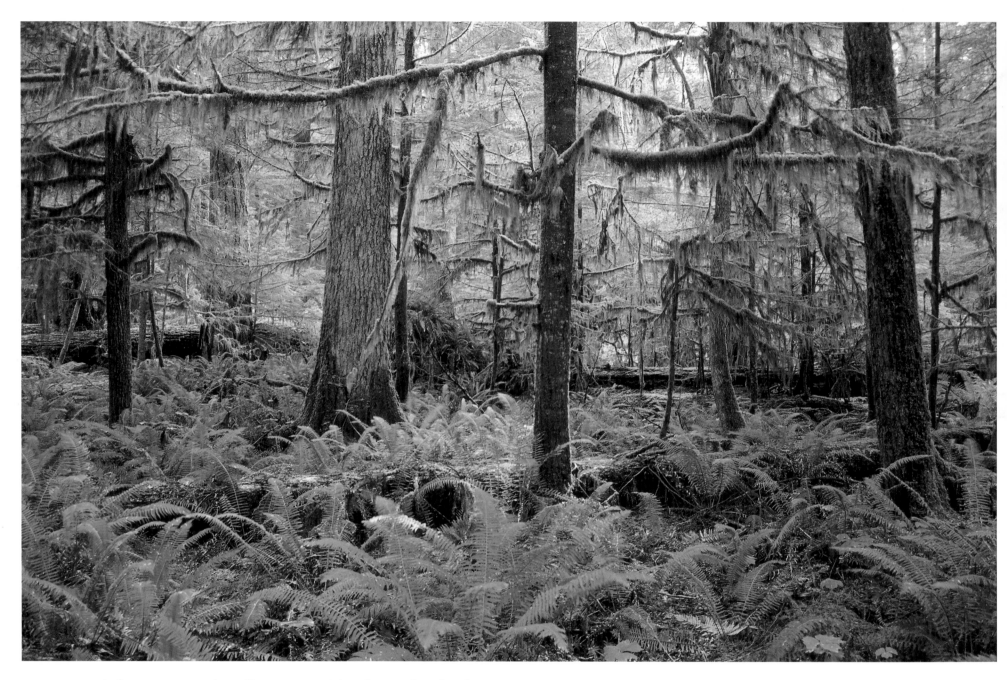

Temperate rainforest, Carmanah-Walbran Provincial Park, British Columbia

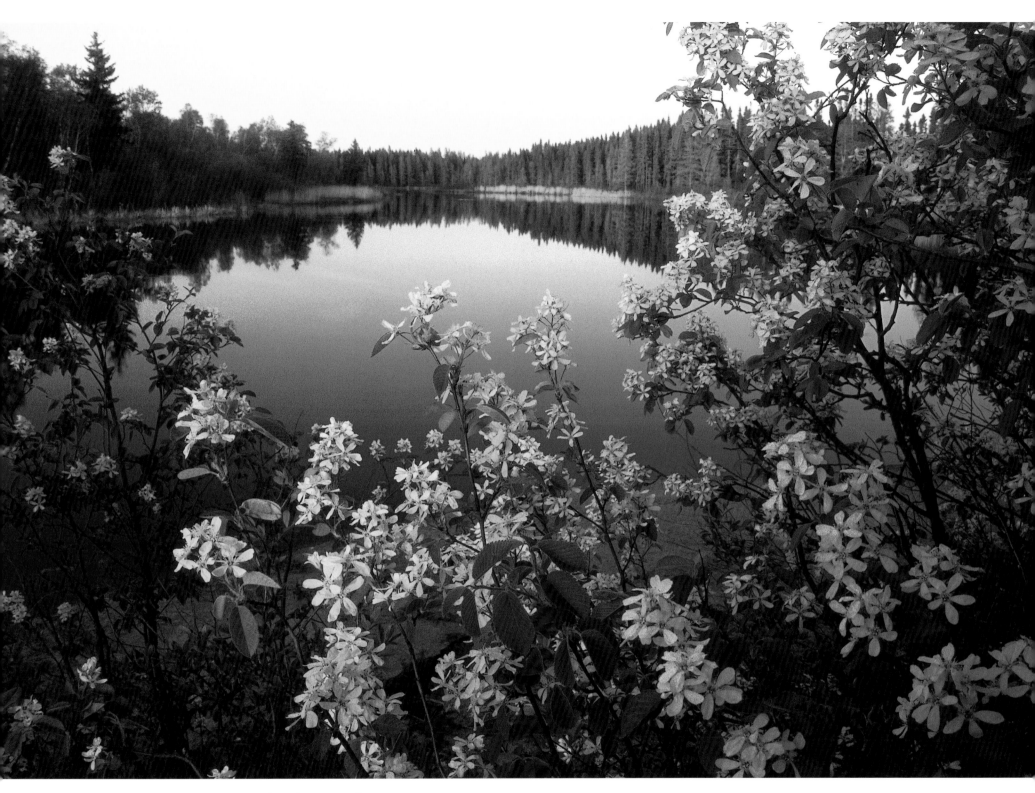

Saskatoon blossoms, Whiteshell Provincial Park, Manitoba

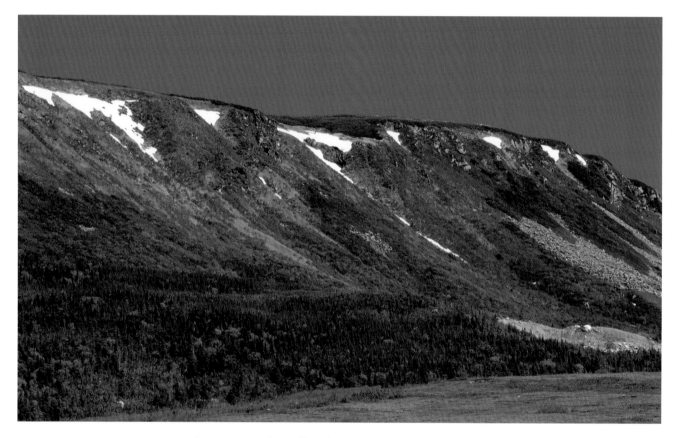

Long Range Mountains, Southwest Newfoundland

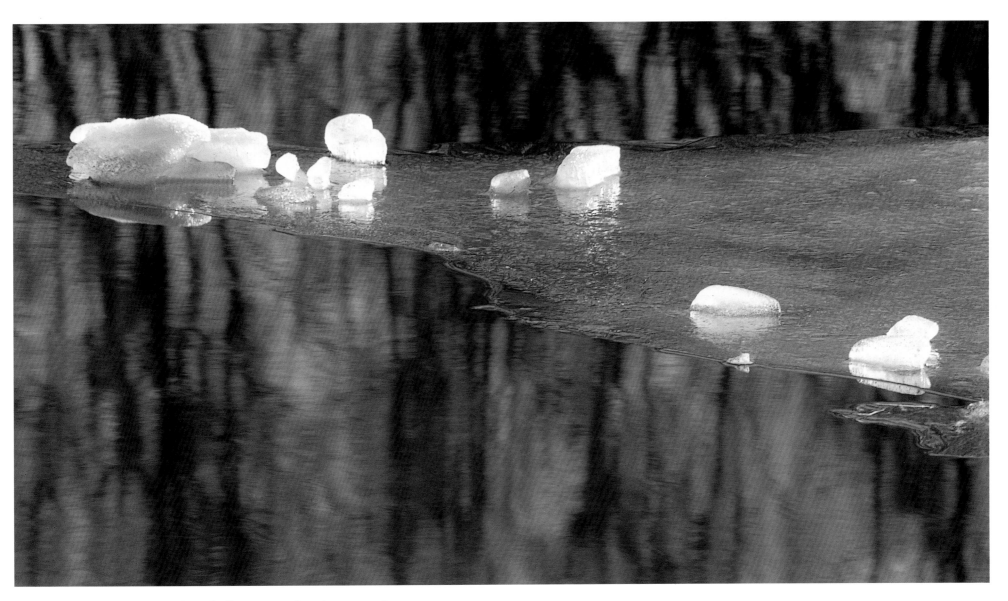

Ice on Whiteshell River, Whiteshell Provincial Park, Manitoba

OVERLEAF Niagara Falls, Ontario

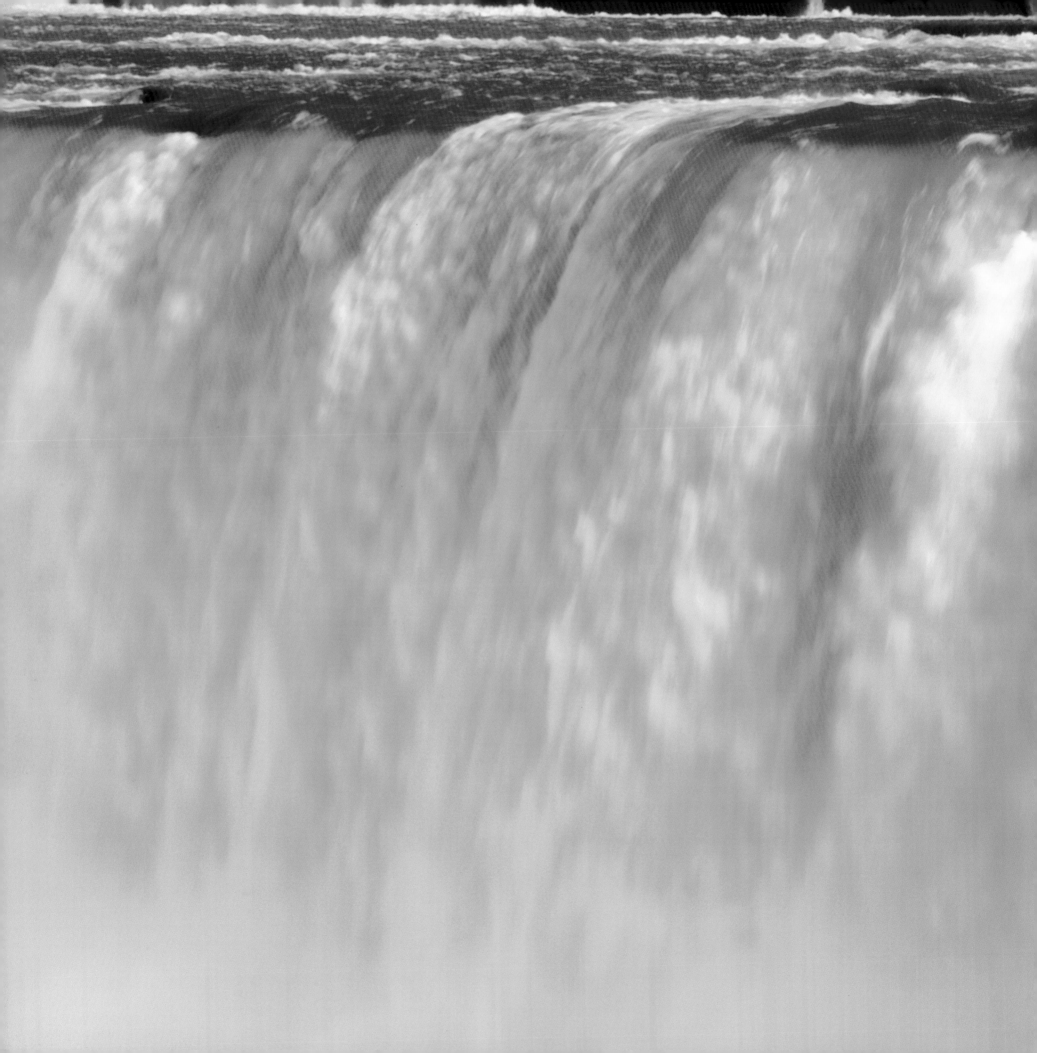

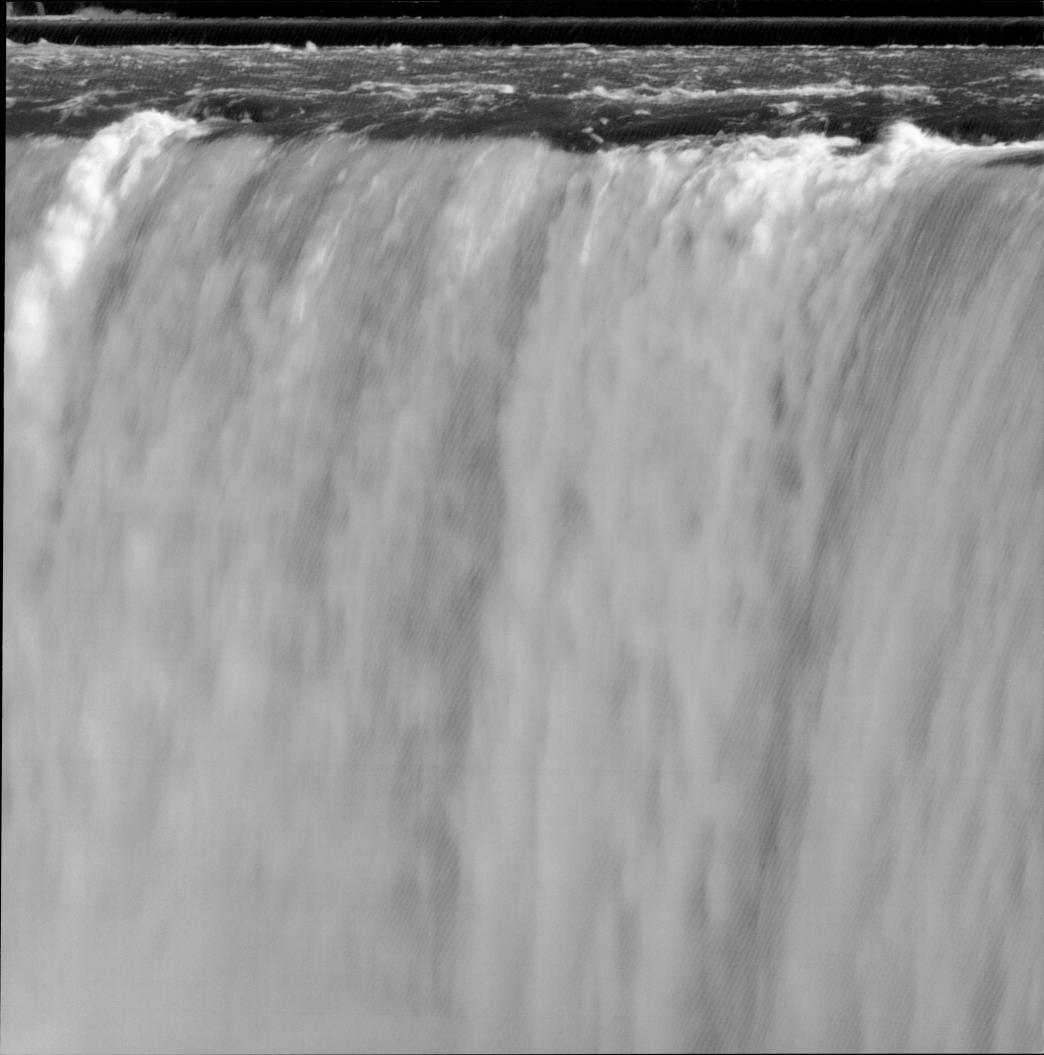

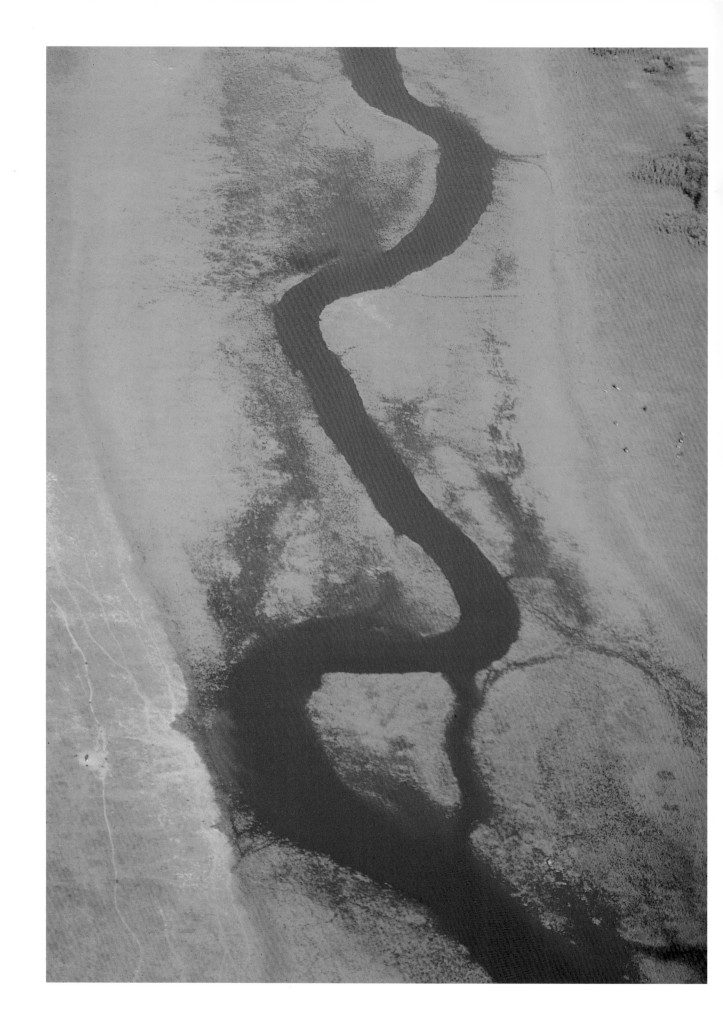

Meandering river, Central Alberta

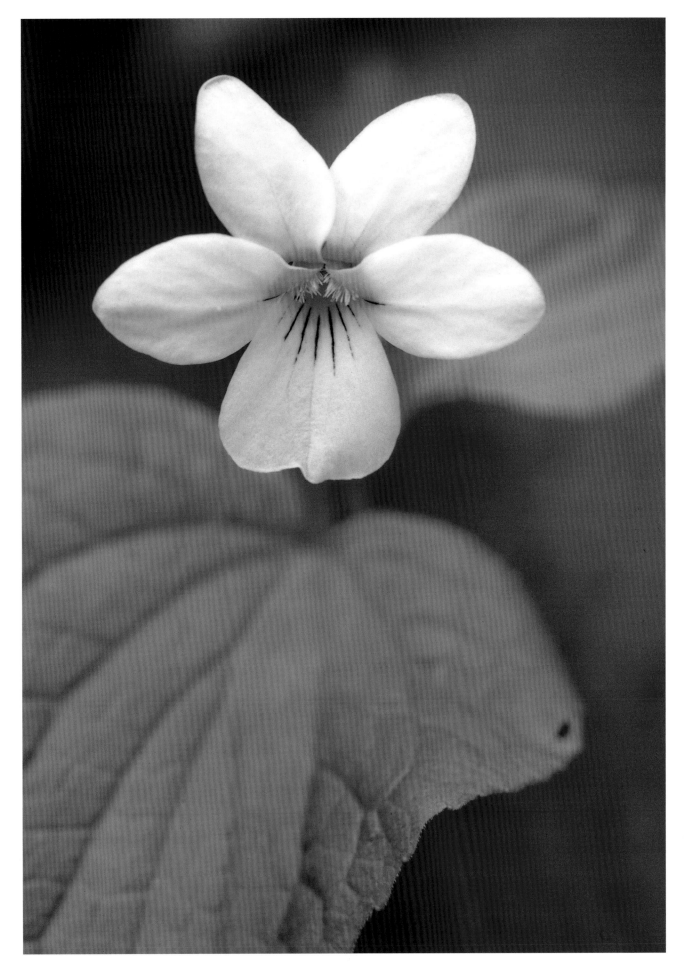

Canada violet, Duck Mountain Provincial Park,
Manitoba

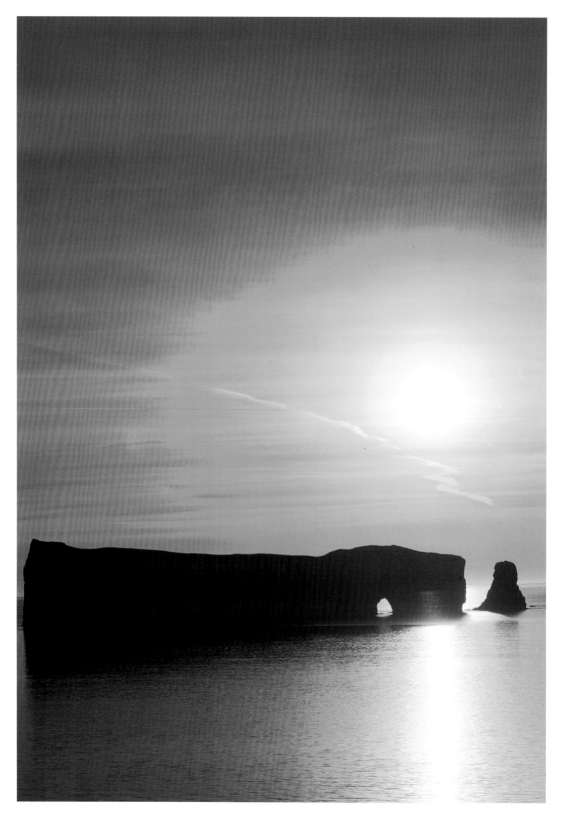

Roché Percé at sunrise, Percé, Québec

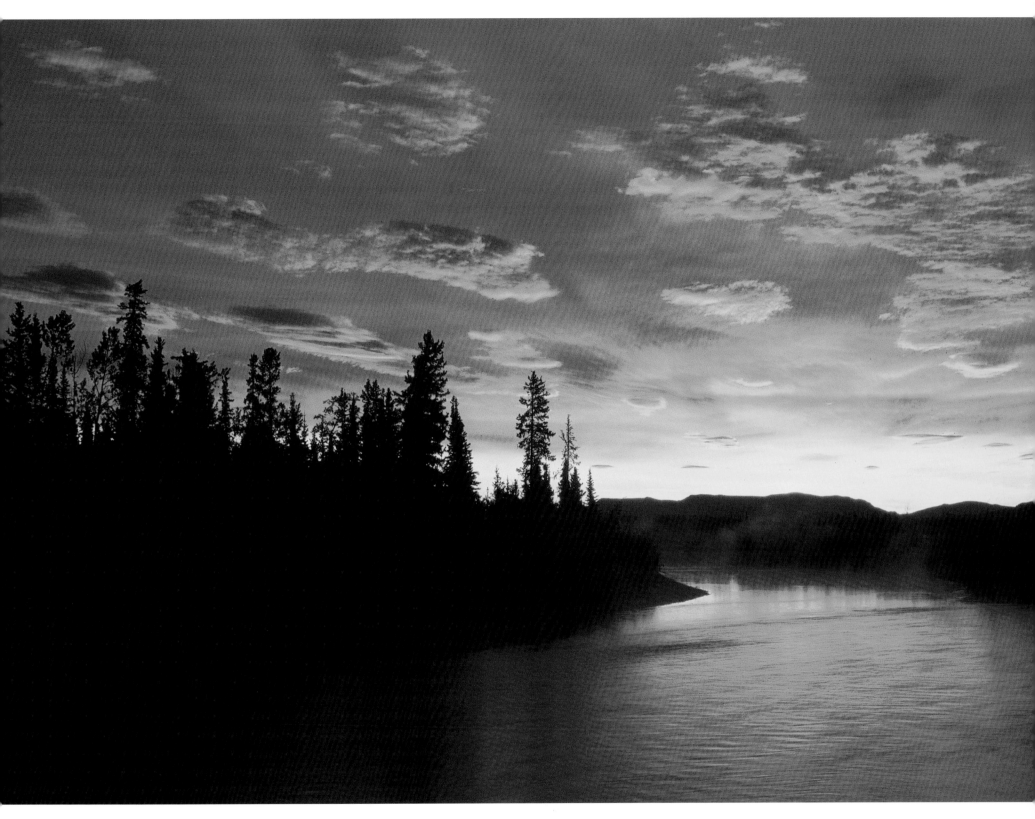

Dezadeash River at dawn, Haines Junction, Yukon

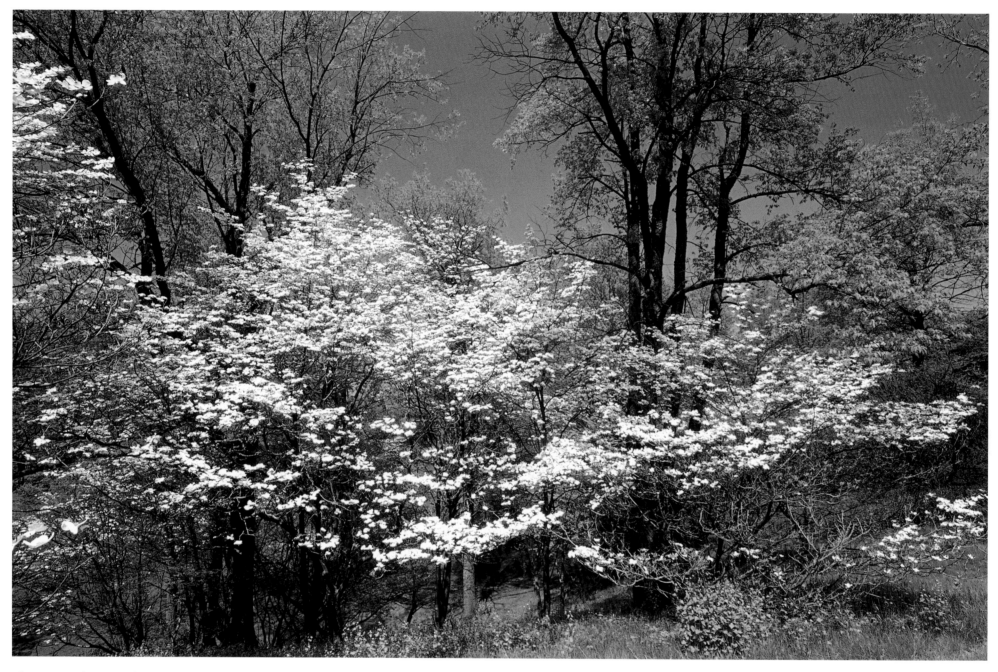

Flowering dogwood, Hamilton, Ontario

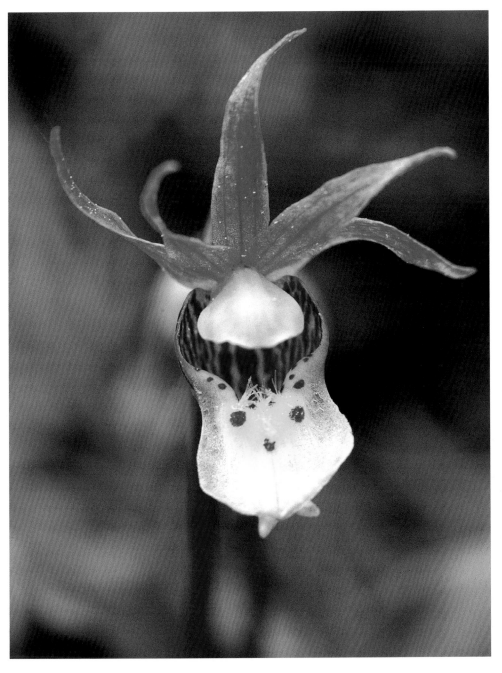

Calypso orchid, Agassiz Provincial Forest, Manitoba

Manitoba maple flowers, Winnipeg, Manitoba

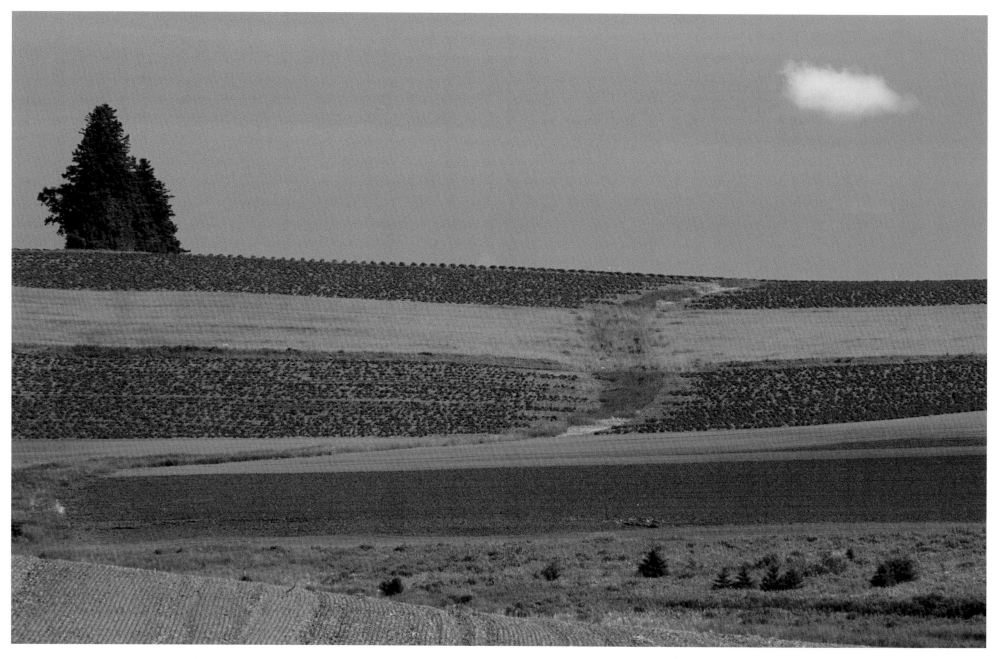

Farmer's field, Margate, Prince Edward Island

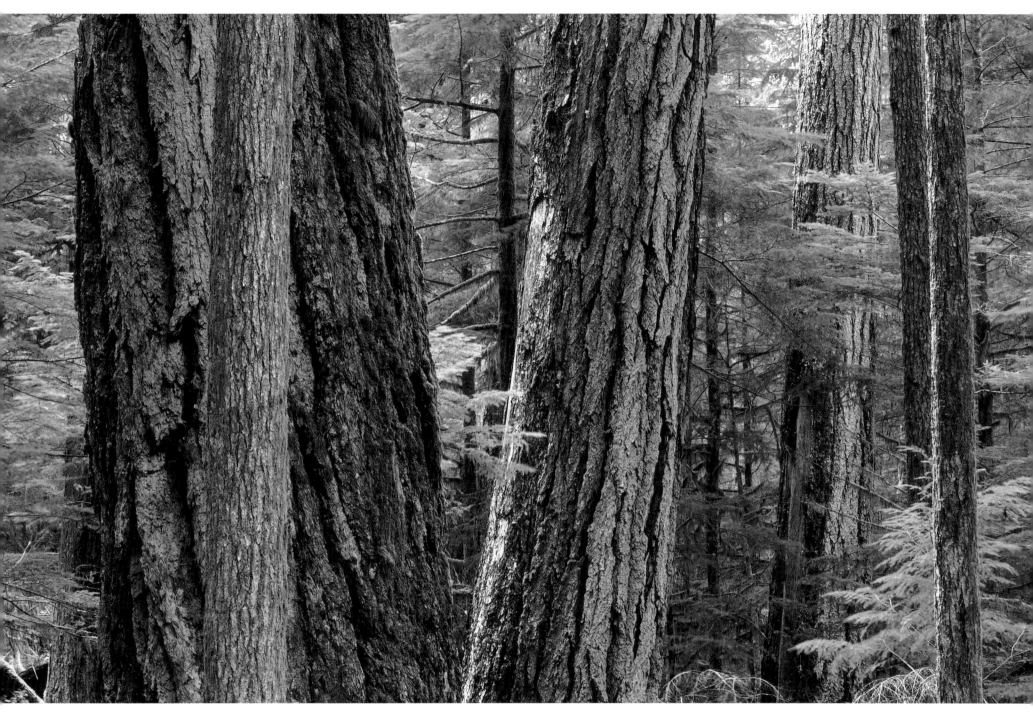

Temperate rainforest, Pacific Rim National Park, British Columbia

Summer

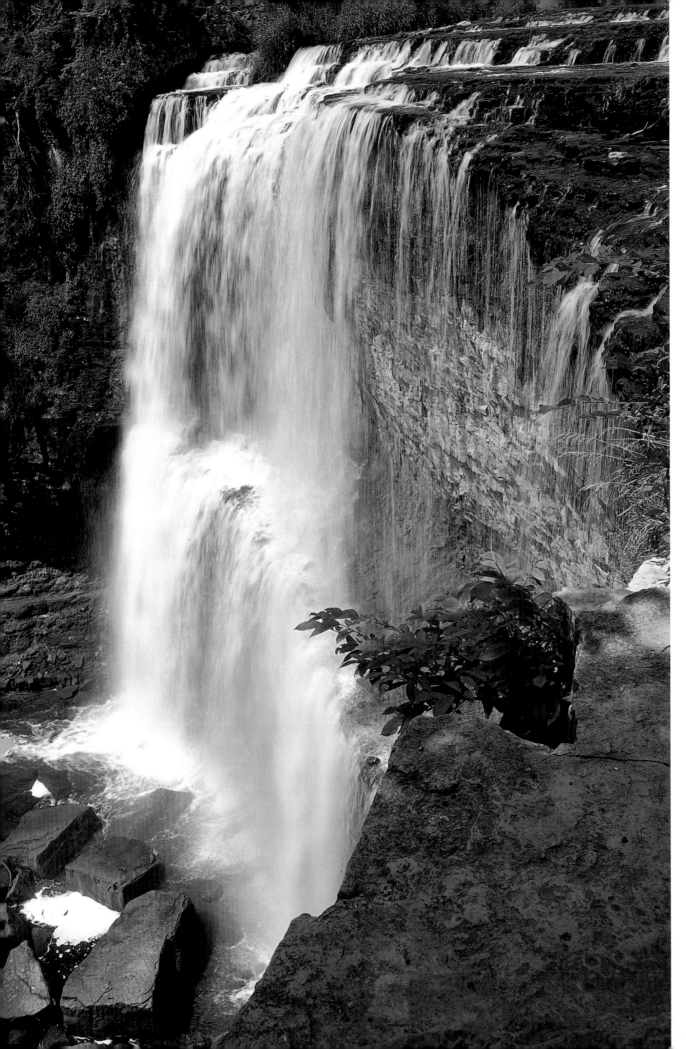

Webster's Falls, Hamilton, Ontario

In summer, there's a different kind of time—suspended time—in the land north of 49. In the afternoon it can feel like four, but it's really only two. The sun sets at 9 p.m., but the light goes on and on. A friend who has a cottage on an island in Georgian Bay gets in her motorboat before the sun goes down and chases the sunset. She's been doing this since she was a kid and she now takes her own children out to hunt it down. Accurate clocks seem to lie, as they display time as measurable and finite.

In summer time gets lost. Words like "dock" or "beach," "barbecue" or "boathouse" suggest taking it easy in those languid days. We unwind to our more natural selves.

And if there is ever a time that we venture out into nature, it is during the summer. A few years ago, I took part in a kayak trip in the waters around Telegraph Cove and Alert Bay at the northern part of Vancouver Island. The wilderness outfitters who organized it billed it as a whale-watching trip. By day seven out of nine, there was still no sign of the whales, the orcas who thrive on the salmon of these waters. Having just paddled through a fast eddy, we were all weary. Suddenly, about 50 yards (80 metres) away, an orca leapt vertically out of the water, a move known as a spy hop. And it was not alone. The entire "G" pod, with its identifying call of "ee-ah," was out to play. They surfaced by our quiet little cluster of puffing kayakers. We promptly forgot how tired we were and were too amazed to be frightened. I have pictures of the orcas, which look like abstract paintings—solid black and white. They were so close. I can't help thinking that as the whales viewed us from beneath the surface, with our kayaks and outstretched oars, we must have looked like cocktail sausages with toothpicks through the middle. It was, in any case, one of those moments I would live over again, if I could.

I love kayaking, sitting close to the surface of the water while balancing with paddles on both sides. Canada's foremost canoe writer and paddling song collector James Raffan has done extensive research into the canoe and Canadian culture. And one of the (smaller) points he treasures most is that the word "canoe" is an anagram of ocean. James's friend, the patron saint of canoeing in Canada, Bill Mason, wrote in his book *Path of the Paddle*: "When you look at the face of Canada and study the geography carefully, you come away with the feeling that God could have designed the canoe first and then set about to conceive a land in which it could flourish."

The canoe is one of the most iconic images of

this country. In 1985, architect Arthur Erickson asked Bill Reid, the Haida sculptor, to create a work for the Canadian Embassy in Washington. Reid settled on a design of a canoe with thirteen mythical travellers, both human and animal. He called it "The Spirit of Haida Gwaii," the spirit of the Islands of the People. And if you look at a new Canadian twenty-dollar bill, Reid's canoe is depicted on the back. Nice to have Bill Reid's work in our wallets.

First Nations people, of course, had canoes long before Canada was even a concept. In keeping with their connection to the land, canoes came from it—they were dug out of trees, birch bark and spruce, and returned to the land, disintegrated into it when they were beyond use.

Another mythic image of the canoe from more recent history would have to be that of Pierre Trudeau, out solo, in his buckskin jacket with Canada emblazoned on the back. He had a lifelong love affair with canoeing, from his trips on the fast water of Ontario rivers to his fabled paddle on the Nahanni in the Yukon. Canoeing was about a quest and what he called the joys of hard living. Surely it also had to be about privacy and peace. I don't know if Pierre Trudeau ever paddled the Lièvre River in the Laurentian Mountains of Québec, but I hope that he experienced the peace that the poet Archibald Lampman found and wrote about in his poem, "Morning on the Lièvre."

> Softly as a cloud we go,
> Sky above and sky below,
> Down the river; and the dip
> Of the paddles scarcely breaks,
> With the little silvery drip

> Of the water as it shakes
> From the blades, the crystal deep
> Of the silence of the morn,
> Of the forest yet asleep;
> And the river reaches borne
> In a mirror, purple gray,
> Sheer away
> To the misty line of light,
> Where the forest and the stream
> In the shadow meet and plight,
> Like a dream.

The land fully alive in the Summer, as you'll see, is a ravishing sight.

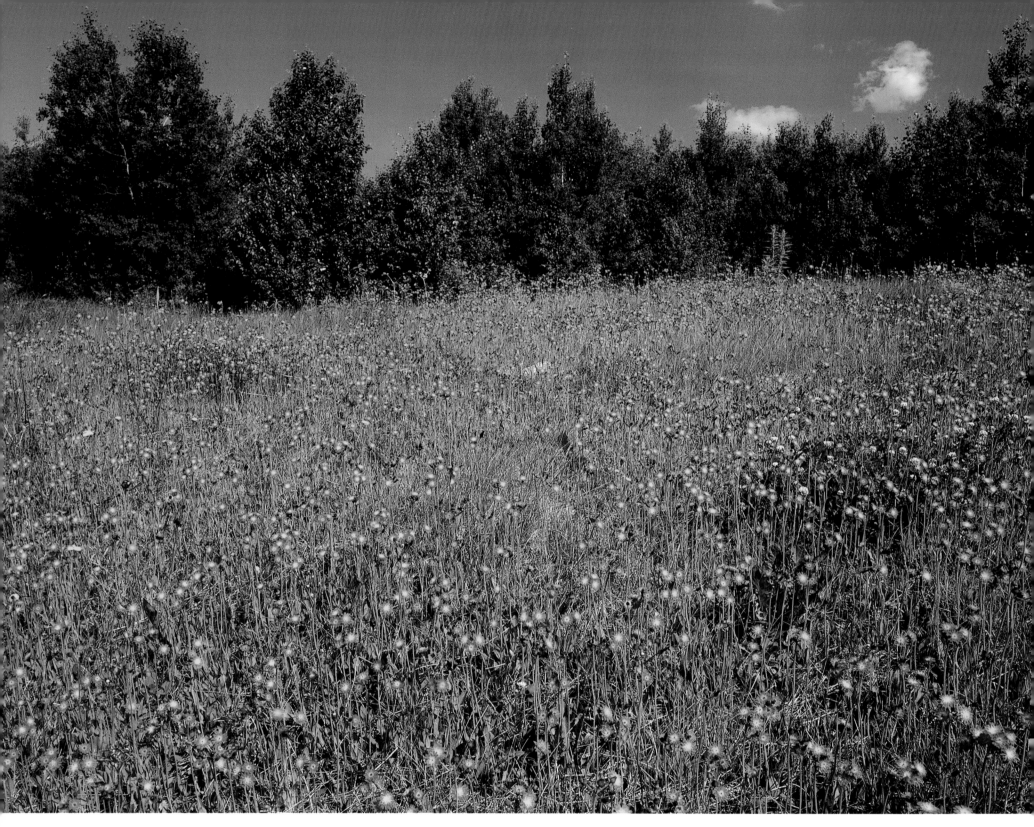

Devil's paintbrush, Whitefish, Ontario

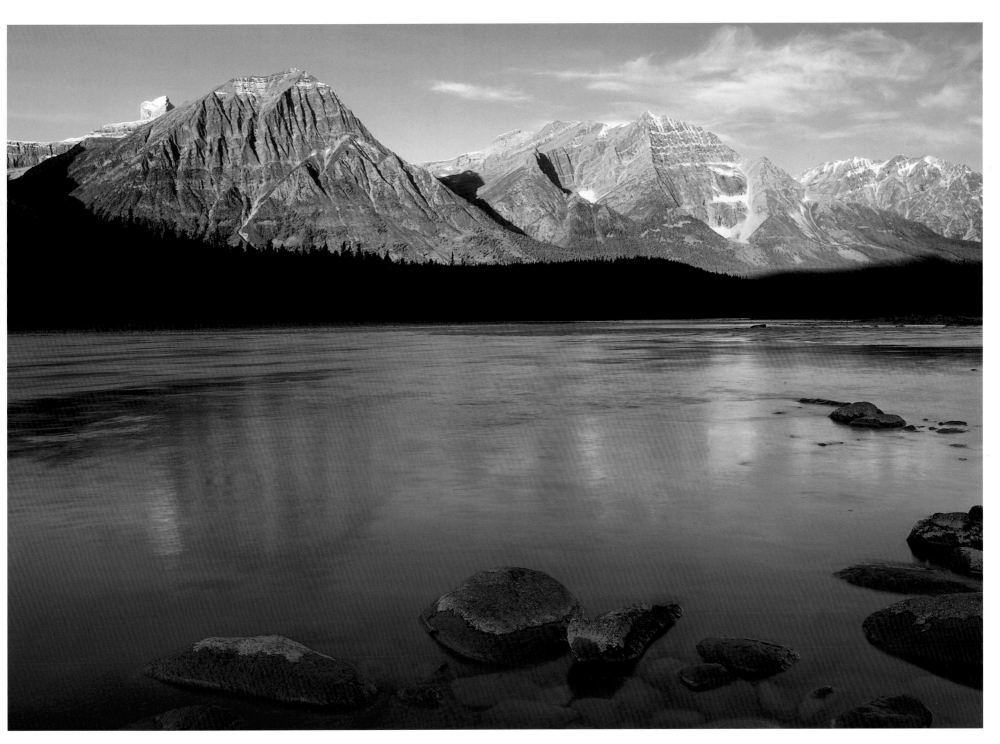

Athabasca River and the Canadian Rockies, Jasper National Park, Alberta

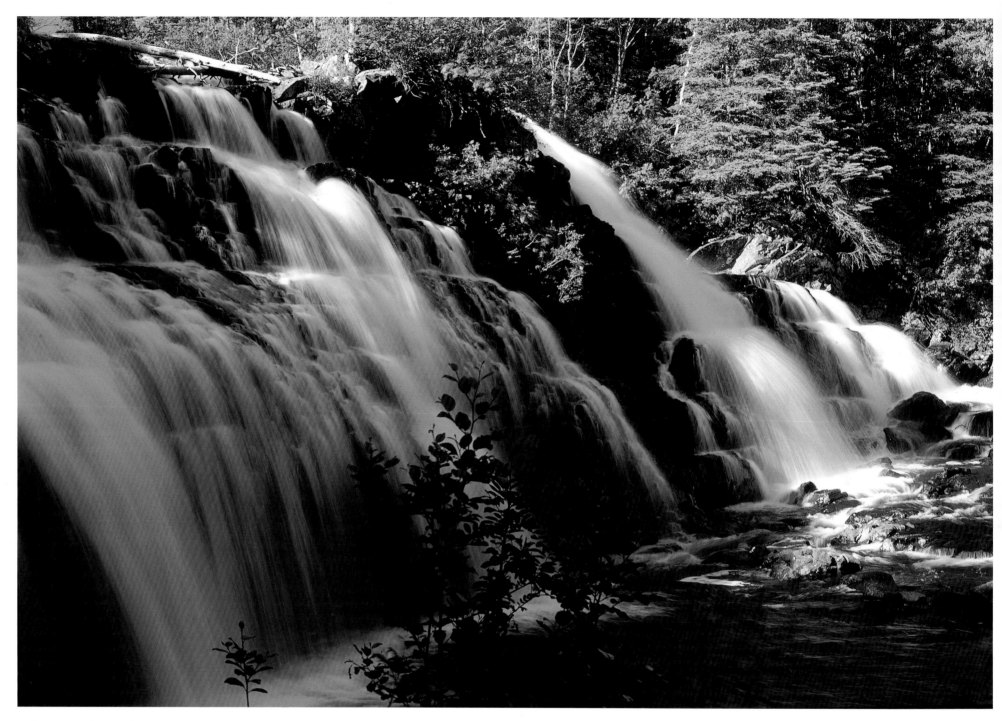

Falls at Mink Creek near Marathon, Ontario

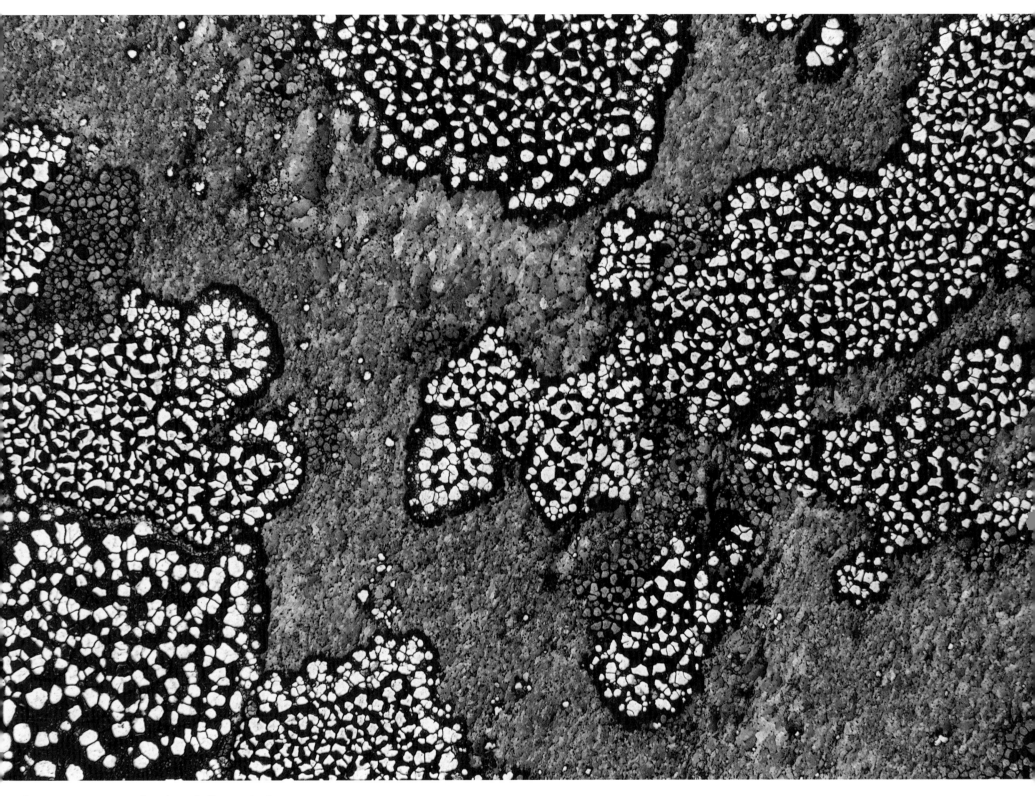

Lichen pattern on rock, Churchill, Manitoba

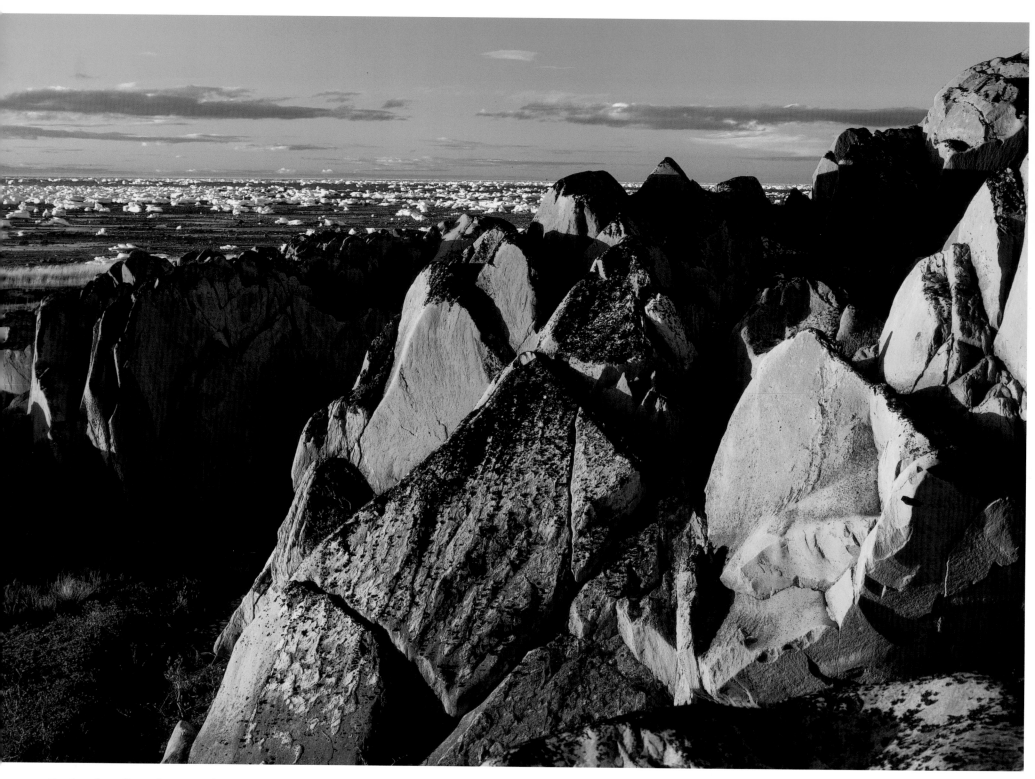

Rocky shoreline along Hudson Bay, Churchill, Manitoba

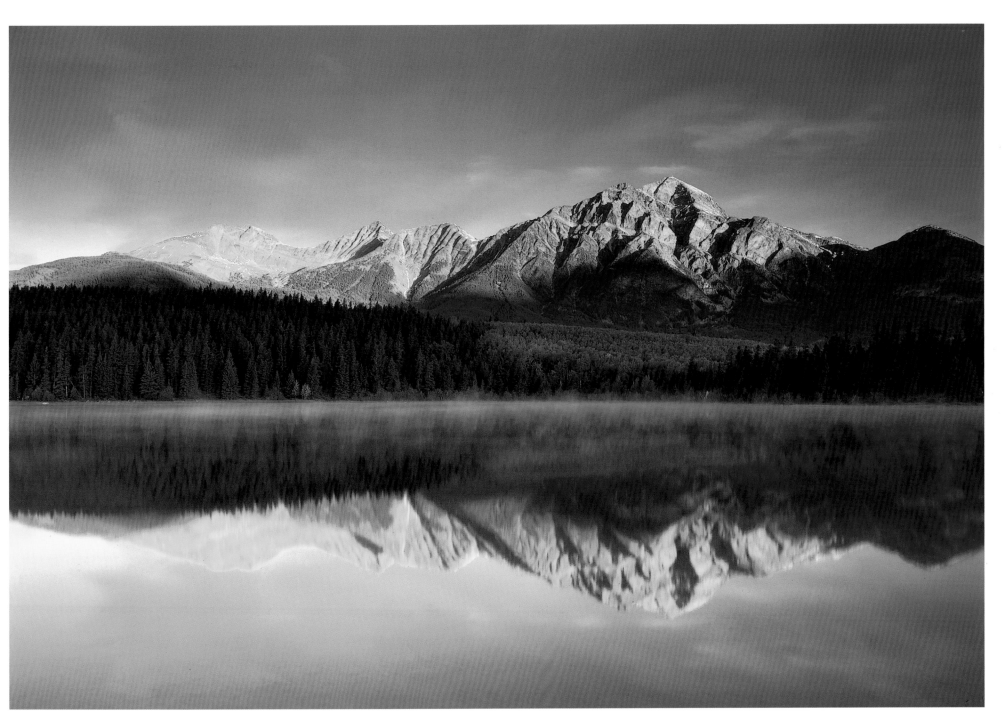

Pyramid Lake, Jasper National Park, Alberta

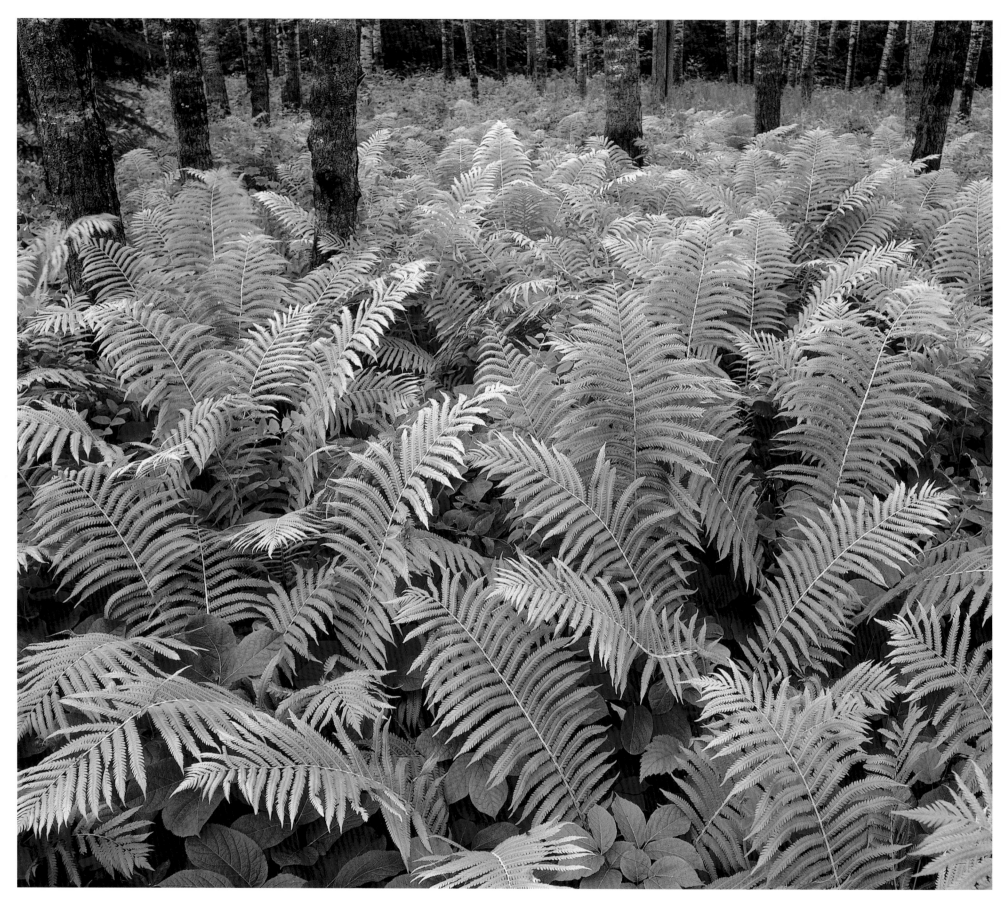

Ferns, Birch River, Manitoba

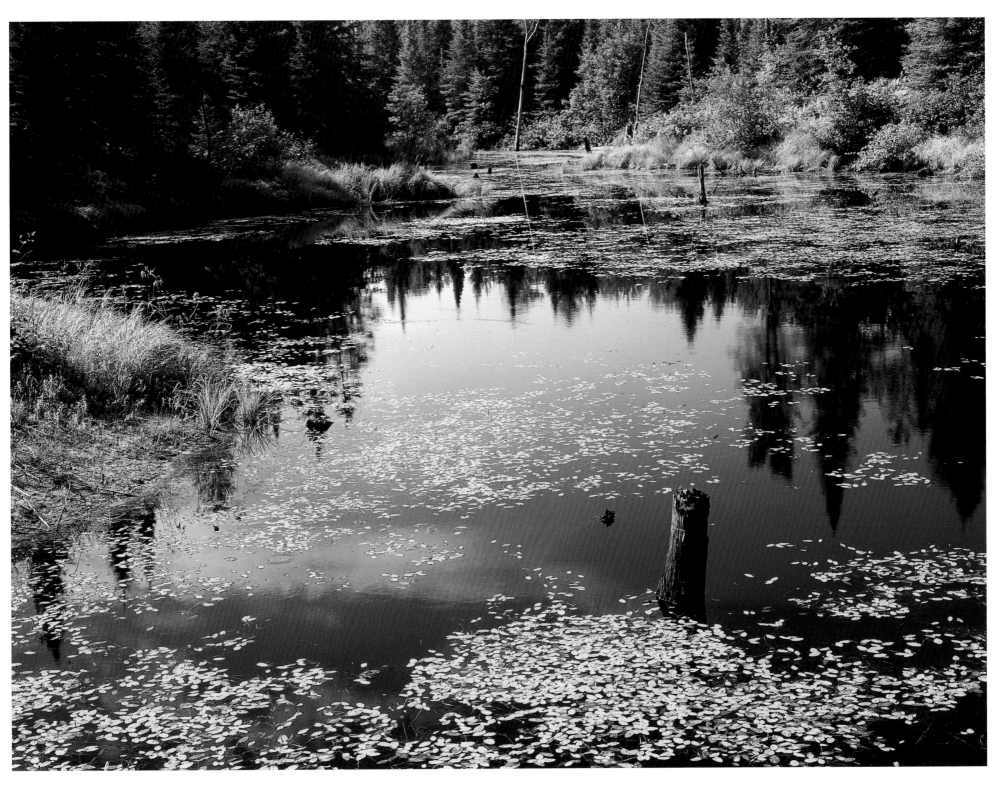

Wetland, Worthington, Ontario

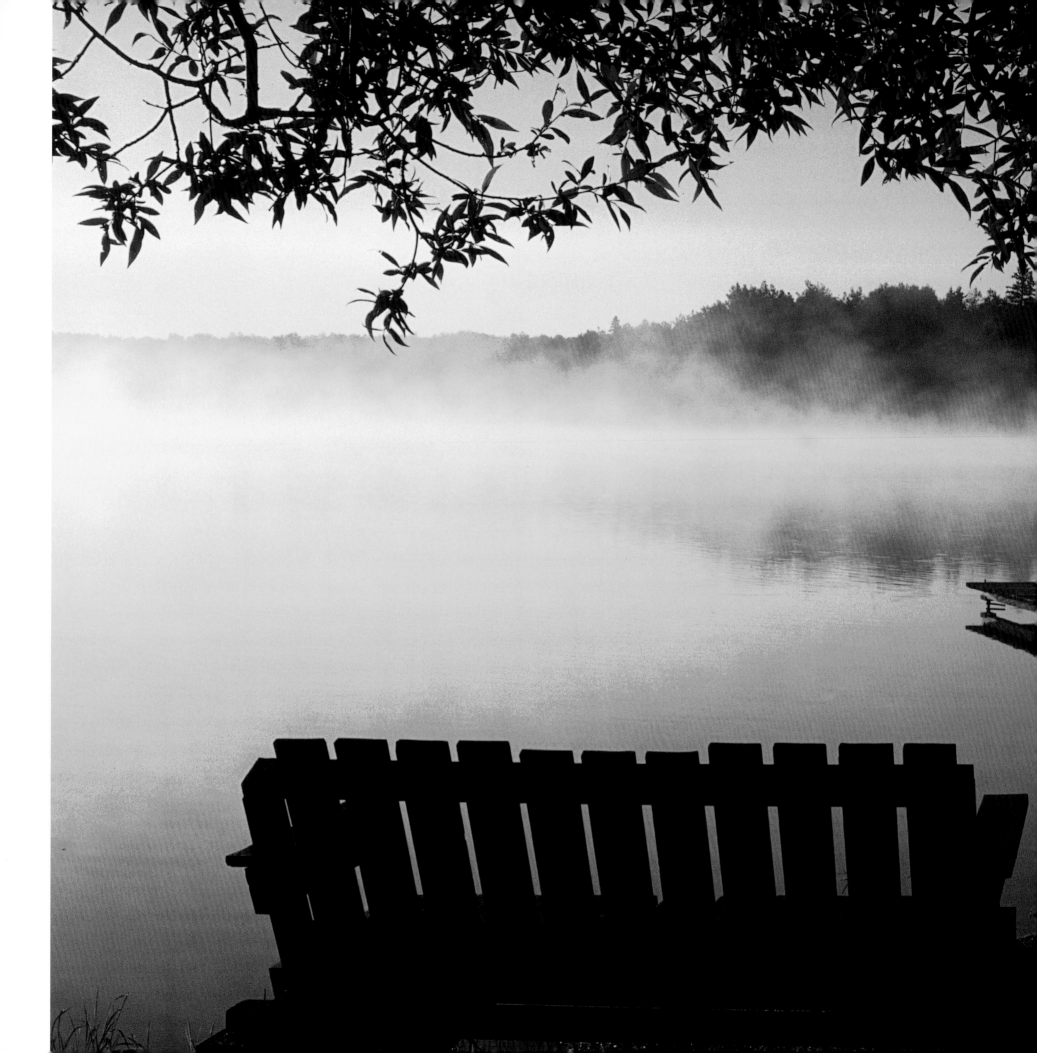

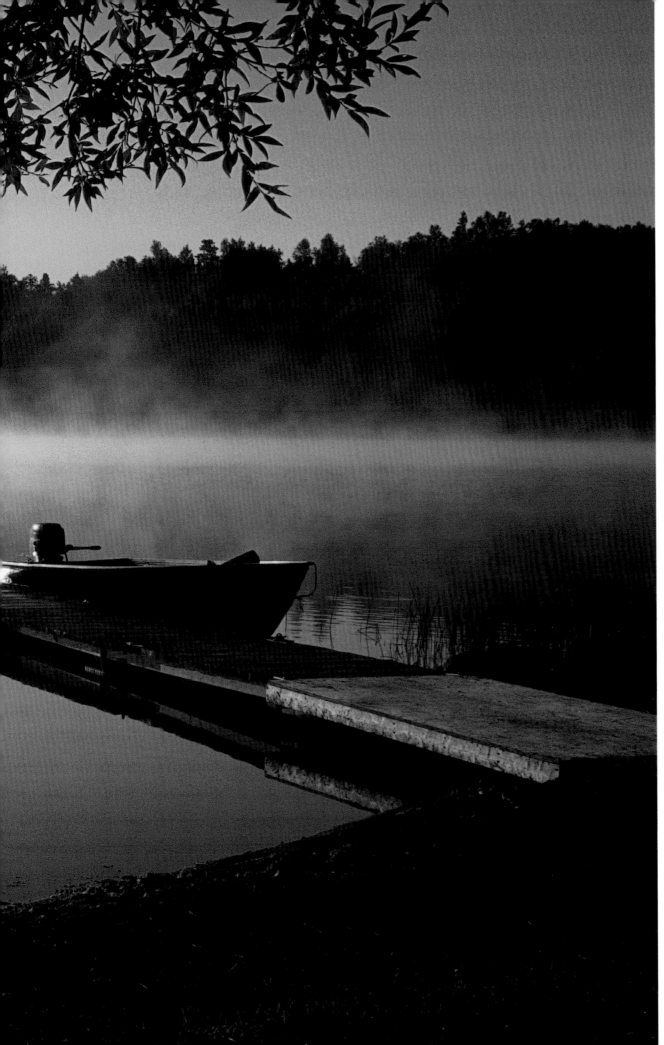

Tilton Lake at sunrise,
Sudbury, Ontario

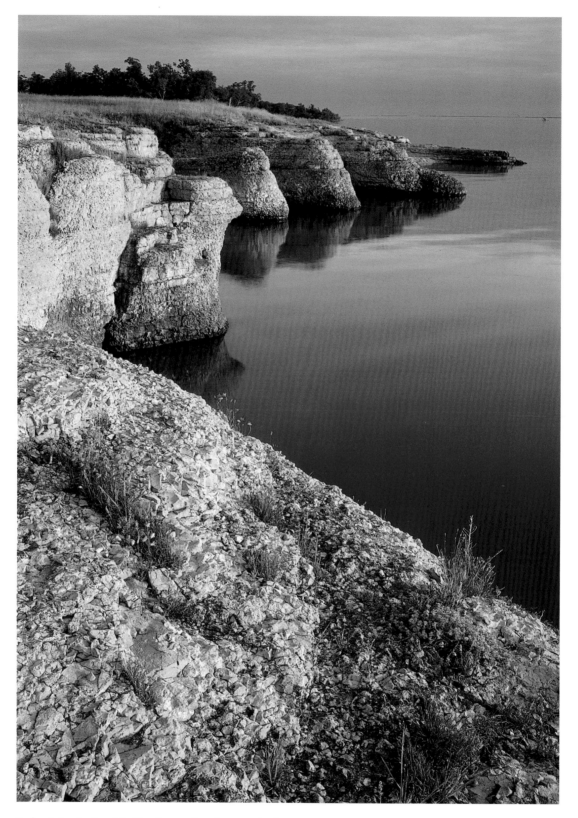

Lake Manitoba bluffs, Steep Rock, Manitoba

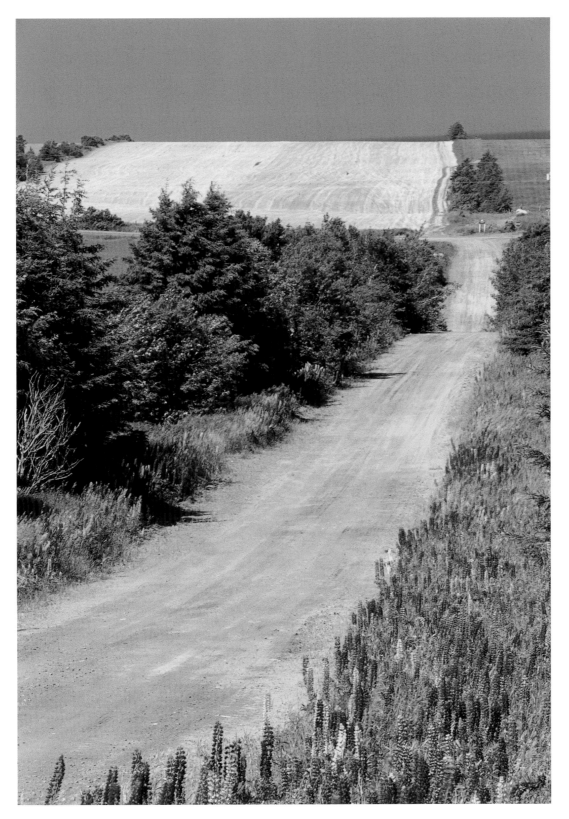

Lupines along a country road, Seaview, Prince Edward Island

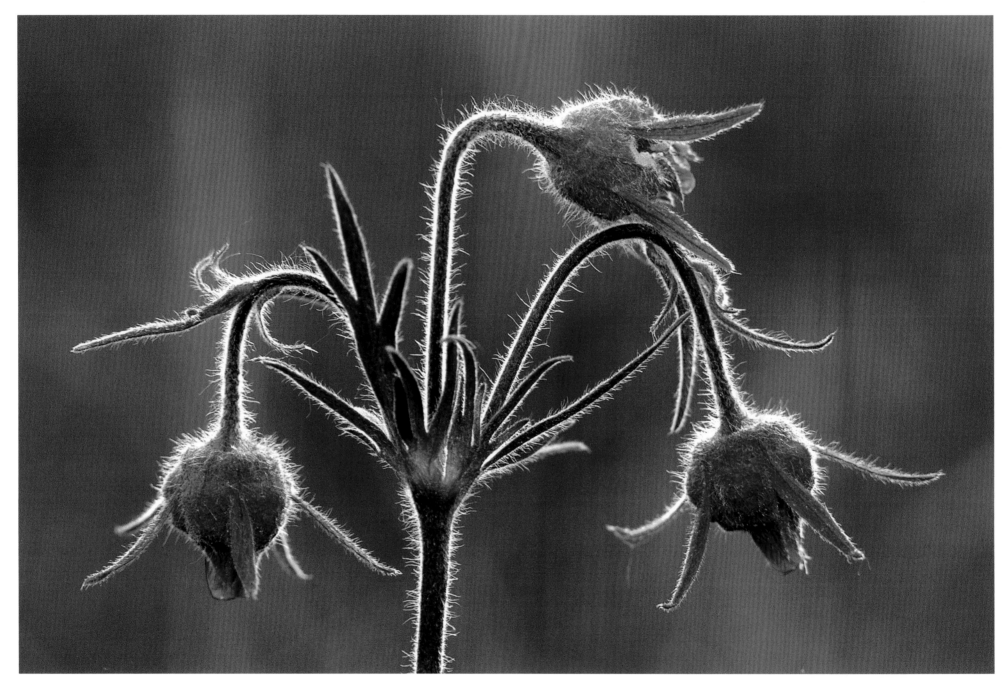

Three-flowered avens, The Pas, Manitoba

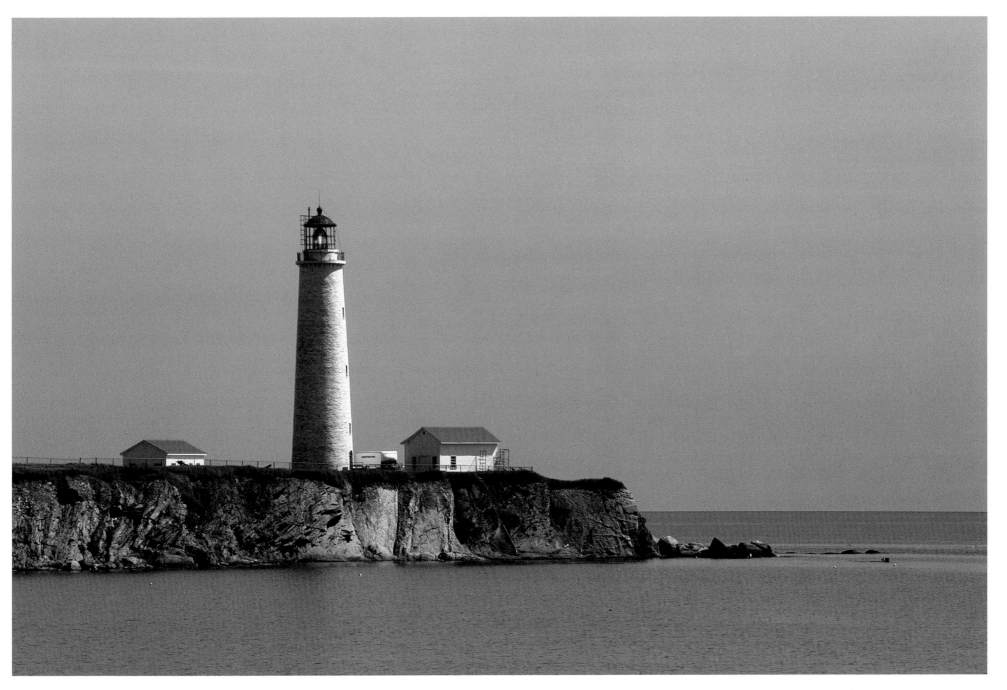

Lighthouse, Cap-des-Rosiers, Québec

Canola and sky, Somerset, Manitoba

Clearwater Lake, Clearwater Provincial Park, Manitoba

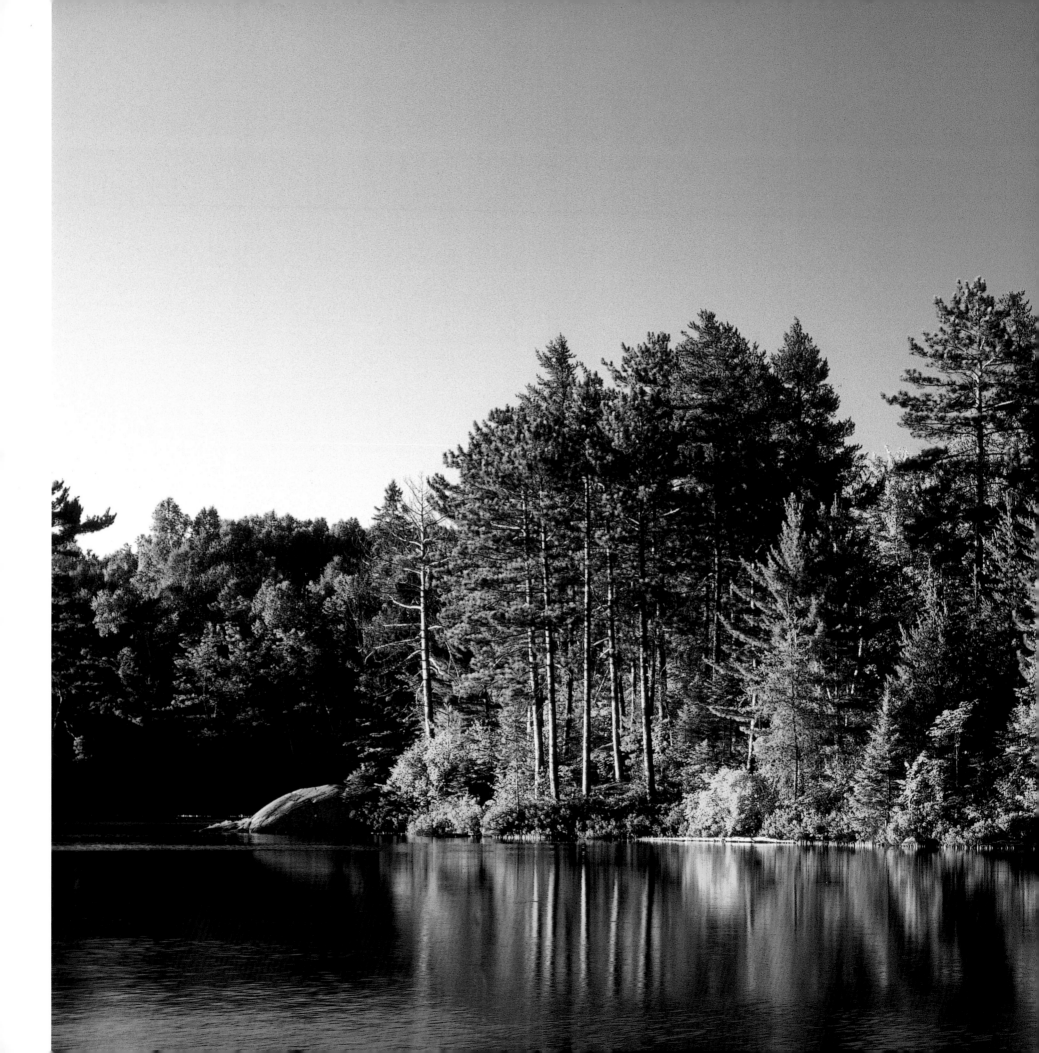

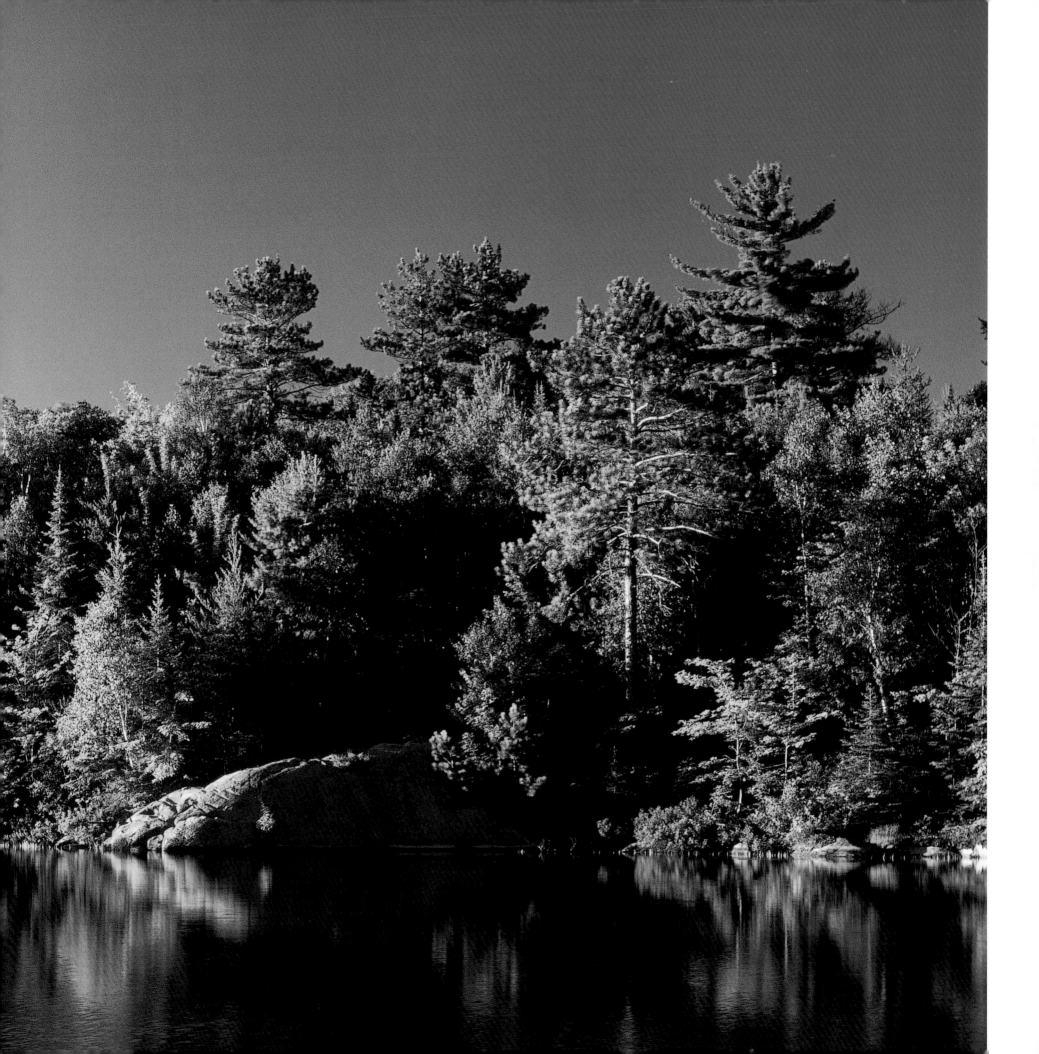

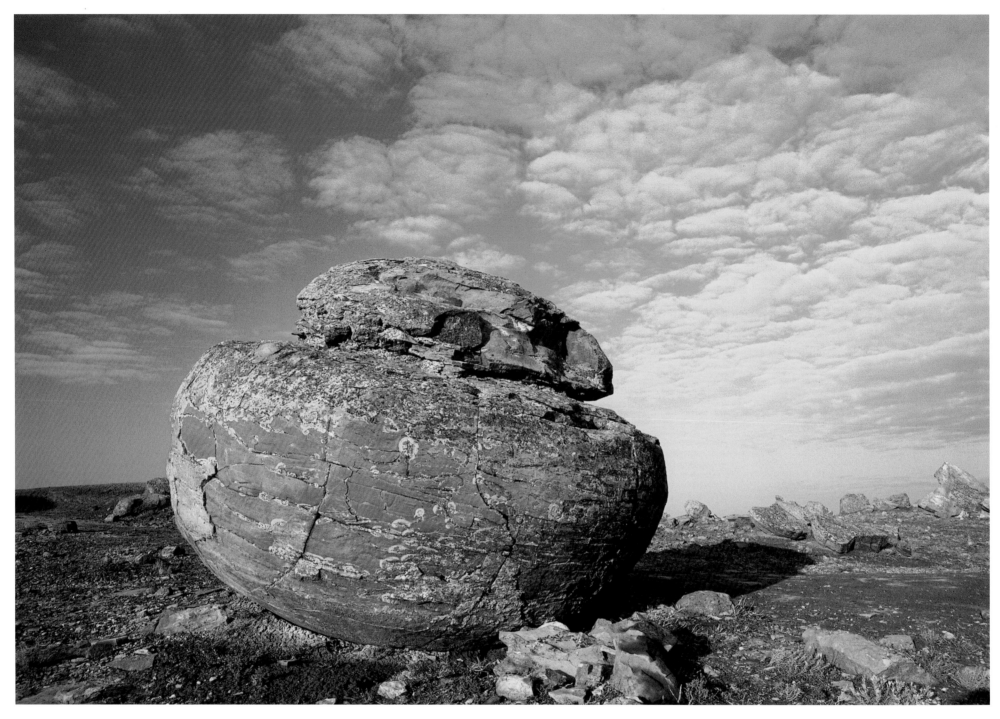

Marine concretions, Red Rock Coulee Natural Area, Alberta

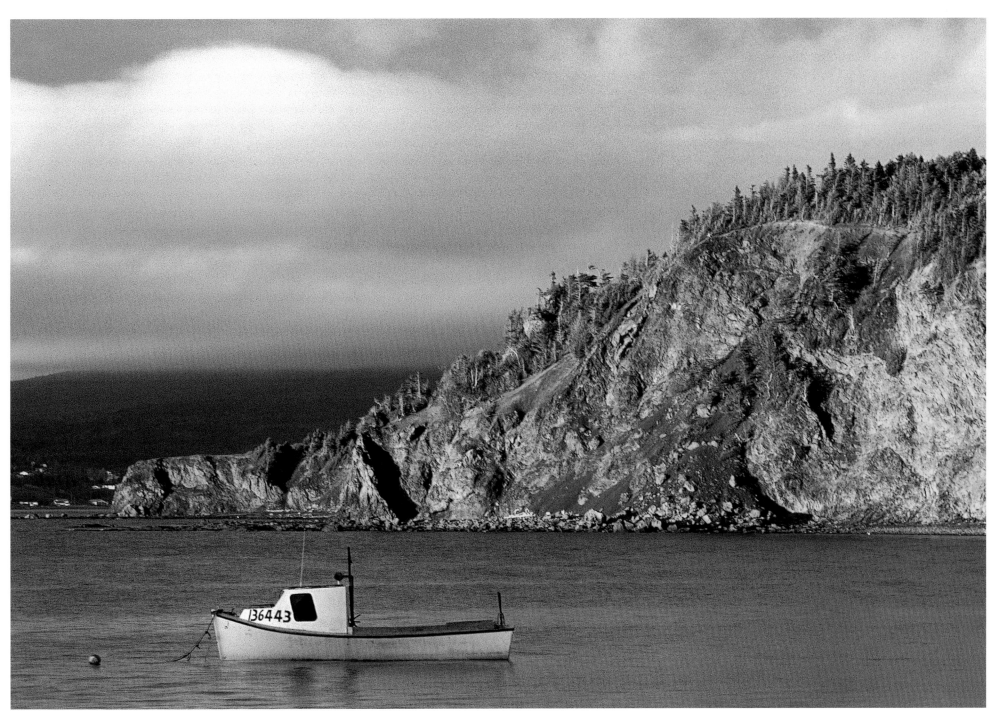

Fishing boat, Frenchman's Cove, Newfoundland

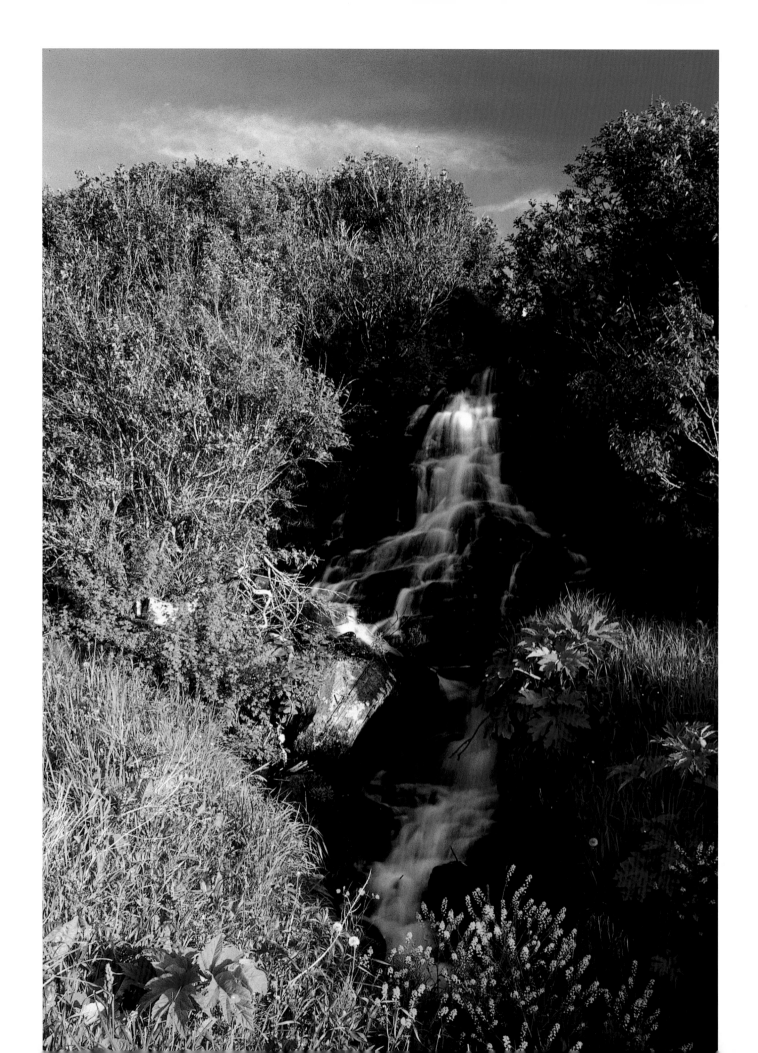

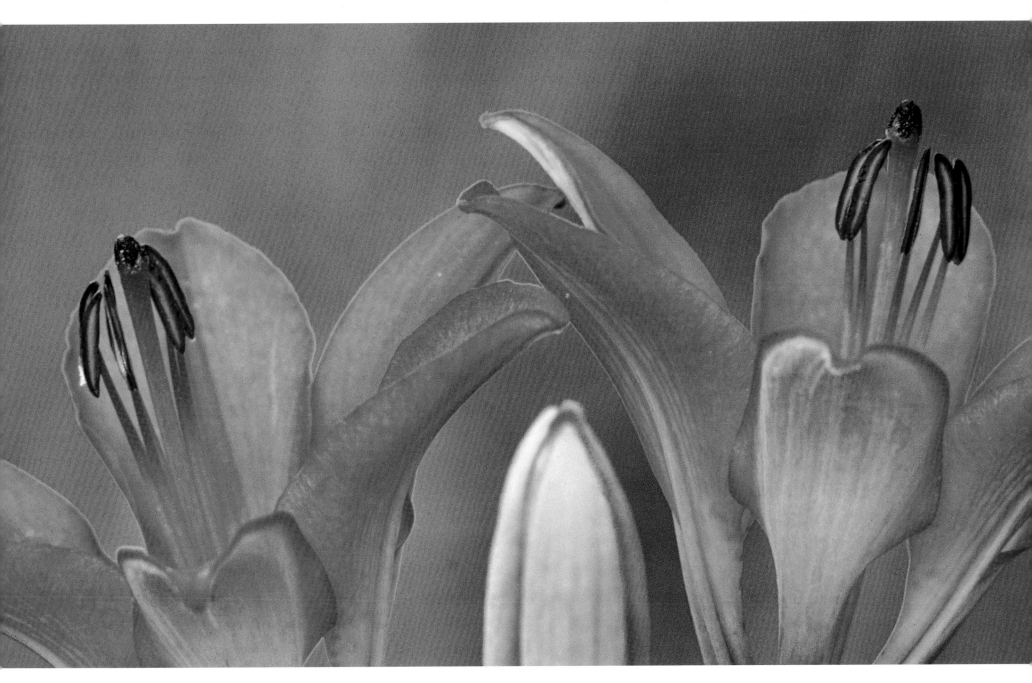

Wood lilies, Duck Mountain Provincial Forest, Manitoba

Stream at sunset, Madeleine Centre, Québec

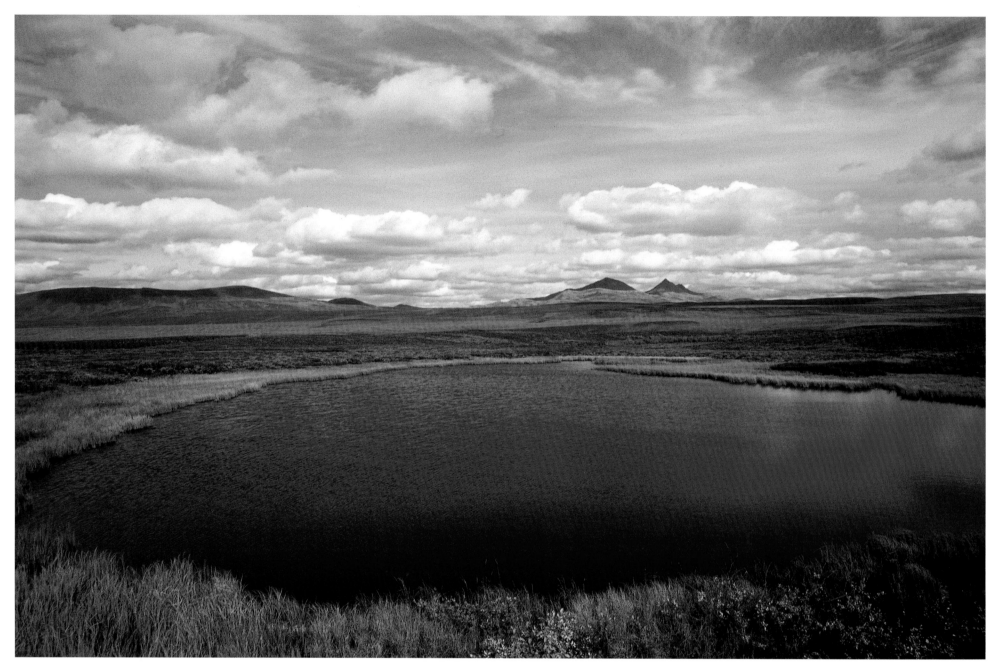

Pond along the Dempster Highway, Yukon

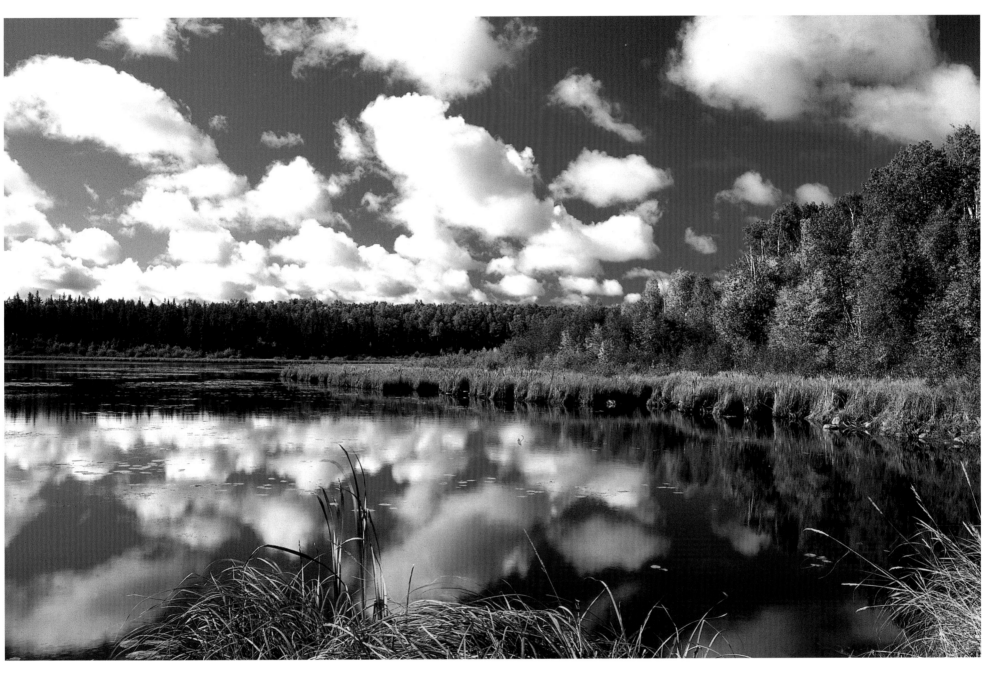

Pond, Prince Albert National Park, Saskatchewan

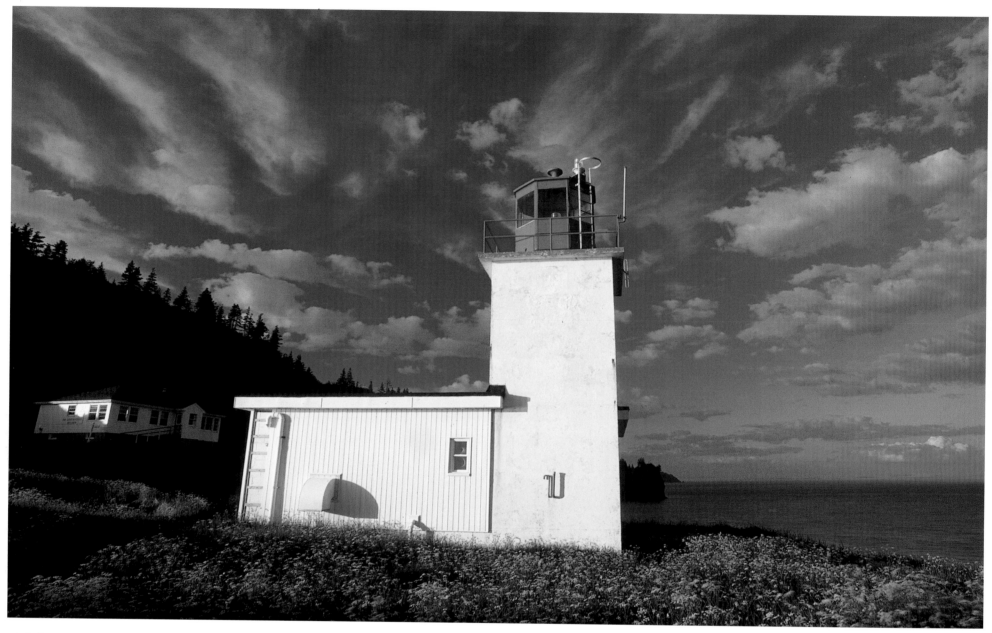

Lighthouse, Cape d'Or, Nova Scotia

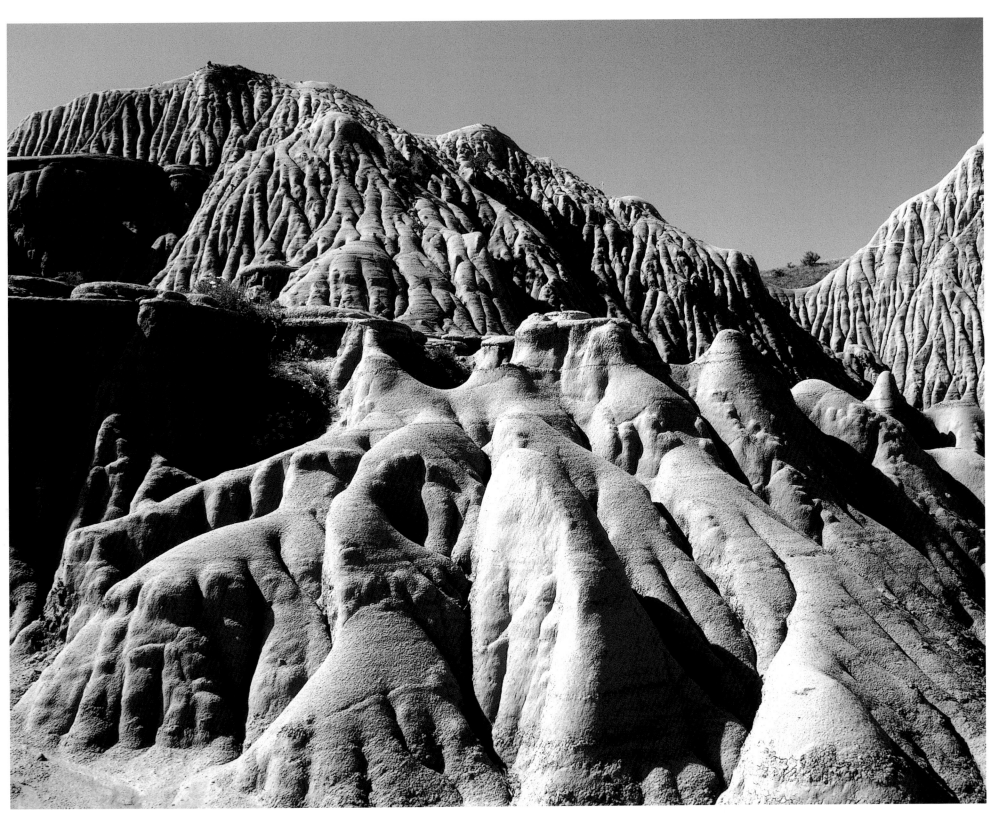

Badlands, Dinosaur Provincial Park, Alberta

OVERLEAF Pitt-Addington Marsh Wildlife Management Area, near Pitt Meadows, British Columbia

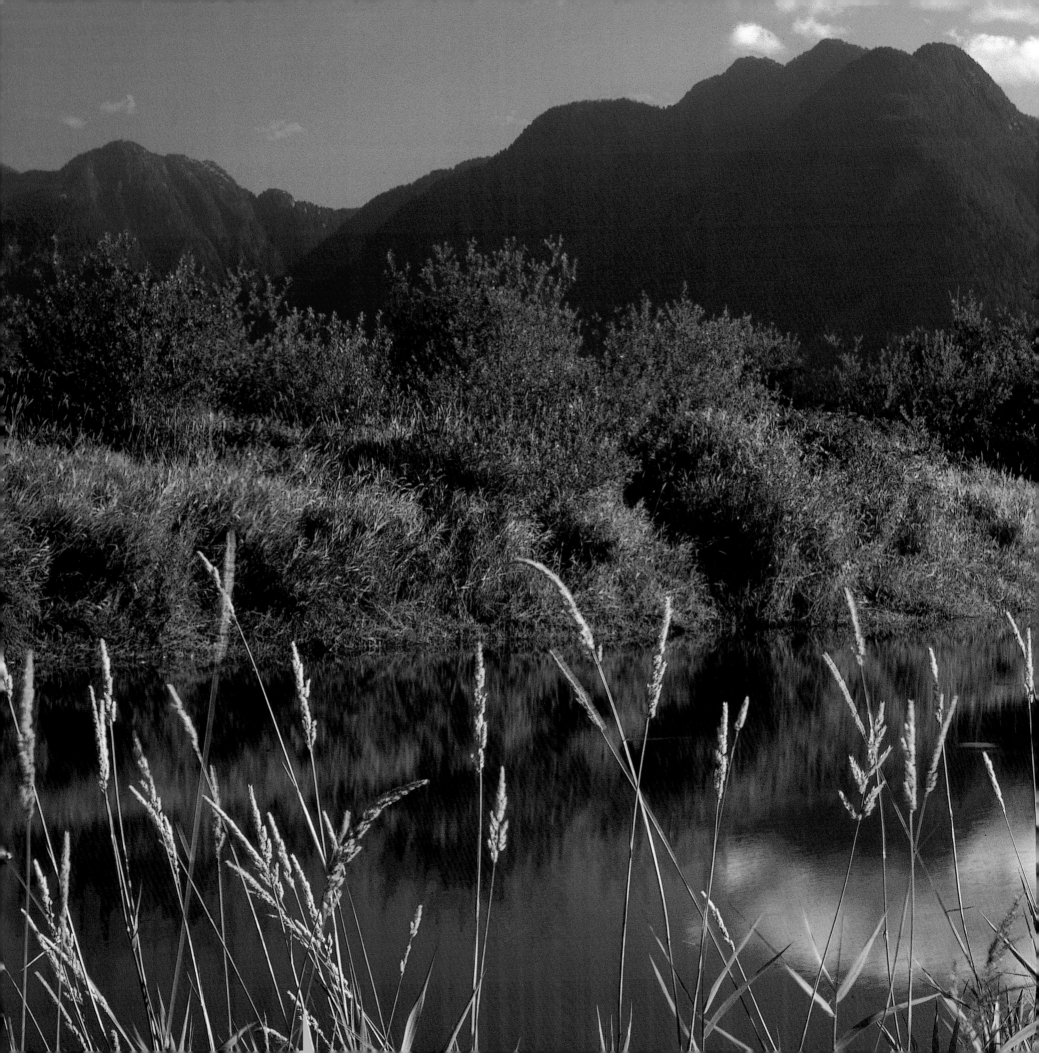

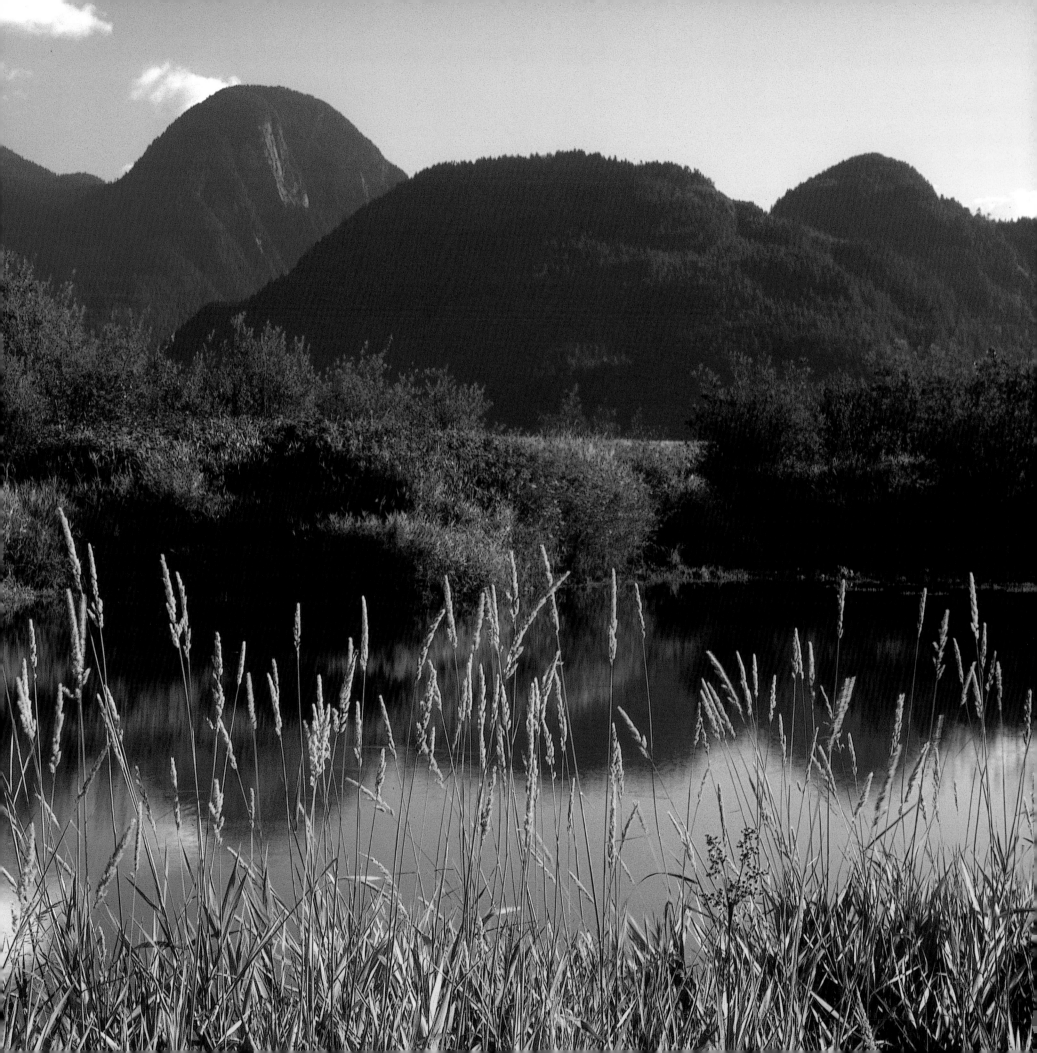

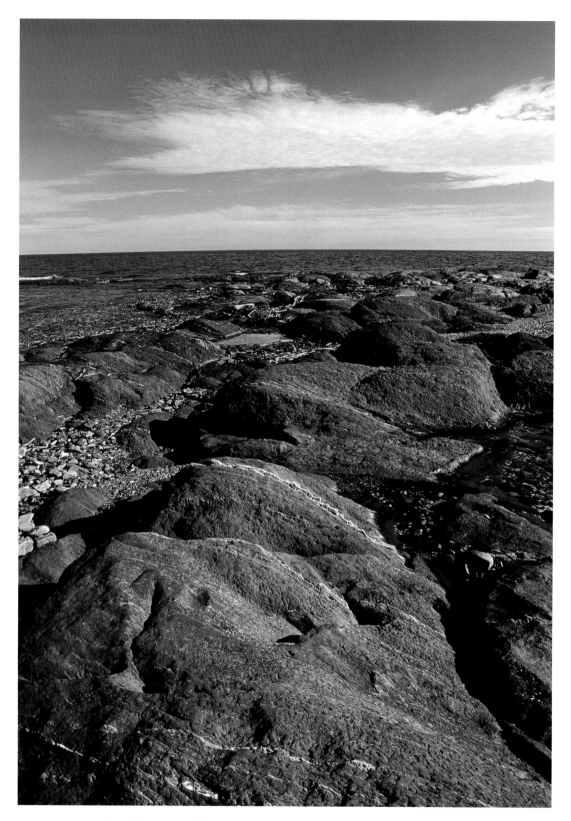

St. Lawrence shoreline, Baie-des-Sables, Québec

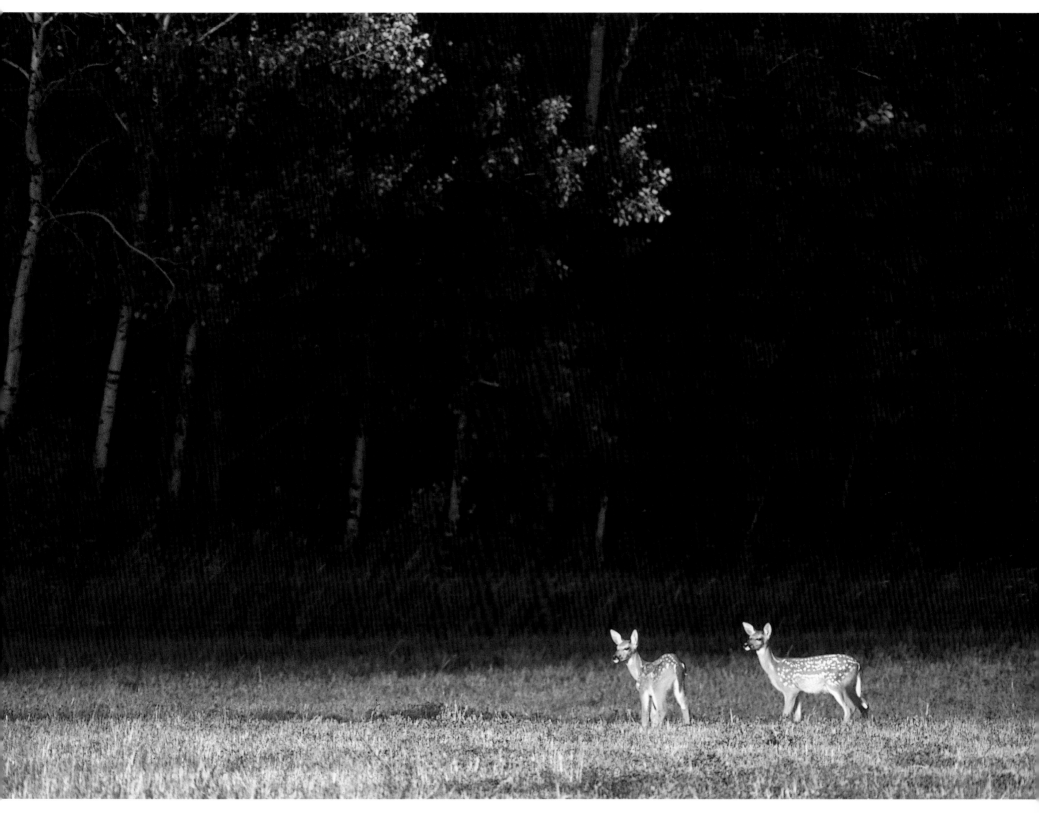

Whitetail deer fawns near Marchand, Manitoba

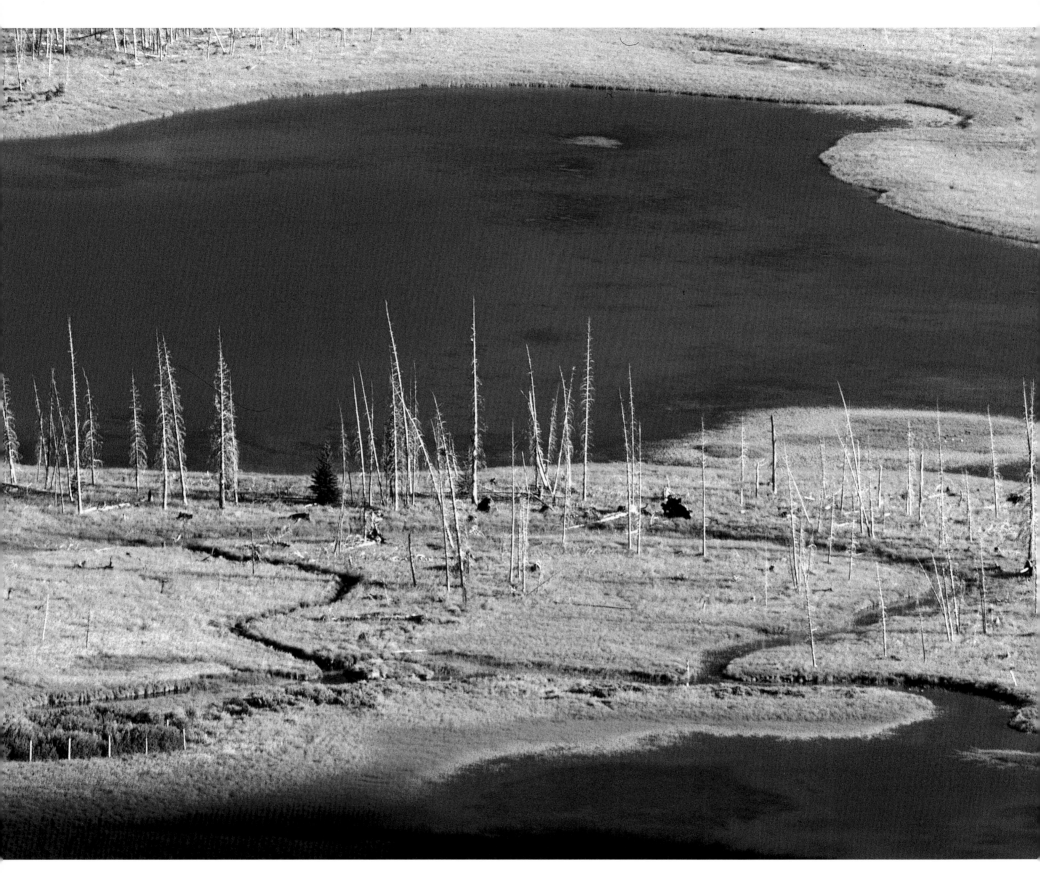

Vermillion Lake, Banff National Park, Alberta

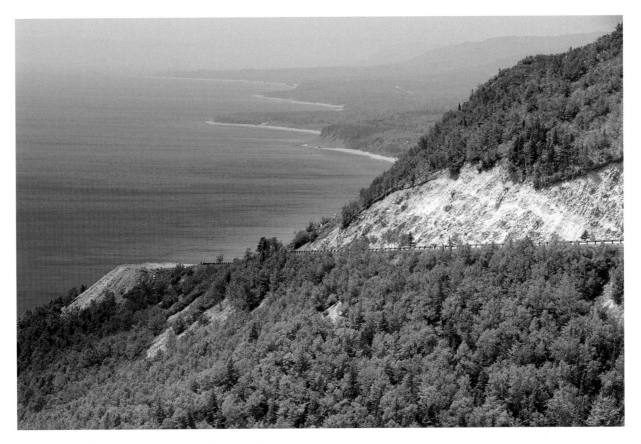

Gaspé coastline, Anse de la Rivière Madeleine, Québec

Sunset on the Gulf of St. Lawrence, Madeleine
Centre, Québec

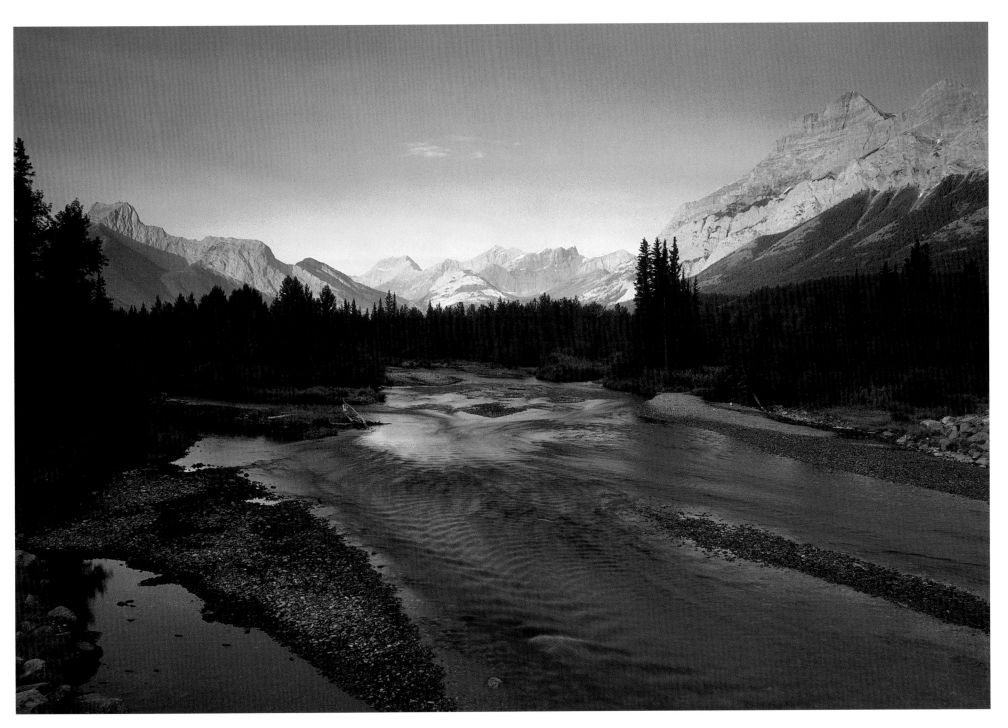

Kananaskis River, Kananaskis Provincial Park, Alberta

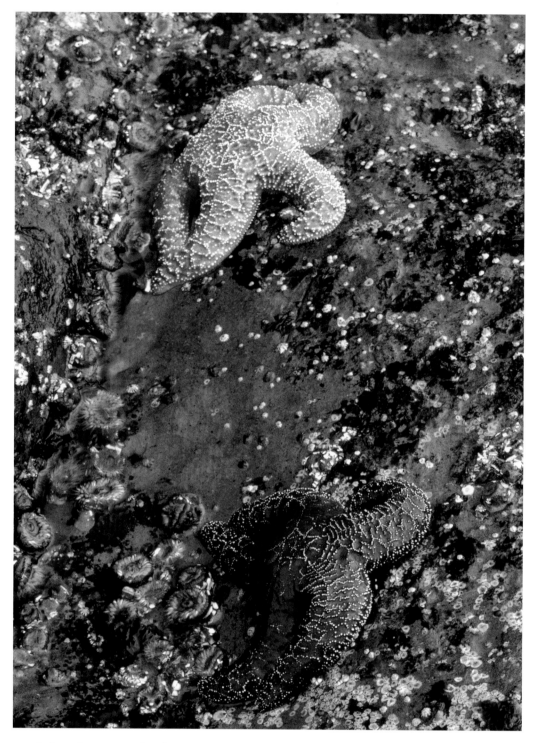

Starfish, Saltspring Island, British Columbia

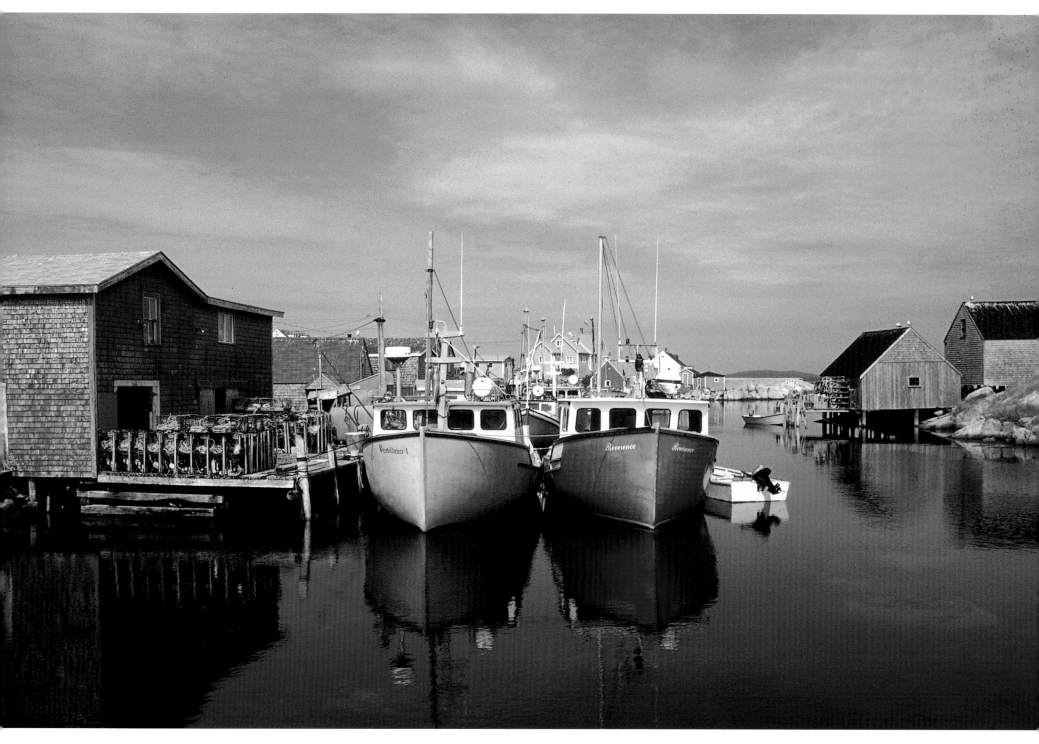

Fishing village, Peggy's Cove, Nova Scotia

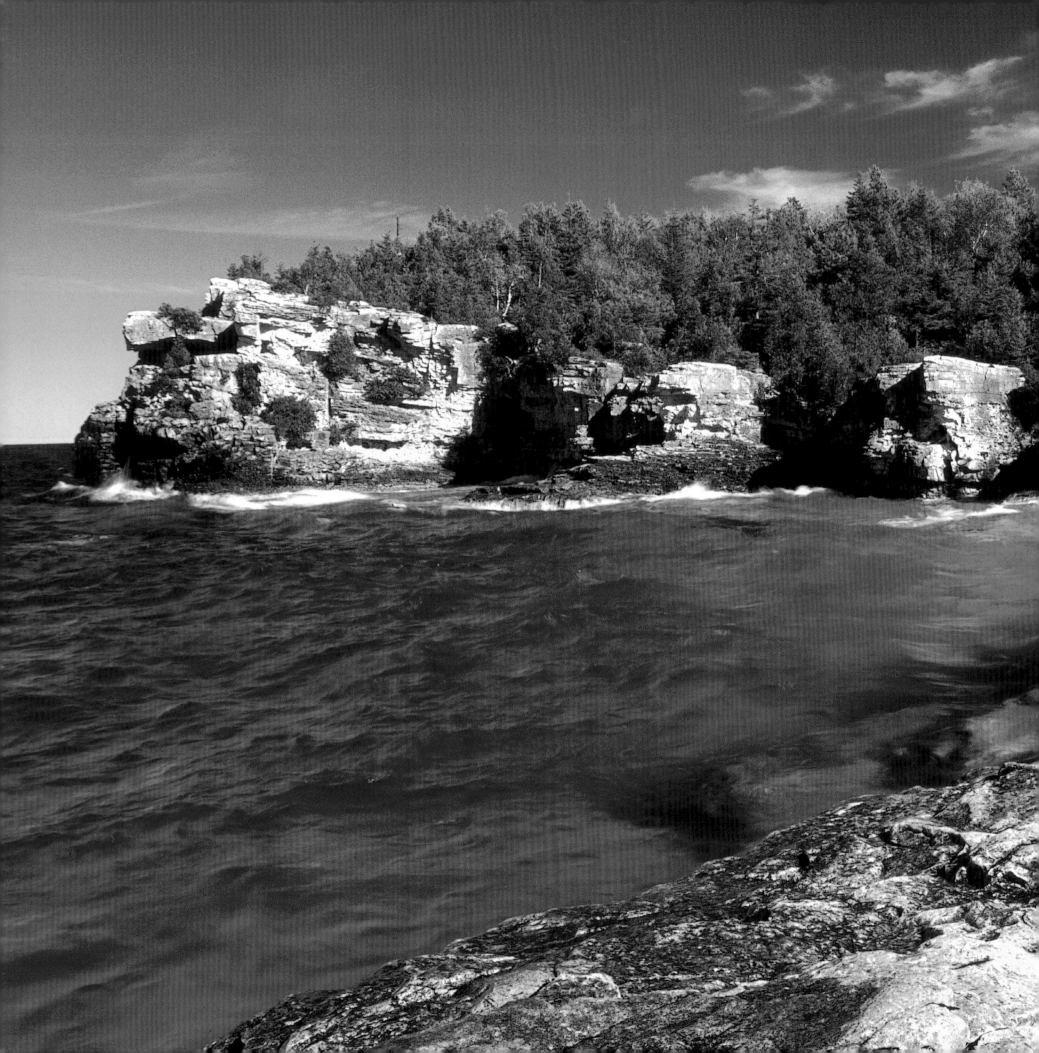

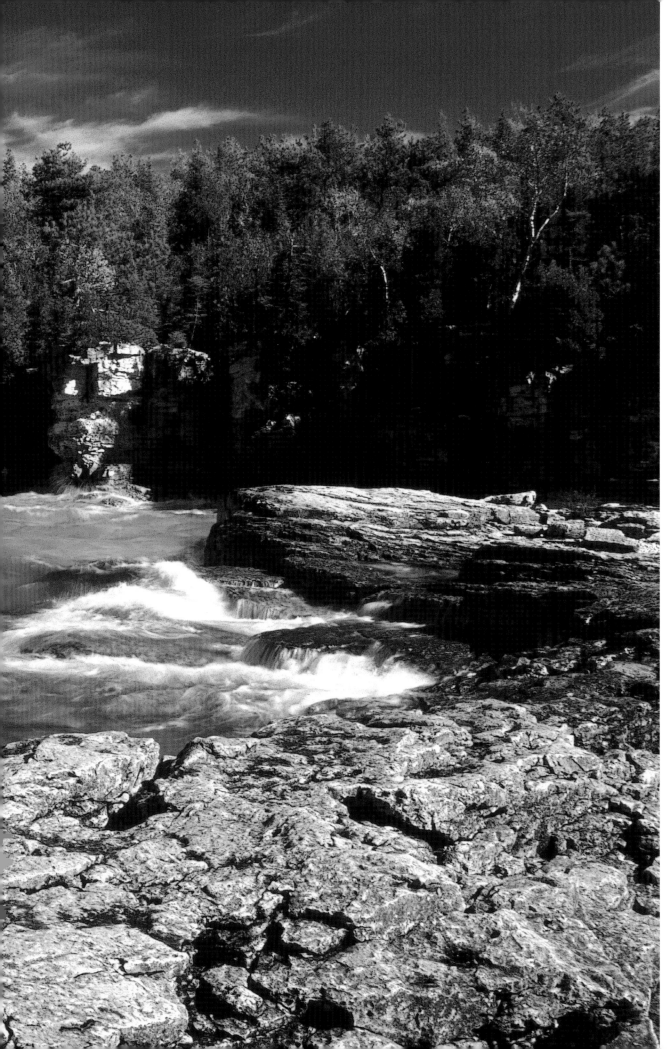

Lake Huron, Bruce Peninsula National Park, Ontario

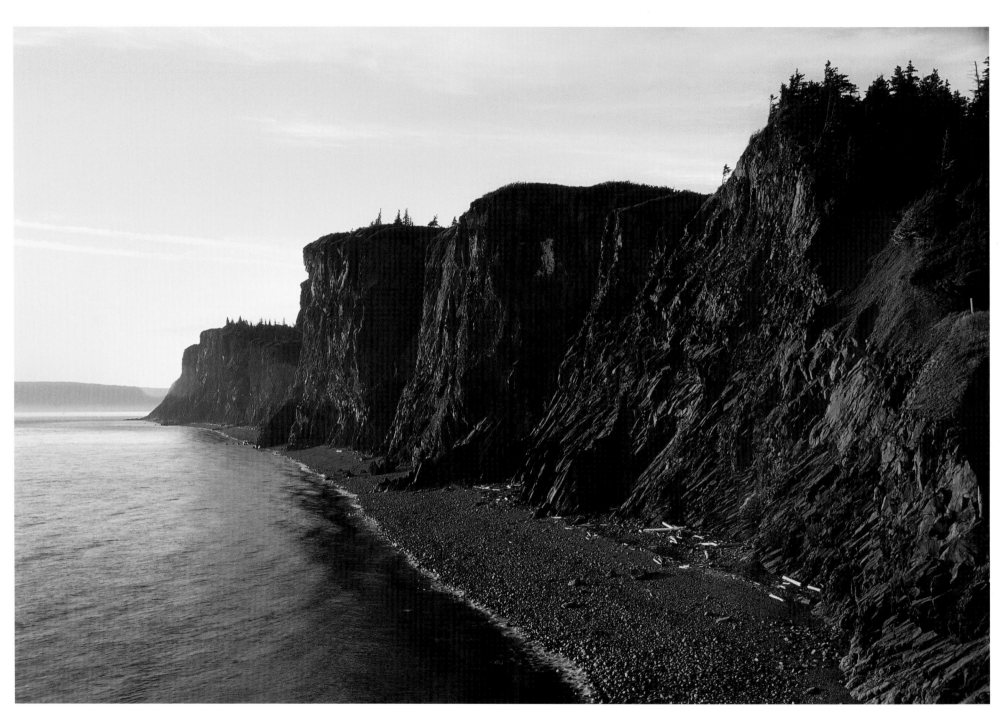

Cliffs along the Bay of Fundy, Cape d'Or, Nova Scotia

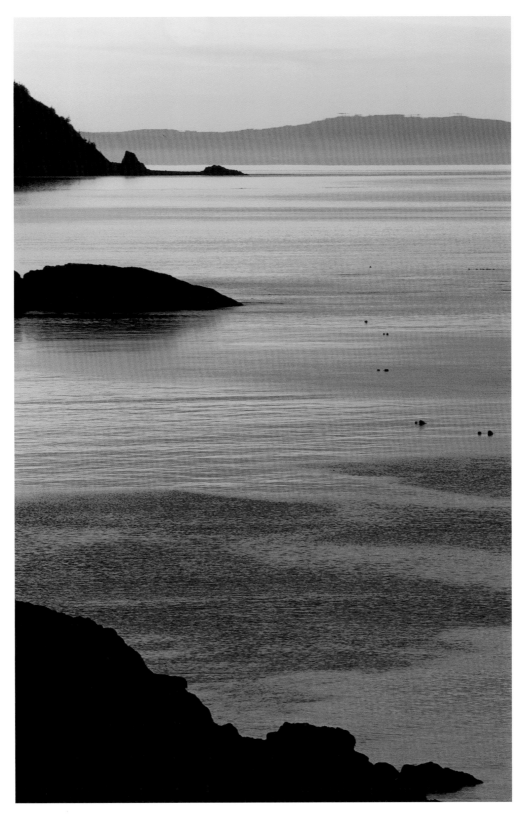

Dawn on the Bay of Fundy, Cape d'Or, Nova Scotia

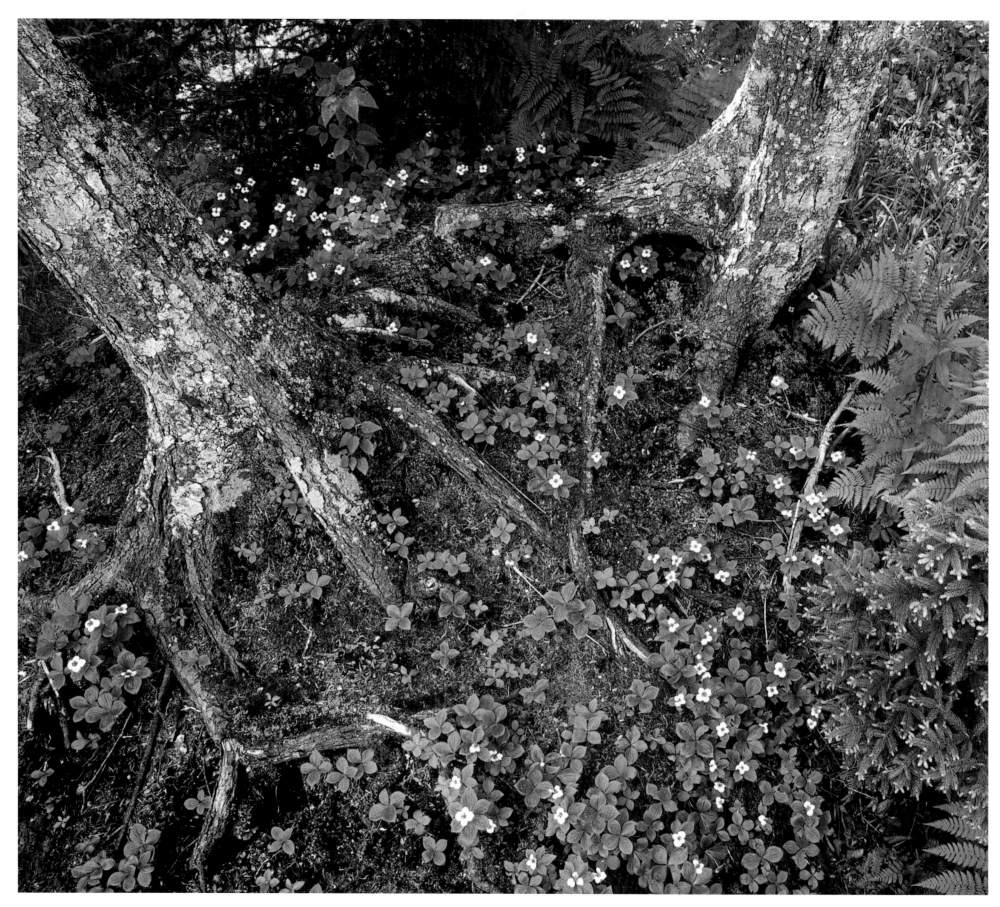

Bunchberries, Fundy National Park, New Brunswick

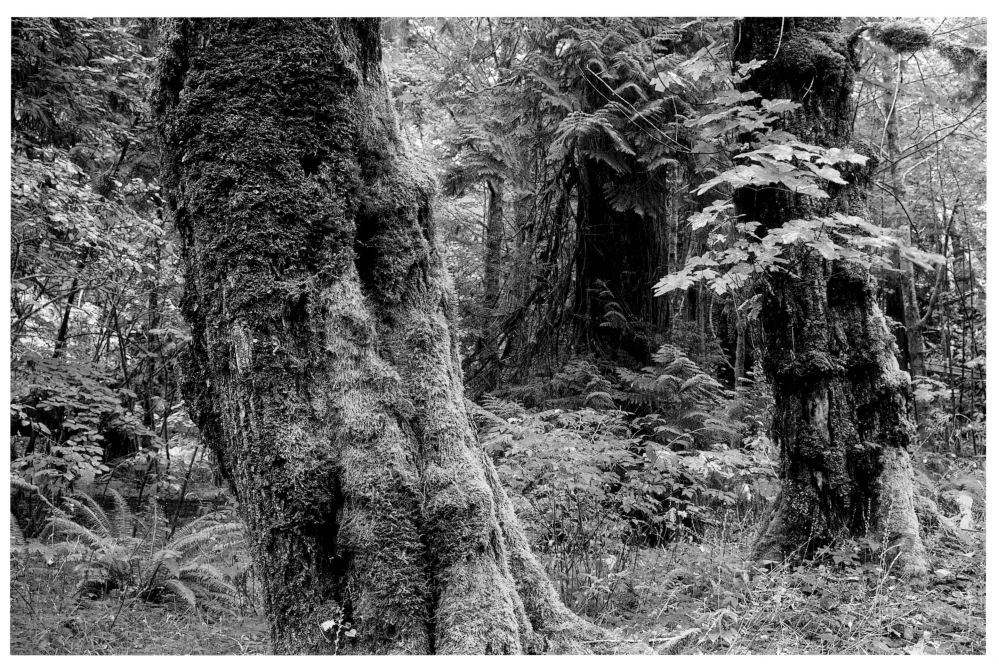

Old growth temperate rain forest, Goldstream Provincial Park, British Columbia

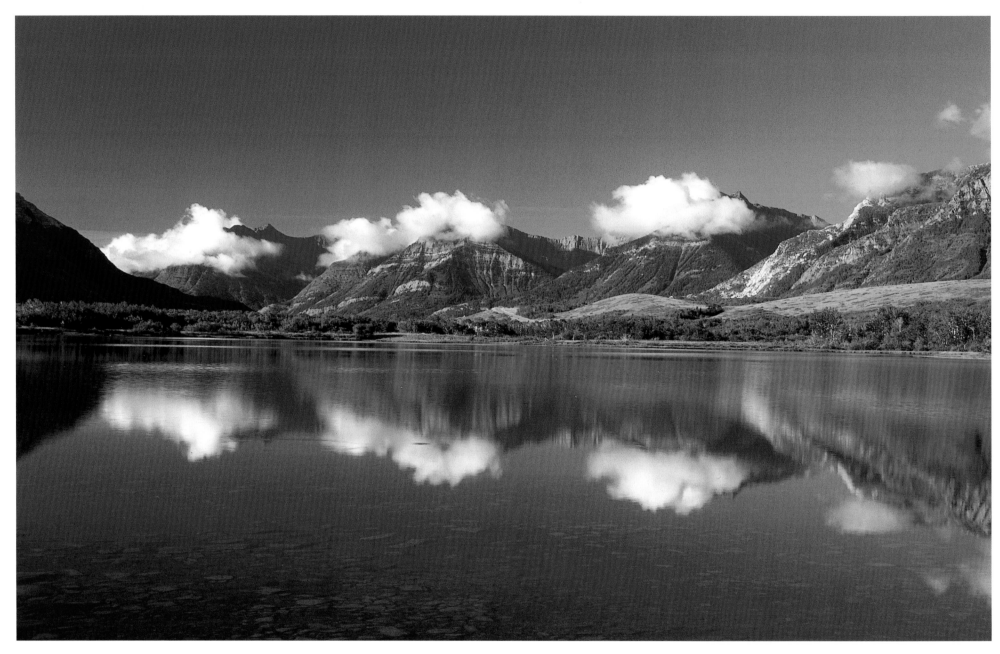

Clouds reflected in Waterton Lake, Waterton Lakes National Park, Alberta

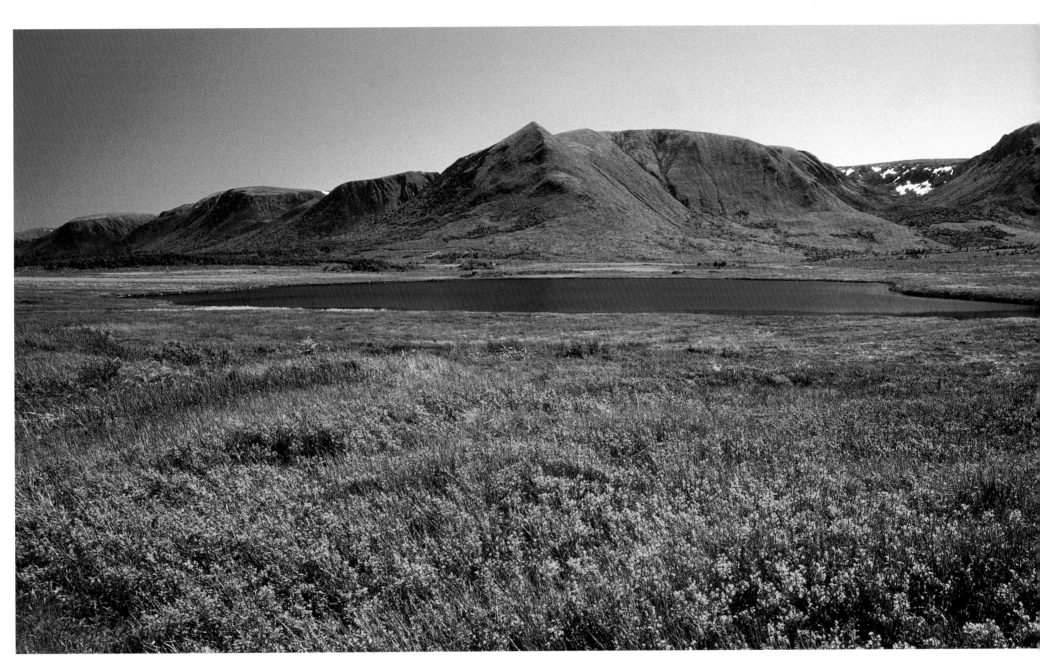

Long Range Mountains and wetland, Newfoundland

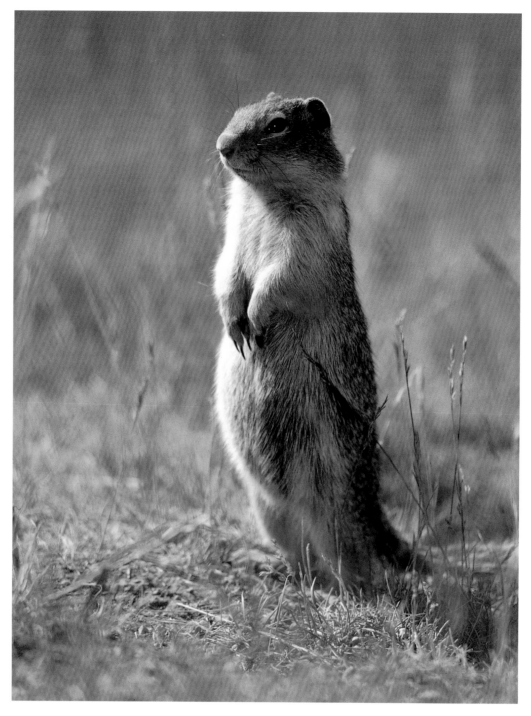

Columbian ground squirrel, Banff National Park, Alberta

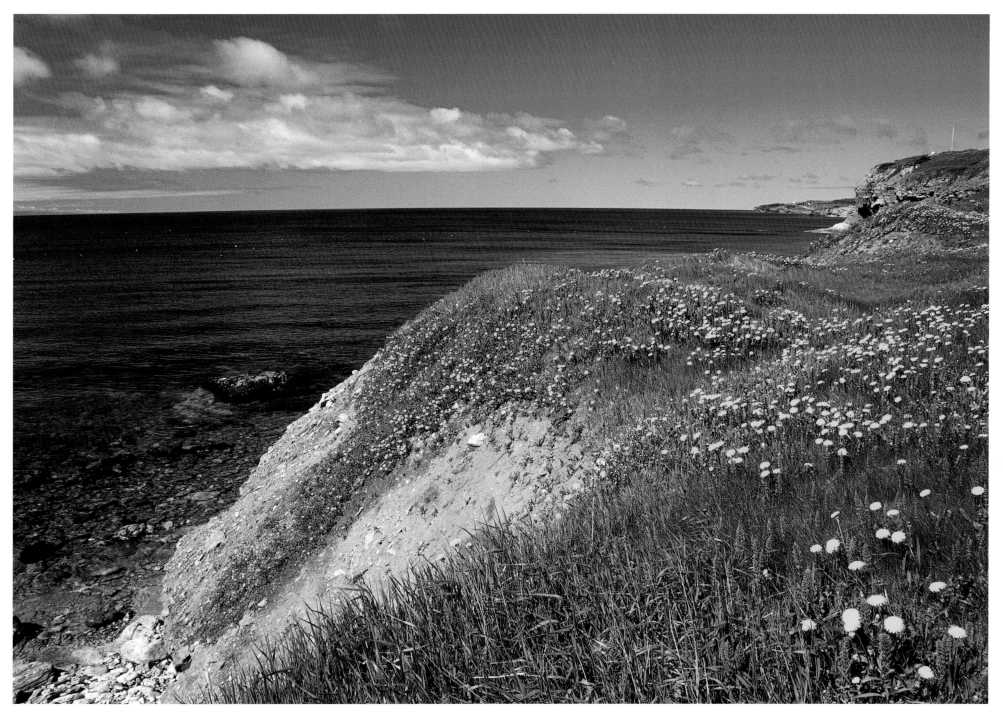

Cliffs along St. George's Bay, Port au Port Peninsula, Newfoundland

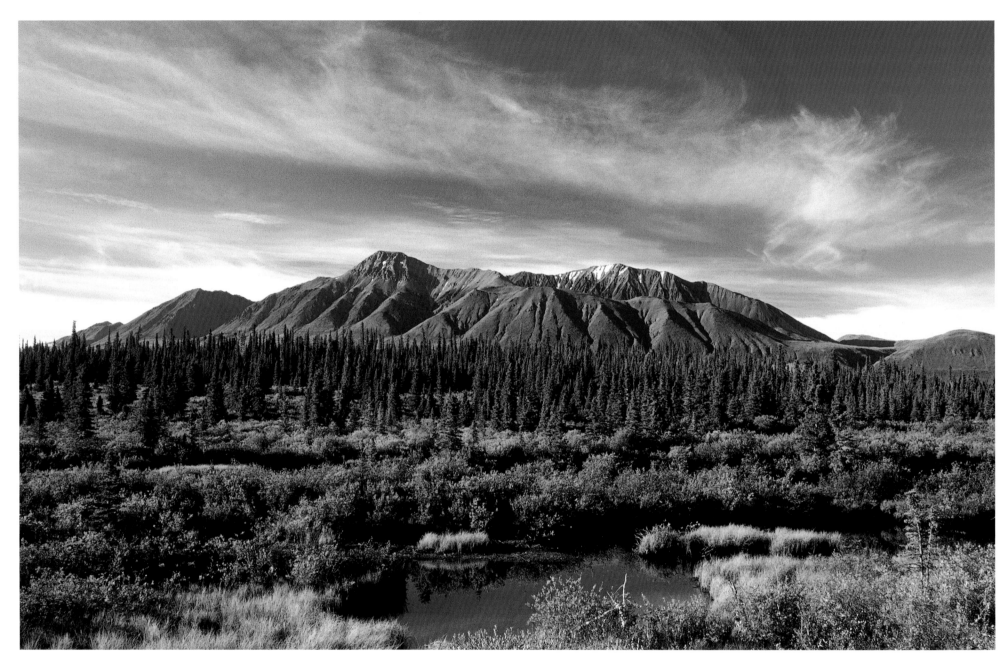

Wetland and mountains, Kluane National Park, Yukon

Daisies, Prince Rupert, British Columbia

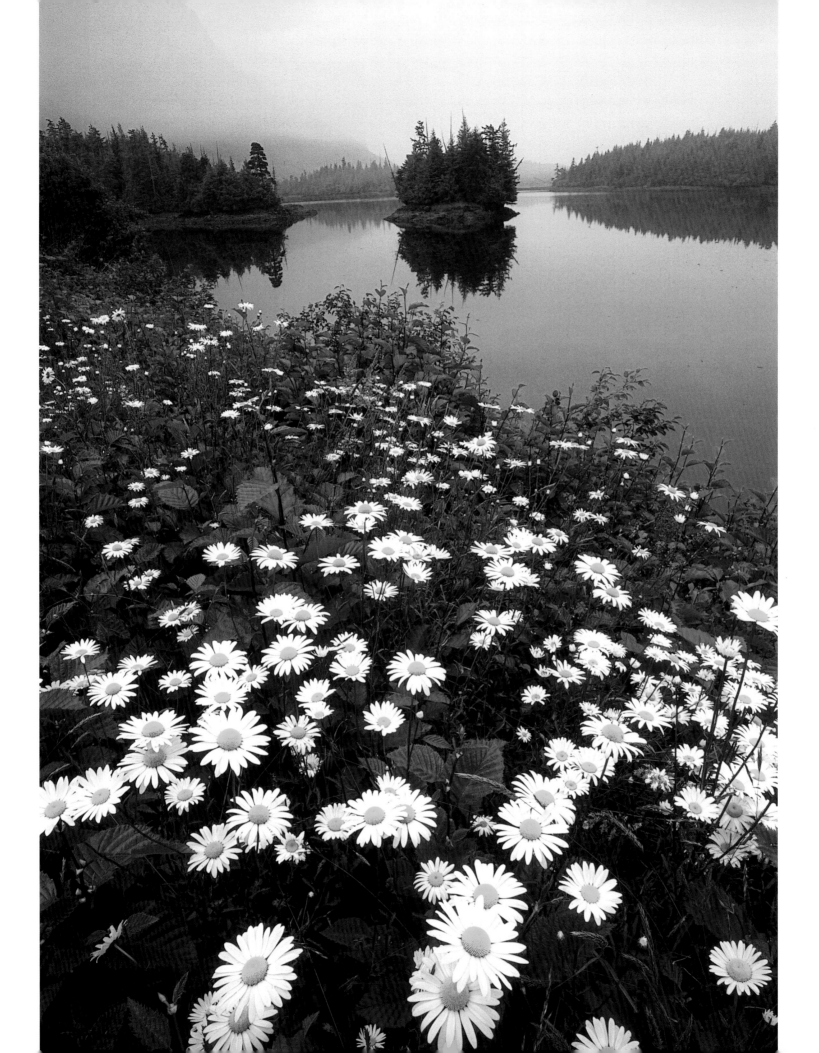

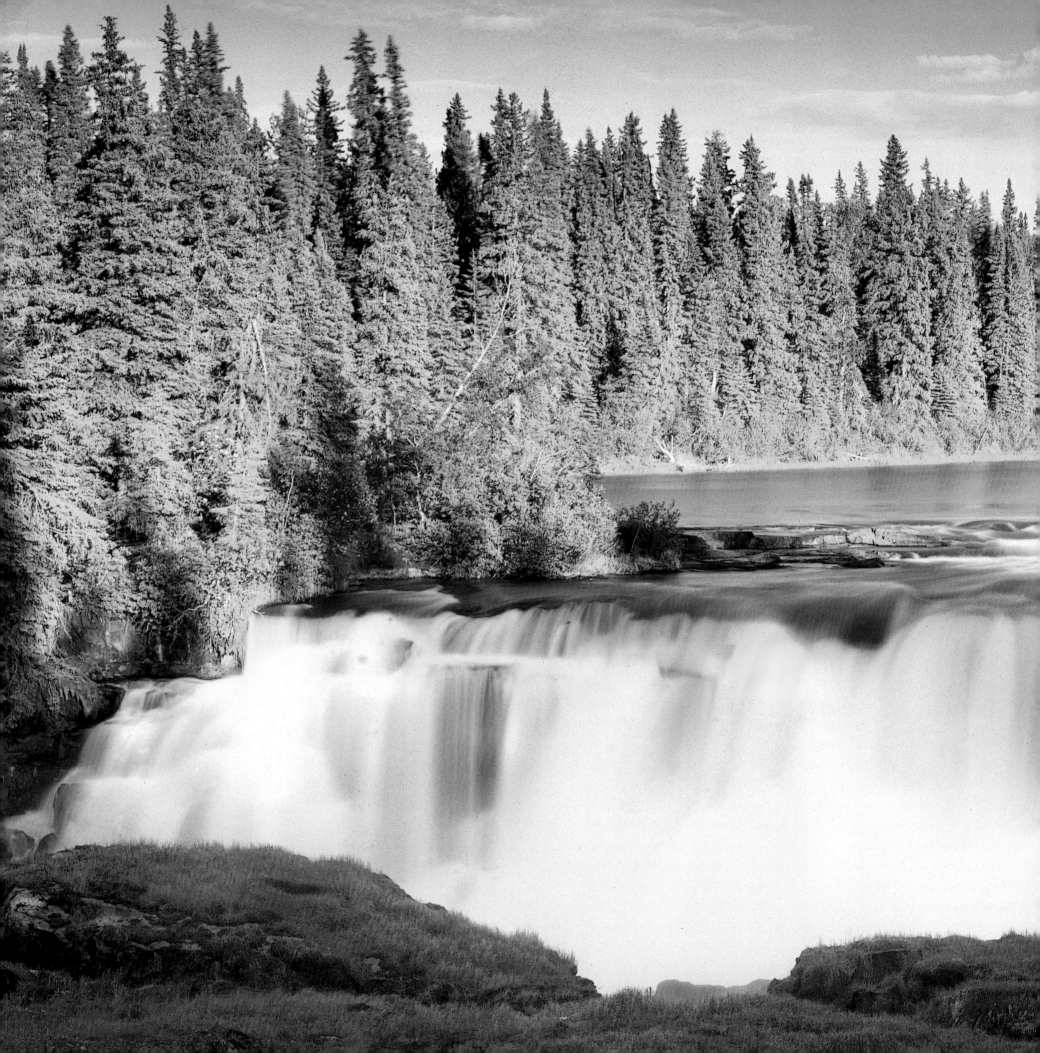

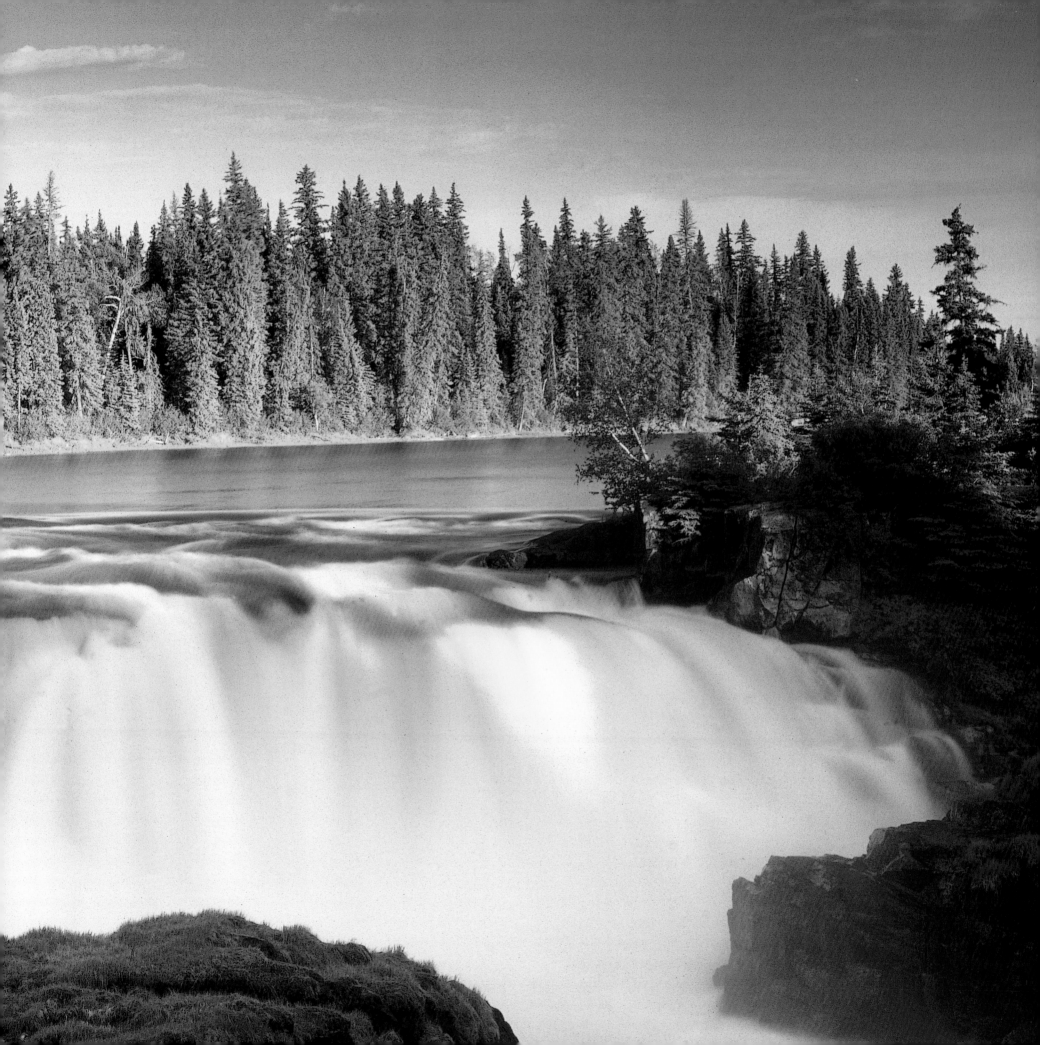

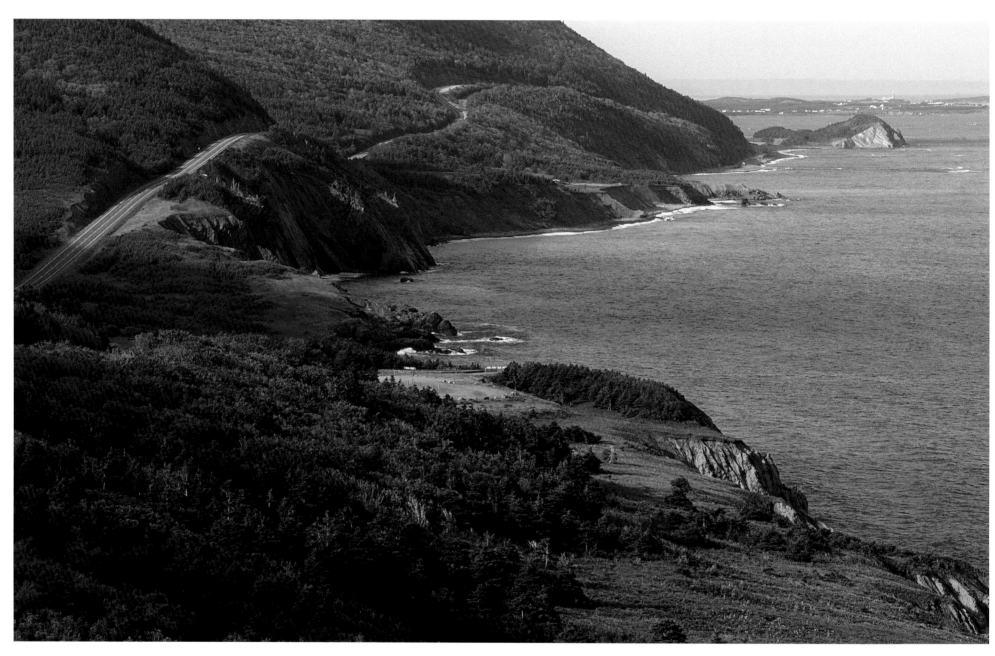

Cabot Trail. Cape Breton, Nova Scotia

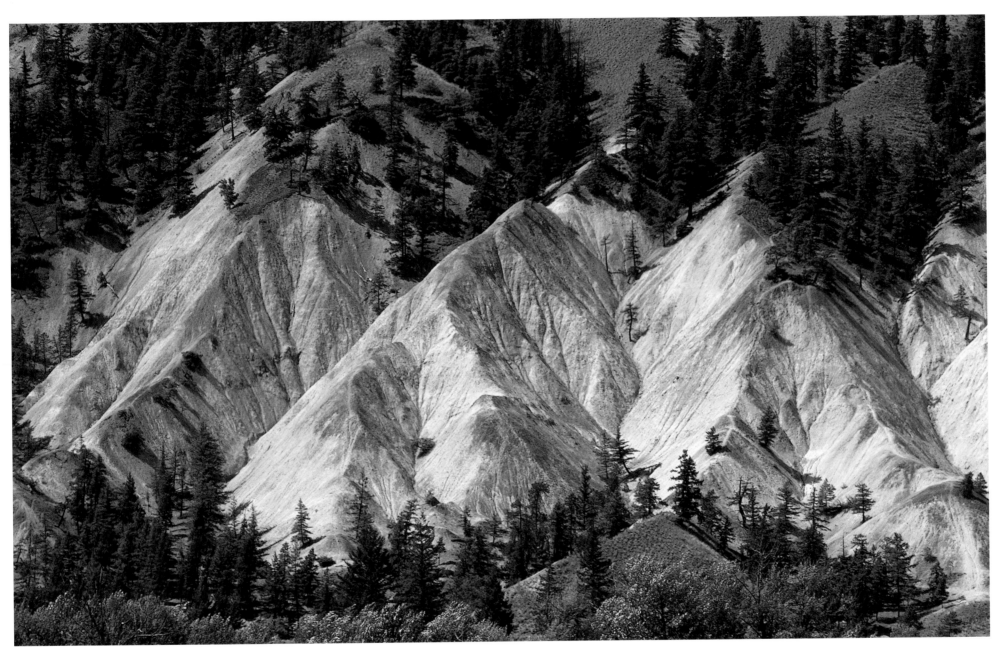

Clay formations, Hat Creek Historic Ranch, British Columbia

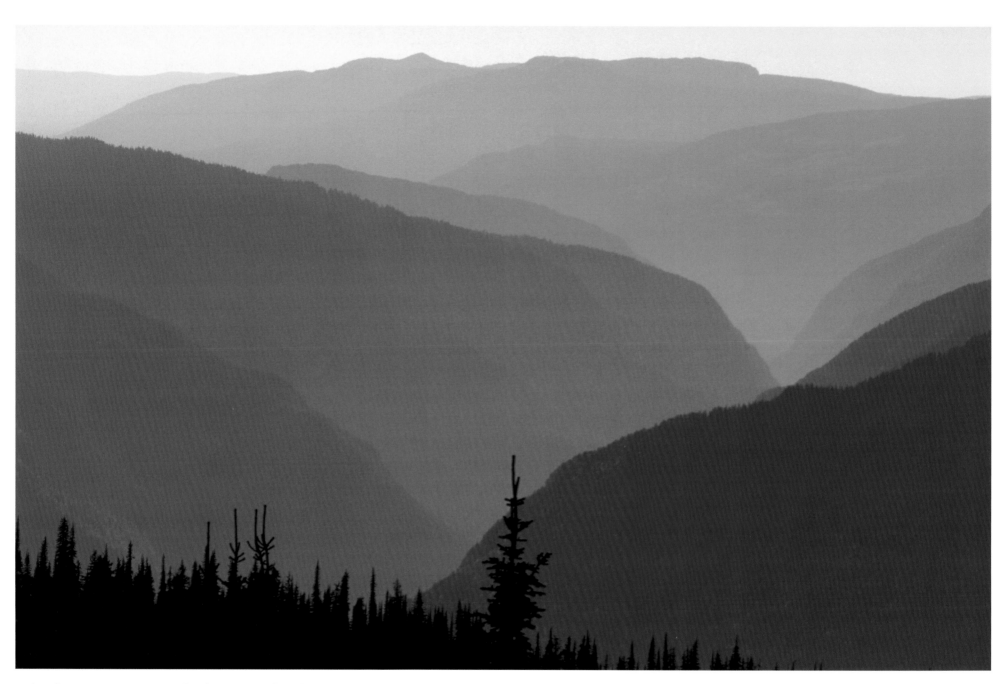

Columbia Mountains, Revelstoke National Park, British Columbia

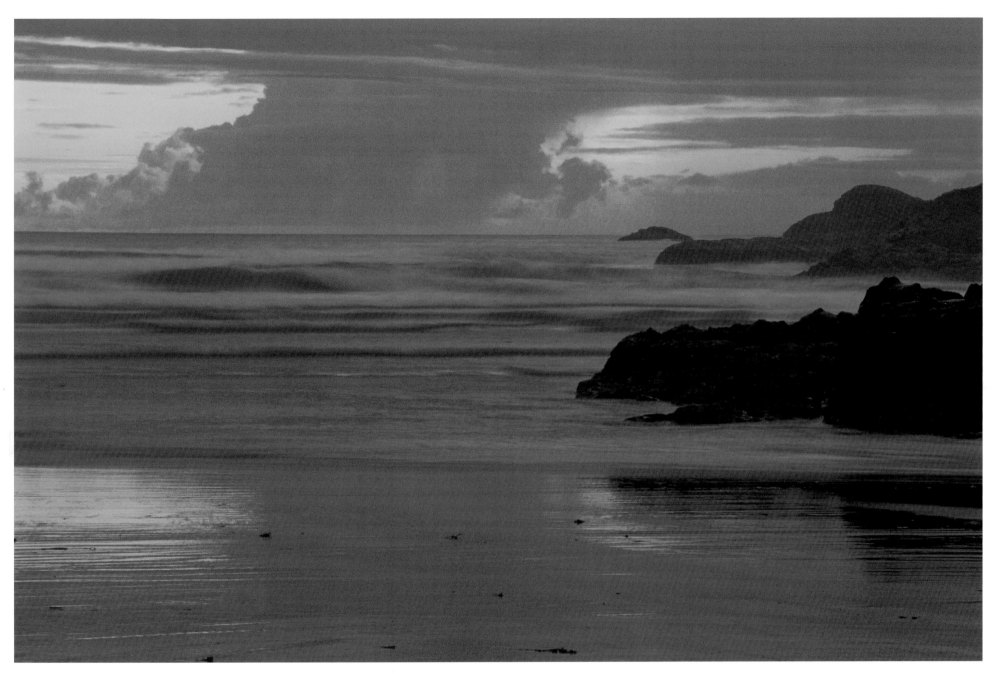

Long Beach at dusk, Pacific Rim National Park, British Columbia

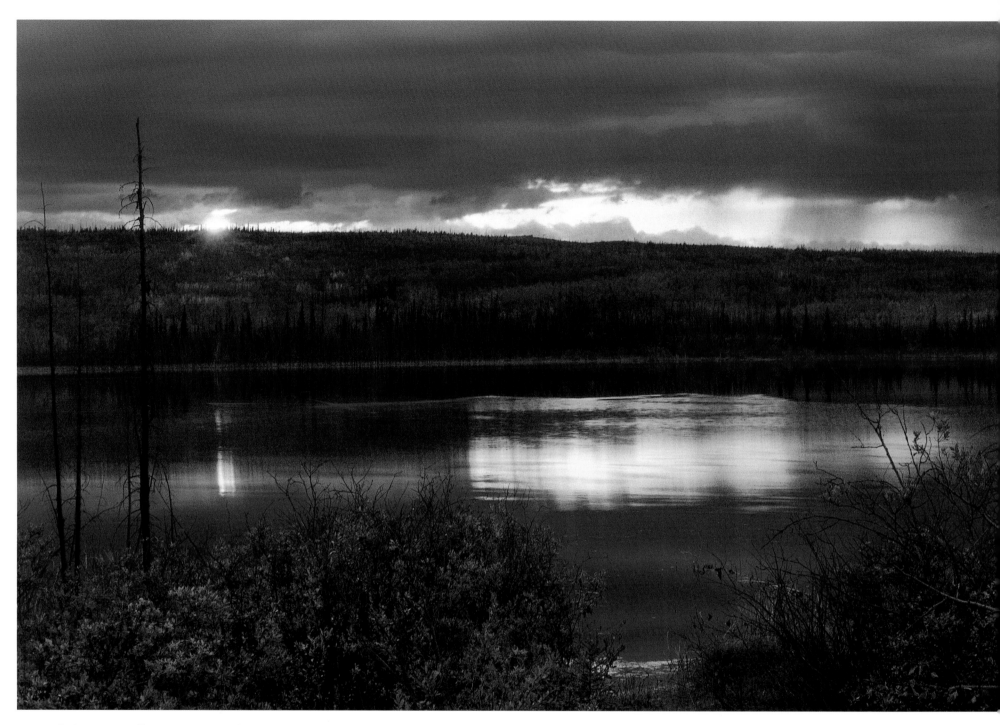

Storm light near Pelley Crossing, Yukon

Moon rise over the prairie near Elm Creek, Manitoba

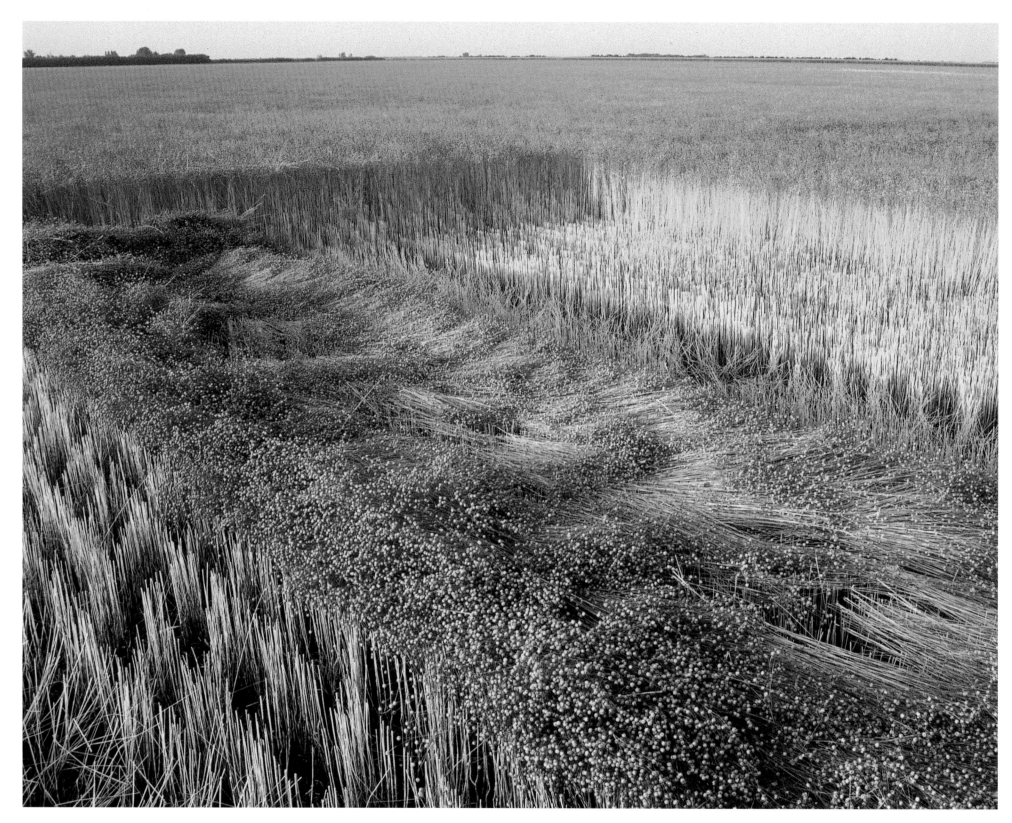

Flax field at harvest near Carmen, Manitoba

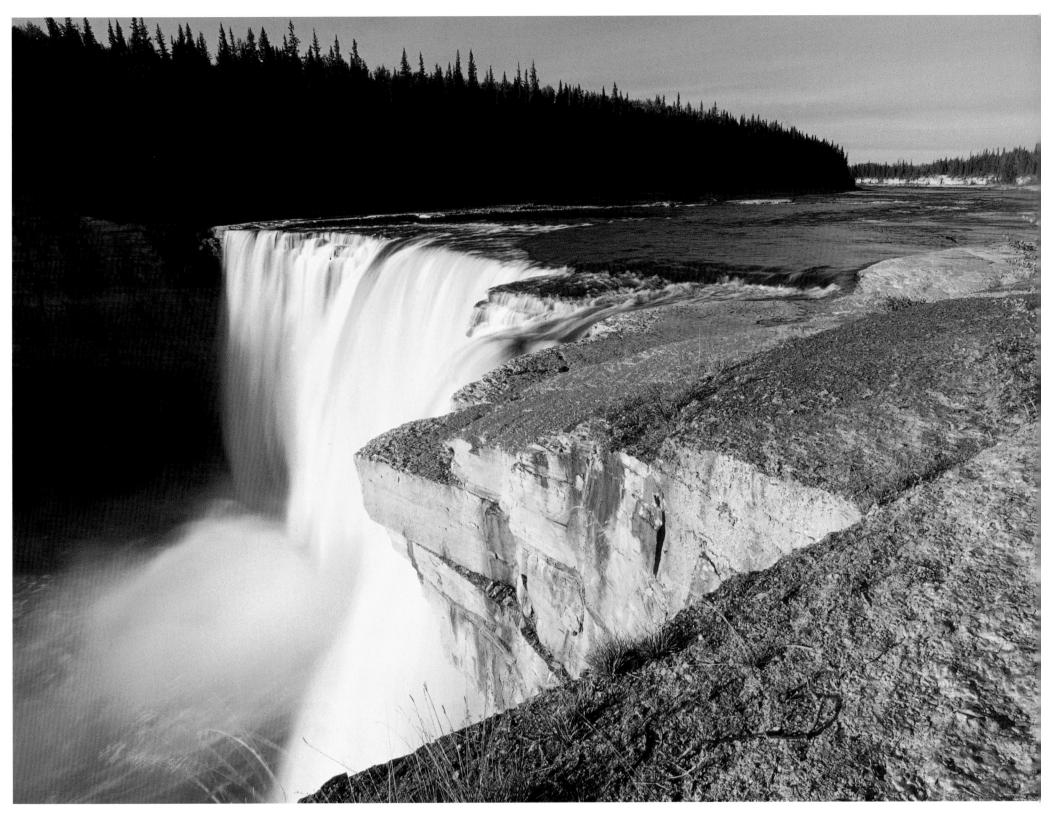

Alexandra Falls, Northwest Territories

Storm light, Humber Arm, Newfoundland

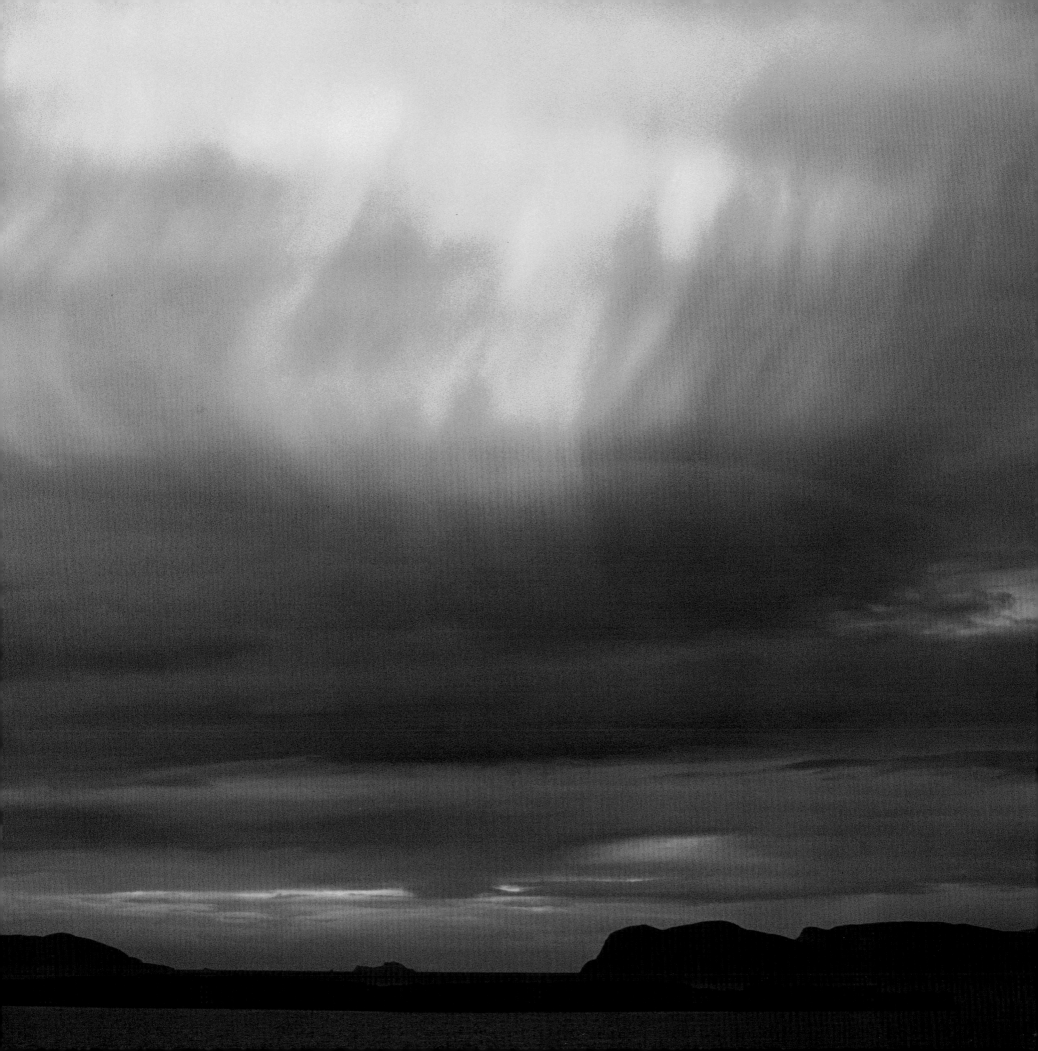

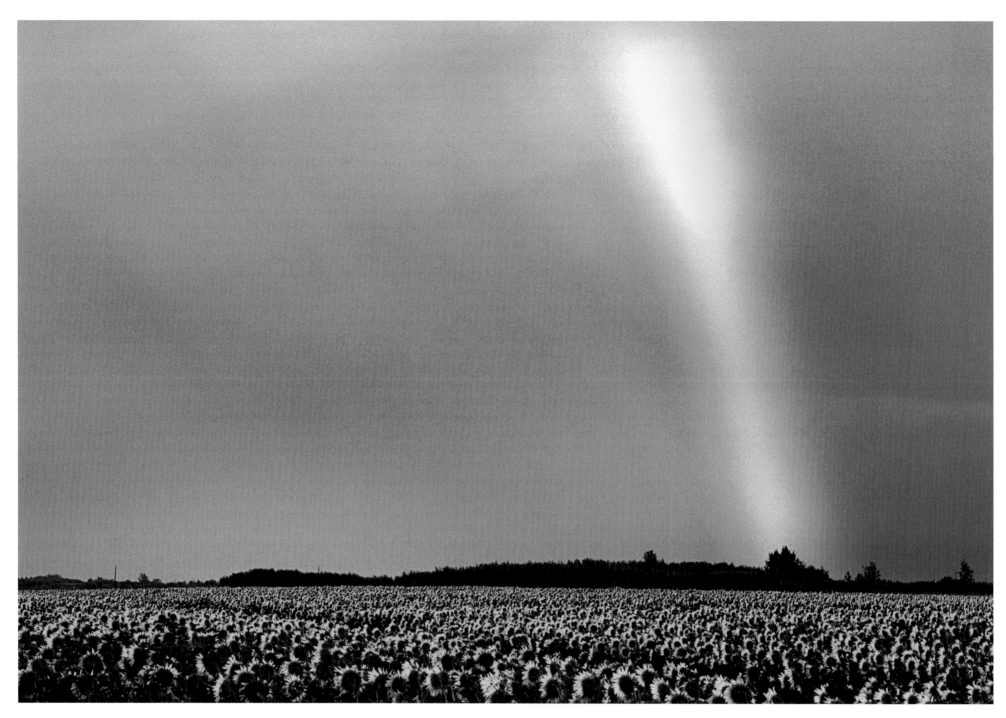

Rainbow over a sunflower field, Dufresne, Manitoba

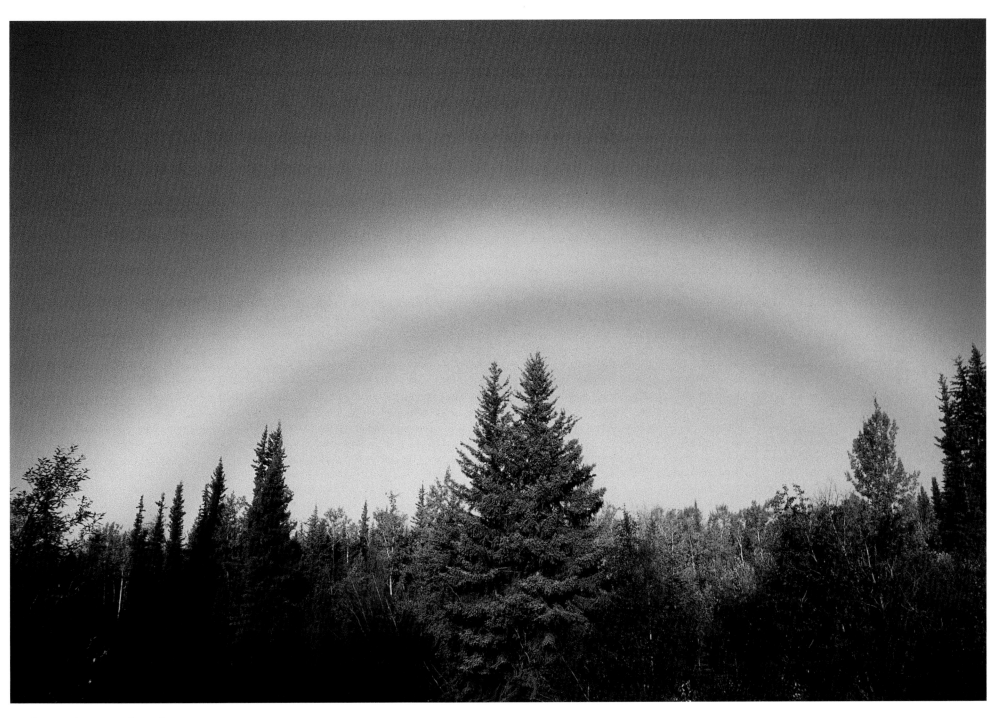

Fogbow, Clear Creek, Yukon

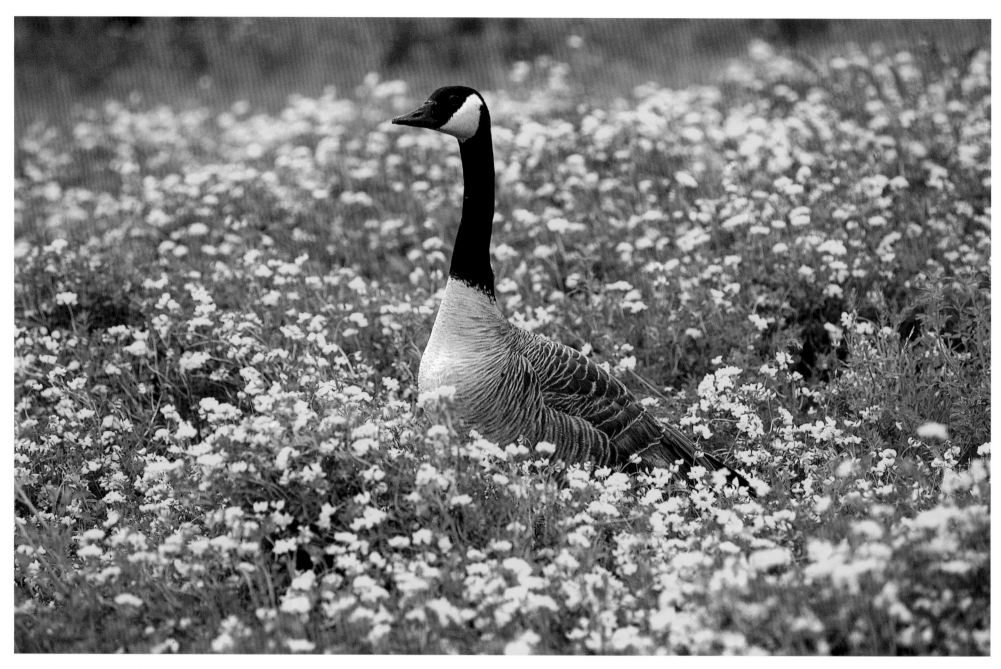

Canada goose in trefoil, Winnipeg, Manitoba

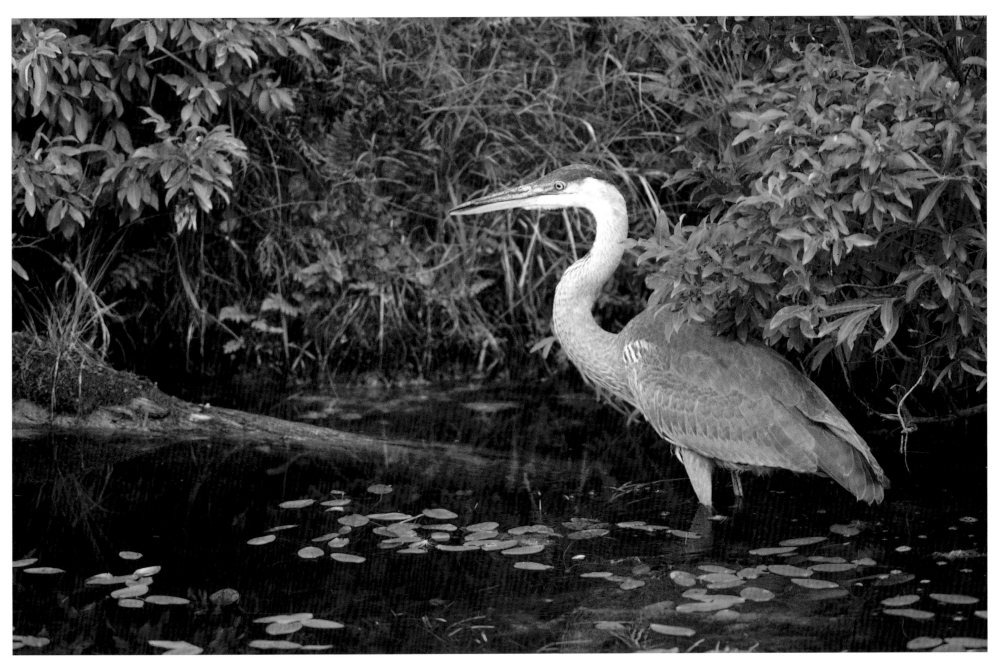

Great blue heron, Northwest Angle Provincial Forest, Manitoba

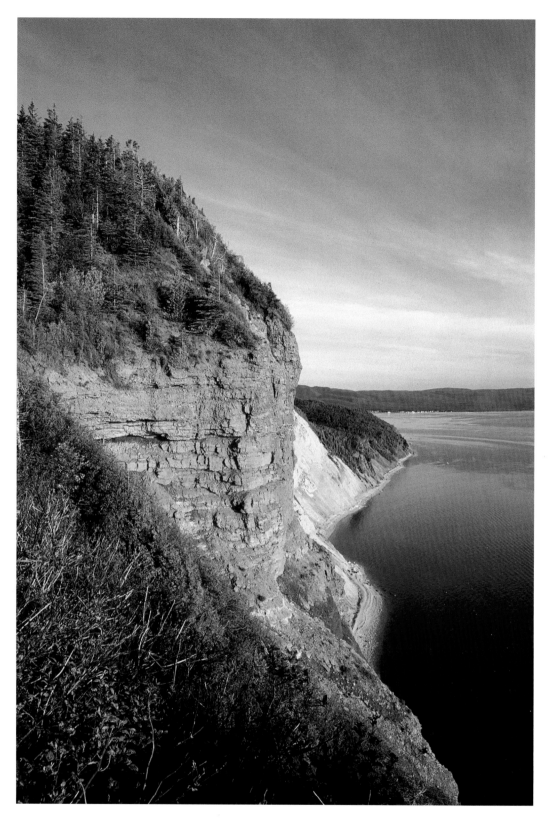

Cliffs. Percé, Québec

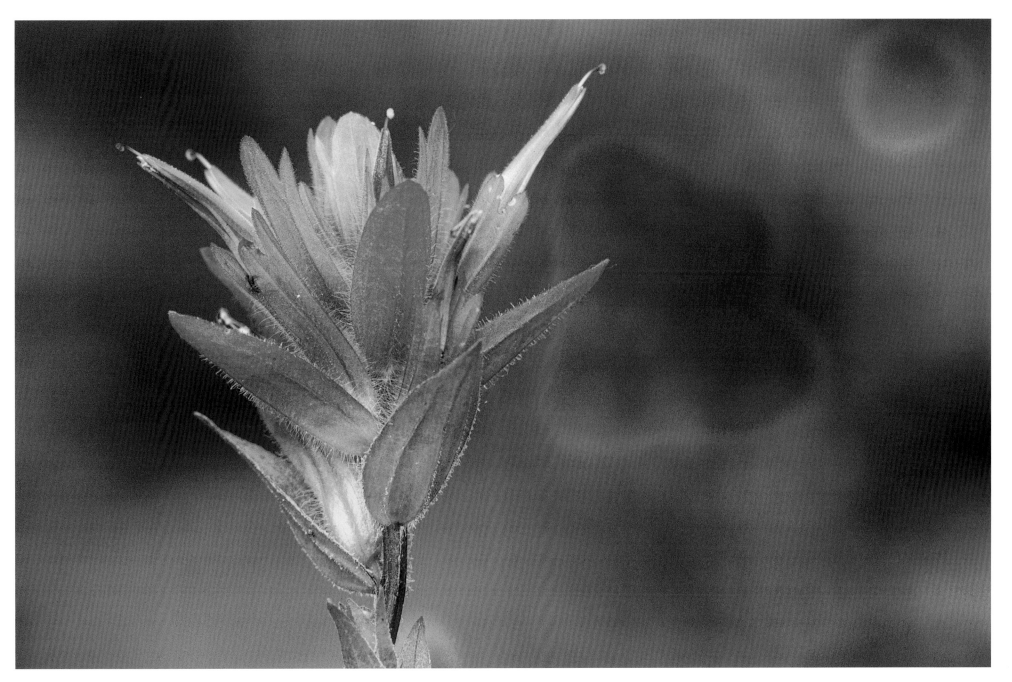

Indian paintbrush, Valemount, British Columbia

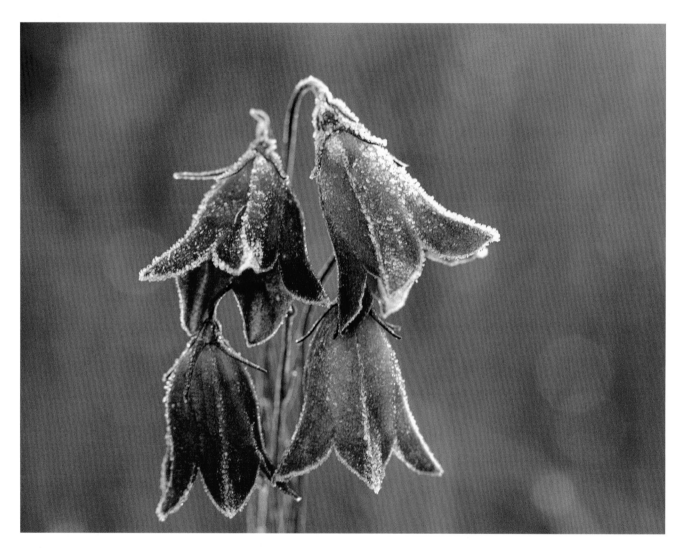

Harebells in frost, Valemount, British Columbia

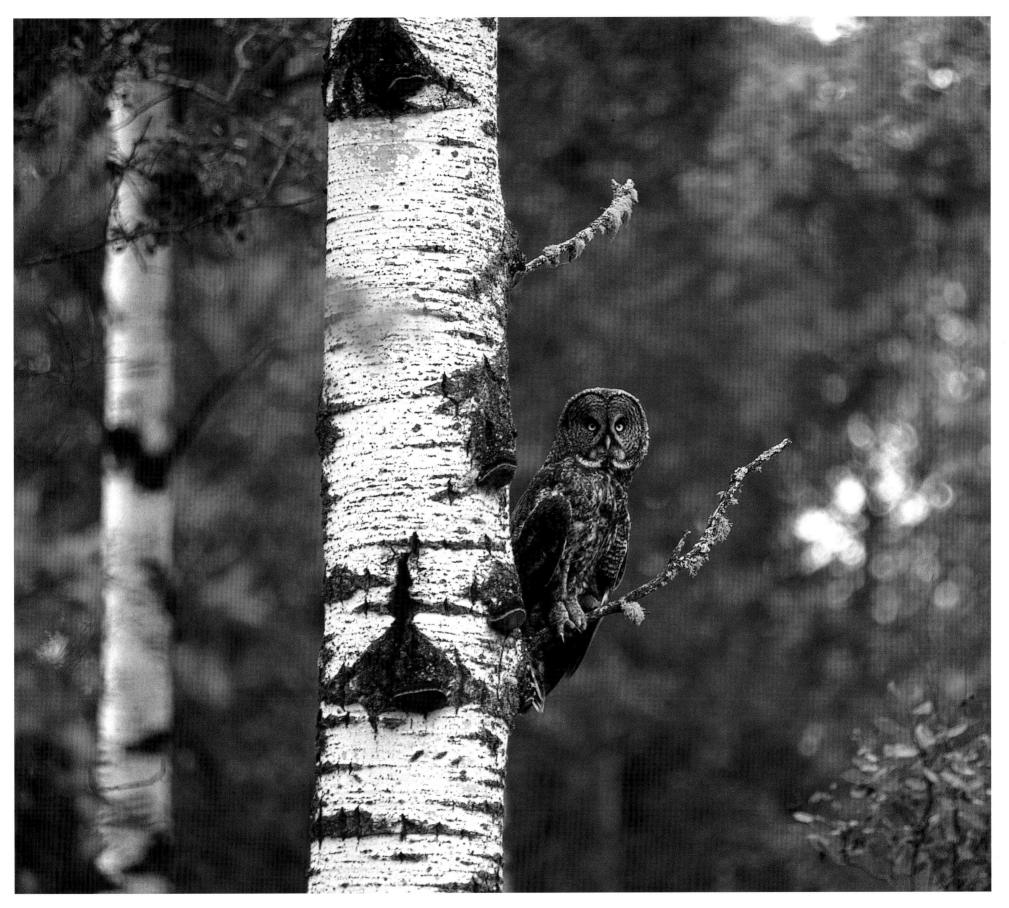

Great grey owl, Duck Mountain Provincial Park, Manitoba

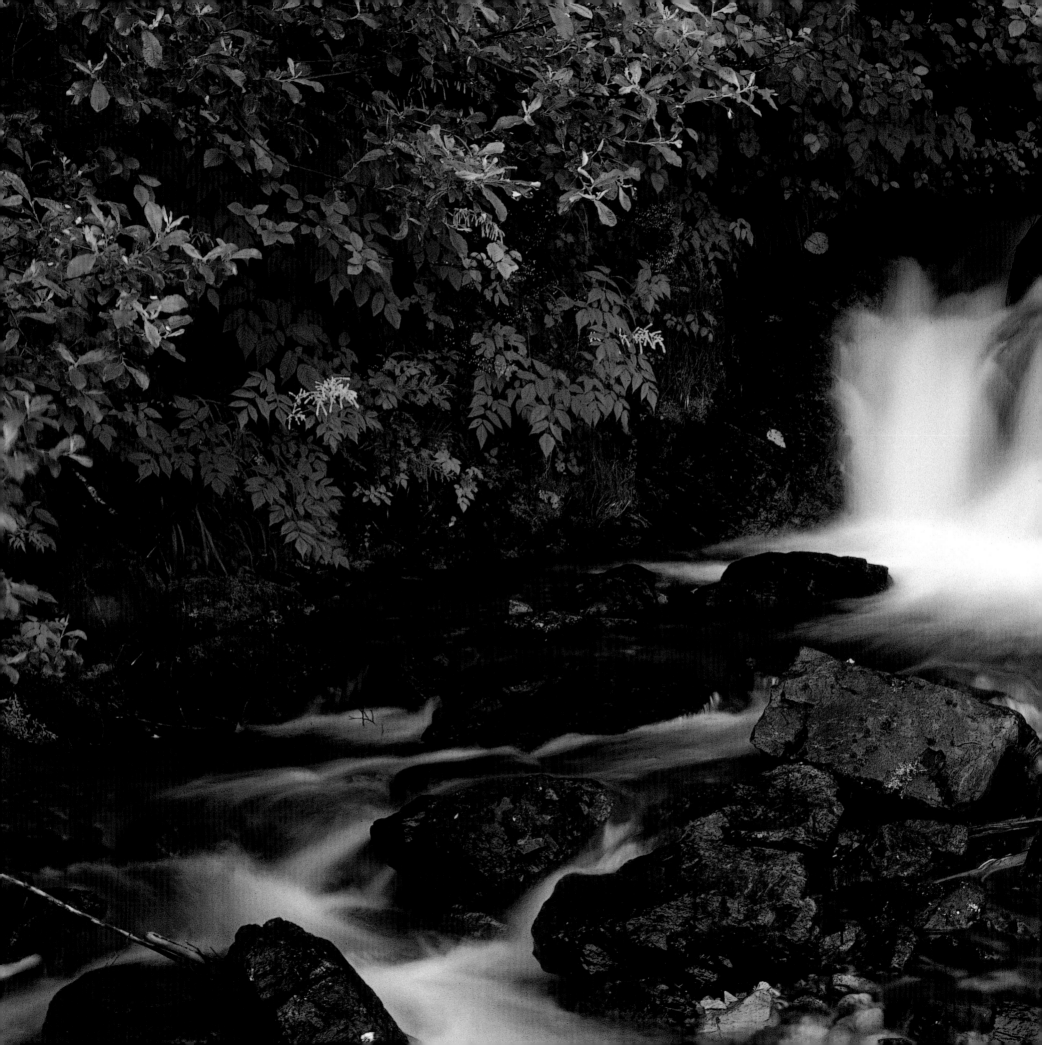

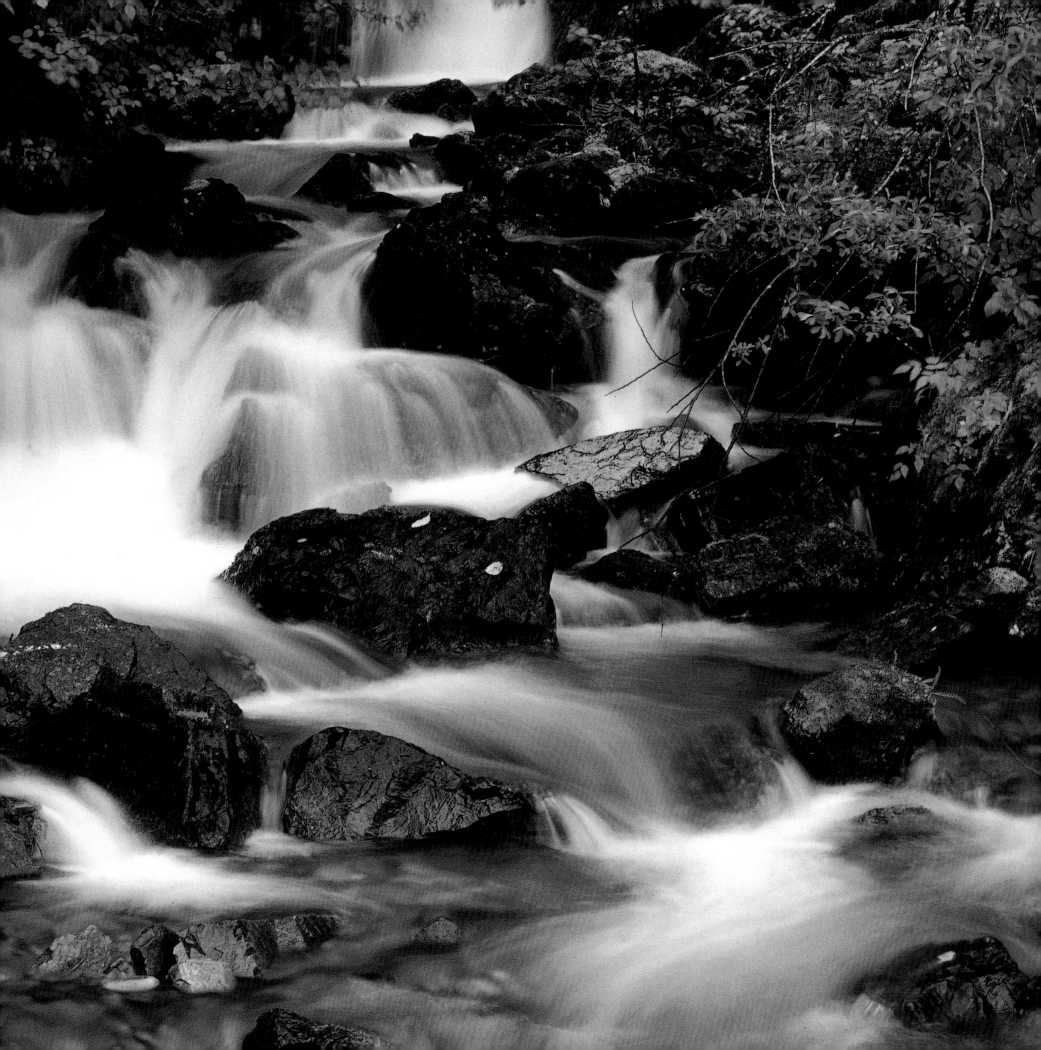

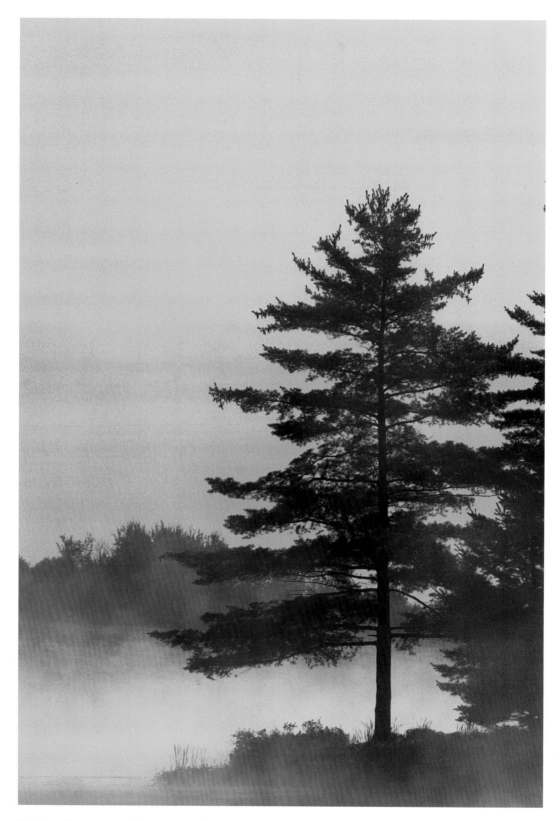

White pine at sunrise, Burwash, Ontario

PREVIOUS PAGE Mountain stream near Prince Rupert, British Columbia

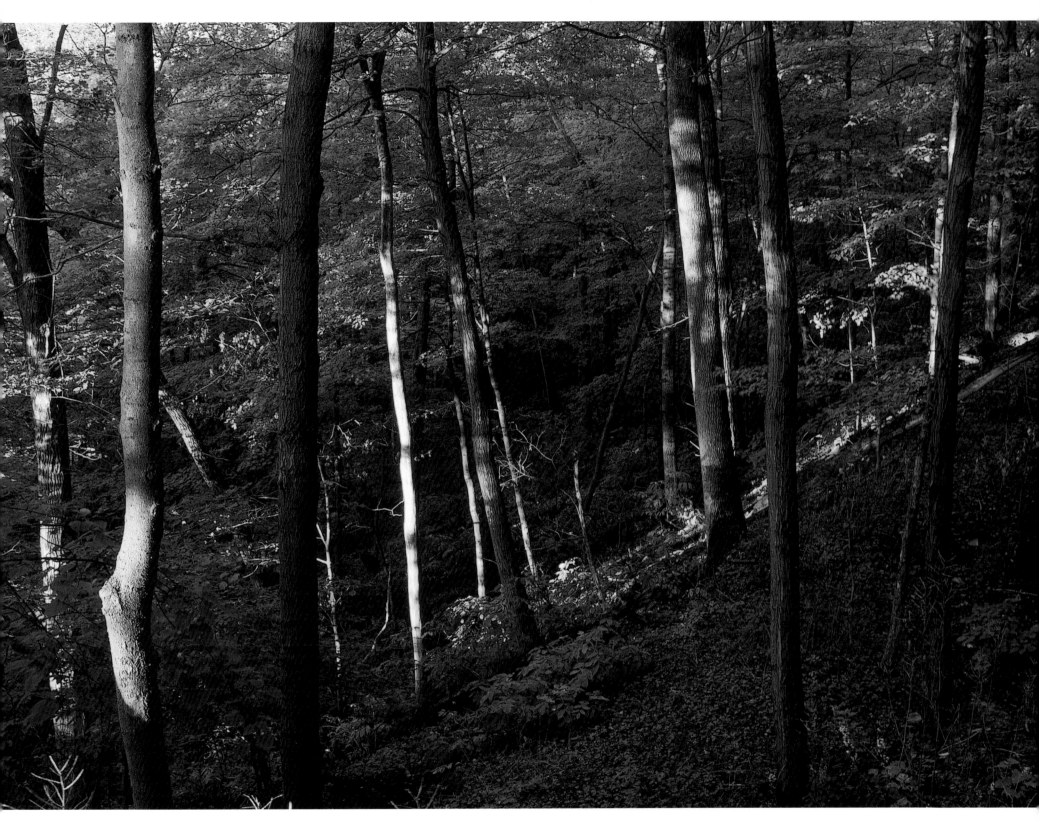

Bruce Trail near Queenston, Ontario

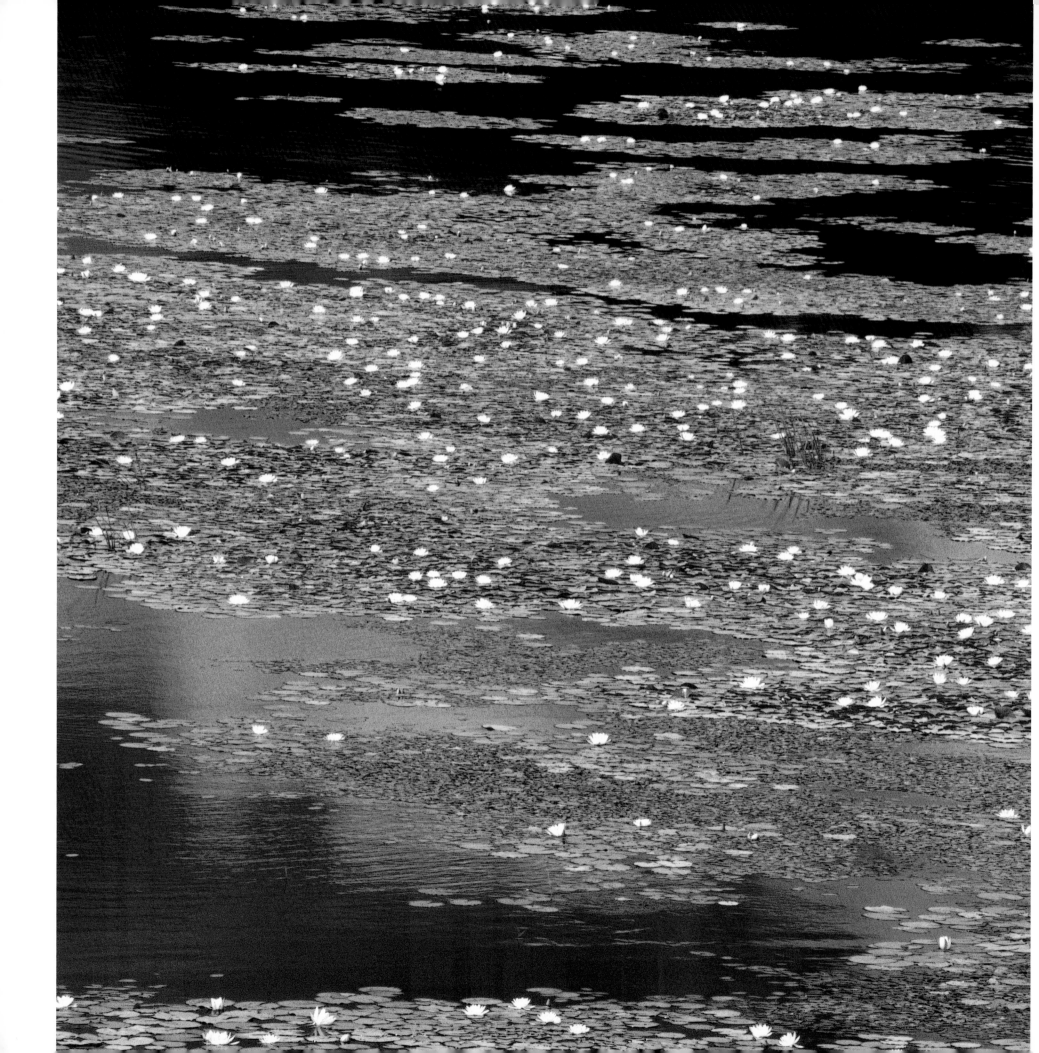

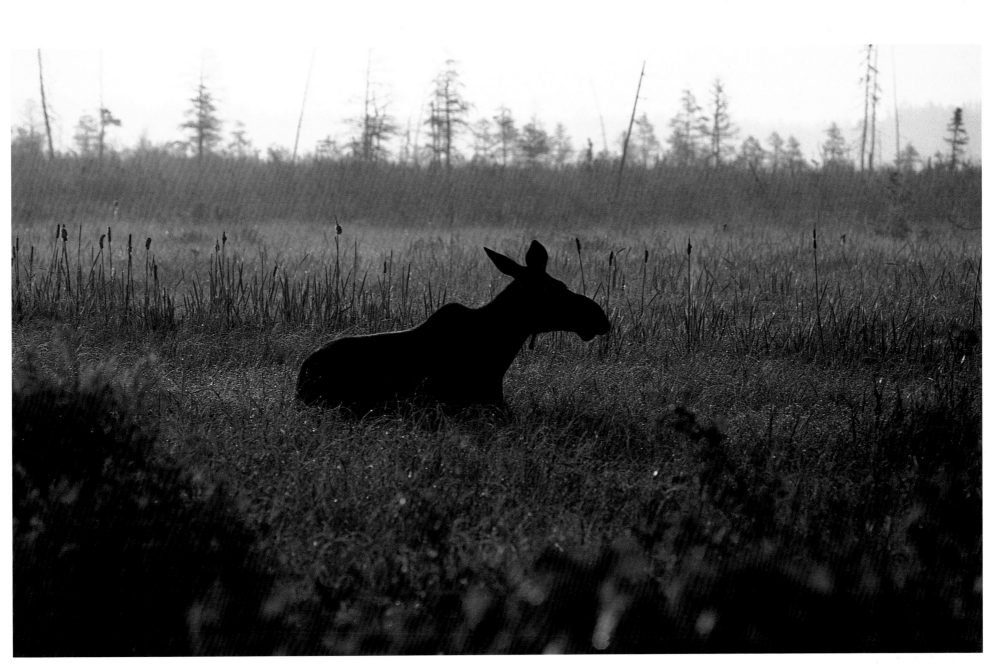

Moose in marsh, Riding Mountain National Park, Manitoba

White water lilies near Parry Sound, Ontario

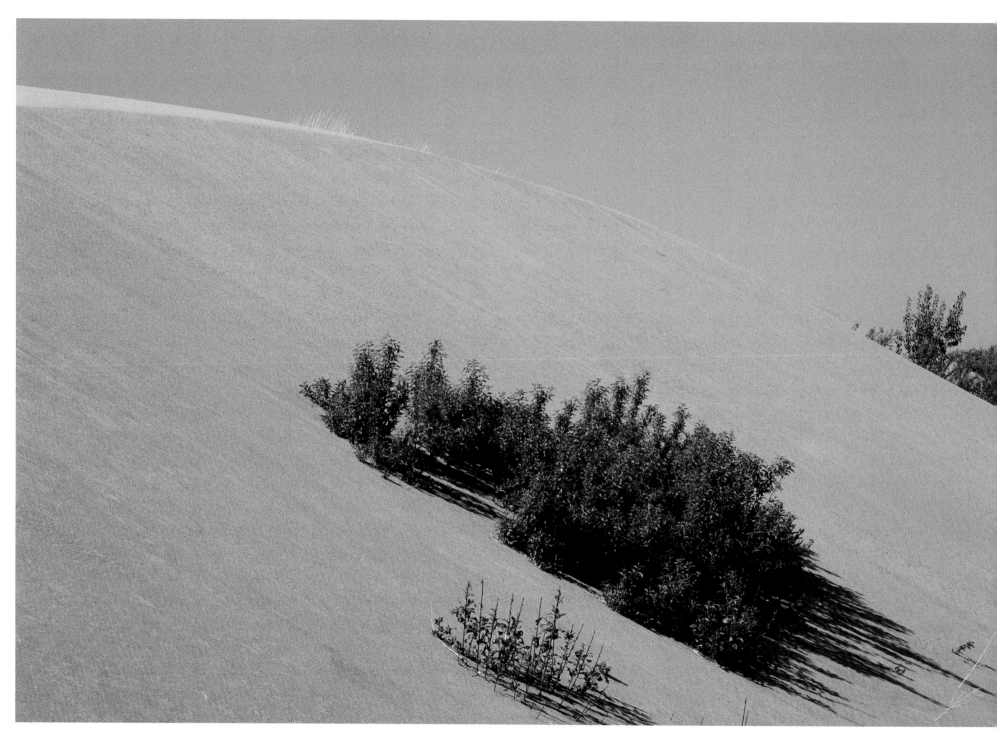

Carberry dunes, Spruce Woods Provincial Park, Manitoba

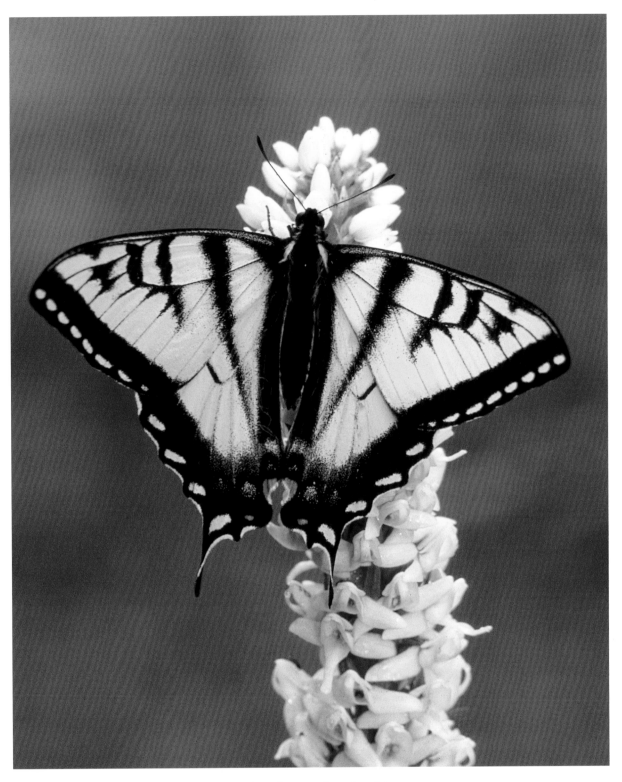

Tiger swallowtail, Wells Gray Provincial Park, British Columbia

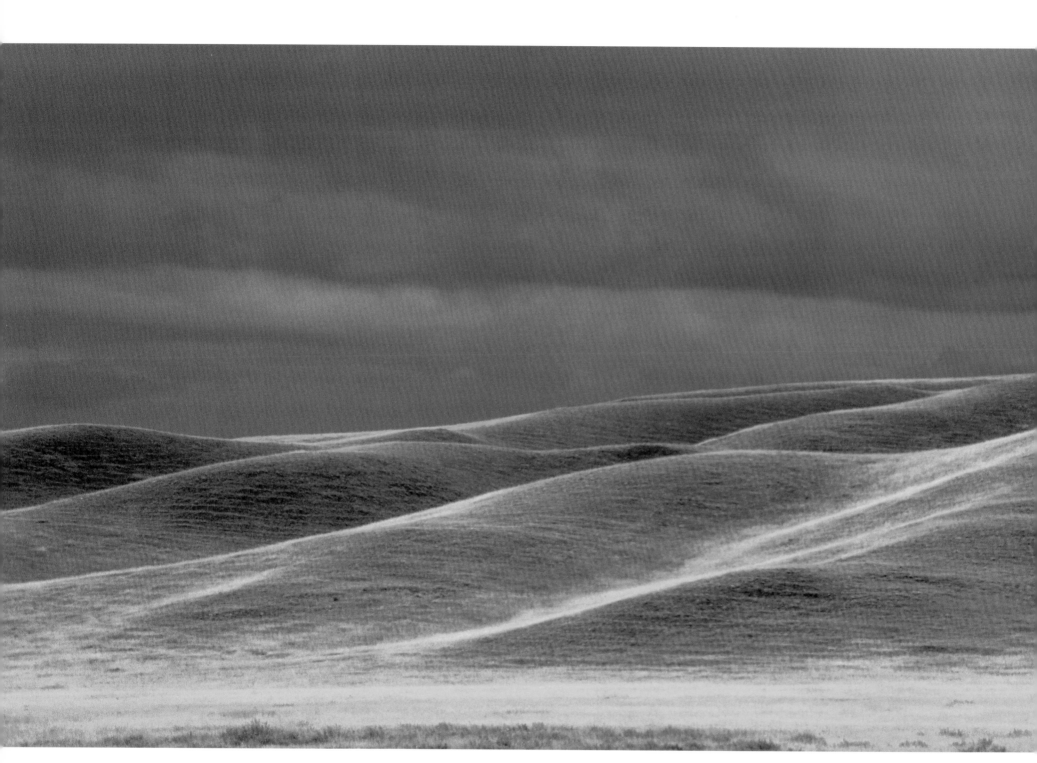

Rolling hills near Maple Creek, Saskatchewan

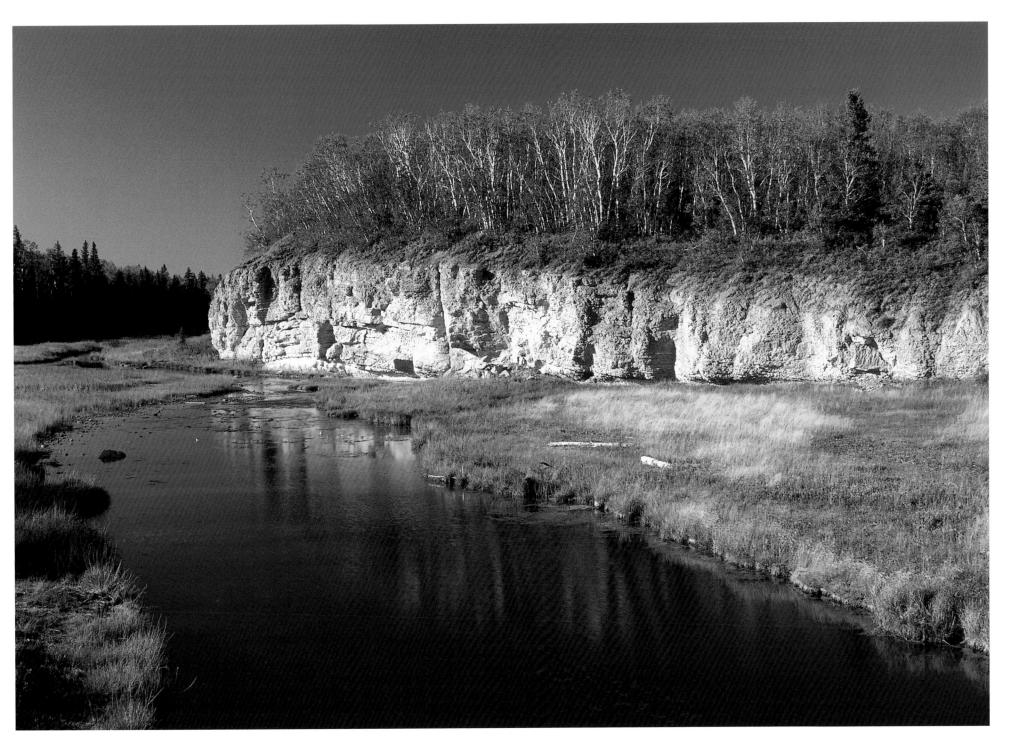

Boundary Creek, Wood Buffalo National Park, Northwest Territories

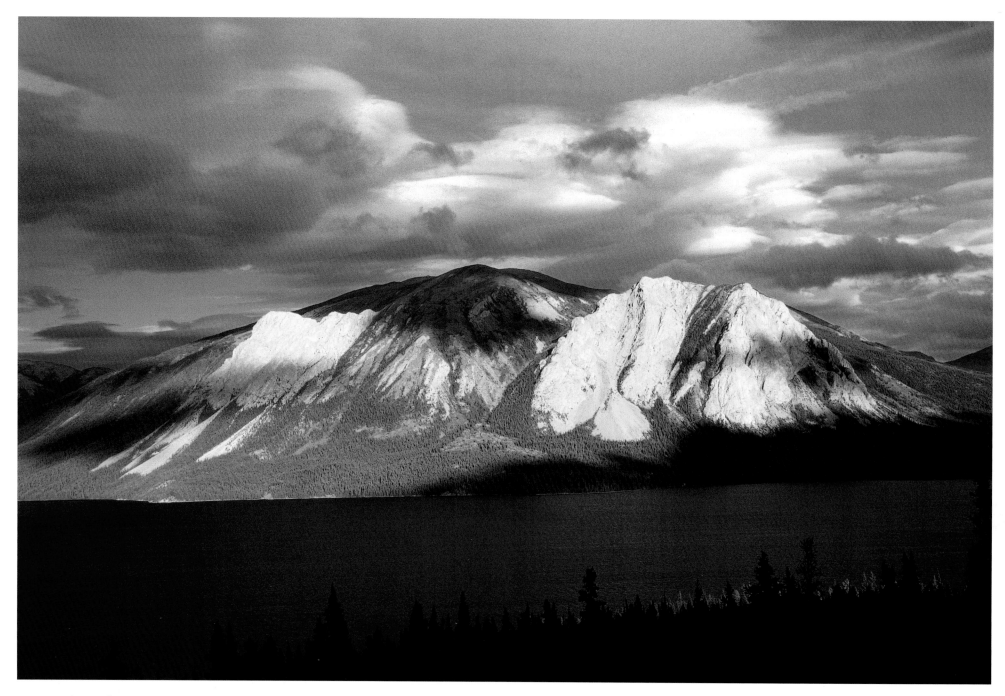

Nares Lake, Yukon

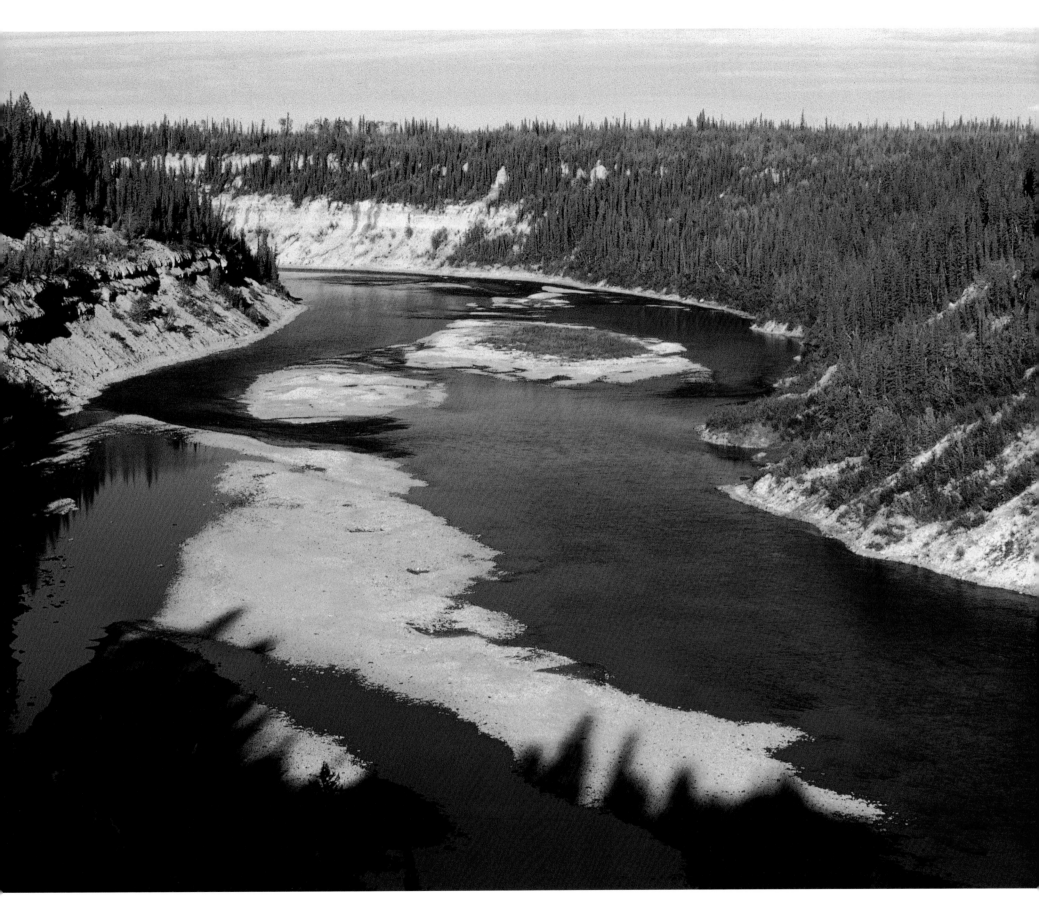

Hay River, Enterprise, Northwest Territories

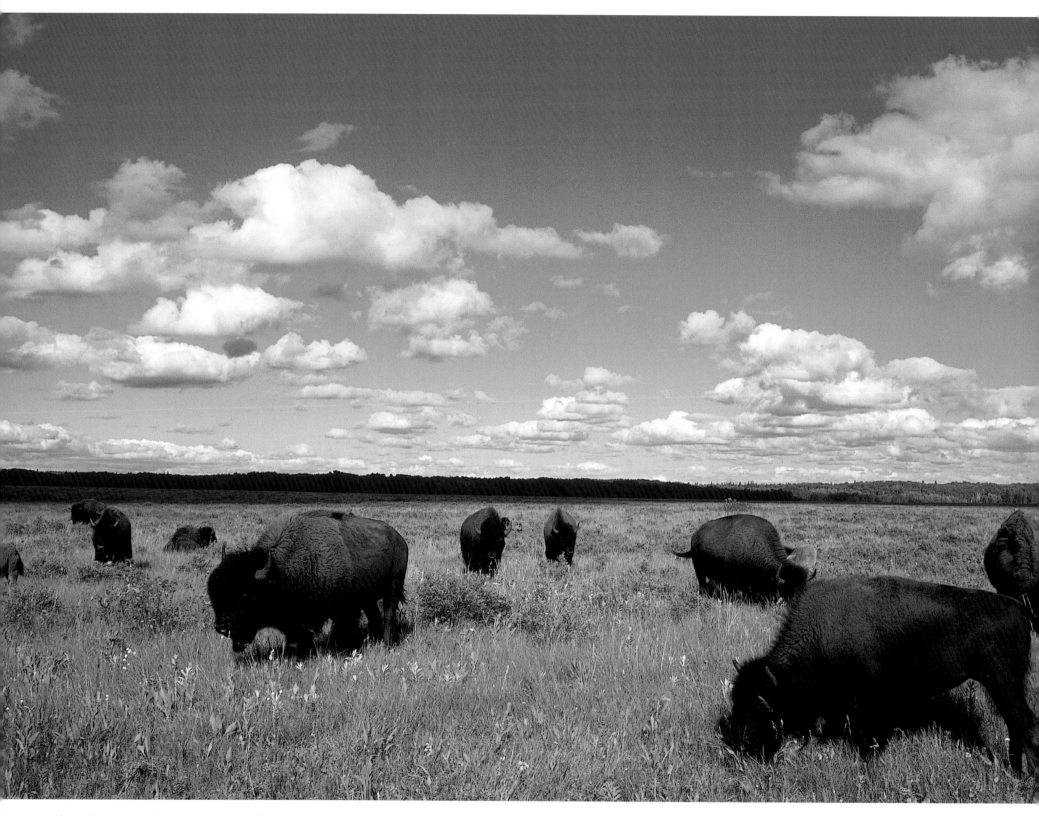

Plains bison on fescue prairie, Riding Mountain National Park, Manitoba

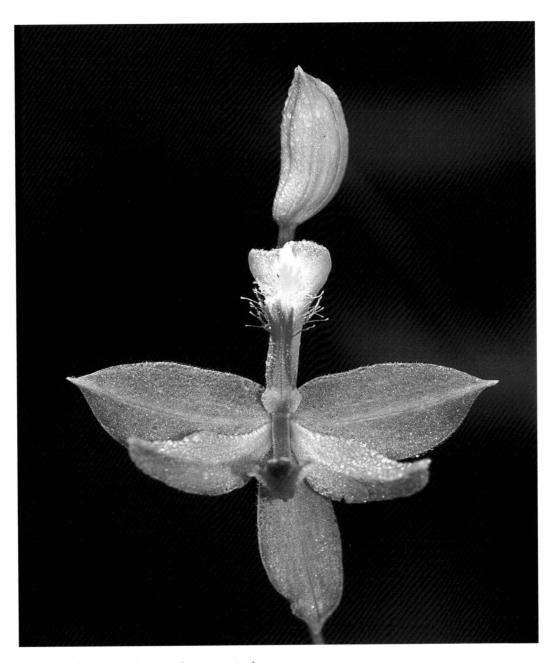

Grass pink near Milner Ridge, Manitoba

OVERLEAF Lake Annette, Jasper National Park, Alberta

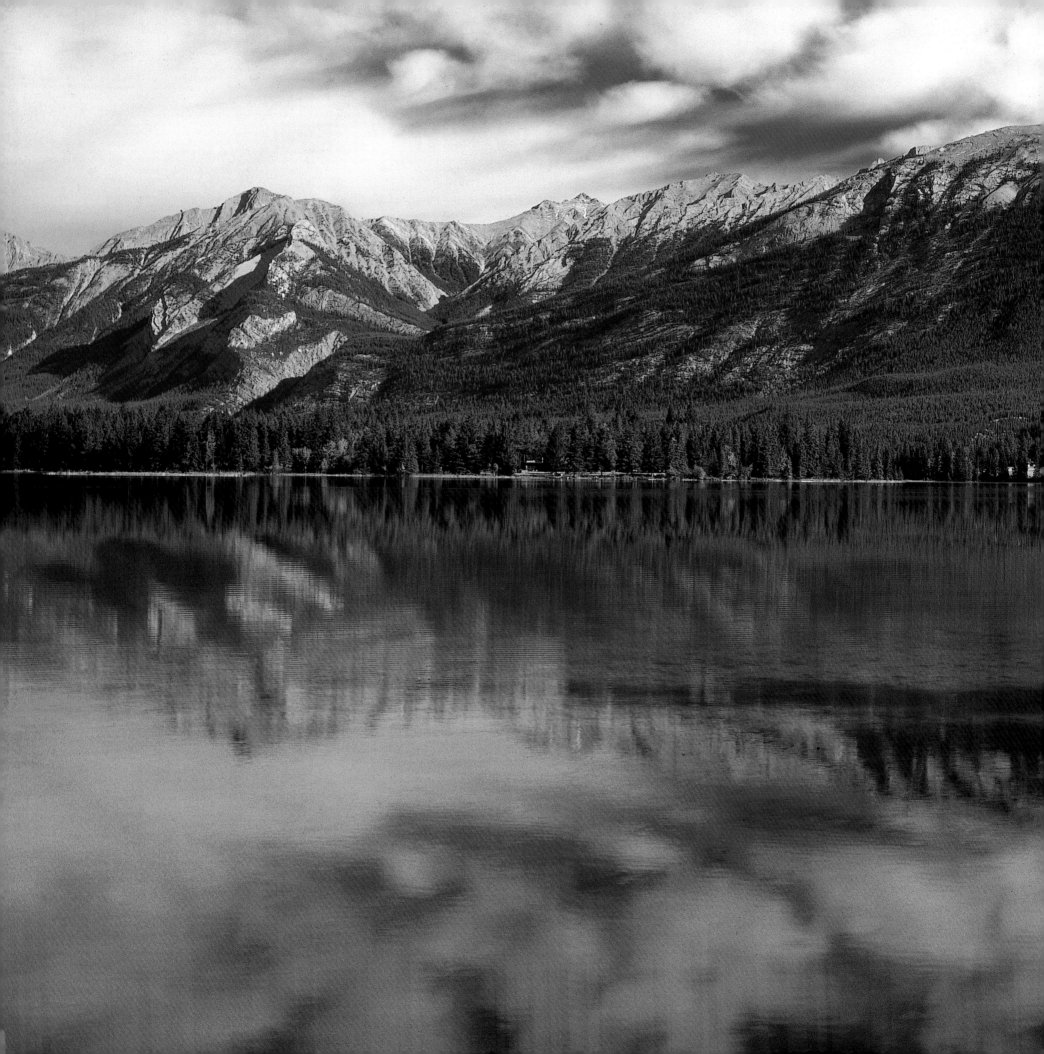

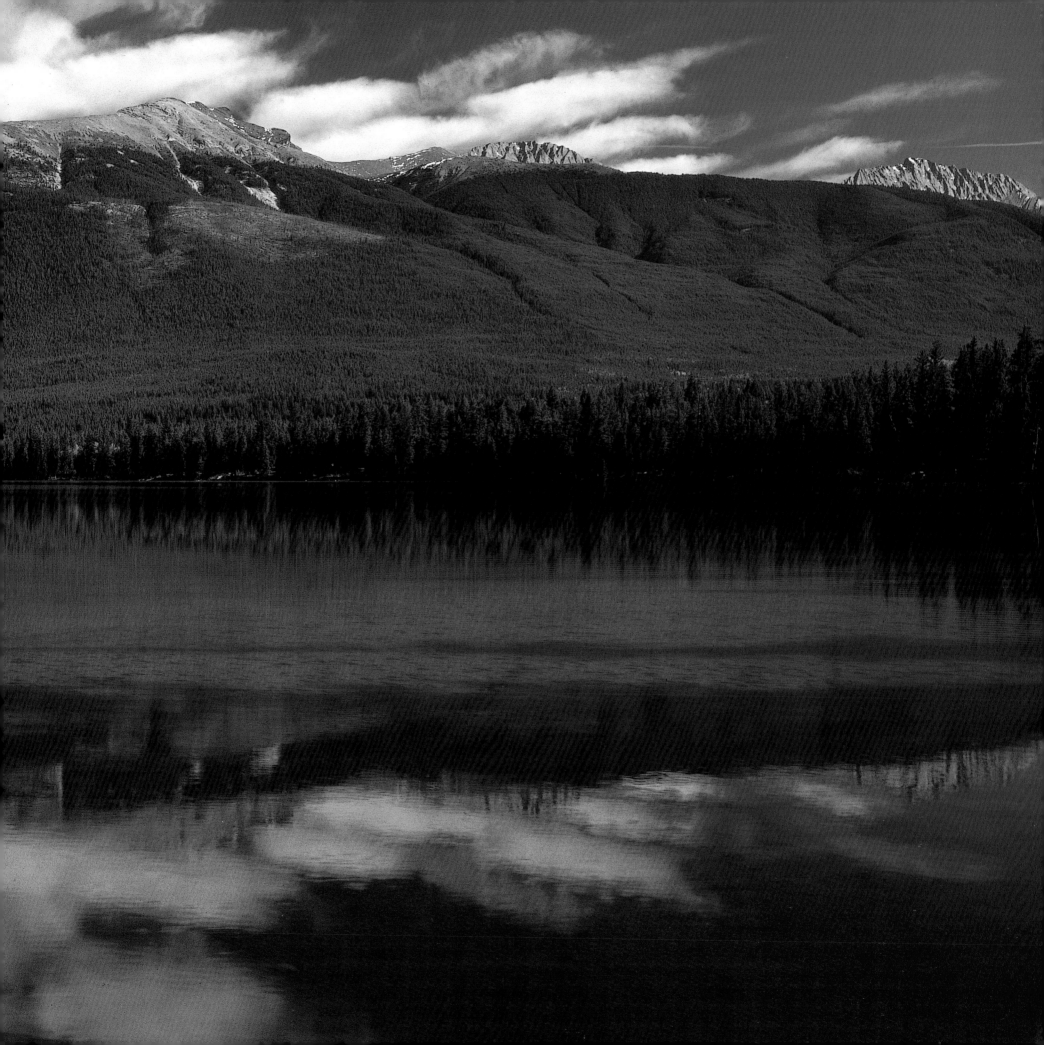

I love this country we call Canada. I'm one of those unabashed Canadians passionate about the country. Very early in my career I decided to focus my lens on Canada, as it seemed right to get to know one's own country before exploring another.

As a child, my father would take our family to the country around Markstay, Ontario (his old stomping grounds) for a little fishing. He would relish in the telling of stories about his own youth while showing us familiar landmarks that he remembered from his past. These early outdoor experiences, along with our time at the cottage on Tilton Lake, sparked my interest in the natural world. At Laurentian University I earned a degree in biology and then worked in the field for the next twenty years or so. I've been fortunate to have travelled much during my career and have seen some spectacular sites in the process. In 1996, I changed careers and followed my creative aspirations to make photography my profession. I made a lifelong commitment to explore the breadth of this country, capturing the essence of this land in evocative images that would speak to the heart.

I feel very fortunate to have been born in Canada. I believe very strongly that I live in the best country in the world, bar none, from a political, social, and economic point of view, to say nothing of its incredible and wild beauty! We are all familiar with the majestic mountains of the Canadian Rockies, the breathtaking Niagara Falls, the quaint little fishing village of Peggy's Cove, but there is so much more to Canada than these familiar icons. You begin to understand this as you travel through the many different parts of the country, not by gazing over the landscape from an airplane window, but by driving the country's roads and hiking its trails—which gives you a true sense of the land and how it unfolds in front of you.

What I love most about this country is its sheer beauty and diversity. Canada's vastness truly boggles the mind. Ecologically, it boasts numerous biomes or ecosystems so diverse they are classified as arctic, alpine, badlands, prairie, marine, wetland, desert, mountains, and forests. Each biome has its own uniqueness, its own beauty, harbouring a distinct community of plants, animals, and physical environment. While Canada is host to abundant and varied wildlife, it

also faces a growing loss of habitat and species. We must not only acknowledge this, but also act now to preserve what we still can. We owe it to our children to leave this world in a better state than it is now. And we must be vigilant about this.

I was born in Sudbury, Ontario, a land ravaged by mining, lumbering, and forest fires. When I was attending university, a consciousness developed on campus that we should try and reclaim this damaged landscape. Through the valiant efforts of dedicated scientists like Keith Winterhalder, Peter Beckett and Gérard Courtin, who built relationships with the Sudbury Municipality, both federal and provincial governments, and industry, the Sudbury area was progressively and significantly "greened up." The healing of the land had begun. Others living in a similar situation can look at this model and think of ways to improve their own situation. I've seen some excellent conservation work in other areas of Canada too. In Manitoba, for instance, individuals like Marilyn Latta and John Morgan, and organizations like the Manitoba Naturalists Society, the Critical Wildlife Habitat Program and The Nature Conservancy of Canada have fought long and hard to preserve one of Canada's most threatened and rarest ecosystems—the tall grass prairie. Less than 1 percent of tall grass prairie habitat now remains. Recent battles led by Bev Sawchuk and S.O.S. (Save Our Seine), a community-based stewardship group in Winnipeg, have also resulted in the preservation of urban forest and river habitat previously destined for housing. There are many other such battles currently being waged across this country, too many to mention here. These are fine examples of how individual Canadians have made significant commitments to improve their local environment; although our awareness of the environment is increasing, we have a long road to travel yet.

It's often the little experiences that move me the most, like standing in a boreal forest in northern Manitoba and being surprised by an owl sweeping across my path. Or sitting on a log on a dreary day along the shore of Hudson Bay in northern Ontario, looking up only to find myself in the midst of a migrating herd of barren ground caribou. Or feeling the silence and isolation atop Ogilvie Ridge on the Dempster Highway in the Yukon. Or experiencing the aroma, greenness,

and extreme humidity of the temperate rainforest in the Carmanah Valley in British Columbia! Or the power of a Lake Superior storm! Or a crisp, foggy autumn dawn at Herbert Lake in Banff! Or the rugged, rocky coastline of the Gaspé! Or the windswept shoreline of Georgian Bay with its majestic, iconic white pines and wide, sweeping branches! Or the elusive but awe-inspiring displays of northern lights visible from many parts of this country. I could go on and on, but I think you get the picture! What often triggers my memory of a place has to do with the senses; other times it's the haunting cry of a loon or the way the light gently kisses the edge of a tree.

Photography has allowed me to explore the subtleties of the natural world in a way that complements the academic knowledge I gathered during my formative years. By walking a little slower, waiting a little longer, looking a little closer or deeper, I discovered the many nuances of colour, line, form, texture and pattern that can be so easily missed. Photography was the vehicle from which I was able to discover this great country. As a result of looking through my camera's viewfinder, I have become much more aware of my surroundings. Photography has heightened my ability to see and feel.

I love to capture fleeting moments of light. I often wait for the "sweet light," that time of day in the morning and evening around the rising and setting of the sun when the light is warm. But I photograph frequently in the middle of the day too. By keeping an open mind, I am able to continuously discover photo opportunities nearly anywhere. For me, enjoying the outdoor experience is as important as capturing the final image. A photograph can never replace the experience of taking the picture or of actually experiencing the moment. While the memory will fail, the photograph will be a constant reminder of a moment in time, an experience cherished.

Each of the images selected represents but a single view of one person's vision at a particular moment in time, just as you would see if you walked a mile in my shoes, at the same time, under the same light, in the same season. This is a work in progress which will evolve throughout my lifetime. It is my hope that this portfolio will inspire you to discover for yourself this most beautiful of countries, Canada!

Mike Grandmaison

The Photographs

Introduction

1. A solitary cottonwood covered in hoarfrost, in the middle of the open prairie is a testament to the hardiness of all living things found in this northern climate. Yet, in this struggle, there is simplicity, elegance and beauty to be found.

2. As you drive along Dempster Highway, you pass by the unglaciated Tombstone Range, part of the Ogilvie Mountains. You will see few tourists here, no roadside cafés, just mile after mile of awe-inspiring scenery. Autumn comes early in these parts, often peaking in late August or early September.

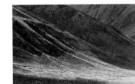

5. LEFT The David Thompson Highway, one of the less frequently travelled roads in the Rockies begins in Red Deer and winds westward to Saskatchewan River Crossing. As you approach the mountains, you witness some incredible scenery, particularly in the autumn.

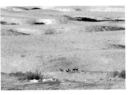

5. MIDDLE Mule deer, also known as "muleys," range over a varied landscape (mountains, prairie, badlands, desert, etc) and are seen here atop some rolling hills in southwestern Saskatchewan.

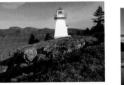

5. RIGHT The East Coast of Canada is dotted with lighthouses of every imaginable shape and size. You can often plan a travel route with just lighthouses in mind.

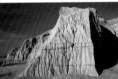

6. Tucked into southern Saskatchewan, the Big Muddy Badlands is an excellent example of an eroded sandstone landscape deeply carved by the glacial melt waters of Lake Agassiz. Castle Butte is its most familiar landmark.

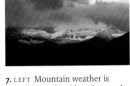

7. LEFT Mountain weather is always unpredictable at best and, on my first winter trip, I saw the sun only briefly during my five-day stay. Being prepared allowed me to capture this fleeting moment of light.

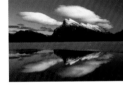

7. MIDDLE On the edge of the Banff town site is a very popular series of three lakes called Vermillion Lakes. I have photographed here on many occasions, and one of my favourite times occured in winter when lenticular clouds above Mount Rundle reflected in the partly frozen lake a few minutes before sunset.

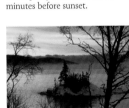

7. RIGHT The "North Shore" of Lake Superior is one of this country's remarkable drives, in any season. It's a rugged landscape sparsely inhabited but offers some of the most picturesque scenery. Driving back from visiting my family in Sudbury one holiday season, we drove past this small island near Rossport. The warm colours of dawn, along with the mist rising over the lake provided an opportunity I just couldn't resist.

8. LEFT Getting in close to your subject allows you to see things that you wouldn't normally expect. This small detail of a melting stream in late winter all but disappears in the summer only to return with greater force the following spring.

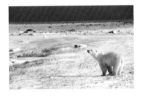

8. MIDDLE Churchill is recognized as the "Polar Bear Capital of the World." During early winter, large concentrations of polar bears congregate on the shores of Hudson Bay waiting for the ice to freeze so that they may once again resume feeding on seals.

8. RIGHT The prairie crocus is Manitoba's provincial flower emblem and one of the first wildflowers to bloom in the spring. This particular clump was photographed at the edge of a jack pine forest as the sun was setting.

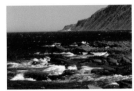

11. LEFT The Gaspé Peninsula offers some of the most spectacular and rugged coastal scenery on the East Coast. Hugging the shore of the Gulf of St. Lawrence, the winding Trans Canada highway functions as the main artery to countless little villages.

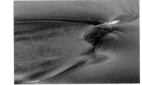

11. MIDDLE The great grey owl, also known as the "Phantom of the North," is one of the world's largest owls and the provincial bird of Manitoba. I am always in awe when confronted with this most beautiful of birds. I often choose to photograph wildlife as an incidental component of a landscape rather than focusing on a close-up portrait.

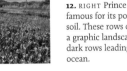

11. RIGHT The wild lily-of-the-valley, also known as the Canada mayflower, is a sure sign that spring is well underway. Like many of our native plants, this member of the lily family was brewed by Native peoples as a tea to cure headaches. This patch at the edge of Forillon National Park was one of the largest I have ever seen.

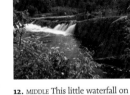

12. LEFT I love photographing water. On this particular Easter Sunday I lost myself discovering various compositions as the rising sun reflected off the rock and the cool blue waters.

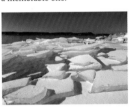

12. MIDDLE This little waterfall on the Whiteshell River is one that I revisit over and over again. Located near the Manitoba–Ontario border on the edge of the Precambrian Shield, this is a popular location for photographers, swimmers, and fishermen.

12. RIGHT Prince Edward Island is famous for its potatoes and its red soil. These rows of potatoes create a graphic landscape of light and dark rows leading the eye into the ocean.

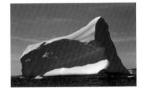

15. LEFT Off the northwest coast near Griquet, I witnessed a most awesome spectacle, an enormous iceberg up close. Tobias Miller of White Islands Boat Tours also treated me to legendary Newfoundland hospitality, making the entire experience a memorable one.

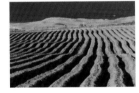

15. MIDDLE Toward the end of winter, the ice along Lake Superior's shore breaks up into large chunks and is moved around by the lake's powerful waves.

15. RIGHT Not far from Seven Persons, southwest of Medicine Hat, one arrives at Red Rock Coulee, the site of an ancient seabed of shallow waters. Here and there one finds red rocks called marine concretions. Some are intact, but many have broken as a result of weathering. Varying in size from 1.5 to 13 feet (0.5 to 4 metres), these mostly roundish rocks are thought to be the largest such structures in the world.

Autumn

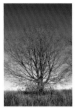

17. Autumn is a favourite season for many Canadians. Depending on where you live, you may experience autumn in all its glory. This is particularly true for those living in Central Canada (Québec and Ontario). Denuded of its leaves but rich in colour from a setting sun, this solitary deciduous tree evokes a sense of nostalgia.

20. A few kilometres above the world-famous Montmorency Waterfall, located within a short driving distance from Québec City, lies a large whitewater river called "La Montmorency." As it travels through various forest ecosystems in the Laurentians, it provides spectacular views of "wall-to-wall" autumn display from the mixed wood forest in the valleys.

21. As days shorten and cool off in the fall, the green pigments of leaves break down and are replaced by other coloured pigments, giving way to the brightly coloured leaves we are so accustomed to seeing at this time of year.

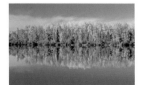

22–23. In autumn the forests of the Great Lakes -St. Lawrence forest region are something to behold. Dazzling displays of autumn colors are typical at this time of year and particularly brilliant on a clear, blue-sky day as evidenced in this tranquil scene of trees reflected in the still waters of the Ottawa River looking across to the province of Québec.

24. Fireweed, the flower of the Yukon, flourishes in disturbed grounds such as roadsides, cutover, or burned forests and swamps and avalanche areas. This perennial is named for its tendency to colonize the landscape following fires. As summer progresses, the plant blooms, creating a wash of pink in the landscape, but, come autumn, the leaves turn a bold, bright red.

25. Sumac is one of my favourite shrubs to photograph in autumn. Before it turns completely red, the leaves first begin to change various colours offering endless possibilities for photographs.

26. Banff National Park attracts some 4.5 million tourists annually from all over the world. The drive along the Icefields Parkway from Banff to Jasper offers some of the world's most breathtaking scenery, like Rampart Creek just off the road.

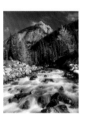

27. Another view of Mount Rundle, this one taken from above the Vermillion Lakes area at the height of autumn colour. The common deciduous tree in the area is the trembling or quacking aspen, a species of poplar that ranges across the country. Although the exact time for peak autumn colour in this area varies somewhat from year to year, the second and third weeks of September are often the best time for witnessing this glorious spectacle.

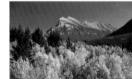

28. As you drive along the Dempster Highway, you pass by the unglaciated Tombstone Range, part of the Ogilvie Mountains. You will see few tourists here, no roadside cafés, just mile after mile of awe-inspiring scenery. Autumn comes early in these parts, often peaking in late August or early September.

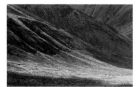

29. Kluane National Park not only represents a significant example of Canada's North Coast Mountains natural region, it is also part of a larger area protected as a UNESCO World Heritage Site. The St. Elias Mountains include Canada's highest peaks and the world's largest non-polar icefields. There are no roads leading into the park, but the grandeur of these mountains can be appreciated all along the Alaska Highway and parts of the Haines Road.

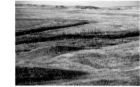

30. My favourite time of the year to visit this park is the fall when I can leisurely stroll along the shores isolating intimate landscapes from the "bigger picture." In this image, I cropped out all unnecessary elements to focus on the interplay of warm and cool colours provided by the reflected yellow birch leaves and flowing water respectively.

31. The highway straddling the north shore of the world's largest freshwater lake offers tourists some spectacular and breathtaking views of a lake that has many moods that change depending on whether there are clear, blue skies or brooding storm clouds. It inspired the Group of Seven to paint many of their great canvases here. A storm may develop quickly and suddenly. Much of this rugged beauty is preserved in one national park, Pukaskwa, and various provincial parks, including Neys, Superior, and Sleeping Giant.

32. Wetlands are some of the most productive ecosystems in the world, and conserving these important ecological areas should be one of our priorities. As habitats disappear and become more fragmented, animal and plant species are also disappearing at an alarming rate. We all have a responsibility to maintain the integrity of existing habitats.

33. Lenticular clouds form as a result of strong wind flow over rough terrain such as mountains and take on a characteristic lens shape. I spotted this particular cloud as I was returning to Whitehorse and drove frantically to find a decent foreground before the pink sunset light disappeared altogether.

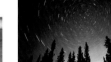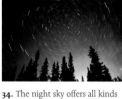

34. The night sky offers all kinds of photo opportunities. With the camera on a sturdy tripod, set for a long exposure and aimed at the North Star polaris, stars are captured on film as trails revolving around Polaris because the earth rotates on its own axis during the long exposure. The longer the exposure, the longer the star trail. To obtain a blue background rather than a black one, start your exposure when there is still some dark blue in the sky. Scouting beforehand for interesting foreground enhances the composition.

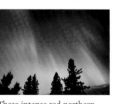

35. These intense red northern lights or aurora borealis were captured in November 2001 near Winnipeg. Displays like these are rather uncommon and since then I have experienced it only a couple of times. Generally, the displays are green, but sometimes the resulting light show is blue/violet or red. Auroras not only vary in colour, they also differ in shape, duration, and intensity. Seeing one of these celestial shows by yourself in the middle of nowhere is an experience you will never forget.

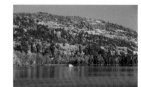

36. What a way to see the country—by boat! How romantic!

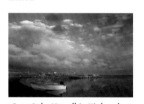

37. While some landscapes are bold, dramatic, and showy, others are much more subtle and require a little more time to take in the nuances or subtleties present. Such is the case with this grassland scene, which is essentially a study in tonality. It is now estimated that 75 percent of mixed prairie grasslands have been heavily altered.

38–39 Lake Newell in Kinbrook Island Provincial Park offers an excellent opportunity for bird watching and is considered one of Alberta's best waterfowl nesting and staging areas. It is also an inviting place for relaxing in this hot, dry area.

40. Arriving late in the day, hoping to capture prime autumn colours the following day, I awoke to a landscape heavily coated with fresh snow! Rather than be disappointed with the new reality, I proceeded to capture some very unique images.

41. The last light of the day strikes the branches of some aspen trees creating a composition based on lines and a contrast of light and dark.

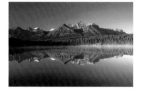

42. Herbert Lake is an icon of the Canadian Rockies if ever there was one. This is one of the few places where I have lined up with other photographers to photograph anything, especially at dawn! Although I've also had some significant waits at Moraine Lake, Peyto Lake, Niagara Falls and Peggy's Cove, this isn't very common in Canada.

43. The quintessential maritime scene! You could be in any number of small villages on the East Coast.

44. Another UNESCO World Heritage Site, this one preserving an excellent example of Aboriginal peoples' culture. For a few thousand years, bison herds were driven to their deaths off the cliffs. The Native peoples would then butcher the animals to provide their basic needs of food, clothing, and shelter. What attracted me to this area was the grasslands, particularly how the prairie meets the distant mountains in the background.

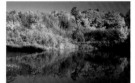

45. Not far from Seven Persons, southwest of Medicine Hat, one arrives at Red Rock Coulee, the site of an ancient seabed of shallow waters. Here and there, one finds red rocks called marine concretions. Some are intact, but many have broken as a result of weathering. Varying in size from 1.5 to 13 feet (0.5 to 4 metres), these mostly roundish rocks are thought to be the largest such structures in the world.

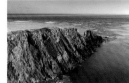

46. The cliffs, jutting westward from the Bay of Fundy, offer an excellent sunset photographic opportunity. If you move a few feet away and point in the opposite direction, you will have an excellent sunrise opportunity. A lighthouse at the left edge of the image warns boats of rocky hazards during heavy fog, which was the case when I first arrived here. The fog cleared within half an hour and revealed a most beautiful location. I also had a nice meal and slept over at the Lighthouse Kitchen and Guest House!

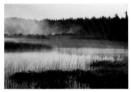

47. As the evening air cools in mid-summer, moisture from the warmer waters evaporate into mist and creates the quintessential northern scene.

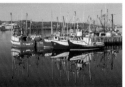

48. I have to thank my good friend Ian Tamblyn for this image. While visiting the area, Ian offered to take me around one of his favourite areas by canoe so that I might capture a few fall scenics. The colours were at their peak and the ride was relaxing and inspiring. Living in an area like that has to be inspiring, especially for Ian, who is one of Canada's finest musicians. He evokes the true spirit of the North in his eclectic choice of music and lyrics.

49. The display of autumn colours is enhanced when a dry late summer is followed by bright, sunny days and cool, but not freezing, nights in the fall. This combination of weather increases the production of anthocyanin pigments, which are responsible for the bright red and purple. Carotene and xanthophyll pigments produce the orange and yellows respectively. On the other hand, when autumn has many cloudy days and warm days, the display tends to be lacklustre. One of the most beautiful and colourful displays I have ever experienced is in the Gatineau Hills.

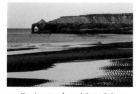

50. During my last visit to Prince Edward Island, it rained for the first couple of days. On my last day on the island, the clouds cleared, the sun shone, and I set out to cover as much country as I could. It was a glorious day and I visited some beautiful places, including this beach area with surrounding cliffs of red earth, the trademark of the island.

51. The first time I visited the flowerpots, the fog had rolled in and lingered for much of the day. Twenty years later, I was greeted again by fog, but this time the sun eventually broke through and created interesting opportunities different from the standard image you see published.

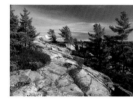

52. Killarney, with its majestic, mountainous wilderness of pine forests and sapphire lakes, is one of the crown jewels of the Ontario provincial park system. It is a canoeing paradise that I've experienced on numerous occasions. I once canoed the entire periphery of the park, meeting only one other canoe on the trip. This park also boasts excellent hiking trails; one is the Chikanishing Trail, which cuts through forest and pink granite to the shore of Lake Huron.

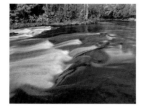

53. Known for its forests of maples, spruce bogs inhabited by moose, and countless waterways, the Algonquin area is popular year round. In the fall, the area explodes with colour. I captured a quiet moment as the Oxtongue River spilled over the falls at the western edge of Ontario's oldest provincial park.

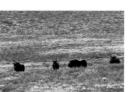

54. I had been hunkered down in a small gully for hours with two friends when a small group of muskoxen crossed a stream below us and moved up a facing ridge. Several of them picked up our scent as they passed and stared in our direction for several minutes. Time seemed suspended until they broke rank and vanished over the next hill. I could breathe again!

55. Nothing beats the riot of colour that covers the tundra in early fall. I had been wandering all day in a rolling landscape covered by the reds of bearberry and blueberry, accented by stands of tamarack (larches) turning shades of gold, when this caribou mother and calf strolled by. They watched me for many minutes with almost the same fascination I held for them before trotting off into this magical scene.

56–57. I have driven the North Shore of Lake Superior on countless occasions and I always look forward to the drive. In autumn, the forests near Sault Sainte Marie and Lake Superior Provincial Park beckon you to stop and explore. The leaves of maple trees typically change from green to red, orange and yellow before the foliage of other trees such as poplars and birches change.

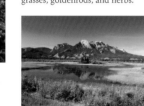

58. The Richardson Mountains are the northern extremity of the Rockies and are parallel with the Yukon–Northwest Territories border. From the top of Ogilvie Ridge along the Dempster Highway, I captured the glowing peaks as the sun was setting below the horizon. Alone and miles from anywhere, I felt a sense of isolation and discomfort. Though the drive was long and arduous, the scenery was simply breathtaking!

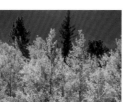

59. The size of this landscape is misleading without any clues for scale. This image is in fact an intimate view of wet sand on a quiet beach. Come here in the middle of summer and see if you can find a few inches of untrampled beach!

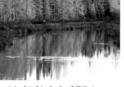

60. Although this red fox meandered in and out of the forest, it remained at the edge long enough for me to take a few frames, creating an environmental portrait that, for me, says much more than an in-your-face kind of photo.

61. As the sun reached the horizon on this cool autumn morning, it cast a warm glow on the marsh vegetation, which consisted of grasses, goldenrods, and herbs.

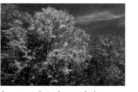

62. The eastern entrance of Jasper National Park abounds with mountain vistas, and the warm and cool colour combination of this autumn scenic makes me want to be there. For those who prefer quiet surroundings, Jasper provides just that. Teeming with wildlife—black and grizzly bears, bighorn sheep, mountain goat, mule deer, moose, elk, and coyotes—it is a photographer's paradise.

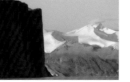

63. Nahanni National Park (also a UNESCO World Heritage site) was established to protect the Mackenzie Mountains Natural Region. A well-planned trip for the experienced canoeist will offer spectacular views of Virginia Falls and deep canyons (up to 1200 metres high) along the Nahanni River.

64. The David Thompson Highway is often considered one of the most spectacular gateways to the Rockies. Because it is a less travelled route, it is also a more tranquil alternative to the bustling Trans-Canada Highway.

65. It's this kind of wildlife imagery that I like best, one in which you discover the animal as you explore the scene. The bull moose was too busy feeding to notice me. The moose, the largest member of the deer family, is another of those wilderness icons and is beautifully captured against a backdrop of flaming larch (tamarack) trees.

66. Many have the perception that Saskatchewan is a flat, boring, and treeless landscape, but nothing can be further from the truth. By getting off the beaten path, you will discover a varied landscape of rolling hills, badlands, deserts, aspen parklands, and boreal forest such as this scene in Prince Albert National Park.

67. Not only is the Muskoka country known as "cottage country," it is also "maple country." Bright oranges, yellows, and reds liven up the landscape in September and October.

68. At Gibbs Fjord, on the northeastern coast of Baffin Island, one can explore some of the most spectacular fjords and sheer walls in the world. Adventurous folk including climbers, base jumpers, skiers and kayakers are drawn here to experience these overwhelming landscapes shaped by the powerful movements of massive glacial forces.

69 I arrived at this location on the shore of Great Slave Lake just as the sun was beginning to dip below the horizon. I worked feverishly, trying to find the best vantage point. The warm light was so pleasing as it cast an orange wash over the entire scene.

Winter

71. I enjoy the winter season. As a nature photographer, it allows me to capture impressions of the natural world that few experience. It is a quiet time, a time to enjoy solitude and to appreciate the unique qualities of yet another part of the natural sequence of events, at least in this northern climate.

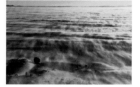

74. From the warmth of your home, you can explore the fascinating shapes of frost on windows, particularly toward sunrise or sunset as the warm glow of the light creates an interesting contrast of warm and cool colours.

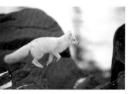

75. Two white pines stand alone by a fence as thin, pink clouds seem to emanate from their swooping limbs.

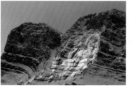

76. I'm always on the lookout for situations where a touch of light might create a dramatic scene. This often occurs in the mountains. These moments are fleeting and while sometimes you can't capture it on film, at least you'll always cherish the memory!

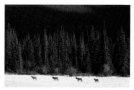

77. When I arrived to photograph the exterior of the Château Lake Louise, storm clouds had covered the sky. The sun would break through momentarily, but seldom with enough time to make an image, although I did manage a single photo. A little patience and some thirty minutes later, the sky cleared up!

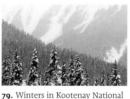

78. This image and the one across the page were taken in the same area but on different days. It snowed for much of the time I spent in the mountains on that occasion, although the sun would shine briefly, allowing me to catch just a glimpse of it.

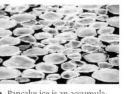

79. Winters in Kootenay National Park tend to be long and snowy. At the south end of the park lies Radium Hot Spring Pools in a picturesque setting below the cliffs of Sinclair Canyon. After a good day of winter shooting, I love nothing more than to soak my tired body in its warm waters, especially if it's snowing!

80–81. Blowing snow on the open prairie can make driving treacherous, but it also creates interesting image possibilities.

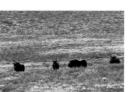

82. Pancake ice is an accumulation of slush in which a solid sheet of ice has formed on top. It is circular and has raised edges as a result of collisions with neighbouring pieces.

83. Elk or wapiti (meaning "white rump" in Shawnee) is one of the most common wildlife species you will encounter in the park. While composing for a landscape, I spotted this small group of elk crossing Vermillion Lake and I swung around quickly to capture an image.

84. Hoarfrost usually melts shortly after the sun rises, but, on occasion, it will linger all day and sometimes even into the next. As I drove around the countryside late one afternoon, I spotted this shelter belt of poplars. The backlit hoarfrost was simply stunning.

85. The prairie winter can be chilly to say the least. On this particular day, it was extremely cold, complete with a howling wind. I didn't dare stay out too long, and even the warm light of the setting sun didn't help much. That day I managed to freeze up two cameras and suffer some minor frostbite on my face.

86. I spotted this Arctic fox around the rocks on a few occasions as I drove by and thought that if I was prepared, I might be lucky enough some day to photograph it. I caught a glimpse of the fox on another occasion, and this time I had a camera close by with a telephoto lens. As there is seldom much traffic on that road, I stopped suddenly, reached for the camera, aimed at the fox through the open window, and fired a couple of shots. One of the two images captured the fox just as it leaped off a rock. Sometimes planning ahead and being prepared means everything!

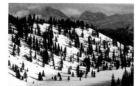

87. The Icefields Highway between Jasper and Banff is one of the most spectacular drives anywhere and in any season. Driving around the north end of Banff park close to the border of Jasper park, I stopped to photograph as the sun broke though and illuminated the mountain side but kept the peaks in shadow, creating a sense of depth.

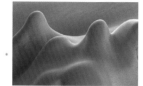

88. Snow simplifies many landscapes. Cluttered foregrounds and backgrounds often disappear under a blanket of freshly fallen snow, giving a sense of delicacy and subtlety to many winter images. Here the small trees are completely covered, resulting in a study of forms.

89. The first vantage point from which you see a subject is often not the most interesting. By moving around the subject and exploring, you can often find another viewpoint that affords a more exciting view. Looking down from a bridge, I isolated a small section of the frozen river into an abstraction.

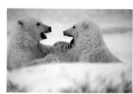

90. This is by far my favourite polar bear photograph. From the safety and comfort of a small tundra buggy, we spotted a sow and two cubs nursing in the distance. I photographed them for a few minutes when the two cubs suddenly left their mother, became very playful, started to roll around in the snow, and began sparring or play-fighting. These cuddly things will eventually grow up to be the world's largest terrestrial carnivores with adult males weighing between 1,000 and 1,800 pounds (454 and 817 kilograms).

91. On yet another occasion, the peak of Mount Victoria disappeared behind the clouds.

92. The Ottawa River/Témiskaming Lake functions as a natural barrier between the provinces of Québec and Ontario. Témiskaming means "deep river" in Algonquin.

93. Water tumbling from a rock outcrop along the highway west of Sudbury had frozen solid into many sheets of ice.

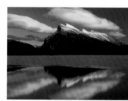

94. On the edge of the Banff town site is a very popular series of three lakes called Vermillion Lakes. I have photographed here on many occasions, and one of my favourite times occured in winter when lenticular clouds above Mount Rundle reflected in the partly frozen lake a few minutes before sunset.

95. Because the sun is much lower in the sky in winter, the light is also warmer for a longer period, giving photographers more opportunities to capture the "sweet light." As I wanted to photograph into the sun for greater impact, but still hold detail in the foreground, I used a neutral graduated filter to better balance the foreground and background detail.

96–97. Morning light shines on the eastern slopes of the Selkirk Mountains. The Selkirks are distinct from the Rockies and are nestled between the Purcell Mountains on the east and the Monashee Mountains in the west.

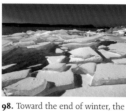

98. Toward the end of winter, the ice along Lake Superior's shore breaks up into large chunks and is moved around by the lake's powerful waves.

99. The "North Shore" of Lake Superior is one of this country's remarkable drives, in any season. It's a rugged landscape sparsely inhabited but offers some of the most picturesque scenery. Driving back from visiting my family in Sudbury one holiday season, we drove past this small island near Rossport. The warm colours of dawn, along with the mist rising over the lake provided an opportunity I just couldn't resist.

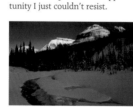

100. The Continental Divide runs along the top of the Rocky Mountains and divides the flow of water between the Pacific Ocean and the Atlantic Ocean. On the Alberta–British Columbia border, I photographed the last light caressing the mountain peak using a neutral graduated filter to balance the exposure between sky and foreground.

101. The Grass River has Manitoba's two highest waterfalls: Kwasitchewan Falls and Pisew Falls. Pisew Falls is the most easily accessible of the two and offers breathtaking vistas throughout the year via a long boardwalk. In winter, even at temperatures of –40 C, the water flows freely and at sunrise, you might be lucky enough to capture the fog as it rises.

102. A small river, partly frozen and snowbound, winds past Emerald Lake in Yoho National Park.

103. The sun sets over north Baffin Island on a flight from Clyde to Pond Inlet. In this area northeast of the Barnes Ice Cap, very little of humanity has set foot in this region. Looking down from 10,000 feet I yearn to explore the glorious landscape beneath me.

104–105. Some of my best photographs are taken in my own backyard, so to speak. I am very familiar and comfortable with my surroundings, so I quickly chose this stand of planted Scots pine to photograph this thick cover of hoarfrost.

Spring

107. One-hundred-foot- (30-metre) high Beulach Ban Falls greets the visitor after a short side trip from the main Cabot Trail that runs through Cape Breton Highlands National Park.

110. It is not uncommon for the snow to fall when the prairie crocus is blooming, and you are almost guaranteed frost on the flowers on many mornings too. As the sun rises and the ambient temperature warms up, the petals eventually open up in a parabolic shape, funnelling the sun's rays into the flower, making it very attractive for its insect pollinators like bees, flies, beetles, etc.

111. In the spring, I'm always anxious for my neighbour's apple tree to bloom because I might see a northern (Baltimore) oriole feeding in the tree. Planting trees and shrubs that attract wildlife not only increases the aesthetics of your neighbourhood but also provides you with pleasure when you sit in your backyard.

112. The name Rose Blanche is a corruption of "Roche Blanche," meaning "white rock," referring to the white quartz outcroppings in the area. This is also the site of an old historic stone lighthouse built in 1873 and the last remaining granite lighthouse in the country. This little fishing village is also very photogenic.

113. I always look forward to the flushing of the first leaves of the trembling aspen in the spring. That delicate lime green colour is so inviting! You aren't likely to miss it if you look for it as it is the most widely distributed tree species in North America. Because aspen reproduce mostly by cloning, it tends to grow in pure stands.

114. Wetlands are an important habitat for many species of wildlife and the moose, imported to the province in 1904, is no exception. The Newfoundland landscape has provided a haven for the moose, so much so that it is now considered to be one of the densest populations in North America. While driving on the northwestern tip of the island at dusk, I experienced this first hand; I counted forty-six moose in less than an hour and that's just what I could see quickly on the side of the road.

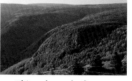

115. This park was the first national park to be established in the Maritimes and is situated at the northern tip of Cape Breton Island. One of Canada's most scenic drives takes you to both sides of the peninsula where you will experience breathtaking vistas of coastal scenery whether you travel by car, bike, foot, or sea kayak.

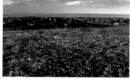

116–117. The Churchill area, where polar bears concentrate in early winter waiting for the pack ice to form on the Hudson Bay, is also one of the most accessible places to experience the low Arctic. Located just north of the tree line, this area is for the most part treeless and contains mostly Arctic species. In early July the tundra (Finnish for "barren land") can be completely blanketed by white mountain avens. This area is also an excellent place to view northern lights, beluga whales, and Arctic and sub-Arctic bird species.

118. Meaning "river of long tides" from the Micmac, Kouchibouguac preserves an interesting mosaic of bogs, salt marshes, tidal rivers, sheltered lagoons, and freshwater bodies as well as shifting dunes, fields, and forests. Here you'll find the second largest tern colony in North America.

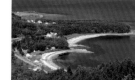

119. The Gaspé Peninsula is surrounded by ocean, mostly the Gulf of St. Lawrence, and it offers incredible seashore views, especially if you can gain a higher vantage point by driving to the summit of one of the many hills in the region. Seen below is the small village of Grande-Anse, typical of the area. This coastal highway is as breathtaking as the Cabot Trail, the north shore of Lake Superior, the Ice Fields Parkway in the Canadian Rockies, the Sea-to-Sea Highway north of Vancouver, and the Dempster Highway in the Yukon.

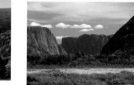

120. This UNESCO World Heritage site has towering freshwater fiords carved out by glaciers. It also provides a rare example of the process of continental drift, where deep ocean crust and the rocks of the earth's mantle lie exposed. If you hike to the top on a sunny day, a most impressive view awaits you. For those who want a different experience, a tour boat takes visitors down the fiords, but be sure to book ahead.

121. On a smaller scale but no less important is the tall grass prairie habitat in southern Manitoba. The tall grass prairie ecosystem is one of the three most threatened ecologically significant habitat in North America. It is estimated to be less than 1 percent of its former range. Here, a lone cottonwood at dusk stands as a sentinel over the prairie.

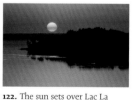

122. The sun sets over Lac La Biche where you can find an old growth boreal forest in Sir Winston Churchill Provincial Park, situated on an island in Lac La Biche.

123. Can you ever imagine yourself photographing ice floes on July 1, around midnight no less? Well, the Hudson Bay shoreline near Churchill can provide you with such an opportunity. One must always be careful when walking the shallow waters exploring ice floes as polar bears, although not as common at this time of year, could be lurking nearby.

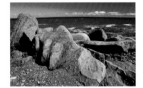

124. Although I was born in north-central Ontario, I have always had an affinity for the Gaspe. Perhaps there is something in the blood—my paternal grandfather's family was from this area. The smell of the sea is one of the first things I look forward to experiencing each time I return.

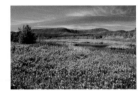

125. The wild lily-of-the-valley, also known as the Canada mayflower, is a sure sign that spring is well underway. Like many of our native plants, this member of the lily family was brewed by Native peoples as a tea to cure headaches. This patch at the edge of Forillon National Park was one of the largest I have ever seen.

126. Bog laurels offer a dazzling display of wildflowers, carpeting the boggy terrain near Miramichi.

127. Pussy willows are a sure sign that spring has sprung! Willows produce a compound called salicin, which has similar properties to the active ingredient salicylic acid in some over-the-counter painkillers such as Aspirin. In fact, many of our drugs and remedies come from plants.

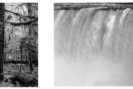

128. One of my most incredible experiences in the wilderness was entering the northern section of the Carmanah-Walbran temperate rainforest. After a long, slow, dusty drive down a logging road through clear-cut after clear-cut, my family and I finally reached the edge of the forest. After walking over a large tree that served as a natural bridge over Carmanah Creek, we entered the rainforest and I was struck by the incredible beauty, lushness, greenness, humidity, and aroma! What a place! I can still vividly recall that experience.

129. Who has not tasted delicious pie or jam made from Saskatoon berries? The shrubs can be found from Ontario westward growing in a wide range of climatic conditions.

130. The Long Range Mountains is the first ecoregion you encounter as you head north from Port aux Basques and continue to the northwestern tip of the island. It has some of the oldest rock on the island. The flat-top nature of these mountains have led locals in the Cordroy Valley area to refer to them as the Table Mountains. These mountains are much older than the Rockies and at one point used to be much higher as well.

131. In spring, I like to get out and photograph as often as I can because the landscape changes so quickly. Not long after this image was taken, the ice melted away and the scene had changed forever. Photography allows me to explore the great outdoors and keep in touch with my creative side.

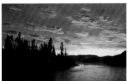

132–133. Niagara Falls is one of the most visited natural wonders of the world. The Horseshoe Falls are 180 feet (55 metres) high and 2,460 feet (750 metres) wide. The falls were formed about 12,000 years ago as the ice retreated during the last ice age. They were originally located 7 miles (11 kilometres) downstream! The town is known as the honeymoon capital of the world. Guess where my parents went as newlyweds in 1950!

134. A meandering river in central Alberta has an oxbow at the bottom of the image. The newer and narrower channel will eventually cut off the old channel from the rest of the river. Rivers are dynamic systems and channels change constantly.

135. The Canada violet is typical of a moist coniferous forest habitat like that found at the bottom of Baldy Mountain, Manitoba's highest point. OK, so it's not the Canadian Rockies, but if you climb the observation tower at the summit, you'll witness a great view of the boreal forest surrounded by prairie.

136. At the eastern end of the Gaspé Peninsula, a block of limestone (1,437 feet/438 metres wide by 289 feet/88 metres high), carved by the wind and sea over 350 million years, juts out from the Atlantic Ocean. At low tide, you can walk over to the rock and see fossils from millions of years

ago. Nearby, on Bonaventure Island, is the North Atlantic coast's largest bird colony, which is home to gannets, kittiwakes, murres, puffins, and more.

137. Just outside of Haines Junction, the Dezadeash River reflects a fiery sky at dawn. If you turn around 180 degrees, you can photograph the sun striking the St. Elias Mountains. Some places seem to have it all!

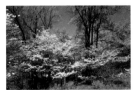

138. On the outskirts of the Royal Botanical Gardens in Hamilton, I spotted some flowering dogwoods, and was surprised to find that it grows in Southern Ontario as an understory tree in deciduous forests.

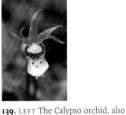

139. LEFT The Calypso orchid, also known as the fairy slipper, grows across the boreal forest region. It flowers from late April to July, depending on where you live.

139. RIGHT The Manitoba maple is most commonly found in Manitoba and Saskatchewan. The seeds, which overwinter on the tree, are an important food source for birds and small mammals.

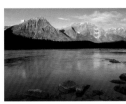

140. The spring landscape of Prince Edward Island is fascinating in part because of the red soil, which is due to the high iron oxide (rust) content of the red sandstone. As crops begin to grow, a kaleidoscope of colour emerges.

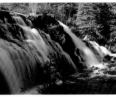

141. The temperate rainforest of British Columbia 's west coast is a result of high precipitation and moderate temperatures. This forest is dominated by conifers, including western red cedar, Sitka spruce, western hemlock, and amabilis fir. These giant trees can be 2,000 years old and measure 66 feet (20 metres) in circumference. A long boardwalk facilitates walking through parts of the Pacific Rim Trail.

Summer

143. The Niagara Escarpment is a massive ridge of sedimentary rock that originated some 450 million years ago. Measuring about 1,429 miles (2300 kilometres) long, the escarpment features many waterfalls, one of the most outstanding being Webster's Falls at 134.5 feet (41 metres) tall. It offers a spectacular view of the gorge, which is also rich in fossils. The Niagara Escarpment was named a UNESCO World Biosphere Reserve in 1991.

146. Considered a weed by some, devil's paintbrush or orange hawkweed brightens up the landscape of fields and roadsides.

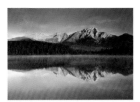

147. The Athabasca River, the largest water system in the park, originates from the glaciers of the Columbia Icefield, pours over Athabasca Falls, the most powerful falls in the mountain national parks, then empties into Lake Athabasca in northeastern Alberta. Throughout the park, this river offers many wonderful vantage points to view the mountains.

148. Most of the falls in this country are relatively unknown, including this one on Mink Creek, about 10 miles (17 kilometres) west of Marathon on the Trans-Canada Highway. A short, forested trail from the highway leads to the bottom of the falls. It would take a few lifetimes to discover them all!

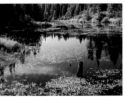

149. Lichens are truly amazing plants. They are comprised of two species from two very separate kingdoms (fungi and algae) together in a symbiotic (mutually beneficial) relationship. Lichens are often the first form of life to colonize rocks and are also excellent biological indicators of environmental change. The rocks around Churchill are well known for their incredible display of lichens.

150. The outcrops of Precambrian Shield are quite evident in the Churchill area. I 'm always mindful of the potential for polar bears lurking behind any one of these rocks as polar bears are not only masters of camouflage, they also have an excellent sense of smell.

151. Pyramid Mountain, part of the Victoria Cross Range, is reflected in Pyramid Lake as the rising sun brightens the top of the range while a light mist rises from the waters. Pyramid is the highest peak in the vicinity of the Jasper town site.

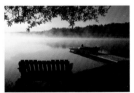

152. I love ferns and enjoy photographing their delicate forms, whether it's in the temperate rainforest or a boreal forest such as this amazing understory in a poplar forest. Ferns are a very ancient family of plants and most prefer a moist habitat.

153. Most Canadians (77 percent) live in cities and are surrounded by buildings, roads, concrete, and vehicles. With the exception of some parks and urban green spaces, we seldom experience the natural world. How many of us have ever left our native province to explore the beauty in a neighbouring province? There is so much to see and so little time.

154–155. This is my favourite piece of Canadian real estate and the view from my parents' cottage in Sudbury, situated just within the city limits. I grew up here and share many fond memories of it with many people. This was my dad's pride and joy until he passed away recently. I remember making this photograph very clearly. It was such a calm, serene morning, my family asleep in the cottage, my dad waving to me from the porch with a cup of coffee in his hand while I was trying to capture the quintessential cottage scene. I can still see him sitting on the bench, enjoying the view. Photographs can be such powerful reminders of experiences past.

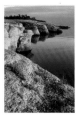

156. A setting sun bathes, with a warm wash of colour, the limestone cliffs along the shore of Lake Manitoba, the world's tenth largest freshwater lake

157. Lupines and red soil are two of Prince Edward Island's icons. Although Canada's smallest province in terms of size and population, it sure packs a punch in terms of beauty. Some 1.2 million people "from away" visit "The Island."

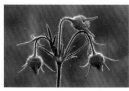

158. The three-flowered avens or prairie smoke is another prairie plant I look forward to in early summer. It can often carpet meadows, creating a wash of red colour.

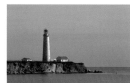

159. This lighthouse, at the entrance to Forillon National Park, is quite a photogenic one. And it was from this place in 1759 that the French caught sight of General Wolfe's fleet navigating toward Québec City.

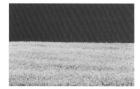

160. Manitoba has the greatest diversity of colourful crops in Canada. In the Pembina Hills, southwest of Winnipeg, the hilly country offers a different vantage point to explore familiar subjects in different ways. Making extraordinary images of ordinary subjects is something I often try to achieve.

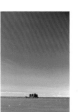

161. What is someone's backyard can often be someone else's exotic or travel destination! This image and the one opposite are excellent examples of simplifying a scene, including only the essentials and cropping everything else out, resulting in very graphic images.

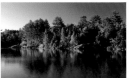

162–163. With one-tenth of the world's forest cover, 7 percent of the world's renewable freshwater and 25 percent of global wetlands, Canada is an incredibly resource-rich country. We must, however, ensure that we preserve much of our remaining wilderness areas in parks and preserves. Scenes like this early morning reflection exist everywhere across the country and we need only make a small effort to appreciate them.

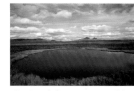

164. When it rains, the clay surrounding these marine concretions is extremely slippery, making walking in the area fairly treacherous. In contrast, on hot days you should be mindful of rattlesnakes in the area.

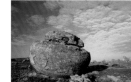

165. There are two villages in Newfoundland called Frenchman's Cove! The one depicted here is on the western coast, near Corner Brook, where a fishing boat floats in the calm waters of the Humber River as the setting sun sets the neighbouring cliffs aglow.

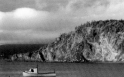

166. From a hillside along the Gaspé, a small, unassuming little waterfall flows quietly, emptying into the Gulf of St. Lawrence.

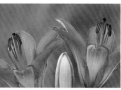

167. The wood lily is Saskatchewan's floral emblem, and is commonly found in moist meadows, edges of aspen groves, thickets, and roadside ditches. My main interest in university was botany, the study of plants and that interest has remained with me ever since.

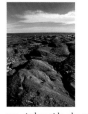

168. Canada has 25 percent of the world's wetlands. The drive along the Dempster Highway has so much to offer, including mountain ranges, tundra, the crossing of the Arctic Circle, marshes, and wildlife. It's an unforgettable journey.

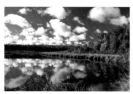

169. The boreal forest covers much of northern Saskatchewan, and Prince Albert National Park protects an excellent example of it. Here you'll find the only fully protected nesting white pelican colony in Canada, rare fescue grasslands, free-ranging bison and other wildlife, and many lakes and ponds.

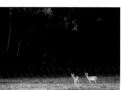

170. Like cabooses and grain elevators, lighthouses are disappearing, although some tourist associations are making an effort to rekindle an interest in them by designating special lighthouse routes. This one on the Bay of Fundy was still quite active and you had to plug your ears when the foghorn sounded.

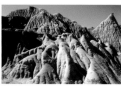

171. Seventy-five million years ago, in a subtropical climate much like that of today's northern Florida, roamed thirty-five species of dinosaurs. This area of eastern Alberta is now protected as Dinosaur Provincial Park and con-

[continued at top of next column]

tains some of the most important fossil discoveries ever made. It is a haunting and compelling landscape of lines, shapes, and forms that has also been protected as a UNESCO World Heritage Site.

172–173. Against a backdrop of the Coast Mountains, this wetland and upland forest habitat helps protect local wildlife including mammals, birds, amphibians, reptiles, fish and insects. The area borders on Pitt Lake, the largest fresh water tidal lake in North America. The area may be explored via dyke-top trails, forest trails, covered viewing towers and covered hillside viewing platforms.

174. At low tide, the rocky shore along the Gulf of St. Lawrence is revealed.

175. I captured these two white-tail deer fawns in a clearing at the edge of an aspen forest. The white spots on their coat is an adaptation to help in camouflage when lying down in a sun-dappled forest, but I doubt it helps them much here. Fawns lose their spots when they are about three months old.

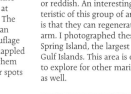

176. Vermillion Lake is depicted from a high vantage point on the road up Mount Norquay as the sun begins to cast its long shadows. It's amazing how different a familiar scene can appear from a unique angle.

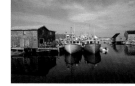

177. This Gaspé coastline is not for the meek!

178. A long exposure captures an intimate view of swirling seawater as the sun begins to sink below the horizon.

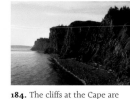

179. Kananaskis Country is a group of provincial parks south of Banff National Park. If you would like to explore something a little different, consider this less-travelled road that has mountain scenery as magnificent as anywhere else in the area. Here, the sun just begins to illuminate the mountains while the Kananaskis River will remain in the shadows for a little longer yet. Later that day, I came across a grizzly bear.

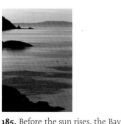

180. Ochre sea stars or starfish come in a various colours, including brown, yellow, purple, orange, or reddish. An interesting characteristic of this group of animal is that they can regenerate a lost arm. I photographed these on Salt Spring Island, the largest of the Gulf Islands. This area is excellent to explore for other marine life as well.

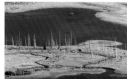

181. On the opposite coast, Peggy's Cove is probably the most photographed coastal village in Canada. It was twenty-five years before I returned, and the village seemed much the same as I remembered it. It remains a picture-perfect postcard scene.

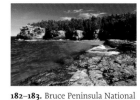

182–183. Bruce Peninsula National Park preserves one of the largest remaining expanse of forests in Southern Ontario as well as a rugged limestone landscape along Lake Huron.

184. The cliffs at the Cape are made of basalt from the Triassic age and at least six separate lava flows have been counted in this area. The tides here are some of the largest in the world and extreme caution should be taken when exploring the beaches.

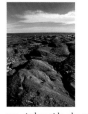

185. Before the sun rises, the Bay of Fundy displays contrasting cool and warm colours as the wind picks up, creating texture on the surface waters.

186. Bunchberries, wood ferns, and moss are often found on the forest floor of the Acadian forest in Fundy National Park, which preserves some of the last wilderness areas in southern New Brunswick.

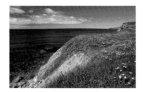

187. Along with the works of the Group of Seven painters, I feel great affinity for the paintings of Emily Carr, who spent a lifetime trying to capture the spirit of the rainforest near her home. She finally moved away from Victoria to live in a trailer nearby in Goldstream Provincial Park where this image was made.

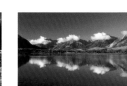

188. Lower Waterton Lake is one of the first sights you come to as you enter this national park. In 1932, the park was joined with Montana's Glacier National Park to form the Glacier-Waterton International Peace Park, a world's first.

189. Another landscape from Newfoundland that reminded me of the Yukon.

190. I sat around for over an hour on the grassy meadow alongside Two Jack Lake following an early rise. The sun was warm and I felt quite relaxed. I amused myself by studying the behaviour of the Columbian ground squirrels in front of me and then started to follow them through my viewfinder. Wildlife photography requires a lot of patience, some decent equipment, and a little luck!

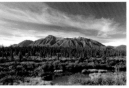

191. Many French-speaking Acadian settlers from Cape Breton settled in this area at the end of the eighteenth century. Other settlers included the English, Irish, Scottish, and Micmac. From the dandelion-covered cliffs at St. George's Bay, one can see forever.

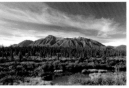

192. Weather is always a challenge for photographers. When you travel long distances in the hopes of obtaining beautiful images, weather can be your worst enemy. While on some occasions you may not be too lucky, on others, like this particular day, you count your blessings.

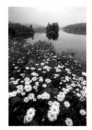

193. I reached Prince Rupert by road and was greeted by an evening of sun. The next day, cloud and fog had returned and added atmosphere to these roadside daisies.

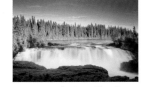

194–195. As the Grass River drops 13 meters (42.7 feet), it shifts direction as it meanders through a gorge where tourists may experience the area via a wooden boardwalk and bridge leading to hiking trails. The Grass River passes through a vast wilderness of lakes and boreal forest, crossing 5 provincial parks and 12 communities as it empties into Hudson Bay via the Nelson River.

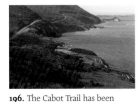

196. The Cabot Trail has been referred by some as the most beautiful drive in North America. Well, you won't be disappointed. The trail loops around the northwest end of Cape Breton Island and covers some 186 miles (300 kilometres) of rugged and stunning scenery. One of the main attractions is Cape Breton Highlands National Park. It's simply one of the prettiest drives around!

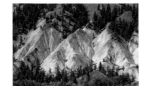

197. I made this image a few years ago while returning from a family visit at the cottage on Canim Lake. I was captivated by the forms of the clay hills and the mosaic of colour.

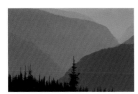

198. From the summit of Mount Revelstoke, the views of the Columbia Mountains are breath-taking. By the middle of August, wildflower displays are at their peak and can be appreciated from the meadows in the Sky Trail. Elsewhere, the Hemlock Grove Trail lets you explore the rainforest where an ancient stand of western hemlock trees is easily accessible via a short walk along a boardwalk.

199. One of this country's famous beaches, Long Beach, is synonymous with the Pacific Ocean. I've camped many times in the rain here, but also witnessed some amazing sunsets too.

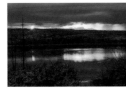

200. Travelling along the Klondike Highway after a few days of rain, I saw a glimmer of hope in the western sky. I stopped along the narrow highway to capture the sun breaking through the storm.

201. A full moon rises over the prairie landscape.

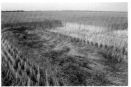

202. Manitoba is alive with colour in the summer from the varied crops planted in the southern landscape. Here, the harvest of golden flax has begun.

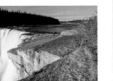

203. Twin Falls Gorge Territorial Park, just north of the Alberta border, is located on the Waterfalls Route. The Hay River flows into one of the most dramatic and spectacular waterfalls in the area: Alexandra Falls. A short distance downstream you'll find Louise Falls. Other beautiful falls within a short distance away are McNallie Creek Falls and Lady Evelyn Falls.

204–205. Newfoundland has its share of inclement weather. While in the Corner Brook area, I drove down the south shore of the Humber Arm and experienced some very interesting storm light.

206. Chasing rainbows is not the easiest thing to do because, by the time you find a nice foreground, the rainbow has often disappeared. In this case, I was already photographing sunflowers when the storm came.

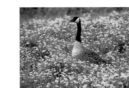

207. Fog bows or white rainbows occur when fog, rather than rain, is present. Polarizing filters can enhance the effect of both types of rainbows.

208. At the turn of the nineteenth century, populations of Canada geese were brought to near extinction by over-hunting and mass killing for market. After very successful efforts to revive the populations, many people think we now face an urban problem, although I personally don't mind living with the geese in my backyard. If you want nature, you must take it on its own terms.

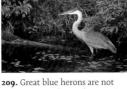

209. Great blue herons are not easy to approach. On this occasion I used the car as a blind and left the engine running so as not to disturb the heron. Slowly I crept closer and managed to fire off a few images before it flew off. I always think of great blues as symbols of the wilderness, particularly when I paddle in a canoe.

210. The red cliffs along the Percé coastline are the end of the Appalachian range on the mainland, although they continue into Newfoundland as the Long Range Mountains. The Appalachians are much older and more worn than the Canadian Rockies.

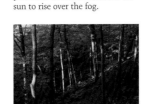

211. I photographed this Indian paintbrush in a field outside Valemount. That particular July it snowed through the Rockies as we tried to cross over to British Columbia. Although we managed to avoid most of the snow, the following morning temperatures had dipped near freezing.

212. These harebells were photographed in July when a hard frost hit the area.

213. The great grey owl, also known as the Phantom of the North, is one of the world's largest owls and the provincial bird of Manitoba. I am always in awe when confronted with this most beautiful of birds. I often choose to photograph wildlife as an incidental component of a landscape rather than focusing on a close-up portrait.

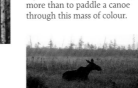

214–215. The Yellowhead Highway leading to Prince Rupert at the edge of the Pacific Ocean offers spectacular scenery including numerous streams cascading down mountainsides. You can walk through lush old-growth coastal forests, try sports fishing, kayak along the coast or ride a ferry through the Inside Passage or to the Queen Charlotte Islands.

216. The white pine is my favourite tree, perhaps because it's a symbol of the area I was born in. I was driving around with a colleague when we spotted this particular tree and waited for the sun to rise over the fog.

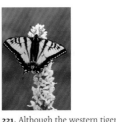

217. The Bruce Trail, a world-famous hiking trail, runs along the Niagara Escarpment from Queenston to Tobermory. At almost 497 miles (800 kilometres) long, it is Ontario's lengthiest trail. Some sections of the trail are well known for large varieties of orchids and wildflowers.

218. The sight of water lilies always reminds me that summer is in full swing. I love nothing more than to paddle a canoe through this mass of colour.

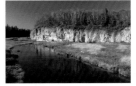

219. The moose is an odd looking animal, but has an impressive majestic look. For me, it's a symbol of the north country. As I approached the marsh at Whirlpool Lake at sunrise, a moose was bedded down close by. We both surprised each other and I quickly spread the legs of the tripod and managed two exposures before it got up and trotted off. That made my day!

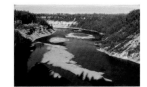

220. I have an affinity for dry areas, places like deserts, badlands, etc. Perhaps it's because of the apparent simplicity of these systems, the often uncluttered look. In Manitoba, there are active sand dunes in the Carberry Desert of Spruce Woods Provincial Park.

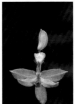

221. Although the western tiger swallowtail is a familiar species in Western Canada, what is less common is the plant on which it is feeding on, the northern white bog orchid.

222. These rolling hills are one of my favourite areas in southern Saskatchewan. There is a simplicity of colour and form about this area that I like; it reminds me of a grassy desert. The pronghorn antelope, one of the fastest land mammals in the world, roams freely here.

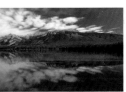

223. Wood Buffalo is Canada's largest national park and one of the largest in the world, established to preserve the last remaining herds of bison in northern Canada as well as its habitat. The park is also an important breeding habitat for whooping cranes. While in 1964 only 42 of these large birds were found, in 2004, there were 450 birds, 192 of which were from the wild flock in Wood Buffalo.

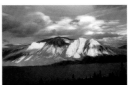

224. A view of Nares Lake alongside the Klondike Highway in Southern Yukon. Not far from here is the Carcross Desert, affectionately known locally as the smallest desert in the world.

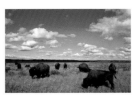

225. The Hay River near Enterprise follows its course as it nears its destination to Great Slave Lake, the deepest lake in North America and one of the world's largest.

226. A captive herd of plains bison feeds on rough fescue grasslands. The bison, improperly referred to as buffalo, used to roam the prairies freely in numbers too large to count. Riding Mountain National Park, surrounded by agricultural land, also preserves a fine example of the Manitoba Escarpment.

227. There is always an aura of mystique about orchids. I personally find great joy in discovering one in the field. This little grass pink grows in wet areas, so you may have to get your feet wet to see one. Although one normally thinks of orchids as living in tropical forests, Canada has about seventy-six different species.

228–229. Glacially fed Lake Annette is one of the most popular day use areas in Jasper Park. It is only one of many beautiful lakes near town; others include Patricia Lake, Pyramid Lake, Maligne Lake and Lake Edith. Although traveling great distances is often required to experience specific sites, it is not a prerequisite to experiencing nature. Many of us can experience nature in the relative comfort of our own "backyard."

Canada

was designed by Peter Maher and typeset in
Cartier, the first text typeface designed in Canada
by Carl Dare in 1967 and since reworked by
Rod McDonald. The display face is Voluta.
Scans are by David Carson of Quadratone.
Printed and bound by
Friesens of Altona, Manitoba
on 100lb Luna Matte.
Spring 05